For Philippa

Visual Culture

Second Edition

**Richard Howells
Joaquim Negreiros**

polity

ISBN-13: 978-0-7456-5070-8
ISBN-13: 978-0-7456-5071-5(pb)

A catalogue record for this book is available from the British Library.

Typeset in 10.5 on 12pt Plantin
by Servis Filmsetting Ltd, Stockport, Cheshire
Printed and bound in Great Britain by
TJ International Ltd, Padstow, Cornwall

The publisher has used its best endeavours to ensure that the URLs for external websites referred to in this book are correct and active at the time of going to press. However, the publisher has no responsibility for the websites and can make no guarantee that a site will remain live or that the content is or will remain appropriate.

Every effort has been made to trace all copyright holders, but if any have been inadvertently overlooked the publisher will be pleased to include any necessary credits in any subsequent reprint or edition.

For further information on Polity, visit our website: www.politybooks.com

CONTENTS

ILLUSTRATIONS

PREFACE TO THE FIRST EDITION: A NOTE FOR LECTURERS, TUTORS AND FACULTY

The purpose of this book is to introduce university and college students to the analysis of visual culture. It does so by seeking to increase their visual literacy. It does not aim to provide solutions to the meanings of specific visual texts, but instead to equip students with the means to discover for themselves what and how such texts communicate. Its approach is broadly theoretical, but it makes sense of the theory by the use of examples. Its scope is wide: it ranges from fine art to photography, film, television and new media. It does not seek to impress fellow scholars with the depth of my knowledge, but rather to explain sometimes complex concepts to new readers with clarity and even a sense of enjoyment.

In encouraging students to greater degrees of visual literacy, this book also acquaints them with the work and thought of important – and sometimes canonical – figures in the field. In doing so, it seeks not to serve as a substitute for them but, rather, as an introduction to them. It also brings a variety of diverse and sometimes competing approaches under one volume. It evaluates both their benefits and their shortcomings while at the same time suggesting that they may sometimes be used in concert rather than in disharmony. It aims, ultimately, to equip (and sometimes even to provoke) students to look for themselves.

To an extent, therefore, this is a 'how-to' book. It is a primer for the practice of looking. In this way, its approach echoes something of the 'practical criticism' of I. A. Richards and F. R. Leavis. It advocates a close and active scrutiny of the (visual) text by the reader him- or herself. It does not aim to map an entire intellectual history of the whole of visual theory. It focuses instead on basic concepts and seminal – even classic – authorities. It aspires to engage student readers and then to lead them towards the pleasure and the value of visual analysis. Finally, it hopes to urge them to use the concepts and authorities used here as departure points towards further reading, study and debate. It does not aim to be the last

word in visual culture. For many of its readers, though, it would be happy to serve as the first.

Many people have contributed to the writing of this book with their expertise, advice, encouragement and support. Prominent among them have been: Kate and Richard Crowder, Sarah Dancy, Henry Devlin, David Gauntlett, Stephen Hay, Sheila, Bill and Philippa Howells, Sarah Howson, Fred Inglis, Steve Lax, Brent MacGregor, Gill Motley, Victoria and Matthew O'Dowd, Terry Prendergast, Emyr Rees, Hilary Savage-Martin, Leanda Shrimpton, John R. Stilgoe, Ann Sutton, Elwin Sykes, Pam Thomas, John B. Thompson, Carolyn Twigg and Tony Wilkinson. I am indebted, finally, to my undergraduate students at the University of Leeds in England and my summer school students at Phillips Academy in Massachusetts. They have allowed me to hone the arguments and approaches put forward in this book, and have never slept – audibly – in my presence.

Richard Howells
Saltaire

PREFACE TO THE SECOND EDITION

In the eight years since the first edition of *Visual Culture*, the importance of the topic has grown still further. The first edition began with a rallying call for visual literacy, and in the years that have followed, the importance of this skill – both to scholars and to citizens – only continues to increase.

It is not simply the multimedia, celebrity-intensive cycle of twenty-four-hour information that impinges upon so much of our life on a seemingly escalating basis. We continue to be surrounded by the whole assemblage of fine art, photographic, filmic, televisual, commercial and new media imaging that was at the core of the first edition. Technologies have continued to change, adding to both the prevalence and the availability of visual culture. It has become still more pervasive and sophisticated.

Since the first edition, a new round of world events has become imprinted on our visual memory. Iraq was invaded for a second time and the president executed, Hurricane Katrina devastated New Orleans, Facebook was launched, a tsunami caused massive loss of life in South East Asia, terrorist attacks hit central London, Michael Jackson died and Barack Obama was elected the first African-American president of the United States.

Two additional events stand out to the student of visual culture: in May 2003, President George W. Bush held a news conference on the deck of the aircraft carrier the USS *Abraham Lincoln*. In the golden glow of twilight he was backed by loyal servicemen and a red, white and blue banner reading 'mission accomplished'. We could have written an entire chapter analysing this image alone. Suffice to say in this introduction that the event made a classic case study for Frank Rich – the former theatre critic of the *New York Times* who has forsaken Broadway to write instead about politics and news. His 2006 book *The Greatest Story Ever Told: From 9/11 to Hurricane Katrina* was a study of what the *New York Times* called 'the creation of false reality'.[1] *Harvard Magazine* described these as 'pseudo events' and wrote of the need for Rich and others to

'distinguish the smoke of real fires from the ubiquitous fumes of smoke-making machines'. They continued:

> Image wins out over reality more and more in the battle for attention and belief. Virtually every public event now arrives filtered through a lens, laptop computer, or recording device, and hence nearly all our daily news has been 'produced' and woven into some kind of narrative. Old-fashioned, relatively unmediated reality at times appears obsolete.[2]

Whether one's politics are liberal or conservative, it remains hard not to conclude that sophisticated image-making (and manipulation) on all sides continues to increase, and that a former theatre critic turning his eye to politics in one of the world's leading newspapers is indicative that visual literacy – and visual culture – is annually more important, not just to the arts but to international affairs.

The second landmark event came in 2005 when the Danish newspaper the *Jyllands-Posten* published twelve satirical cartoons of the prophet Muhammad. To some people, any visual representation of the prophet is unacceptable on purely theological grounds. Here, there was the added political content: one cartoon, for example, showed the prophet with a turban in the shape of a bomb. The controversy became international, including violent demonstrations, personal threats and an estimated 130 deaths.[3]

Our aim here is not to take sides. Rather, it is again to demonstrate that visual culture continues to be of vital and contested importance in the modern world. And, as conflicts increasingly involve the clash of cultures rather than between traditional nation-states, we ignore visual culture at our peril.

Not everything has changed, however. Painting and the art-historical canon are still with us, as are photography, film, television and 'new' media – the latter continuing to change the most. The theoretical approaches advanced in the first volume –iconography, form, art history, ideology, semiotics and hermeneutics – still apply and, selected thoughtfully and appropriately for the task in hand, remain solid bases for the analysis of a wide variety of visual texts. The underlying relationship between representation and reality continues to fascinate.

For these reasons, we have maintained the overall substance and structure of the first edition. We have also retained the approachable expository tone while keeping the fundamental academic content intact. International examples still serve to illustrate the theory. In other words, we have held on to what people seemed to have liked about the first edition.

In this second edition, however, we have updated the content where appropriate, made additional reading suggestions, and further extended our theoretical reach. At the end of each chapter we have added a slightly more advanced Key Debate section, with a view to developing the more explicatory content of the main body of the preceding material. Initially, these new sections may serve simply as aids to seminar and section discussion, along with potential essay and paper topics. More importantly, the aim of these more challenging new sections is to provoke students to set off and think for themselves, having armed themselves with the basic intellectual tools provided here. They can do so in

the company of some important thinkers new to this second volume, including Kant, Baudrillard, Althusser, Deleuze, Benjamin, and Foucault.

We have also improved the quality of illustration. While we admit that colour would have been a further improvement, we were also aware that this second edition needed to remain affordable for students, especially where it was being adopted for reading lists. As a result, we agreed with our publishers that good-quality black-and-white illustrations constituted a fair compromise. Of course, many of the images we have used are easily and additionally available on museum websites in high definition. As specific URLs keep changing we have not quoted them, but are aware that students are probably even more adept than we are at finding them – and fast.

We would like to thank John Thompson, our editor Andrea Drugan and their colleagues at the Polity Press for suggesting and working with us on this second edition. In addition, we acknowledge the help and support of Henry Devlin, Sarah Howson, Maria Álvares Ribeiro, Ann Sutton, the students of King's College, London, the translators of the Chinese and Korean versions – and everyone else whose comments on the first edition have contributed to the emergence of the second.

Richard Howells, London
Joaquim Negreiros, Lisbon

INTRODUCTION

We live in a visual world. We are surrounded by increasingly sophisticated visual images. But unless we are taught how to read them, we run the risk of remaining visually illiterate. This is something that none of us can afford in the modern world.

During our lives, we are usually taught how to read the printed word. We are shown how sentences are made up of grammatical units, how authors go on to use a whole cornucopia of grammatical devices to get their meaning across, and how meaning is both created and communicated at a remarkably sophisticated level. We learn how to read as well as write. Things are much less straightforward in the visual world. Often, we are left on our own when it comes to figuring out what a visual image means.

That is what this book is about. This is a book that explores how meaning is both made and transmitted in the visual world. It seeks not simple solutions – answers – to particular and individual images. Rather, it aims to show us ways of looking *for ourselves* so that we will be able to tackle any visual text – whether it is a drawing, a painting, a photograph, a film, an advertisement, a television programme or a new media text – and be able to start getting to grips with both what it means and how that meaning is communicated. We will discover, even, how some images give away far more in meaning than their authors ever consciously intended.

These comparisons between visual images and printed text are quite deliberate because we will discover how 'visual texts' can be 'read' with just the same rigour – and with just the same reward – as the printed word. We really can get to work on them – to wrestle with them, almost – to begin to discover both how and what they mean. And just as with the printed word, it is best if we begin with deliberate strategies for analysis if we want to get a text to unlock its secrets as revealingly as possible.

In the chapters that follow, we will make our way through some classic

theories of visual analysis. The aim is to explain each one as clearly as possible, while at the same time showing its benefits and disadvantages. We will discover that some will be far more useful than others – but not all in the same way. By the end of the book, we should be able to select each method (or methods) as appropriate for the task in hand, just as we would choose the right tool from the box for a particular hands-on job. This book, therefore, aims to bring all the useful approaches together in one volume, unifying them under a broad overall strategy.

Do not be afraid of the word 'theory'. Yes, it can sound dauntingly abstract at times, and in the hands of some writers can appear to have precious little to do with the actual, visual world around us. Good theory, however, is an awesome thing. Just like a skeleton key, it is remarkable both in itself and also (and equally) in what it can do for us: it opens up all manner of things. But unless we actually *use* it, it borders on the metaphysical and might as well not be used at all. That is why in this book we will always be looking at examples; combining the theory of method with the practice of looking. It also explains why this book is divided into two parts, concentrating first on particular theories and then on specific media. It is designed to introduce us not only to methods we can think about, but methods that we can also actually use.

Those of us who are already creatively involved in the visual arts, or are planning a professional career in the media or communications industries, will need little convincing of the need for visual literacy. Creatively, we need to be able to 'read' as well as 'write', to learn how others have communicated visually in order, in turn, to learn from them. Further, we need to know how others will read our work, be they consumers, clients or critics. We need to be practically accomplished in these skills in order to make a living from them.

Visual literacy, however, should not be limited to those with a creative or professional interest in visual culture. On the contrary, the need is much more widespread. So much of today's culture is visual that we all need to be visually literate in order to function coherently in the contemporary world. Today, for example, more of us get our news, current affairs and information from television than from the newspapers. Television, it need hardly be said, is an essentially visual medium that communicates primarily though pictures. Think of recent world events and you probably think televisually: the open-topped limousines of the Kennedy motorcade in Dallas, the wide-eyed famine victims in Ethiopia, the bifurcating vapour trails of the exploding *Challenger* space shuttle, the funeral cortege of Diana, Princess of Wales, and the explosion of flame as a hijacked airliner slices into the World Trade Center.

Television is constructed around pictures. Television producers know this, and so do politicians. When they seek to persuade, they usually do so televisually. This was something that was first grasped in 1960 when American presidential campaigners first began properly to exploit the new medium. Some 100 million Americans watched a then novel series of debates between Richard M. Nixon and John F. Kennedy. Kennedy looked better on television; most viewers thought he had won the debates and there is no doubt that he won the election.

It may seem strange to us today that there was anything remarkable about

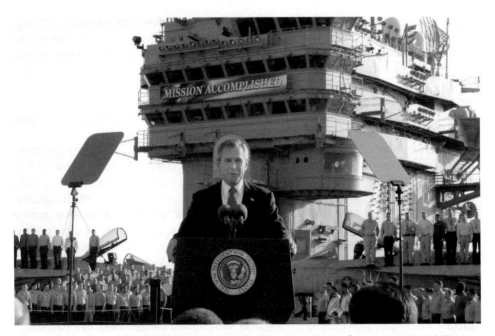

1. President George W. Bush, 'Mission Accomplished' media conference, 1 May 2003; courtesy of J. Scott Applewhite/Associated Press

this. That elections are fought on TV is something we nowadays take for granted. It is not just the formality of debates, or the increasingly expensive and slickly produced election broadcasts. Candidates (and their teams of media handlers) are also aware of the importance of prime-time, editorially covered, photo-opportunities which compete for space in the evening news. A well-organized visual not only gets selected for broadcast; it can also encapsulate just the message the media gurus wish to get across.

Of course, it doesn't always work. Democratic presidential candidate Michael S. Dukakis tried to toughen up his image by riding around in a tank for publicity pictures during the campaign of 1988. Unfortunately, voters thought he looked ridiculous in an overly large military helmet with straps flying like the floppy ears of a cartoon character. He lost. In Britain, Labour Party leader Neil Kinnock tried in 1983 to emulate the Kennedy style by strolling, casually, along the edge of the beach. Unfortunately, the television audience only saw him slip and stumble into the water. The image dogged him, and he never became prime minister. For better or worse, visual culture is very much a part of the democratic process.[1]

International conflict is similarly entwined with the visual world. Long before photography, it was usual for artists to paint battles – usually to the gratification of the winning side. Later, official war artists would sketch or paint on location, and then their work would be engraved for newspaper reproduction. With photojournalism, people began to see what war actually looked like for the first time. Particular images began to take on iconic significance. A group of US marines raising the flag over Iwo Jima, for example, remains one of the abiding

images of the Second World War, while a (then) unknown girl running burned, scared and naked down a Vietnamese road speaks with equal eloquence of the conflict in Indochina. We can probably all 'replay' such images in our minds as we read this; images that somehow concentrate so many feelings about the conflicts they represent. It is a cliché, of course, that a picture is worth a thousand words, but the trouble with clichés is that they are so often true. One of the wonders of pictures, however, as we will see especially in chapter 2, is that they can often take over where words are not enough.

The Gulf War of 1991 broke new ground: not only were images available live to audiences around the world, but pictures were concurrently available from both sides of the conflict. Both parties were seeking international public approval not only for their causes but also for their pursuit of those causes. The Western allies, for example, showed footage of 'precision bombing' with a missile finding its target via an enemy chimney (again, many of us can 'replay' this footage in our heads), while the Iraqis responded with sequences of civilian casualties. It was a sequence played out again with the aerial attacks on Afghanistan, beginning in 2001.

The Kosovo crisis of 1999 was, similarly, a battle for international hearts and minds – in addition, of course, to being a painful military conflict for those directly involved. The propaganda battle was, again, fought visually. Yet, while the military authorities had exploited the advantages of waging war visually in the Gulf, in Kosovo they found themselves on the receiving end of media and public now used to images of conflict. British television journalist Peter Snow, sceptical of allied claims of Serbian atrocities, was therefore able to demand of an increasingly uncomfortable NATO spokesperson: 'Where are the pictures? Show us the pictures!' Visual culture, in other words, had reached such a phase that the word of a NATO official was no longer good enough for the British media. The media wanted *proof*; the media wanted pictures.[2]

The pictures that depict our world are not necessarily moving pictures, despite the pre-eminence of television, cinema and related media. Newspaper and magazine photographs remain important, and have a 'fixity' that gives them more staying power than a fleeting, moving image. Just as in television, however, the images are by no means secondary to the words. Newspaper editors know this: the lead picture will always be above the front-page fold so that it attracts our attention on the news-stand. One hardly needs to stress the importance of the cover photograph of a magazine, no matter how fashionable or weighty its content.

Visual images, however, are by no means limited to the news media. They surround us every day in advertising, on packaging, on banknotes and on CD covers. They all have something to say, whether they are as informal as family snapshots or as imposing as art gallery canvases.

Try to imagine a world without visual culture. It is impossible. If we doubt this, we should just try closing our eyes for half an hour, or (on the other hand) walking down the street making a mental note of every form of visual communication that we see. Imagine, next, the same brief walk without the visual images. Visual culture, then, is not limited to museums and cable television. It has a part to play in decisions as important as whom we elect to govern us,

and as seemingly trivial as which cereal we will choose for breakfast. If we are unable to read visual culture, we are at the mercy of those who write it on our behalf.

Let us return, then, to the concept of visual literacy. If we are presented with a piece of printed text, we can easily begin to get to work on it. We can note its content, style and structure. We can spot the literary and rhetorical devices used to present us with an argument, to persuade us of the writer's point of view. We read such texts critically. If it is a contract, we look for the small print. If it is a sales pitch, we look for the 'weasel words', such as '*a chance to win*' or 'savings of *up to* 50%'. We ask, quite rightly, what is really being offered. We look for what is left out as much as what is included. We ask who is the author of a particular text, and how that may influence what they are trying to say.

We may of course differ on the meaning of a text. Anyone who has read T. S. Eliot, Shakespeare or scripture will understand this. Our disagreements, however, will be based upon a searching and sophisticated analysis of the words, together with all manner of reference to and quotation from the texts themselves. This is something at which we are all pretty good, at which we have had instruction, and with which we still get a lot of practice. How many of us, however, can apply the same logic, rigour and analysis to visual as to 'verbal' text?

It is important to stress here that this does not mean we should abandon verbal or literary analysis in favour of the visual. Despite the pre-eminence of visual communication today, we still need words and we still need to know how to read them in both the narrowest and the widest sense. We can see also how many of today's new media texts (more of which in the final chapter) combine the visual with the verbal in order to get multilayered messages across. We need, therefore, to take both seriously. But it is to the visual that we need to pay remedial attention.

This introduction began with a deliberately provocative claim about visual illiteracy. Surely, we may respond, we are all perfectly visually literate in our increasingly visual world. The point is that we are not. Certainly, we are practised and experienced viewers of contemporary visual texts, but so much of this experience is grounded in habit rather than analysis. We are all too often complacent and accept visual literacy as a passive rather than an active pursuit. We take too much for granted, and (consequently) leave too much unseen. Instead of simply ploughing on with the job of reading, then, we need much more actively to think about *how* we read, and whether we ought to be reading differently. Bringing some sort of structure and self-awareness to this process is a very good place to start.

The visual world is not only a modern world. In returning to visual literacy, we are in many ways rediscovering the skills that our cultural predecessors knew better. Five centuries ago, for example, Western Europeans would have been able instantly to recognize each other's precise social standing from the ordered detail of their dress, and they would, at the same time, have been able to interpret religious painting with an acuity that would put contemporary students to shame. In North America, native tribes would have recognized each

other from the significant minutiae of their art and ritual objects, each rich with meaning that today would be dismissed, by the uninitiated, as mere patterns or designs. We need to remember, always, that the printed word is, culturally, a very recent phenomenon. It is a crucially important one, of course, but it needs again to be emphasized that visual literacy has a long and substantial tradition which historically overshadows much more recent kinds of 'reading'. As Gyorgy Kepes argued in *Education of Vision* back in 1965, 'We have to get back to our roots . . . we have to re-educate our vision.'[3]

This book will begin with six chapters on strategies for the analysis of visual texts. They will show us, in other words, six different ways of looking. The first chapter will concentrate on looking at the content of a work of art. We will study the practice of iconology, using an intriguing fifteenth-century wedding portrait as our first example and, to show that iconology is not limited to the past, a famous Beatles CD cover.

For the second chapter, we will move on to a way of looking which concentrates on the form rather than the content of a visual text. We will take as our examples two challenging paintings by American abstract artists – artists whose troubled lives were eloquently reflected in their work.

If anyone thought that this book was going to be all about art history, they would be surprised to discover that the traditional history of art gets only one chapter here, and this third one is it. We will look at a passionate painting by Picasso and a controversial portrait by Rembrandt (but is it?) to help us explore both the usefulness and the limits of art history in reading a visual text.

In angry contrast to the art historical approach, more recent theorists have provoked traditionalists by interpreting treasured works of art ideologically, claiming that such texts reveal entrenched societal attitudes about class, race, gender and wealth. In chapter 4, we will begin by looking at one of the most controversial writers in this area, contrasting his views with those of a direct opponent. The battleground will be two famous paintings from the Dutch golden age. We will then extend the discussion by examining a gender-based approach to the study of film and finally a sociological model of the circumstances in which cultural texts are produced.

In the fifth chapter, we will unravel the seemingly complicated study of semiotics and show how this can provide an extremely useful way of looking at popular culture. We will see how this approach reveals both the intended and unintended messages of advertising.

Part I concludes with a call for an interpretive and multilayered approach to the discovery of meaning in visual texts. We will consider the extent to which we can ever really isolate 'the' meaning, and close this sixth chapter by asking provocative questions about the meaning of culture as a whole.

The second part of this book shifts the focus from general theories to the analysis of specific media forms. It is a section that is, however, underlined by a continuing theoretical question: what is the relationship of visual culture both to reality and to the wider culture that it purports to represent?

We begin Part II with a chapter that examines drawing, printmaking and painting. It wonders how we learn to draw and paint, and discusses how much of what we take to be 'realistic' is simply a matter of learned convention. It asks

how much the traditional fine arts use artifice in pursuit of the illusion of reality. As a case study, we think back to the childish drawings of our youth.

Chapter 8 takes a close look at photography and wonders whether it is a 'realistic' medium which can also be described as an 'art' form. It ponders the role of subjectivity and authorship in photography, and asks whether the camera produces images that are as dispassionate and objective as at first they may appear. Dorothea Lange's Great Depression photograph of a migrant mother provides a first-class example.

From photography we progress to film. In the ninth chapter we discover that film, just like literature, comprises a variety of codes, forms and narrative structures. Unlike its close relation the theatre, however, it is able to transcend both time and space. Using the example of Stanley Kubrick's classic movie *The Shining*, we discover that cinema is much more than simply pictures that move.

Television, the subject of chapter 10, is a medium we all spend a great deal of time watching, but which also tells us a great deal about ourselves. We must learn, however, that television is not a direct, literal reflection of our daily lives. Family comedy *The Cosby Show* provides a telling example.

Our final chapter comes up to date with new media. Video, DVD, multimedia, CGI and a whole host of other computer and digital technologies have brought about changes that would have staggered the old masters of the Renaissance, with whom we begin this study. One wonders whatever they would have made of Facebook. We use examples of World Wide Web pages and an Aerosmith music video to illustrate the theory. But when it all comes down to it, how much has *really* changed? Do these new media demand new analytic strategies? Do they present new challenges to our assumptions about reality, representation and visual culture?

There is both a progression and a symmetry, then, about this book. We begin with the study of relatively simple, fixed and two-dimensional texts and progress to a discussion of complex, multimedia forms. We consider increasingly sophisticated analytical strategies as part of that progression. We conclude by standing at the edge of the increasingly expanding new media frontier and looking back at how much has changed and yet how much has remained constant in our visual world.

Along the way, we will be introduced to some classic writers and writings on visual analysis. The aim is to get back to basics; to engage with the seminal texts on particular approaches. We will see what these authorities – who are too often nowadays referred to only in passing – actually had to say. By starting at the beginning, we will concentrate on the fundamental arguments for particular approaches rather than overwhelm ourselves with later and more sophisticated developments of them. Groundings, after all, should begin on the ground.

Each chapter begins with a 'text box', which contains a concise overview of what the chapter is about and the information it contains. It is aimed to help you get your bearings before we jump into a detailed and sometimes narrative account of a developing theory or approach. At the end of each chapter, you will then find a Key Debates section, which builds upon the previous, explicatory material by asking somewhat more advanced questions – with much less

scope for easy agreement. We close each chapter by suggesting further readings so that, primed with the basics, you can use what we have written as setting-off points to further study for yourself. The aim here is not to précis everything that has ever been said on visual analysis. Rather, it seeks to introduce some fundamental ways of thinking about the visual world.

If we live in a visual world, learning to be visually literate is not a luxury but a necessity. This book seeks simply to begin to open our eyes.

PART I

THEORY

1

ICONOLOGY

This chapter introduces an approach to the analysis of visual culture that concerns itself with the subject matter or content of visual texts. We will discover that we can do much of this for ourselves at a practical, common-sense level, provided we are sufficiently rational and organized in our strategy. Things become more complicated, however, when we discover that a great deal of the content of a work of art can be symbolic, often even while disguised to look like everyday objects. Sometimes, then, the meanings are 'hidden' from immediate view, especially when we look at a work produced hundreds or even thousands of years ago. To help us structure the analysis of these more challenging images, we will follow the system devised by the famous iconologist Erwin Panofsky. Along the way, we will look at examples ranging from Northern Renaissance paintings to a Beatles CD cover. This will help us not only to unlock the meaning of our particular, chosen texts; it will also help us consider the advantages and disadvantages of iconology as a whole in our quest to discover the meanings of visual culture.

When we look at a painting, the first – and certainly the easiest – thing we look at is usually its content. We look to see what it's *of* or what it shows. It is a very good place to start, and we must never be afraid to begin (as Dylan Thomas put it in *Under Milk Wood*) at the beginning.

With simple paintings such as John Constable's famous *The Haywain* of 1821, we can figure out very quickly what it is supposed to be (see figure 2). We look directly to the evidence of the text itself. It is a view of a landscape; a quiet rural scene on a summer's day. The sun is shining and the trees are in full leaf. The quality of the light suggests midday or afternoon. There appears to be little in

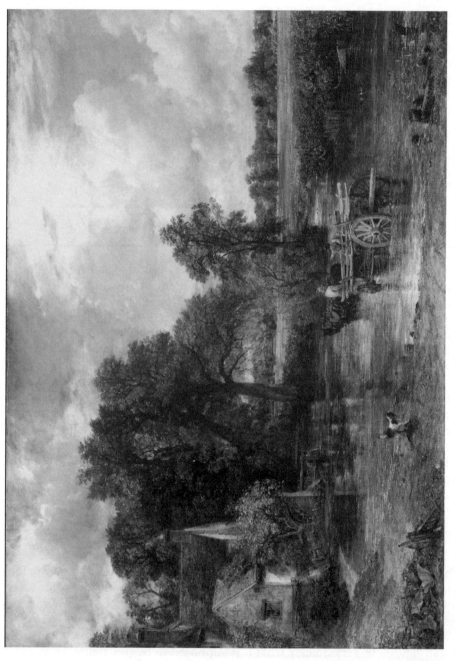

2. John Constable, *The Haywain*, 1821, oil on canvas; courtesy of the National Gallery, London

the way of wind, although the clouds suggest a chance of rain. It looks warm: the river is low, and the men in the middle of the picture are wearing shirtsleeves. The central feature of the work is a horse-driven cart, ridden through the river by the two shirtsleeved men. They seem to be fording the water, moving away from us towards the fields in the middle distance, observed by a small dog on the riverbank nearest to where we are standing. To the left of the scene is a small building which fronts on to the river. It is possibly a mill, but there is little sign of activity, apart from a wisp of smoke from the chimney. If we look carefully, we can see a woman outside washing something in the river. The building does not seem to be in the best state of repair. The cart is empty (apart from the men), so we suspect that it is on its way to collect something, possibly hay, from the fields on the far bank, where there are men working in the distance. Another cart is being loaded on the far side of the large field. Certainly, the driver of the central cart appears to be in no particular hurry. He is moving at walking pace, and there is no evidence of splashing around the wheels of the cart. He is seated, not standing. From the inclusion of a horse-drawn cart (instead of a tractor), from the rustic appearance of the mill, from the dress of the men and from the lack of telephone cables, electricity pylons, roads and bridges, we can deduce that this is a scene from nearly 200 years ago.

There are three things to be said here. First, what we have just done was not entirely difficult. It took no education in the history or theory of art to do it. It was all, really, just common sense. Second, we did what we did simply from the evidence presented to us by the text itself. We didn't have to look up the life and times of the artist, or even find out what a 'haywain' is (it is actually a cart designed to carry hay) to understand the picture. We just looked for ourselves. It all made perfect sense in its own right.

This brings us to our third point: Constable's *Haywain* is a relatively simple picture in which what we see is pretty well what we get. There are no flights of fancy here; it seems to reproduce a real scene just as we might have seen it our-selves had we stood on the same spot as the artist in 1821. It is a pleasant but relatively undemanding piece of work, which probably explains its popularity on calendars, greetings cards and chocolate boxes. It is not difficult to understand.

Looking at paintings such as this, then, need not require an art historical education. All it does require is a modicum of common sense, and a keen eye for observational detail. It is simple detective work based on readily apparent evidence.

So much for *The Haywain*. When we come to look at other paintings, though, we will find the same methodology very useful, especially if we apply the same sort of checklist or system to new or as yet unfamiliar works. It will help us take a disciplined, structured approach, which will guarantee at least some sort of result.

Imagine, then, that we are confronted with a 'mystery painting' about which we know nothing. There is no handy museum label and no gallery catalogue to help us. We need to get to work purely visually on the evidence presented by the 'mystery text' itself.

First, we can ask what kind of painting is it? Paintings are traditionally – and conveniently – sorted into genres or categories of work. A landscape, for

example, is an outdoor scene whose main purpose is to depict what today we may describe as a physical environment. It may or may not have some people in it, but they usually only appear in supporting roles because it is the land and not the population that is the real point of interest. A landscape need not be an old-fashioned, rural scene, although modern, urban versions are often called 'townscapes' or 'cityscapes'. Again, these may or may not have people in them, but the main focus is not the figures but, rather, the lie of the land. The same may be said of the landscape's close relation, the 'seascape'. There may be promontories, lighthouses or even the occasional ship, but the real point of a seascape is, of course, the sea.

A portrait, on the other hand, is a picture of a person. They may be shown full-length, half-length, head-and-shoulders or just the face. There may or may not be some sort of a background, and the 'sitter' (as the subject of a portrait is often called) might be holding some sort of a 'prop', such as a book or even a skull. The main focus remains the person shown or 'portrayed'. Sometimes, there may be several people included at once (a 'group portrait'), or the subject might be riding a horse (a 'mounted portrait'). Occasionally, the portrait may be of an animal (such as a much-loved horse or cat), but these are more usually called 'equestrian' or simply 'animal paintings'. If the subject (and we're talking about humans again now) has no clothes on, we may call this a 'nude portrait'; if the attention is on the body rather than the face or even the character, we may call this, simply, a 'nude'.

The 'still life' is another easily recognized genre. This is a study of inanimate objects such as fruit, flowers or even household objects. The things depicted need not be remarkable in their own right, as still lives are often distinctly everyday in their subject matter. It is possible to speak of subdivisions within the still-life genre, such as 'floral' works (pictures of flowers) or even 'game pieces' (pictures of dead pheasants or hares). They all remain still lives, however.

Finally, and to help avoid confusion, it is worth also mentioning the so-called 'genre painting'. A genre painting is a scene from everyday life. Often, the subject is domestic, but it can never be a remarkable or earth-shattering event if it is to remain a genre painting or piece. The genre painting is much less common than the landscape, portrait or still life, but it is worth mentioning here to pre-empt any confusion between a 'genre of painting' and a 'genre painting'. The similarity of terms is not very helpful; hence the need for an explanation.

Of course, the similarity of terms is not the only problem in describing types or genres of painting. The terms themselves can often falsely suggest distinct and exclusive categories. When, for example, does a landscape become a seascape or a group portrait become a crowd scene? Might there not also be aspects (say) of still life in a genre painting? And what about the categories we haven't even discussed, such as interiors or battle scenes? Categorizing a painting is not an exact science; nor is it a simple one. Broad classification into immediately recognizable genres is, however, a very useful place to start when beginning to describe a painting. If proof were needed, it is remarkable how many works can initially and simply be divided into these basic categories. Do remember, however, that they are best used to aid us rather than constrain us.

Second, when we tackle a painting for the first time, we can ask simply what is

shown. If it is a portrait, for example, is the sitter male or female, young or old? We can approximate the age of someone in a portrait in much the same way we can someone sitting opposite us on a train: is their hair greying or balding? Is their face wrinkled, 'laugh-lined' or fresh? Is there any facial hair? Look at the hands as well as the neck. We can also make an educated guess as to their ethnic group – does the sitter appear Asian, Caucasian or African, for example? What is their expression: friendly, proud, sad, imposing? Look next at what they are wearing. Look, in detail. From their dress, what can we surmise about their life-style, job, social class? Again, just as we would with a stranger on a train (we've all done it!), look at every clue to see what it may visually reveal to us. It really is visual detective work, and the evidence is right in front of us. Now, we can look at any 'props' they are holding or carrying. What do they communicate: a profession, a hobby, a fashion statement? Look also at the background: how does this add to our growing knowledge of the sitter? Is it a castle or a field, a ballroom, a bar-room or a studio? It all helps the building up of the impression, simply using the evidence of what is shown.

The location of a scene depicted in a visual text can provide a third area for analysis. With a landscape, for example, we can use the geographical clues to help us place it with some degree of accuracy. We do not need to be a trans-Saharan explorer, for instance, to deduce that a desert scene is more likely to depict the North of Africa than the North of Scotland, or that cacti are more indicative of New Mexico than of Nova Scotia. In addition, therefore, to the physical geography of the depicted site, we can also look at its vegetation. Wildlife, if any is shown, can also provide useful clues (kangaroos, for example, could be a bit of a give-away), but buildings provide more everyday evidence, from the kraals of Southern Africa to the cottages of England; from the whitewashed villages of the Mediterranean to the high-rise downtowns of North America. Again, we cannot be sure of always being right, but any sort of evidence should never be discounted.

As we begin to assemble more knowledge and information, we should, fourth, be able to start an approximation of the age, period or even year that a painting depicts. Again, look at the clues. If it is a townscape, are the buildings of wood, stone or glass and concrete? What are the roads like, and are they used by horses or cars? If they are cars, what kind of cars? Look at the street lighting: is it gas or electric – or is there none at all? Are there any billboards or advertisements? If so, for what kind of products? And if there are people, what are they wearing – can we use their dress to add to the evidence on which we will base our date? Finally, always be sure to look for what is not shown as well as what is shown. Familiar objects may be more articulate via their absence. Are there power lines, phone booths or parking meters, for example? Is there even a Starbucks? The absence as well as the inclusion of seemingly trivial things such as these in a painting can both provide valuable evidence.

If we are very lucky, we may feel able to make an informed estimate of the year shown in a painting. The time of year is usually much easier, however, and this constitutes our fifth stage for ordered looking at the subject-matter of a painting. For those of us who live in a continental climate, the markedly changing seasons provide a welcome consolation for meteorological extremes. Every

season has its own look, moods and changing activities, to say nothing of types of weather, kinds of wildlife and cycles of nature. Those of us who live in cities have a less educated eye for such things than those from the countryside. It may also be another of those areas of visual literacy at which our ancestors were more proficient than we. How many of us, now, can approximate the date of the last swallow or first cuckoo in our own part of the world? Can we guess, within just a few weeks' accuracy, when the first crocus will appear, or the last day for harvesting wheat? The year-round supply of produce in the shops has dulled our sensitivity to things that were common knowledge a hundred years ago. But we don't need to be a farmer to still know something of the cycle of deciduous trees, or the general pattern of ploughing, sowing and harvesting. Snow, even to the most isolated inhabitant of the urban jungle, still means winter. The clues are still there in the paintings, even if nowadays we have to work harder to read them.

Sixth, we can often tell the time of day from a painting. Light and dark – of course – are good indicators of night or day, and if a clock is shown in a town-scape, don't be afraid to use it. Most situations are rather more challenging, but they are not impossibly difficult. If it is an outdoor scene, look for the height of the sun (highest at midday) or the length of shadows (longer in the mornings and evenings). Look also at the *quality* of the light: daylight has a redder tinge at either end of the day as the sun slants though the earth's atmosphere. There is something wonderfully clear and thin about early morning light, especially before heat haze or even smog have had time to build up. We may also be able to tell the time from simple human activity: are they commuting, lunching, working or dancing? If the streets are empty, why? Are people wearing shorts or tuxedos? Business suits or cocktail dresses? If we look out of the window now, we will see that there are all sorts of ways of telling the time rather than simply looking at a clock. Looking at a painting is, in many ways, just like looking through a window. The visual world is there to be read.

Finally, a painting may even depict a particular moment. It could be a dramatic moment such as when a group of Spanish soldiers face a Napoleonic firing squad, or it could be as gentle as a passing squall at sea. Painting has difficulty in suggesting the passage of time, so traditional works usually depict a specific instant. Don't be afraid, therefore, to notice the weather in detail – as every Englander or New Englander knows, it is likely to change. Is a cloud, for example, passing overhead? Is there a sudden breeze or break in the storm? Look at the characters: is the bride, for instance, stepping out of or into the carriage? Has a horse just started a race or taken a fence? Imagine how the painting might have been if it had been 'taken' two seconds earlier? It might make precious little difference. Then again, it might make all the difference in the world.

What we have just done is create a structured method for looking at the content of a painting. We began with the broad, and gradually increased our focus towards the particular and specific. We have devised a simple, progressional system in which we have examined (1) the type or 'genre' of painting; (2) the central or basic subject-matter; (3) the location or setting of a particular scene; (4) the historical period which the work depicts; (5) the season or time of year shown; (6) the time of day portrayed; and (7) the particular

instant captured by the work in question. This checklist does not, let us all agree, present insurmountable difficulties. It is very much an introductory methodology – but how many of us, up until now, have had any methodology at all when looking at a painting? That is an argument that encourages four further observations. First, our simple method has forced us actively to *look* at a painting, to examine it actively – in detail – rather than simply 'seeing' it in passing. Second, it has focused our attention on the evidence provided not by extraneous brochures or tape-recorded commentaries, but at the visual evidence provided by the painting itself. It has prioritized the text over the context. Third, it has provided us not with easy, pre-written answers about one particular painting but, rather, with an infinitely more useful methodology for approaching painting in general. It is an exercise, after all, in visual literacy, and not just visual memory. This leads us to the fourth and most important point: this is an approach that has encouraged us (forced us, to be honest) to *look for ourselves*. By the end of this book, we will become even more confident in the power of our own observations.

So far, so good. Unfortunately, not all paintings are as easy to read as Constable's *The Haywain*. Fortunately, however, this can make many visual texts much more interesting.

The methodology we have just introduced is ideal for use on 'what-you-see-is-what-you-get' paintings, and especially those where we suspect that all we need to know is contained within the painting itself. This is not always the case, however. If we look, for example, at a portrait of King Henry VIII, our knowledge that he had six wives (and beheaded two of them) certainly adds to the meaning of the painting.[1] It is information, however, that exists both prior to and separate from the text itself. If we didn't know it was Henry VIII, much of this meaning would be lost. This is not only true of Tudor paintings. American photographer Annie Leibovitz, for example, gained a fine reputation for her photographs of rock stars and celebrities for *Rolling Stone* magazine. Her photographs are, of course, fairly interesting in their own right, but unless we know, for example, that the sitter is John Lennon, and we additionally know something about John Lennon, then we are missing a vital slice of the point. Celebrity portraiture depends on us having prior knowledge of the subject.

If historical or celebrity portraits begin to cause us trouble, the 'what-you-see-is-what-you-get' approach proves yet more problematic with mythical and religious scenes. Imagine, for instance, that we are beginning to analyse what we think is simply a group portrait when a Christian friend points out that it is clearly a 'Holy Family'. Equally, a young, medieval man pulling a sword from a stone (a strange activity) can turn out to be the mythical King Arthur of the round table. Literature, too, can play its part: a recently drowned young woman, surrounded by flowers, tends to be Ophelia from Shakespeare's *Hamlet*.

The point here is that when we look at a visual text purely at face value, we often fail to delve beneath its surface. Paintings such as the examples we have just used have meanings that the artist would expect the viewer to understand. The successful communication of these meanings, however, depends upon shared cultural conventions between painter and viewer. Knowing the codes – or at least knowing that there are codes in use – is all a part of visual literacy.

Let us return to the example of religious art. It is a useful example because an understanding of so many of the canonical works of Western art depends upon a working knowledge of Judeo-Christian scripture and tradition. If we see an illustration of a semi-naked couple in a garden, and an apple and a snake are also included, we can be fairly sure that it is an illustration of the story of Adam and Eve from the book of Genesis. An old man with a large wooden houseboat and a variety of pairs of animals tends to be Noah with his ark. If he has three younger men with him, a knowledge of the same Old Testament text will also provide their names. The New Testament provides the life and death of Jesus Christ, together with his family and followers. A basic knowledge of the Christian story helps the viewer instantly to recognize many of the recurring 'set pieces' of Western art, such as the 'nativity' (the scene surrounding Christ's birth in a stable), the 'crucifixion' (in which Christ is nailed to a cross), the 'deposition' (in which the body is removed) and the *pietà* (in which his mother mourns over the corpse in her lap).

A knowledge of Christian scripture and tradition helps us identify these scenes from their familiar ingredients and characters. They are very much bound up in convention, as the physical appearance of the places and the people portrayed usually owes much more to art history than to scripture. Mary, the Mother of Christ, for example, is frequently dressed in blue in religious paintings. There is no biblical source for this. The convention owes much more to the fact that the most expensive paint was typically reserved for this key figure. Lapis lazuli, a blue gemstone, was ground and used for pigment in early painting, and the convention caught on. Similarly, the physical appearance of Christ is one of convention rather than documentation. He is never described in the Bible, and so his typical depiction as tall and bearded with long, golden-brown hair is another art historical tradition. It is interesting to note that his fair skin and blue eyes probably represent the ideals and assumptions of the Western European artists who grounded the convention rather than the typical appearance of an actual working man from the Eastern Mediterranean.

Convention plays an increasingly important part in depictions of the lives of Christian saints. Although we may feel able to describe Christ from his appearance, the saints tend only to be discernible by what they are holding, wearing, carrying or doing. Saint George, the (non-biblical) patron saint of England, for example, is instantly recognizable not by his facial features, but by the way he is nearly always shown killing a dragon. Without the dragon, it's probably not Saint George. Similarly, we recognize Saint Christopher from his traveller's staff and the infant Christ he carries across the river. Saint Peter carries keys, Saint Francis is surrounded by animals, and Saint Jerome is usually accompanied by a cardinal's hat and a friendly lion, from whose wounded paw he removed a painful thorn. Without the hat and the lion . . . it probably isn't Saint Jerome.

The props or objects that help us identify both Christian saints and the mythical characters of classical antiquity are known as their *attributes*. By recognizing the attributes, we recognize the characters and the stories, and so help to crack the codes of much mythological and religious painting. The attribute isn't there because it is a casual part of the scene, but because it is deliberately included to indicate a significance beyond its physical existence. The

'what-you-see-is-what-you-get' approach to painting, then, is proving to be increasingly unsophisticated.

The use of attributes, codes or symbols is not limited to religious or mythological art. It continues every day. Scales are still used, for instance, to stand for justice, the dove for peace, the ass for stupidity and the owl for wisdom. In older visual texts, however, reading the codes is not always so simple. A crane, for example, stands for vigilance: it stands on one leg, holding a small rock with the other foot. If it falls asleep, it drops the rock and falls over. Unlike the wise owl, this is not an everyday symbol. How, then, can we learn to read the more obscure symbols today? One way, of course, is to look them up, which is just what not only viewers but artists did in past centuries. In the seventeenth century, for instance, it was possible to consult 'emblem books' such as Giarda's *Icones Symbolicae* of 1628. Here, we could discover the suitable emblems for 'Lex Civilis' (civil law), 'Medicina' (medicine) and 'Historia' (history). Historia, for example, is depicted as a female figure with three faces so she can look at the past, present and future at the same time. She holds a measuring stick with which to calibrate time. In the eighteenth century, Richardson's *Iconology or a Collection of Emblematical Figures* of 1799 helped both provide and identify figures for characteristics such as vanity, idleness and sterility. Sterility, for example, is illustrated as 'a figure of a woman of a languishing aspect, leaning on a mule, and holding a branch of a willow tree in one hand'.[2]

As the concepts start to become more abstract, it is time for another case study. Let us take a close look at Jan van Eyck's *Arnolfini Wedding Portrait* of 1434,[3] which hangs in the National Gallery in London (see figure 3). This is a double portrait, believed to have been commissioned to record and to celebrate the wedding of the rich Italian merchant Giovanni Arnolfini. Although Arnolfini was Italian, the image was made in Bruges, Belgium, where Arnolfini lived and van Eyck worked. In the days (long) before photography, such a portrait made sense to them just as the traditional wedding album does to us today. Just as wedding photographs provide a kind of visual 'witness' to the event, so does this painting. Indeed, it is even 'signed' 'Johannes de eyck fuit hic 1434' ('Jan van eyck was here, 1434') with a graffitto-like inscription on the back wall of the Arnolfini bedroom. To add to the artist's sense of fun (and witness), we can even see what may be van Eyck himself reflected in the circular mirror on the back wall below the signature. Certainly, we can see the reflected backs of the Arnolfinis, together with what appears to be two other people standing in the doorway. As ever, it pays to look carefully.

At face value, we can see that husband and wife are a prosperous couple; they are expensively and fashionably dressed, and their room is furnished luxuriously by the standards of the day. It is much more than a simple domestic scene, however, because many of what may appear to be ordinary household objects also have an emblematic significance. This is achieved through a technique known as 'disguised symbolism' in which everyday things can have a double life by having both a realistic and symbolic existence.

Let us begin by looking (actively and carefully, as ever) at the elaborate candelabra hanging from the middle of the room. There are two unusual things about this. First, although the candelabra contains many branches and holders,

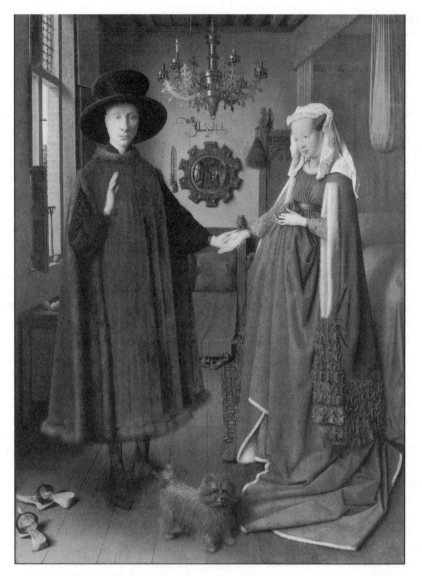

3. Jan van Eyck, *The Arnolfini Wedding Portrait*, 1434, oil on panel; courtesy of the National Gallery, London

there is a candle in only one of them. Second, although it is daylight, this single candle is lit. Symbolically, it seems that this candle stands for the presence of an all-seeing Christ, who is another, perpetual witness to the marriage. If we look both to the middle and the bottom, left-hand corner of the painting, we can see that both the Arnolfinis have removed their shoes: hers are to the back of the room, while his are in the foreground. It may seem odd not only to remove one's shoes for a formal portrait but also to leave them so conspicuously in the picture. If, however, this has been deliberately done to suggest that marriage is

a sacred institution and that the couple are therefore standing on 'holy ground', the gesture begins to make much more sense.

The small dog at the bottom centre may be a much-loved family pet. It may also be a symbol of marital fidelity. Dogs have long been admired for their faithfulness – which is one reason why 'Fido' was a traditional name for a dog. It comes from the Latin for 'faithful'. If we look back to the mirror, we see that there is a string of crystal beads hanging to the left of the mirror. Mirrors and crystal have symbolic meaning (we still say 'crystal clear') and in this case could stand for the Virgin Mary (a mirror without blemish) or even virginity itself. The importance of the mirror is underlined by the way in which it is surrounded by ten scenes depicting the Passion (the suffering and crucifixion) of Christ. The fruit by the window may be symbolic of the Garden of Eden, while the apple on the windowsill could stand as a reminder for the innocence that Adam and Eve enjoyed before their fall from grace.

While virginity and sexual innocence were praised before marriage, it was equally understood that reproduction was expected once the bond had been entered into. The curtains on the bed appear to be drawn back ready for use (it would be considered more than unusual to include a bed in modern wedding photographs), and, as if to underline the point, a carving of Saint Margaret, the patron saint of childbirth, appears to decorate the bed. This leads us finally to the strange way in which the new Mrs Arnolfini appears to be patting – or at least holding – her well-rounded stomach. To the modern eye, she looks pregnant, a condition that does not seem to rest well with a wedding portrait which at the same time appears to value premarital innocence and virginity. There are two possible explanations here. First, it may be that it was simply the fashion in fifteenth-century Bruges for well-to-do women to clutch and lift the fronts of their copious dresses, as she is doing here. Fashion often defies logic, then just as now. On the other hand, it could be that she is demonstrating not her pregnancy but her *potential* for childbearing in an age in which the ability of a healthy woman to reproduce and continue the male line was considered an enormous attribute in a possible bride.[4]

We will have noticed that, in practice, interpreting 'disguised symbolism' is not quite as simple as looking things up in a code book. Direct translation is not always possible. There are various theories about the Arnolfini portrait both in general and in detail, and Signora Arnolfini's stomach is just one of the areas of dispute.

Another case study will help to underline the point. It is a painting from a similar time and place: *The Annunciation* from the Merode Altarpiece painted by an artist known simply as the Master of Flémalle (see figure 4).[5] It was made in around 1428 and is held today in the Cloisters collection of the Metropolitan Museum of Art in New York. An 'annunciation' is another of those recurring 'set pieces' in Christian painting. In these cases, an angel is seen appearing to Mary, the mother of Christ, to tell her that although she is a virgin, she is going to have a baby who will be the son of God.

This is not an easy painting. Indeed, it may strike us as a bizarre combination of a fantastical biblical scene with an everyday fifteenth-century Netherlandish interior. In the left-hand panel (altarpieces often comprised

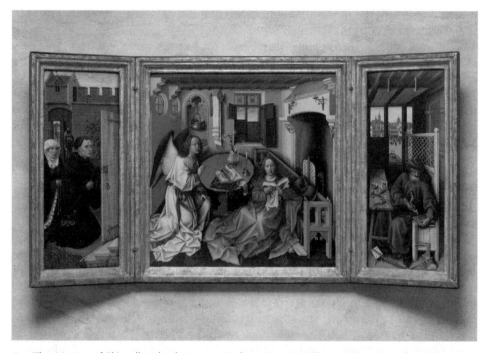

4. The Master of Flémalle, also known as Robert Campin, *The Annunciation* from the
Merode Altarpiece, circa 1428, oil on panel; courtesy of The Metropolitan Museum of
Art, New York, The Cloisters Collection Art Resource Scala, Florence

three sections which could be opened and closed like shutters), a man and a
woman kneel outside an open door as they observe the scene within. In the
right-hand panel, an older man is at work in what appears to be a carpenter's
workshop. In the centre, shown here, a young woman is sitting on the floor,
quietly reading by the fire. There is a table in the middle of the room, and,
to the left, a male angel has appeared. If we begin with the 'what-you-see-
is-what-you-get' checklist we devised earlier, we certainly get some of the way
into the painting. We can approximate the location, period, season and even the
time of day. This is all useful observation. It takes a working knowledge of the
Christian New Testament, however, to delve beyond the appearances of this
work. The concept of a virgin birth is not an easy one, and is certainly neither
communicated nor explained by the surface content of the painting. With some
knowledge of the Christian story, however, we can start to put names to the
characters – a feat that would have presented no difficulty at all to medieval
observers. They would easily have identified the angel as Gabriel and the carpen-
ter in the workshop next door as Joseph, the husband of Mary. The small cross
which has entered the room from one of the upper windows to the left would
appear to be carried by the unborn Christ. The couple kneeling and observing
to the left, however, do not appear in the Bible stories. Rather, the coat of arms
in the rear window suggests that they are wealthy merchant Jan Engelbrecht
and his wife. It may seem unusual to us today, but in fifteenth-century Europe

it was quite common for the people who paid for a painting to have themselves included in the work, no matter how obviously anachronistic.

So far, then, we have a most interesting amalgam: a scene believed by Christians to have taken place in Nazareth in the year zero represented as though it was taking place in the Netherlands some fourteen hundred years later. The mixture is further compounded by the bold juxtaposition of the divine with the domestic. It is here, however, that the painting becomes doubly interesting because there is much more religious symbolism in this work, disguised, as we have come to expect, as everyday objects.

The lilies in the centre of the table symbolize the purity of Mary, as do the towel and basin in the corner of the centre panel. To the right, we can see on the window ledge that Joseph has made a wooden mousetrap; according to Saint Augustine, the cross was a 'mousetrap' designed by God to catch the devil. This, of course, ties in with the cross that the unborn Christ is carrying into the room, neatly prefiguring both his birth and death and the fulfilment of Christian prophecy. Just as with the Arnolfini portrait, candles play a symbolic role in this painting. We can see, mysteriously, that only one of the holders on each side of the chimney breast holds a candle, and that it is not lit. Even more intriguingly, the candle by which Mary has been reading (on the centre table) has only just been extinguished: we can see the wisp of smoke still rising from the wick. What does this mean? Could it be that divine light has overcome the need for candle-light? Or does it suggest, rather, that the candle, which once stood for divine light, is no longer needed because God now has a physical presence in the form of Jesus Christ? Or, simply, has the candle been blown out by the flapping of the angel's wings?

This painting is a complicated and challenging text, built up of layers of meaning. Our 'what-you-see-is-what-you-get' approach certainly helped us begin work on the painting, but we discovered that we really needed prior knowledge of Christian theology to delve deeper. Only in this way could we discover that the young woman in the fifteenth-century Flemish interior was also supposed to be the mother of God from the Christian Bible. To dig at an even deeper level, we needed to combine our knowledge of Christian stories with the conventions of medieval art to help identify not only the obvious but also the disguised symbolism in the painting.

There is yet another level of meaning which is shared by both this annunciation and the Arnolfini portrait. We notice that both are full of deliberate symbols, and we suspect that there would have been little point in putting them in if viewers had not been expected to understand them. More than that, we can see that the artists of both paintings assumed that their viewers were not only Christian but also had a solid knowledge of Christian scripture, lore and symbolism. Finally, we can see that by combining religious stories, events and symbols with the ordinary rooms, trappings and activities of medieval Europe, the paintings depicted medieval Europe as a place in which religion played a central and dominating role in everyday life. At their deepest level, then, these paintings can be examined to reveal evidence not only about themselves but also (and even more interestingly) about the life, times and values of the cultures they represent.

This is all beginning to get rather complex. What we need, therefore, is a structured way of looking at paintings which will not only help us to understand them at all the different levels, but which we can also apply to other paintings that we have not yet seen. Fortunately, such a method already exists. It is called 'iconology' (although occasionally referred to as 'iconography'[6]), and it is a method that helps us to study the subject-matter of works of art at each of the levels we have just been discussing.

The person we most famously connect with iconology is Erwin Panofsky. He was a professor at Hamburg University in Germany until 1933, when he was sacked by the Nazis. He moved to the United States, where he became a professor at the Institute for Advanced Study at Princeton University. In 1939, he published *Studies in Iconology*, a book that has remained influential ever since. We will pay special attention to Panofsky because his is the seminal work on the subject.[7] Not only does he demonstrate iconology at work with plentiful examples and case studies from the Renaissance; he presents us with a structured, progressive and logical system for iconological analysis that we can use for ourselves and on images of our own choice. *Studies in Iconology* is an extremely scholarly work, and it goes into a great deal of detail which need not necessarily concern us at this stage. What we shall borrow from Panofsky is not his findings but his method, and that is both easily explained and remembered.

According to Panofsky, iconology is the branch of art history which 'concerns itself with the subject matter or meaning of works of art'.[8] To get at the meaning, he devised a three-point system which could be applied to works of art, which he said had three levels or 'strata' of meaning. To help explain these, he used the (now) old-fashioned example of a man walking down a street and raising his hat in greeting. At the first level we can safely say that, factually, a man has briefly lifted his hat from his head and then replaced it. We can at the same time interpret this expressionally: we can sense that it is a friendly gesture. We can understand what has happened factually and expressionally simply from our experience of everyday life.

At a second level, however, we also understand that when someone raises their hat to us it means or stands for something more than a simple practical action. Just like shaking hands (an odd custom, if we really think about it), it means more than it physically is. It is a form of communication that we understand: it is a sign of politeness. Panofsky explains that this is different from the first level because we have previously to know what the action means in order to understand what is being communicated. It does not speak for itself. Someone from an entirely different culture (Panofsky uses the example of an 'ancient Greek') would understand the hat-lifting at the first level but not the second, because they would not be familiar with the conventions of contemporary Western culture.

At the third level, Panofsky says that we can tell something of the man's personality along with his national, social, educational and cultural background from the fact that he chose to lift his hat as a greeting. He may not have been conscious that he was communicating all those things; he may not deliberately have intended to reveal so much about himself in that single gesture, but such meanings were communicated just the same.

This is all very well for hats, but we now need to make this into much more of a formula so that we can apply it, in future, to works of art of our choice. Fortunately, Panofsky does this for us. The first level he calls the 'primary' or 'natural' level, and it is in turn subdivided into the 'factual' and the 'expressional' sections. At this level, in other words, we can identify only the very basic subject-matter of a painting: what (briefly) is shown and what atmosphere the subject-matter communicates. To understand the meaning at this primary level, we do not need any inside cultural, conventional or art historical knowledge. We need only to bring our 'practical experience' of daily life into play. If in doubt, apply Panofsky's 'ancient Greek' test: at the first level, we can understand only as much as someone from another culture would understand. What we see is what we get. This all takes place, therefore, at a 'pre-iconographical' level.

The 'secondary' or 'conventional' level is where the real work of iconology begins. As Panofsky's term suggests, we have to know the conventions in use in order to understand a painting at this second, deeper level of meaning. Only now can we correctly identify a man with a lion and a hat as Saint Jerome, or an owl as a personification of wisdom. An ancient Greek could not be expected to know this: to him it would be no more than an assorted collection of people, headgear and wildlife. He certainly wouldn't be expected to recognize the 'disguised symbolism' of an apple or a mousetrap, because he lacks the conventional knowledge. At this secondary or conventional level, however, we can now tell the difference between a casual meal out and 'The Last Supper', because we have brought our existing literary, artistic and cultural knowledge into play. We have progressed from the mere identification of motifs in level one to the interpretation of images in level two.

The third (and deepest) level is where we find what Panofsky calls the 'intrinsic' meaning or content. This is the level of meaning which reveals the underlying 'basic attitude of a nation, a period, a class, a religious or philosophical persuasion – unconsciously qualified by one personality and condensed into one work'.[9] In this way, our example of the Arnolfini portrait could tell us a great deal about attitudes towards marriage, religion, wealth and domesticity in fifteenth-century Flanders as a whole, rather than just being a picture of the Anolfini bedroom in particular. This third level of penetration is, for Panofsky, the 'ultimate goal' of iconology.[10] It is important to stress (as Panofsky did) that, unlike levels one and two, this is an unconscious process. The artist probably did not *intend* to encapsulate so many cultural attitudes and assumptions in his painting, but that is not to say that they are not there. In so many things in life (and painting is only one of them), we often communicate far more than we deliberately intend.

We have just spent some time looking in detail at Northern European painting from the fifteenth and sixteenth centuries. This has (we hope) been interesting in its own right: if nothing else, it has shown that there is often more to painting than meets the eye, and has demonstrated the benefits of looking as opposed to just seeing. Panofsky's iconological method has helped us find a structured way of penetrating three layers of meaning in a visual text. This is just the sort of approach (and especially at the secondary level) that Dan Brown's professorial hero Robert Langdon uses in his twenty-first-century page-turner

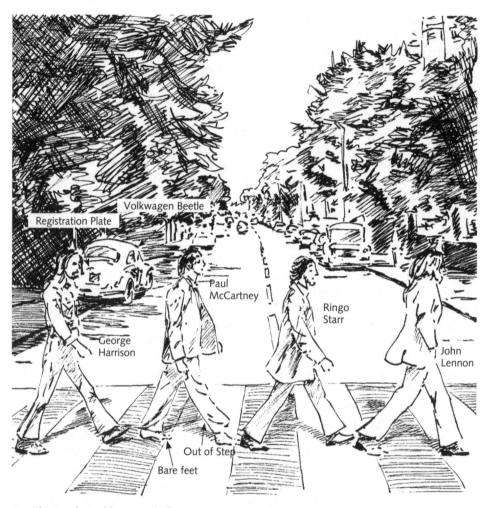

5. The Beatles' *Abbey Road* album cover, 1969; schematic sketch of the original
photograph; drawing: Sarah Howson

The Da Vinci Code. It is the hidden meaning of works of art that leads fiction's
most famous iconographer to discover (supposedly) one of the greatest secrets
of Western civilization.[11] But even in the real world, there is much more to
visual literacy than the study of medieval and Renaissance painting. How useful,
then, is the iconological 'way of looking' for the analysis of other, more contem-
porary, sorts of visual text?

To help us find out, we will make a case study of a very well-known twentieth-
century image: the cover of The Beatles' *Abbey Road* album (see figure 5). Many
people already have a copy of this; the image is also widely available on the
Internet.[12] *Abbey Road* was the last album The Beatles ever made.[13] Recorded
in 1969, it is arguably one of their best. Certainly, the cover is among the most
memorable, and the site of the original shoot has become a tourist attraction
for people from all over the world. In 2010, it was formally listed as a protected

site by the English Heritage organization for its 'cultural and historical importance'. Let us look, however, at the purely visual evidence provided by the original cover image, using the same methodology that Erwin Panofsky applied to Renaissance painting. The result, if we are careful, should tell us something not only about *Abbey Road*, but also about the usefulness of the iconological approach in the modern world.

At the primary or natural level, we need first to look at the factual evidence. Here, we can see a leafy, urban street on a sunny summer's day. Four men, each aged between about twenty and thirty, are crossing the road in single file, from left to right. It is a moot point whether Panofsky's first level of analysis permits us to identify the black-and-white markings as a pedestrian crossing. As pedestrian crossings, however, might reasonably come under the heading of 'practical experience' as opposed to 'literary sources', we can probably identify it as such at this stage.[14] Next we look at the expressional evidence. From the manner of the men crossing the street we can discern a relaxed – if somewhat self-aware – attitude both to anyone who might be watching and to the task of actually crossing the road.

We could, of course, go into rather more detail at this level by doing many of the things we did with our 'what-you-see-is-what-you-get' approach to *The Haywain*. It is a country in which people drive on the left, for example. However, it is at the second and third levels that the *Abbey Road* cover becomes much more interesting, and so that is where we will concentrate our analytic attention.

At Panofsky's secondary or conventional level of analysis, we begin our iconological investigation. When we look closely at the men crossing the road, we can bring our prior knowledge to bear to identify them as The Beatles. If we were to have seen them individually, we may not have been able to recognize them unless we were real fans. We don't actually see much of their faces, for example. But when we see four of them together, we can much more easily identify them as that group of individuals known collectively as The Beatles. If there had been three or five of them, the identification would have been much more difficult – or indeed impossible – because of our prior knowledge that there were in fact four Beatles. Once we have established them as The Beatles, we can then begin to identify the individual members of the group much more easily. Again, using our prior knowledge, we can identify the first (in order of crossing) as John Lennon, the second as Ringo Starr, the third as Paul McCartney and the fourth as George Harrison. We can do this even though they are not carrying their instruments (rhythm guitar, drums, bass guitar and lead guitar, respectively). If we know something more of the group, we can even recognize that this is an image of them towards the end of their collective career. They have long and (in two cases) facial hair. They are also dressed individually. We know from other representations of The Beatles that, at the start of their fame, they all had comparatively short hair, were clean-shaven and dressed identically. We know this not (unless we are very fortunate!) from practical experience, but from knowledge of other photographs, posters and artwork. If we really know our Beatles, we will recognize the location as the actual Abbey Road in north London, the home of the EMI studios in which The Beatles were recording this album at the time of the shoot.[15]

Our knowledge of the disguised symbolism of the Renaissance art studied by Panofsky may inspire us to look even more closely at the *Abbey Road* cover, however. If we look carefully at Paul McCartney, we notice two things that differentiate him from the others in the group. First, he has his right foot forward, where all the others are in synchronized step, leading with the left. Second, McCartney is wearing neither shoes nor socks. What does this mean? McCartney is 'out of step' with the rest, both literally and figuratively. There is something markedly different about him. And what of the bare feet? Is he walking on holy or consecrated ground? And is walking barefoot also an old Sicilian sign of mourning? Someone must have died. Could it have been Paul McCartney himself? We need more visual evidence. Let us look at the cover again. When a group of friends crosses the road, they normally do it as a group, all at once. What we have here is much more of a procession. It is in single file, equally spaced and even (with the notable exception of McCartney) in coordinated step. Could this be a *funeral* procession? Leading the procession we have the priest (John Lennon) dressed completely in white. He is followed by the sober-suited pallbearer or funeral director (Ringo Starr). Bringing up the rear, in his working denims and sneakers is the gravedigger (George Harrison). That leaves only Paul McCartney as the corpse.

There are further clues. McCartney is cupping a cigarette in his right hand. It is widely known, however, that Beatle Paul is left-handed. Could this therefore be a telltale sign that this is not the real Paul McCartney? Look now at the car parked closest to the group on the left-hand side of the street. It is a Volkswagen Beetle. Surely the pun could not be unintentional. Look closely at the last line of the registration plate: '28 IF'. The Beatle in question, then, would have been aged twenty-eight *if* he were alive. This was not the case, however. A detailed, secondary or conventional study of the iconology of The Beatles' *Abbey Road* cover reveals to us that Paul was, in fact, dead.

This is all, of course, a load of nonsense. Paul McCartney was not dead at all. The image finally selected for the cover of *Abbey Road* was one of six shots hastily taken by photographer Iain Macmillan from a stepladder set up in the middle of the busy street with the help of a policeman, who temporarily held up the traffic. Study of the other five shots reveals that Paul is wearing shoes in two of them. As the shoot wore on, it is reported, he took them off because they were getting uncomfortable. The shot finally featured on the cover is number five of six.[16] As for the Volkswagen, Paul was actually twenty-seven, not twenty-eight.

What we have done here is fall into the trap of reading a text from 1969 as if it were a painting from medieval Europe. In the fifteenth and sixteenth centuries, symbolism, religion and painting were all very much wrapped up with each other. Difficult theological concepts were often explained visually (especially to the illiterate) and this, inevitably, involved the use of symbolism and visual metaphor. To many intellectuals, the whole world was one big symbol anyway. It is entirely appropriate, then, to be alert to both overt and disguised symbolism when looking at a medieval work of art. The *Abbey Road* cover does not fall into that category.

On the face of it, then, Panofsky's iconological system is inappropriate for use with contemporary visual texts. This would be a hasty conclusion, however, for

two reasons. First, over-interpretation can be a menace with medieval paint-
ing too. Every apple, dog, flower or bare foot does not have to have a symbolic
meaning. It could be just an apple, a dog, a flower, a foot. The lesson, then, is
to beware of over-interpretation in general.[17] The second point is to remember
that we have only completed the second stage of Panofsky's tripartite system.
The third and the deepest level is still to come.

What can an analysis of the *Abbey Road* cover tell us about the intrinsic
'attitudes' of the culture from which it arose? What, in other words, does it
unconsciously tell us about the *Zeitgeist* (the spirit of the age) of Britain in the
late 1960s?

It must have been a very casual era. The musicians here are not the clean-
cut, tuxedo-wearing artistes of previous times. McCartney doesn't even have
his shoes. There is something of an arrogance about them too: none of them
engages the camera directly, and there is no attempt at a winning smile for the
viewer. The accent is on 'cool' rather than on personability. We notice (picking
up on something we spotted earlier) that the band members are very differ-
ently dressed. The accent is on individuality rather than on conformity. It is
not simply that The Beatles as a group do not wish to conform to mainstream
society as a whole (they began making that point with their original 'Beatle cuts'
which were considered an outrage in 1963), but more importantly that they no
longer wish conformity or cohesion within the band itself. Clearly, by the end of
the decade, individual and personal expression were all.

There is something much more important here, however, and this leads
us to a crucial general as well as specific point: we should always be aware of
what is *not* shown in a visual text as well as what is simply shown. Often, that
which is omitted (intentionally or otherwise) is actually much more revealing.
What is missing from The Beatles' *Abbey Road* cover? Yes, it's extraordinary.
What is missing here is the first thing we would normally expect to see on the
cover of a record: the name of the band. Here, however, we have the cover to
a Beatles album that says nothing about 'The Beatles'. Why? Intrinsically, we
can conclude that The Beatles were so famous in 1969 that they were instantly
recognizable to everybody and that printing the name of the band along with the
picture was, therefore, superfluous. This tells us a great deal not only about The
Beatles, but also (and more importantly) about the importance of the popular
musician in late twentieth- and early twenty-first-century culture.

There is something else we should bear in mind here. The whole 'Paul is
dead' phenomenon, which flourished as an underground conspiracy theory at
the time, is actually only a part of a far greater cultural obsession with the cult
of the dead rock star. We have only to think of Jim Morrison, Jimmy Hendrix,
Kurt Cobain, Elvis Presley and even Michael Jackson (to provide just a handful
of examples) to realize that death and rock celebrity seem so often to go hand in
hand. Dying young, indeed, seems to give the charismatic performer some kind
of eternal life.

This may seem to have taken us a long way from the good burghers and suf-
fering saints of Renaissance painting, but, actually, it hasn't. It has shown us,
rather, that iconology need not be limited to the art of centuries past. Although
Panofsky was indeed much more interested in Western European painting than

in contemporary popular culture, the way of looking he advocated can still be used to unlock meanings in all manner of visual texts. But let us, finally, take this even further. Our intrinsic examination of the *Abbey Road* cover can take us back to the Renaissance in ways that we had not, perhaps, expected. In the *Abbey Road* cover, we have four people so instantly recognizable to people of our time that they do not need signs or labels to identify or distinguish them. Much the same can be said of the 'celebrities' of Renaissance painting. Old and New Testament characters were all frequently represented and instantly recognized. It was even quite usual for sacred images (often in print form) to decorate private rooms and houses. But how often do we see this now? Does the typical teenage bedroom contain devotional images of biblical characters? Probably not, but the walls may quite likely be adorned with much more contemporary 'devotional' images of the popular 'icons' of today. Student rooms will often go further, with reverent images of musicians who have died violently or tragically and yet who have at the same time gained some kind of (cultural) immortality. Could it be, then, that we today have much more in common than we had suspected with the people of centuries ago? Is it simply that we have found new idols to worship?

We have come a long way in this chapter. We started with the basic identification of subject-matter and have moved through the interpretation of symbolism to an intrinsic analysis that has taken us way beyond the conscious intent of the individual artist to provide an insight into the deeper, cultural values of whole societies. It is not necessary, however, to agree with our particular arguments over saints and singers in order to agree with our much broader – and much more important – point that the rigorous analysis of the content of a visual text can reveal unexpected meanings from the text itself, but also unexpected aspects of ourselves.

Key Debate

What do we mean when we say 'image'?

As we have seen, Panofsky's approach to the image is not limited only to the identification of the various symbolic motifs that constitute it. His perspective also values the interpretation of the image's whole symbolic horizon. But what do we mean when we say 'image'?

The American art historian and visual culture thinker W. J. T. Mitchell stimulates this debate by focusing upon the very idea of imagery itself. The concern with how the image is conceived, used across different institutional discourses, and linked with ideology and power, gains a particular significance if we take into account, as Mitchell does, the deeply 'problematic' nature that the concept of the image has assumed in our time.

Mitchell claims that 'language and imagery are no longer what they promised to be for critics and philosophers of the Enlightenment – perfect, transparent media through which reality may be represented to the understanding', adding that 'for modern criticism, language and imagery have become enigmas, problems to be explained, prison houses which lock the understanding away from the world'.[18]

As the modern notion that images are 'transparent windows on the world' dissipated, they became increasingly regarded as 'the sort of sign that presents a deceptive appearance of naturalness and transparency concealing an opaque, distorting, arbitrary mechanism of representation, a process of ideological mystification'.[19] Mitchell locates this contemporary, radical critique of modern idolatry within the context of an ongoing 'war of signs' in which what stands to be conquered by the rival armies is nothing less than access to truth, reality, nature and the human mind. Each type of art, he explains, assumes that its particular kind of signs provide better symbolic equipment to mediate certain things.

The comparison between poetry and painting, which has been a central issue in aesthetics since Aristotle (384 BC–322 BC), provides an outstanding example of the struggle of signs. The importance of poetry is often asserted through the emphasis upon the unique efficacy of conventional, 'unnatural' signs of verbal expression when it comes to represent the invisible realm of feelings and ideas. As for the representation of the visible world, on the other hand, the fitness of the 'natural' signs of imagery is underlined so as to establish the superior ability of painting in the production of that kind of representation.

An equally ancient struggle takes place in connection with the tension between word and image, and this involves the conflicting perspectives of iconoclasm and idolatry. According to Mitchell, the task of the iconologist is to uncover the ways in which the notion of ideology, 'rooted in the concept of imagery',[20] re-enacts the ancient struggle over the place of images 'in the stories we tell ourselves about our own evolution from creatures "made in the image" of a creator, to creatures who make themselves and their world in their own image'.[21]

To help us grasp the implications of these fundamental tensions, we should consider the myriad of things we might be referring to when we use the term 'image'. Mitchell takes the different meanings associated with the idea of 'image' as a family and so presents them in a family tree, organized according to specific appropriations of the notion of 'image' within the boundaries of various institutional discourses. In the discourse of art history, for instance, 'image' is primarily understood as a graphic representation, such as a painting or a statue. Other types of imagery are designated by other intellectual disciplines, which actually use such particular meanings as central elements of their discourses: optical images in physics, mental images in psychology and epistemology, and verbal images in literary criticism. Continuing with the family tree analogy, Mitchell points out that not all members of the family have the same status. From the perspective of so-called common sense, the term 'image' is strictly and properly used only when it designates graphic and optical representations. They are the 'proper' offspring of the image family tree. Contrastingly, 'illegitimate' offspring are mental and verbal images, which correspond to an extended, figurative and somehow abusive use of the notion of imagery. The distinction is anchored in the idea that legitimate images – 'real' optical and graphic images – are the strictly visual ones that we can see in an objective and publicly shared space, whereas 'illegitimate' mental and verbal images cannot be checked objectively, lack the permanency of their 'proper' relatives, and involve other senses.

Mitchell finds the contrast 'suspect', arguing that 'real proper images have much more in common with their bastard children than they might like to admit'.[22] Contrary to the 'common-sense' view, he claims, 'proper' images are not as stable, permanent and strictly visual as one might think. Conversely, 'illegitimate' images cannot accurately be described as purely immaterial, in that a mental image, for example, is inconceivable without the support provided by the material body of the beholder.

While we acknowledge the various notions of image privileged in different fields of discourse, this should not make us rush headlong into the 'proper' versus 'illegitimate' dichotomy. A big problem with the 'common-sense' duality is that it overshadows what Mitchell calls the 'perceptual realm', shared by all kinds of sense data that go by the name of 'image'. Giving centre stage to the perceptual realm would lead us to locate images – all images, regardless of the specific character underlined by the intellectual discipline within which a certain notion of imagery is given priority – not 'outside' in the world or 'inside' in the mind, but in the interface between the two. In that sense, Mitchell claims that 'if the key to the recognition of real material images in the world is our curious ability to say "there" and "not there" at the same time, we must then ask why mental images should be seen as any more – or any less – mysterious than "real" images'.[23]

Mitchell's intellectual trajectory is frequently oriented by a critical refusal of dichotomic views that tend to emerge in conceptions of the visual. As we have seen, the 'paradoxical trick of consciousness' that enables us to see something as 'there' and 'not there' at the same time is highlighted to define the fundamental ontology of all images and thus question the duality between 'proper' and 'improper' imagery. The iconoclasm-idolatry divide and the 'all-or-nothing' discourse on the future of image are also an object of Mitchell's critical reflections on the dichotomies that often dominate conceptions of the image. His views on such controversial matters are informed by his own view on the very ancient and fundamental question of the relationship between word and image. He points out the inaccuracy of the usual criteria used to draw the boundaries between word and image – the idea that the difference can be explained by the mobilization of distinct areas of our sensory apparatus (the ear/eye explanation) or the semiotic[24] distinction between words as signs that convey meaning by convention and images as signs that mean by resemblance. Consequently, he acknowledges his own 'inability to discover a firm, unequivocal basis for the distinction between words and images'.[25]

This confessed inability does not mean that the differences are non-existent; what it rather suggests 'is that the word/image difference is not likely to be definitely stabilized by any pair of defining terms or any static binary opposition'.[26] Instead, Mitchell argues, the word and image relation should be understood as a 'dialectic trope'[27] which 'resists stabilization as a binary opposition, shifting and transforming itself from one conceptual level to another, and shuttles between relations of contrariety and identity, difference and sameness'.[28] Mitchell regards this 'shuttling' of the word–image relation as a dynamic process linked to wider social and cultural issues. Traditional clichés like 'black people are natural mimics' or 'the masses are easily taken in by images' are mentioned as examples

of a tacit socio-cultural agreement on the superiority of words over images, which in turn is a constitutive part of an historically rooted social practice. But, as Howells and Matson assert in their *Using Visual Evidence*, it is important in the modern, image-intensive, visual world to: 'redress the balance'.[29]

Taking words and images as 'a pair of terms whose relation opens a space of intellectual struggle, historical investigation and artistic/cultural practice',[30] leads us to a crucial question: how is the iconologist supposed to deal with that space? The answer is both stimulating and demanding. We have no choice but creatively to inhabit such space, in an attitude of permanent exploration urged by the need to reinvent it as we go along.

Further Study

The best place to start is, of course, with a close reading of Panofsky's *Studies in Iconology*. Special attention should be paid to the introductory section, in which he lays down both a theory and a methodology for iconological analysis. The remainder of the book is a collection of case studies, which shows Panofsky's iconology in action with real examples. Although Panofsky provided the classic text on this subject, his thinking is indebted to the German art historian Aby Warburg (1866–1929). Warburg himself published little (especially in English), but he in many ways set the scene for Panofsky by learning how to 'decode' the subject-matter of Renaissance frescoes (the Palazzo Schifanoia at Ferrara, Italy is his most famous example), rather than simply responding to their formal qualities. Warburg's library became the basis of the Warburg Institute (now a part of the University of London), whose students included Ernst Gombrich. Gombrich (whom we shall meet again in chapter 3) later became director of the institute and also wrote *Aby Warburg: An Intellectual Biography*.[31]

The first works on iconology, however, were simply practical handbooks of emblems and 'personifications', which showed artists how to represent particular people, virtues and so on. They gave practical advice on how visually to represent abstract ideas. Foremost among these was Cesare Ripa's *Iconologia*,[32] published originally in Italy in 1593, with an illustrated edition in 1603. As artists around Europe became increasingly keen to include emblematic symbolism in their work, other volumes followed, such as Christophorus Giarda's *Icones Symbolicae* of 1628 and George Richardson's *Iconology* of 1779, which introduced Ripa's iconology to an English-speaking audience.[33] These books are rare and valuable in their original editions, but facsimiles and later, annotated editions are available in many college and university libraries.

Iconology underpins many traditional histories of art, as the identification of subject-matter is important to nearly all figurative works. The medieval and Renaissance periods are particularly rich in emblems and symbols, both overt and disguised, and so studies concentrating on these periods are especially interesting to those who enjoy the iconological approach. Emile Mâle demonstrates the importance of symbolism to the medieval mind in two volumes: *Religious Art in France: The XIIIth Century* and *Religious Art in France: The Late Middle Ages* – both of which have as a subtitle *A Study of Medieval Iconography*

and its Sources.[34] Johan Huizinga's *The Waning of the Middle Ages* helps set the cultural scene for the Renaissance, while Panofsky himself provides a number of iconological tours de force in *The Life and Art of Albrecht Dürer*. This includes a particularly close reading of Dürer's enigmatic engraving *Melencolia I*.[35]

The work of Chicago-based W. J. T. Mitchell is central for the understanding of the relations between image and word, namely in what concerns the ideological implications of such relation. Apart from Mitchell's own writings, his activity as editor of the journal *Critical Inquiry* has crucially contributed to deepen the discussion on the role of verbal and visual representations in the context of social issues. A particularly intriguing approach to the theme is offered in Mitchell's *What do Pictures Want? The Lives and Loves of Images*.[36]

Finally, it is worth bearing the concept of iconology in mind while reading the fifth chapter of this book, 'Semiology'. The idea of something standing for something else is fundamental to semiotics, and the title of Roland Barthes' essay 'The Iconography of the Abbé Pierre', in his *Mythologies*, suggests unexpected confluences of approach which the current volume ultimately advocates.[37]

2

FORM

This chapter introduces us to the role of form in the meaning of the visual texts. It moves our focus away from *what* is being shown and on to *the manner* in which it is depicted. We will see, therefore, how meaning can be communicated as much by form as it is by content. In some cases, it will be shown that form is actually the more important of the two. In others, indeed, it will be argued that subject-matter is so eclipsed by form as to make the content practically 'irrelevant'. This becomes particularly important with 'modern' and especially abstract art, in which there is no discernible subject-matter at all. To help us see this argument develop, we will be guided by the changing aesthetic of Roger Fry. Fry will explain not only the use of form in the communication of emotion; he will also provide us with a five-point system for the analysis of form within visual art. Along the way, we will take a close look at work by the Post-Impressionist painter Paul Cézanne, together with American Abstract Expressionists Mark Rothko and Jackson Pollock. As we do so, we may see this chapter on form as developing a counter-argument to the previous chapter on content.

In the previous chapter, we learned how to try and discover the meaning of a visual text by examining its subject-matter or content. For Panofsky, we remember, content and meaning were pretty much the same thing. We used his three-part system of iconography to help us get to grips with the meaning of texts as diverse as the *Arnolfini Wedding Portrait* and the Beatles' *Abbey Road* cover. How does this help us, then, to discover the meaning of a painting by the American artist Jackson Pollock (see figure 6)? How do we identify, describe, classify and interpret the subject-matter here? Quite simply, we can't. Does

6. Jackson Pollock, *Number 32*, 1950, enamel on canvas; courtesy of Kunstsammlung Nordrhein-Westfalen. Copyright Pollock-Krasner Foundation/VG Bildkunst, Bonn 2010

this mean, then, that an image with no obvious subject-matter can have no meaning? What are we to do? What we need to do is take an intellectual journey in the agreeable company of Roger Fry.

Fry is the ideal person to follow here because his thoughts about form and content in painting changed just as painting itself was turning away from the pursuit of realism at the start of the twentieth century. As his own views changed, he tried to change public opinion too, even though their initial reaction was one of hostile resistance. Rather than try and baffle people with complex art theoretical prose, however, Fry maintained a clear and persuasive writing style that maintains its freshness for contemporary readers. In addition to the theoretical arguments, he defined a set of 'elements of design' that we can use for ourselves in our own analysis of form in painting. Fry's writings were important in their time and remain influential today.

Roger Fry was born into a Quaker family in England in 1866. His parents, Sir Edward, a judge, and Lady Mariabella Fry, lived in Highgate, London. His upbringing was understandably traditional, but Fry himself was not. As a schoolboy at Clifton, he 'hid his latent antagonism under a deep surface of conformity',[1] but as a student at King's College, Cambridge, he found he actually began to enjoy the intellectual (and, it must be said, social) life. Although he was formally studying Natural Sciences, he became increasingly involved in discussing the great intellectual issues of the day, whether they were philosophy, politics, religion or, increasingly, art.[2] Having graduated with first class honours in science, Fry then incurred the displeasure of his family by deciding to become an artist. In 1896 he even married one, adding to family concerns.

As an artist, Roger Fry enjoyed only moderate success. As a lecturer and critic, however, he became increasingly renowned. His passion and expertise was in the Italian 'Old Masters', such as Raphael, Titian and Botticelli, and this led to his increasing celebrity in the United States. In 1906, while travelling in the private railway carriage of the prominent American financier, philanthropist and art collector, J. Pierpont Morgan, the forty-year-old Fry accepted the directorship of New York's Metropolitan Museum of Art. In reality, he did not spend a great deal of time in New York. He spent far longer in Europe buying paintings for the museum, and it was in Europe that he discovered a love even greater than that which he had developed for the 'Old Masters': the Post-Impressionists. This proved to be yet another outrage.

The thinking – the realization, even – behind Fry's new passion was frighteningly simple: there had to be more to art than the simple imitation of reality. This may not strike us as a particularly controversial insight today, but to Fry – and certainly to the cultured society of the early 1900s – it most certainly was. We have to remember that until that moment, Fry's taste and expertise had been in Italian 'Old Master' paintings, paintings in which artists had finally conquered the challenges of proportion, perspective, colour and harmony to provide works so realistic that the canvas had become a window on to reality; it was as though looking though the frame were looking out and into the real world beyond it. Realism and painting seemed synonymous for the next 500 years. In seventeenth-century Holland, for example, artists were able to paint still lives with such almost-photographic accuracy that they could capture details

such as light-reflecting dew on finely veined leaves among botanically authentic bunches of flowers. Fry agreed that all this was remarkably skilful, but finally dared to wonder what all this realistic accuracy was actually *for*. 'If imitation is the sole purpose of the graphic arts', he wrote, 'it is surprising that the works of such arts are ever looked upon as more than curiosities or ingenious toys.'[3] It is a simple and elegant sentence, but one that went directly against the received wisdom of half a millennium of educated thought. How did Fry explain this?

According to Fry, people had two kinds of life: the actual and the imaginative, and the work of art was 'intimately connected' with the second. The actual life was concerned with the humdrum detail of everyday experience, while the imaginative life formed 'the completest expression' of human nature. It was, he explained, rather like the difference between walking down a street or catching a train and watching a film of a similar event. If one was actually involved in either of these activities, one was an actor engaged in the drama, busy looking for friends or trying to find a seat on the train. Watching the same things on screen, however, one was able to '*see* the event much more clearly' (Fry's emphasis). More than that, when watching the scene rather than participating in it, one didn't have physically to react to everything one saw (such as running away from a real bull in a field). One reacted, instead, in one's imagination. The graphic arts, therefore, were 'the expression of the imaginative life rather than a copy of actual life'. Children understood this when they drew, expressing 'with delightful freedom and sincerity, the mental images which make up their own imaginative lives'. Fry here was using children as an example, but he made exactly the same distinctions when explaining adult painting, and this applied equally to the artist as to the spectator. The imaginative life, of which art was the 'chief organ', was 'distinguished by the greater clearness of perception and the greater purity and freedom of its emotion'. Art, therefore, was the medium through which this higher state could be attained. Fry concluded: 'We must therefore give up the attempt to judge the work of art by its reaction on life and consider it as an expression of emotions regarded as ends in themselves.'[4]

How was this emotion to be communicated? Certainly not by a mimetic or 'realistic' allusion to the actual world. Rather, it was to be communicated by the formal arrangement of the artwork itself. In other words, the work of art communicated not by *what* it showed but by *how* it showed it. 'We may, then, dispose once and for all with the idea of likeness to Nature, of correctness or incorrectness as a test, and consider only whether the emotional elements inherent in natural form are adequately discovered.'[5]

To his credit, Roger Fry didn't only theorize about art. He didn't just want people to read about his opinions; he wanted them to look at paintings for themselves. In 1910, he left the Metropolitan Museum and returned to England, where he staged an exhibition, *Manet and the Post-Impressionists*, at the Grafton Galleries in London. It was this, however, that created the latest outrage. Thinking about this today, it might be very difficult to see what could be so outrageous about an exhibition of now canonical artists such as Manet, Picasso, Cézanne, Gauguin, Derain and van Gogh. Yet outrage it certainly produced. 'The public of 1910 was thrown into paroxysms of rage and laughter', wrote Virginia Woolf in her biography of Fry. 'The pictures were a joke – a joke at

their expense.' Indeed, 'One gentleman . . . laughed so loud that he had to be taken out and walked up and down for five minutes.'[6]

But greater than the mirth was the anger. According to the British gallery-going public, the pictures were 'outrageous, anarchistic and childish. They were an insult to the British public and the man who was responsible for the insult was either a fool, an impostor or a knave.'[7] The newspapers were full of it, and Fry, whose lectures on the 'Old Masters' had made him the darling of the cultured public, was now considered a traitor. He reflected, ruefully, that they viewed him now as either 'flippant' or 'insane'. Indeed, 'The accusation of anarchism was constantly made.'[8]

Why had the cultured public turned against Fry? He struggled hard to figure out just what he had done. He tried to explain that the Post-Impressionists had simply been trying to get back to the basic ideas of formal design which had reigned supreme in the centuries before everyone became obsessed with creating the illusion of reality. Few were convinced. It was only some ten years later that Fry realized that what he had done had been much more political than he had previously imagined. 'I now see that my crime', he wrote, 'had been to strike at the vested emotional interests.' In order to appreciate the 'Old Masters', it had been necessary to have some learning in art and possibly even in the Classics. One needed to be educated. Many of the great Renaissance paintings, for example, required prior knowledge of Greek or Roman history or mythology in order to make sense of them. Iconography, both overt and disguised, could be used to make theological points in religious works. They made allusions to greater cultural worlds beyond the painting itself, worlds that one needed specialist knowledge to enter. In this way, one had to be a member of the educated elite in order fully to understand them. This, then, was the 'special culture' of a specialist public, and this cerebral appreciation of the arts was one of the 'social assets'. It gave the elite 'a social standing and a distinctive cachet'. To admire a Matisse, on the other hand, 'required only a certain sensibility'. If anyone could understand a Matisse, where was the cachet in that? It was all the more threatening because 'although one could feel fairly sure that one's maid could not rival one' in the appreciation of Amico di Sandro or Baldovinetti, she might 'by a mere haphazard gift of Providence surpass one in the second'. The revolutionary anarchism of which Fry had been accused, then, was 'due to a social rather than an aesthetic prejudice'.[9]

This certainly helps to explain the outrage that Fry's Post-Impressionist exhibition provoked. But how do we explain how a maid might have understood Matisse or van Gogh better than her Edwardian masters and mistresses? And how, indeed, do we begin to explain the meaning of a painting by Jackson Pollock or Mark Rothko? It all, of course, comes down to the formal arrangement of the artwork itself; not *what* it shows, we remember, but *how*. This, in turn, deserves a little extra explanation.

This, we think, is best explained by an analogy with music. Music is not normally mimetic. That is, it does not usually seek to look like something or even to sound like something from the real world outside. A tune is a tune in its own right. But even though it may not look like something we recognize, and even though the melody may not sound like something from nature, it still has

the power to move us emotionally. We are moved, in other words, by its pure form. That is precisely why we can be moved by something as gentle and contemplative as Pachelbel's canon in D, or as intense and adrenaline-filled as the riff to Eric Clapton's 'Layla'.[10] It may be difficult to explain precisely, but there is something about the melody, the pace, the texture, the arrangement and the instrumentation of those two very different pieces that moves us in very different ways. This helps to explain why music is such an important part of so many people's lives; it helps reflect and even create our moods for the day.[11] Music can express or even create our feelings in ways that it is almost impossible to put into words.

Some famously successful pieces of music do have words, though. What we want to suggest, however, is that the words are frequently the least important part. Take, for example, the undeniably emotional 'Nessun Dorma' from Puccini's opera *Turandot*. This is an aria which is probably most associated with the late Italian tenor Luciano Pavarotti, and which became a cornerstone of the Three Tenors' concerts and records around the world. It was even used by BBC Television as the theme tune to the World Cup soccer finals in Italy. We recall the steady build-up of the piece, gathering in passion and intensity (to say nothing of the volume!) until, with the final phrases, the voluminous Pavarotti, sweating with emotion, handkerchief in hand, sparkling eyes staring intensely into space, has the audience rising to its feet in rapture and applause even before the orchestra has reached its final notes. Why? It isn't the words. The words, are, frankly, rather silly:

> None must sleep! None must sleep!
> And you, too, Princess,
> In your cold room
> Look at the stars
> Which tremble with love and hope!
> But my mystery is locked within me
> No one shall know my name!
> No, no, I shall say it as my mouth meets yours
> When dawn is breaking!
> And my kiss will dissolve the silence
> Which makes you mine!
> (No one shall know his name
> And we, alas, shall die!)
> Vanish, o night!
> Fade stars!
> At dawn I shall win!

Oh dear. All that puffing and panting and all those exclamation points. It reads like a scene from a bad romantic novel. It is just as well, then, that it is usually sung in Italian, a language that most of us do not speak. Yet this helps to underline our point. We can be deeply moved by this piece even though the words are either silly or – to most of us – completely unintelligible. What we have, then, is something that is beyond words. The emotion of this piece is not in the content but in the form. It is the form that elates us.

Precisely the same can be said of more contemporary music. If we play back some of our favourite tracks in our heads, how precise is our recollection of the lyrics? We may remember some of them, but it is probably the melody, the bass line or some part of the production that provides the most significant portion of our recall. The words are often there simply to help it all along. If we were to recite the words to some of our favourite tracks to a friend, it would probably have little effect beyond comedy value:

> Backbeat the word is on the street
> That the fire in your eyes is out
> I'm sure you've heard it all before
> But you never really had a doubt
> I don't believe that anybody feels
> The way I do about you now
> And all the roads we have to walk are winding
> And all the lights that lead us there are blinding
> There are many special things that I would like to say to you
> But I don't know how
> Because maybe
> You're gonna be the one that saves me?
> And after all
> You're my wonderwall

So what's that all about? On its own, we would argue, very little. Together with the music, however, Oasis' *Wonderwall* is (arguably) one of the best records of its era. We understand that the words are only a contributory part of the whole concoction, and that with contemporary music it is not only the tune but also the arrangement, the production and even the mix that contribute to the success (or failure) of any given track. Oasis' Noel Gallagher agreed. In an interview with *Q* magazine he explained that when he wrote a new song, the riff came first, then the melody, and then the problem of the lyrics. 'So Oasis is a band that's about the sound and feel of the songs more than what they say?' Gallagher agreed. It was all about 'emotion'.

This may seem to have come a long way from Roger Fry and Post-Impressionist painting. It hasn't, of course. In so many pieces of music, the words, content or subject-matter are not the main point. They are mainly there as something around which the form, which communicates the emotional content of the work, can be exquisitely wrapped. It is just the same with Post-Impressionist painting. If Cézanne, for example, paints a still life of a selection of fruit on a rumpled tablecloth, he is not drawing our attention to the quality of the fruit. We do not, it is to be hoped, react with emotion to a particularly fine example of a pear or an apple. What Cézanne is doing is using the apparent subject-matter as a vehicle for an exploration of his real concern: form.

Painting, then, should be like music for the eyes. This is why Fry thought that servants might be better at understanding Post-Impressionist painting than their educated employers. It takes no particular skill to listen to music. To be sure, a degree of knowledge may add to our intellectual enjoyment of a piece, but, primarily, music takes its effect by washing over us and communicating directly

with our emotions. It takes only a degree of openness, perhaps even innocence. We may be stirred, for example, by Sibelius's triumphal fifth symphony without being able to read the score – and certainly without worrying about whether it is 'realistic' or not. We have only to wait for the horn to arrive in the third movement to be uplifted. When looking at the paintings of Cézanne, van Gogh, Matisse and so forth, the educated viewers of 1910 were unable to get beyond their fixation with realistic 'correctness'. More than that, by seeking meaning in the subject-matter of the paintings, these people were either missing the point or, put another way, seeking a point that wasn't even there. The subject-matter in so many of these paintings is, of course, the subject-matter itself. That is why Fry's maids, armed with sensibility as opposed to learning, were able to 'surpass' their masters and mistresses in their appreciation of the Post-Impressionist exhibition of 1910.

This is all very well, but trying to explain non-mimetic painting as 'music for the eyes' may strike some people as rather vague. How, precisely, is emotion communicated by form in painting, and what sort of system did Roger Fry suggest for the analysis of it? Not surprisingly, perhaps, Fry's emotional approach is rather less structured and precise than Panofsky's essentially cerebral way of looking, but Fry still explained it as best he could.

Art, he argued, was an expression of the imaginative life rather than a copy of actual life. The imaginative life was clearer, freer, and purer than the actual. Art appreciated emotion in and for itself. It was necessary, then, to give up trying to attempt to judge a work of art by its 'realism', but to see it instead as the expression of emotions in their own right.[12] This led him to try and bring some order to his thinking on the qualities required in a work of art.

First of all, a work of art should be designed for intense contemplation rather than physical action. This was achieved by a combination of both order and variety. Without order, we would be confused, yet without variety we would be bored. One of the chief aspects of order was unity, and this was achieved by the compositional balance of objects within the painting itself. It was this that held our attention inside as opposed to outside the frame. Fry had less to say about variety, but proceeded swiftly to make one of his key points, that the artist arouses our emotions by 'the emotional elements of design'. These were: (1) the rhythm of the line; (2) mass; (3) space; (4) light and shade; and (5) colour. The line is that which delineates objects in a painting. More than that, though, it communicates the artist's feelings to us directly. Mass is the way bulk or volume are communicated. The typical painting is only two-dimensional, so the artist needs to convey ideas about (say) inertia or weight by connecting the object in the painting with our experiences in daily life. This connection is made by our imagination. Space is the way size is represented upon a canvas, which is not necessarily the same size as the object represented. This is also connected with proportion, which is concerned with the relative dimensions (or apparent dimensions) of one thing as opposed to another. In this way, said Fry, the same-sized square on two different pieces of paper could appear to represent things either inches or hundreds of feet high. Differences in light and shade could alter our feelings towards exactly the same object. The object could, for example, be strongly illuminated against a black background or, on the other hand, shown

7. Paul Cézanne, *Still Life with Milk Jug and Fruit*, circa 1900, oil on canvas; courtesy of
 the National Gallery of Art, Washington, DC; gift of the W. Averell Harriman Foundation
 in memory of Marie N. Harriman

dark against the light. Colour had a 'direct emotional effect', which was why we
could so easily speak of it in terms of emotional words such as 'bright', 'dull' or
'melancholy'.[13]

Fry's aesthetic, it might be argued, is more useful to us conceptually rather
than practically. His basic argument is perfectly clear: the purpose of art is not
the authentic portrayal of reality, but the communication of emotion from the
artist to the spectator. This is achieved by form rather than by content, and
conveyed by the emotional elements of design. In this way, the meaning of a
painting lies in how it is rather than what it simply purports to show. When it
comes to practical, structured advice on how to analyse art, however, Fry has
rather less to say. Certainly, we should study a painting with quiet, focused
contemplation, and should pay particular attention to those five emotional ele-
ments of design.

Let us take a quiet contemplative look at a Cézanne still life and see how
useful Fry's guidelines are to us (see figure 7). First of all, we see that it is
ordered. The composition is balanced within the frame so that the painting has
a self-contained unity about it. Fry talks about the balance of 'attractions to the

eye',[14] by which we understand those elements in the composition to which our attention is drawn. Balance, of course, is not a matter of mere symmetry, and to the artist it is much more than a matter of mathematics.

If we are practising artists (in no matter what medium), we will already understand the importance of balance in composition. It comes to us intuitively. Yet, even if we are not actively involved in the creation of works of art, we still bring notions of aesthetic balance to bear when, for example, we are rearranging the furniture in a room or hanging pictures on a wall. We rework the 'attractions to the eye' (be they the couch and the rug, or the film poster and the portrait of dear aunt Agatha) until they all look somehow 'right'. Some of us are better at this than others, just as are some artists. If we are beginners in the two-dimensional arts, we will probably be told about the 'rule of thirds', which is an elementary aid to composition. It holds, for example, that a horizon in a landscape usually looks better a third of the way down (or occasionally up) a painting. To put it halfway can look very crude. Similarly, it is often a good idea to arrange major points of interest (such as a tree or a person) along one of the 'thirds' from left to right. This is excellent advice for beginners in photography. In photography, the accurate reproduction of nature is automatically achieved; the composition, therefore, becomes of crucial importance. Of course, whether in photography or any of the graphic arts, rules are consistently – and often effectively – broken, but some sort of order is nearly always attained. If one 'attraction' is moved, then the odds are that another will have to be moved to balance it. We can think about this for ourselves when looking at the Cézanne: if we were to move the milk jug to the centre, for example, how would that affect the rest of the composition? Would we have to move the napkin or some of the fruit elsewhere to compensate for the change? Fry understood this, stressing the importance of the 'unity' of the painting as a whole rather than only its component parts. If it lacks unity, he said, 'we cannot contemplate it in its entirety'.[15]

Cézanne's painting has variety in addition to its unity and order. Although it is organized as a whole, its component parts provide us with a variety of motifs, shapes, colours and textures – to say nothing of the variety of recognizable objects portrayed. The rhythm of the line may seem a more difficult concept: perhaps it is helpful to think of the *quality* of the line as well. Certainly, the line here clearly defines Cézanne's objects. It is drawn with some confidence. He is not concerned with every tiny detail; this painting is not meticulous in its draughtsmanship. Often, the defining line is emphasized in non-realistic black. Fry, we remember, says that the line communicates the artist's feeling directly to us. What can we tell of Cézanne from his use of line? It is often helpful if we try and imagine an artist in the act of drawing when we try to interpret the line, as too often we overlook the physicality of producing art. How might we visualize Leonardo at work, with his busy, finely detailed use of ink and chalk? How might we compare this to Ingres, with his flowing, economic and deliberate lines? Or Picasso's broad and confident strokes? Cézanne's use of line, therefore, reveals not just what he sees, but, much more interestingly, how he *feels* about what he sees. It is a painting, then, that is as much (and probably more) about the artist's personality as it is about a jug and some fruit.

When we come to mass, we notice how Cézanne here seems particularly

interested in the geometric or volumetric properties of the objects he depicts. There is something of the sculptor or the modeller about him in the way he emphasizes the solidity of his forms. His gaze is analytical too: ostensibly, these are items of fruit, but to what extent are they, equally, spheres? To a degree, we can feel their weight because of our own experience of not only eating fruit but also of holding and even playing with it in our hands, as if apples were cricket or baseballs. Cézanne leaves us in no doubt that these are three-dimensional objects with their own mass. It is at the same time fruit, but equally not really fruit at all.

Cézanne handles space here with similar skill. He communicates a real sense of the proportional dimensions of all the objects included in the painting, together with an appropriate sense of depth. At the same time, however, he does not appear to be seeking a photographic illusion of three-dimensional proportion and perspective. In the same way that we saw him outline many of his objects in black, photographic accuracy does not appear to be his prime concern here.

In terms of light and shade, Cézanne seems little concerned with dramatic contrasts and effects in this picture. Some painters, such as Caravaggio and Rembrandt, made a feature of almost operatic lighting effects in their work. Cézanne, on the other hand, prefers a relatively 'flat' light without any unnecessary sense of drama. Nor does he seek to capture the fleeting moods of natural light as did his Impressionist predecessors. This is a painting about forms (and the relationship between them) rather than the naturalistic illumination of them.

We shall not say too much about colour here because our illustration is in black and white. This is because monochrome (as opposed to colour) photographs help to keep the cost of this book down for students. Suffice to say that Cézanne uses fairly flat, 'earthy' tones in this painting, in keeping, perhaps, with the lighting. Unlike more radical Post-Impressionists such as Matisse and Gauguin, whose determinedly non-naturalistic use of colour earned them the nickname the 'Fauves' (savages), Cézanne here essentially respects the colours that nature had originally provided. It remains, though, as if we were viewing the scene through a screen which has filtered out the precise and defined intensity of natural colour.

Taken together, our analysis of this painting using Fry's component criteria underlines our key conclusion: at no point is Cézanne seeking the 'correct' illusion of reality. Quite simply, it is not at all what he intended. He seeks to communicate emotion rather than information; emotion articulated not by subject-matter but by the emotional elements of design.

This conceptual leap away from the importance of 'accuracy' in art opens up far more to us than the work of Cézanne and the Post-Impressionists. It helps us make sense of the majority of 'modern' art. Yet, central though painting since 1900 has been to an appreciation of contemporary Western culture, Fry's aesthetic has the huge advantage of opening up to us a far wider world of art in which the illusion of reality was never the idea in the first place. It helps us to understand types of art which had formally been described (and possibly even dismissed) as 'primitive'. The art, for example, of African, Polynesian and Native American people had never sought the illusion of reality. To them, the

idea that art should mirror nature would probably have been met with the same mirthful incomprehension that greeted Fry's Post-Impressionist exhibition in London. To describe indigenous art as 'primitive' presumes that it was only made as it was because the artists had yet to 'progress' to a mastery of the illusionistic techniques of Western artists within the last 500 years. Fry's aesthetic, however, helps us to understand that indigenous art has many of the same formal aspirations as did the art of the Post-Impressionists, communicated by the emotional elements of design. Viewed in this way, it is rendered considerably less 'primitive'. The native tribes of British Columbia, for example, have never sought to reproduce the natural beauty that surrounds them. To be sure, the eagles, ravens, frogs and whales of the Pacific Northwest appear regularly in Haida, Kwakiutl and Tsimshian art, but only in a very formal, stylized way. Typically, the designs seek nothing more than two dimensions, and frequently only red and black pigments are used. Each creature tends to be constructed using a familiar 'vocabulary' of component parts, the most common of which is the rounded rectangle or 'ovoid'. Looking at such work, it makes sense equally to apply the description Fry made of the French Post-Impressionists: 'They do not seek to imitate form, but to create form.'[16]

So far, we have seen Fry help us to relegate subject-matter to second place in our understanding of works of art. His aesthetic, then, will be particularly useful in helping us to gain an understanding of works of art in which there is no apparent subject-matter at all. We can present ourselves with no greater challenge than the paintings of the twentieth-century American artists Jackson Pollock and Mark Rothko.

Jackson Pollock was born in 1912. He began his career as a realistic painter of American scenes, but from the 1940s developed a wholly abstract style and then, from 1947, his famous 'drip and splash' style of 'action painting'. Here, Pollock would fix his canvas directly to the floor or wall and, instead of using traditional brushes, would drip, drop, hurl and splash the paint directly upon it. Sometimes he would add sand or broken glass to the mix to add texture, and occasionally use sticks or knives to move the paint once it had hit the canvas. His style is instantly recognizable; his paintings are usually large and impressive blizzards in tangled pigment. This kind of 'action painting' (as it was called) has two significant features. First, when we look at it, it is almost inevitable that we at the same time imagine the artist in the act of making the painting. It has a physicality that directly connects the artwork with the act of its creation. This, in turn, reminds us of the way in which Fry saw the rhythm of the line in a work of art as a kind of autograph of the personality or even the mood of the individual artist. When we look at any of Jackson Pollock's works in this style, we can imagine him actually working on the piece, spontaneously hurling paint across the canvas as if he were trying to exorcize some personal demon. This brings us to the second feature, the belief that in 'action painting' the motion of the artist is presented raw and direct upon the canvas rather than having to be mediated through recognizable subject-matter. Rather than depict the experience of rage, for example, the artist would depict rage itself. If one looks for subject-matter in these paintings, then, one looks in vain. Indeed, these paintings lack not only recognizable motifs, but also any central point of focus or attention. They are

examples of what critics came to regard as 'all-over' paintings, in which the edges can be of equal importance to the centre. In traditional composition, the artist can focus our attention wherever he or she wishes. Here, we need to contemplate the work in its entirety.

The work of Mark Rothko provides us with a similar yet contrasting example. Rothko was born in Russia in 1903, and moved to the United States at the age of ten. He studied at Yale rather than at art school, but, like Jackson Pollock, developed his own, instantly recognizable style from the late 1940s. He is known as a 'colour field' painter: that is to say, he worked using large expanses of unmodulated colour rather than painting distinct forms or motifs (see figure 8). His paintings are distinctive in that they usually feature two or three square or rectangular blocks of colour superimposed on a larger field. His works are typically simple in composition, even though he worked with perfectionism and great attention to detail. Where we can (quite rightly) envisage Jackson Pollock hurling his spattering paint at the canvas, we see Rothko working smoothly with brushes, using broad strokes of the arm and wrist. Where Pollock's lines were energetic and distinct, Rothko's are calm and diffuse. Towards the start of this distinctive phase of his career, Rothko worked with a variety of vibrant colours, including oranges and yellows. Later work became much more sombre and contemplative, with darker reds and greens, while his final pieces are remarkably 'dark', with frequent and brooding use of grey and black. This was a transition well described at a major retrospective of Rothko's work at the Tate Modern museum in London in 2008–9. The brown, grey and black works from the end of his career made a particularly powerful statement in comparison with the earlier and considerably brighter paintings.

We look in vain for recognizable subject-matter in these works. If we were to try, therefore, to discover the meaning of work by artists such as Pollock or Rothko using Panofsky's iconographical system, we would get nowhere. For Panofsky, we remember, subject-matter and meaning were one and the same thing. Does this mean, therefore, that works such as those by Jackson Pollock and Mark Rothko have no meaning? Far from it. We have already come to sense the frenetic energy of Pollock and the gathering gloom of Rothko from even this brief examination. We can examine their work using Fry's 'emotional elements of design' (as best we can; line and colour are particularly useful here, as are order and variety) to give us some analytical structure, but we can still be guided by our 'sensibility' in responding to heavily emotional works at a distinctly emotional level. We need no knowledge of history, classical mythology or Renaissance iconology to understand such works. We respond to them just as we would to instrumental music: at an entirely formal level. Our sensibility persuades us that although such works have no clear subject-matter at all, they still have much to say about the emotions communicated by their respective artists. Having contemplated these works for their formal qualities alone, we can entirely reasonably interpret them as 'emotional self-portraits' of the artists who created them. It should come as no surprise at all to discover, therefore, that Jackson Pollock was an alcoholic who died in a car crash in 1956, or that Mark Rothko suffered increasingly from depression and took his own life in 1970.

Does this mean, then, that the subject-matter is of no consequence in our

8. Mark Rothko, untitled, 1969, acrylic on canvas; courtesy of the National Gallery of Art, Washington, DC. Copyright 1997 Christopher Rothko and Kate Rothko Prizel

understanding of a work of art? Fry certainly leads us in that direction. He saw art as dealing with the imaginary rather than the actual in life, and argued for the necessity of 'cutting off the practical sensations of ordinary life' in order to experience art more clearly and intensely. This emotional communication was made via form and not content. Therefore, he admitted that the 'logical extreme' of this argument would be to give up all attempts at resembling the recognizable world and instead to 'create a purely abstract language of form' which he described as 'visual music'.[17] Where Fry may have hesitated, however, Clive Bell did not fear to tread. Clive Bell was a British critic who helped Fry set up a second Post-Impressionist exhibition in London in 1912. Bell argued that all works of visual art, whether they were ancient or modern, Eastern or Western, shared a common and essential quality called 'significant form'. This

was a combination of lines, colours and forms which worked together to stir our 'aesthetic emotions'. This aesthetic emotion was, in turn, a special and particular emotion provoked by art.[18]

Bell echoed Fry when he wrote unenthusiastically about what he called 'descriptive painting': painting that conveyed information rather than emotion. If it did not convey emotion by way of form, he argued, then it was not a work of art. He went on to praise what he described as 'primitive' art because it eschewed representation and 'technical swagger' but dedicated itself instead to 'sublimely impressive form'. In this way, they had created 'the finest works of art that we possess'.[19]

Bell did not argue that representation was bad in itself. It was not always harmful, but to appreciate a work of art properly, we had to cut ourselves off from the familiarities and realities of ordinary life and bring with us nothing more than a sense of form, colour and three-dimensional space. Representation in art, he proceeded majestically to conclude, was always 'irrelevant'. Great art, therefore, was independent of time and place. To those who were fortunate enough to understand the significance of form, what did it matter if a piece were made in Paris the day before yesterday or in Babylon fifty centuries ago? All lead 'by the same road of aesthetic emotion to the world of aesthetic ecstasy'.[20]

Fry thought this was a little extreme, but he still valued Bell's attempt to isolate purely aesthetic feelings from the whole mass of emotions created by a work of art. He used the example of Christian art as a kind of thought experiment. A Christian spectator might be moved by his prior knowledge of the New Testament stories illustrated in works such as Raphael's *Transfiguration* or Giotto's *Pietà*. A viewer with no knowledge of Christianity, however, would react far more to their formal qualities. However, even though this spectator may have no knowledge of Christianity, he would still have knowledge of the world, of life, people and experiences and so could not help but refer his experience of the artwork back to his or her experience of life. On the one hand, then, Fry thought the attempt to isolate and explain the aesthetic reaction was 'the most important advance in modern times' in practical aesthetics. On the other hand, he was equally forced to conclude that the total separation of form from content was not possible.

This makes sense. We know from personal experience that it is impossible to separate form from content when looking at a figurative work of art. Where there is content, it cannot help but influence our reaction to a work as, in many cases, it was intended to do. How can we look at a Rembrandt self-portrait, for example, without examining the face of Rembrandt? Rembrandt was a regular self-portraitist who recorded his changing appearance throughout his entire adult life. We can see the fresh-faced young man who started his career as a painter in the Dutch town of Leiden in the 1620s, and then the confident, well-dressed and highly successful artist who bought a grand house in fashionable Amsterdam in 1639. From the 1650s, however, a different Rembrandt begins to emerge: older, wiser and eventually bankrupt. He depicts himself in his working clothes, having discarded the pomp and swagger of wealthier times. In his final self-portraits, his attention moves from the physical to the psychological. In

1669, the year of his death, he painted his final self-portrait: an old man full in the knowledge that his life was drawing to a close.[21]

To interpret Rembrandt's self-portraits simply as a combination of lines, colours and forms – as Bell would have us do – verges on the absurd. Bell would have us cut out any real-world associations we have with Rembrandt and interpret the works simply as designs. Taken to the extreme, Bell's aesthetic would presumably have us pretend that we did not recognize the appearance of a human face.

Perhaps it was Bell's extremism that prompted Fry finally to retreat even from his own position that subject-matter was only of secondary importance. In 1933, speaking thirteen years after the original publication of *Vision and Design*, and one year before his death, Fry finally announced that 'painting has always been, and probably will remain, for the greater part a representational art'.[22] He had not given up his interest in form completely, however. What he advocated now was a unification of form and content in the same way that music and words were inextricably linked in songs or operas. He admitted that this ideal perfect fusion was only rarely accomplished: Giorgione's *The Three Philosophers* was 'a picture in which the two elements combine and enrich each other'. Rembrandt was another artist who combined 'an extreme poetic exultation' with 'great plastic construction' to bring about 'a complete fusion of the two'.[23] His article used an illustration of Rembrandt's self-portrait of 1663 as an example (see figure 9).[24] In works such as this, form and content came together such that the artist was 'doubly a genius'. This was what he now called the 'double nature' of painting.[25]

This may all seem very confusing. Bell was extreme but constant, while the articulate and persuasive Fry appears to have changed his mind twice. In an unexpected way, however, this turns out to be rather engaging because Fry was the first to admit that 'I have never prided myself upon my unchanging constancy of attitude'.[26] This is perfectly fair; commendable, even. Artists and philosophers change their ideas over time, and so why not the critic? Dogged constancy is not always a virtue. Real insight, on the other hand, tends to evolve. The question of 'who was right?', therefore, is neither a simple nor even a good one.

It seems to us that the answer to the form versus content debate lies not in siding wholly with any particular critic (at any particular time), but rather to conclude that each aesthetic is best selected according to the work of art under analysis. Different works of art, after all, communicate different things in different ways. Looking at some of the works we studied in the previous chapter, for example, it is clear that certain kinds of visual text (such as those deliberately filled with overt and hidden symbolism, together with deliberate biblical or classical allusions) lend themselves particularly well to Panofsky's style of iconological approach. For Panofsky, we remember, subject-matter and meaning were the same thing. He wasn't always right, of course, but with the type of Renaissance artwork with which he most famously concerned himself, he often was. He understood how the Renaissance artist sought to create meaning, and so Panofsky sought to interpret it in the same way. Fry's relegation of subject-matter to a supporting role, on the other hand, was entirely appropriate for the

9. Rembrandt van Rijn, self-portrait, circa 1663, oil on canvas; courtesy of Kenwood House, London, Iveagh Bequest

understanding of early twentieth-century, Post-Impressionist painting. In this context, the viewer is seriously missing the point if she or he starts to try and find profound or even hidden meanings in a bowl of fruit. Clive Bell's aesthetic seemed extreme when confronted with a figurative or representational work of art such as a Rembrandt self-portrait, but was entirely appropriate when looking at abstract or colour-field painting in which there is deliberately no subject-matter at all. In this context, Bell is absolutely right in urging us to reject the

crass temptation to try and figure out 'what it is supposed to be'. What we now have, then, is something to which we shall return in the chapters that follow: a gathering awareness that no one aesthetic theory will unlock all the meanings of all visual texts at all times. Instead we have a box full of refreshingly varied and diversely useful tools, each of which needs to be selected and used according to the particular needs of the specific job in hand.

We have shown here that Roger Fry has made three significant contributions to our understanding of visual culture. First, with the elements of design, he has provided a structured toolkit for the analysis of form in visual texts. This is extremely valuable because it helps us get beyond a purely subjective reaction to a visual text – especially when the balance of the text is in favour of form rather than content. It helps us get away from those annoying things that uninformed people say, such as 'I don't know much about art, but I know what I like' and (even worse) 'It's all a matter of personal opinion, isn't it?' No: it isn't. However, the role of personal taste and judgment in the arts (and much else besides) is still a complicated issue that has exercised thinkers long before Roger Fry. Prominent among these is the great eighteenth-century German philosopher Immanuel Kant.

Kant (1724–1804) was famously concerned with the extent to which any kind of knowledge or judgement could be truly objective. In doing so, he negotiated between two established but opposing philosophical traditions: rationalism, which argued that knowledge is based upon objective reason, and empiricism, which held that knowledge was based purely on personal experience and was therefore wholly subjective. In this way, rationalism was a fundamental part of the European Enlightenment, while empiricism (and there are echoes to Postmodernism here) contended that knowledge was simply a point of view and so objectivity was simply an illusion. We can imagine not only the threat to science of the empiricist argument, but of the rationalist point of view to the arts.

Kant set about his analysis of the dichotomy in two landmark studies: the *Critique of Pure Reason* (1781) and the *Critique of Judgment* (1790).[27] The first is concerned with the broader questions of objective knowledge, while the second proceeds to the issue of aesthetics. Ideally, one should work through the first to prepare for the second, but frankly this is not an easy task for the non-specialist. What we offer here, then, is an overview of the central arguments which will, gratifyingly, lead us back to Fry.

Kant argues that neither pure reason nor personal experience alone is adequate to solve the problem of objective truth. What is needed is a combination of the two. Central to Kant's argument is the concept of *a priori* knowledge, in which truths remain constant no matter what our point of view or how much individual experience varies.[28] This contrasts directly with *a posteriori* truths, which could become false if experience were to change. Kant seeks to synthesize both with his concept of *synthetic a priori* knowledge (for some the Holy Grail of philosophical inquiry). His famous example of this is taste.

The details of Kant's long, meticulous and complex argument (Roger Scruton goes so far as to call it 'slippery'[29]) need not detain us here. Indeed, we contend that, actually, Kant is better at elucidating the problems of taste and

judgement than he is at resolving them. Nevertheless, his forensic examination of the dichotomy is extremely relevant to us even if we are not wholly persuaded by his conclusions.

We can see exactly what he means, for example, when he states that pure reason alone cannot explain our immediate, emotional reaction to a work of art. As he puts it: 'I must feel the pleasure immediately in the representation of the object, and I cannot be talked into it by any grounds of proof.'[30] However, if we try to explain our reaction to someone else, we inevitably depend on concepts and reason to do so. This in turn presumes that the person we are talking to is party to those universal perspectives and concepts upon which a common, aesthetic understanding can be based. These two apparently conflicting arguments combine in what Kant calls 'the antimony of taste'.[31] And ultimately, he argues, taste and judgement constitute his much sought-after *synthetic a priori* knowledge in that they constitute universal truths which are at the same time based on experience. True knowledge involves a combination of both reason and experience, a concept which Kant calls 'transcendental idealism'. We need both sensibility (based on intuition) and understanding (grounded in concepts). Kant is therefore able to conclude that the sensual and the intellectual 'supply objectively valid judgement about things only in conjunction with one other'.[32] The importance of this for us is to give rigorous, philosophical grounding to the way in which Fry can speak not just of the elements but also of the *emotional* elements of design.

Where Kant's 'solution' is open to criticism, however, is with his proposition that taste is somehow universal. To be fair, Kant was, like the rest of us, a creature of his historical and social context. But later scholarship has contended that taste is in fact much broader and more culturally variable than Kant imagined. Pierre Bourdieu, for example, has shown that taste, rather than being purely aesthetic and disinterested, is in many ways class-based. It is one of the marks of distinction with which the social classes demonstrate the difference between themselves.[33] So, when Kant speaks of a common sensibility[34] in matters of judgement and taste (a point which is a building block to his whole transcendental philosophy) and then proceeds to state: 'the judgement of taste, therefore, depends on our presupposing the existence of a common sense . . . Only on the presupposition, I repeat, of such a common sense, are we able to lay down a judgement of taste,'[35] we have solid grounds with which to doubt both his aesthetic and his total argument. Then again, because there may not be complete, universal agreement on taste does not mean there is still not some empirical consensus. Scruton uses the example of a 'beloved landscape' or a 'beautiful old town';[36] we might cite human beauty. There may not be total agreement, but there still does seem to be a broad consensus on who is, and who is not, good-looking or beautiful. Without such general accord we think that Hollywood, for example, would have a significant problem.

But because Kant does not say everything that needs to be said about judgement and taste, that does not mean that he has nothing to say about it. Perhaps it is enough to agree with him that in aesthetic judgement we are still only 'suitors for agreement' and that such judgements are 'only passed conditionally'.[37] If anything, this adds to what he and Fry have to say about the mysterious 'nature of art'.

The second of Fry's contributions to our understanding of visual texts is his important distinction between form and content. His early insistence on the primacy of form may be contextualized as an antithesis to the received, representative wisdom at the time, but it is still of enormous value to us in explaining how works of art communicate to us – and especially when there is no discernible subject-matter as in 'abstract' painting.

Fry's third major contribution is that his formalist aesthetic leads us to consider the ultimately elusive 'nature of art'. Our reading of Kant provides good preparation for this. Kant writes, for instance, of the ability of genius to surpass nature.[38] Scruton proceeds to argue that Kant's aesthetics are 'premonition' of theology,[39] and we can quite see his point when Kant states that we think of: 'nature itself in its totality as a presentation of something supersensible, without our being able to produce this presentation *objectively*'.[40] Indeed, for Kant, all metaphysics are ultimately directed at: '*God, freedom* and the *immortality of the soul*'.[41] We should beware, however, of taking Kant's thinking as grounded in traditional notions of the divine, for it was much rather what Scruton describes as a 'demythologized religion'.[42]

The Formalists, similarly, have left us with something more than simply a methodology for unlocking the meaning of a work of art. What they were at the same time attempting to discover was something even loftier: the nature of art itself. Fry admitted that nature in itself was aesthetic and that a bunch of flowers, for example, could contain the attributes of order and variety he considered fundamental to beauty. But a work of art, he argued, went further, because here, deep emotions were intentionally communicated to the viewer and so created a 'special tie' with the artist.[43] 'We feel that he has expressed something which was latent in us all the time, but which we never realised, that he has revealed to us ourselves in revealing himself.'[44] This helps us to understand, therefore, that the action paintings of Jackson Pollock and the colour-field works of Mark Rothko can be understood just like the paintings of Rembrandt. They are all, in their different ways, articulate and revealing *self*-portraits. If we then proceed to see something of ourselves in Pollock, Rothko or Rembrandt, then the artist's work is done.

We agree that much or all (depending on the artist) is communicated by form, and that leads us to suspect that this mysterious quality of essential form does indeed lie at the heart of what we call art. Kant was insistent that the nature of art could not be understood by reason alone, criticizing the: 'false hope . . . of bringing our critical judgement of the beautiful under rational principles, and to raise its rules to the rank of a science'.[45] Clearly, there was something more to it than reason. Fry and Bell tried hard to describe and to isolate this elusive factor, and although they were able to make great headway with the emotional elements of design, the nature of art seemed ultimately to evade them. 'I have never believed that I knew what was the ultimate nature of art,' admitted Fry.[46] Perhaps this, though, is one of the great wonders of art, that in defying articulation in words and 'pure reason', it retains the authority of the visual; of the artwork itself. It remains that which, ultimately, we are unable to describe. Fry agreed that the aesthetic emotion was something which was a matter of 'infinite importance'[47] to those who were able to experience it. But he concluded in

Vision and Design: 'Any attempt I might make to explain this would probably land me in the depths of mysticism. On the edge of that gulf I stop.'[48]

And so shall we.

Key Debate

If art is not a copy of nature, than what is it?

Roger Fry claimed that there had to be more to art than the simple imitation of reality. As we have already seen in this chapter, he insisted that graphic arts were 'the expression of the imaginative life rather than a copy of actual life'[49] and should therefore be taken as 'an expression of emotions regarded as ends in themselves'.[50] He confidently described the formal elements through which the artistic communication of emotions was achieved (rhythm of the line, mass, space, light and shade and colour), but he confessedly fell short of defining the ultimate nature of art: 'On the edge of that gulf I stop',[51] as he put it. But the gulf remains, and the debate about form continues – even without him.

In 1908, two years before Roger Fry presented the first Post-Impressionist Exhibition in London, the German art historian Wilhelm Worringer published his doctoral dissertation, completed in Bern and entitled *Abstraktion und Einfühlung: Ein Beitrag zur Stilpsychologie*. Translated to English in 1953 as *Abstraction and Empathy: A Contribution to the Psychology of Style*, Worringer's work ventures into the very theoretical territory at whose edge Fry stopped. What Worringer wanted to do was to uncover the deep fundamental human motivations behind the production of and responses to works of art. Despite weaknesses in its historical basis and its limitations as a systematic model for the analysis of artistic form, Worringer's work still shed new light on the topic – and particularly on abstract art. It retains a long-lasting pertinence, especially due to the provocative character of this 100-year-old text.

Worringer's perspective radiates from a central proposition, according to which art – all art – should be regarded as the manifestation of two fundamental impulses: an urge to empathy and an urge to abstraction. But before we elaborate on these two 'poles' identified by Worringer, and in order to grasp their importance for his very personal understanding of 'human artistic feeling', we should point out that they integrate a perspective that shares Fry's notion with which we started this Key Debate: art does not imitate reality. As Worringer puts it, the work of art is 'an autonomous organism' that 'stands besides nature on equal terms and, in its deepest and innermost essence, devoid of any connection with it'.[52]

If the person who contemplates a work of art is not looking for a representation of the 'visible surface of things', what are they actually doing? And how can the enjoyment of looking at it be explained? Worringer was not the first to ask these questions. His own answers can be seen as a corrective expansion of the theory of empathy systematized by Theodor Lipps,[53] who had similar concerns and is extensively quoted in Worringer's work. According to the theory of empathy which Worringer explicitly presents as the 'foil' to his own ideas,

aesthetic pleasure is the result of a 'positive' act of empathy which enables a connection between a given sensuous object and the apperceptive activity it demands of the one who contemplates it. The work of art, 'each simple line' of a drawing, demands the apperceptive activity of the viewer, who can either exercise the demanded activity or resist it. If the demand is in accordance with the viewer's 'natural striving for self-activation', he or she says 'yes' to the demand and, in freely doing so, experiences a particular kind of pleasure: aesthetic enjoyment. In the language of the theory of empathy, aesthetic enjoyment is 'objectified self-enjoyment': it depends on the ability to 'enjoy myself in a sensuous object diverse from myself, to empathise with it'.[54]

Worringer did not think Lipps's description was totally wrong. What was wrong about it, he claimed, was the notion that it accounted for *every* experience of aesthetic enjoyment, 'at all times and at all places'.[55] What Worringer wanted to do was to demonstrate that the theory of modern aesthetics based on the concept of empathy is only applicable to limited tracts of art history. Therefore, Worringer admits that empathy is *one* pole of artistic feeling, but he insists that a comprehensive aesthetic system must absolutely consider empathy's counterpole: abstraction.

How does Worringer define these opposing yet indispensable poles? Both, he says, are needed if we are to understand the human desires that lead to artistic experience. To help explain the distinction between the urge to empathy and the urge to abstraction, Worringer uses the concept of *Kunstwollen* (often translated as 'artistic volition'), developed by the Viennese art historian and Late Roman specialist Alois Riegl.[56] According to Riegl, the 'absolute artistic volition' is the 'latent inner demand which exists *per se*, entirely independent of the object and of the mode of creation, and that behaves as a *will to form*' (our emphasis).[57]

This is a concept that contradicts previous utilitarian approaches that regarded art history as the product of three factors: utilitarian purpose, raw material and technics. Riegl refuses this utilitarian emphasis on *ability* as the driving force in art history and substitutes it with the primary importance attributed to *volition*, of which ability is only a secondary consequence. As a result, stylistic variations across time and space should not be taken as the product of differentiated artistic ability, but rather as manifestations of differently orientated impulses of artistic volition.[58]

The concept of artistic volition is important in two ways. First, the then widespread belief supported by the *ability* thesis, that artistic production should be judged according to the supposedly superior standards of figurative Graeco-Roman and Renaissance art, becomes meaningless. The value of a work of art, Worringer vehemently claims, is 'its power to bestow happiness' and each style represents 'the maximum bestowal of happiness for the humanity that created it'.[59] Second, artistic volition is an indispensable tool in Worringer's attempt to expand a psychological understanding of the need of art. This brings us back to the empathy and abstraction poles of artistic feeling.

The urge to empathy is present only where the 'will to form' that constitutes artistic volition is directed towards the realm of organic life. This is clearly something different from the simple copying of nature. Indeed, this particular

type of artistic volition corresponds to a particular inner need that is satisfied through the 'mysterious' projection of the viewer into organic visible reality, as in the classical Western canon.

But what about artistic objects that do not enable the projection of the viewer into that organic, visible outer world? Worringer deduces that they can only be the result of a different orientation of artistic volition; distinct responses to distinct psychic needs. Those works of art cannot be explained by the urge to empathy because they are objectivizations of a 'will to form' oriented towards the opposite pole of abstraction.

This brings us to the central – and perhaps the most original and intriguing – claim in Worringer's work: the way different deep human desires lead artistic volition either to empathy or to abstraction. Ultimately, he says, it all depends upon the relation between man and nature. Consequently, he presents three broadly defined situations that correspond to different fundamental motivations of the human spirit, explain distinct orientations of the artistic volition and accordingly define fundamental traditions of style. These are: the 'primitive man', the 'classical man' and the 'oriental'.

In the eyes of the 'primitive man', the phenomena of the outside world appear as a string of unpredictable, inexplicable and dangerous events. The relation with nature is, therefore, one of fear, unrest, helplessness and perplexity. Under such circumstances, the 'primitive man's' artistic volition is directed elsewhere than the projection into the organic reality of the outside world. On the contrary, his 'will to form' is guided by the need to compensate for the arbitrariness of the outside world, which is achieved by 'purifying' form of its dependence upon material life. It is this need for tranquillity and regularity, satisfied by the aesthetic enjoyment of the 'absolute' eternized form, and liberated from the arbitrary nature of organic reality, that explains 'primitive man's' inclination to abstraction at the expense of empathy.

Worringer stresses that the inclination to abstraction is not exclusive to 'primitive man'. This pole of aesthetics can also be seen in complex societies, including 'the civilized peoples of the East'. Using the category of what he called 'the oriental' – an obviously contentious classification that drew criticism – Worringer argues that societies in which there is a strong instinct opposing rationalistic development tend to regard the work of art as a shelter from appearances, thus privileging the urge to abstraction as the basis for an artistic response to a deeper sense of the impenetrable universe.

The urge for empathy is linked to a different relation with the outside world. When spiritual cognition enables mankind to establish a relation of confidence with the visible outside world, the beauty of organic-vital form can become the target of aesthetic projection and provide aesthetic enjoyment achieved through empathy. The anthropologized cosmos of classical Western art provides the spiritual environment that typically promotes this kind of urge to empathy.

Despite Worringer's attention to contemporary art – he is credited with the creation of the designation 'expressionism' in a review of an exhibition by the Munich-based Blauer Reiter group – his essay is not a programmatic text and should be seen instead as a manifesto in defence of abstractionism. Nevertheless, it brought abstraction into the centre of debate about art history

and theory. Moreover, his text contains a provocative hint regarding twentieth-century abstractionism and its possible connections with a crisis of rationality and a problematic relation with nature and the representation of the visible reality. Worringer sees twentieth-century man as 'having slipped down from the pride of knowledge' and being 'just as lost and helpless *vis-a-vis* the world-picture as primitive man'. His diagnosis is followed by a disturbingly opportune quotation by Shopenhauer, who wrote that:

> this visible world where we are is the work of Maya, brought forth by magic, a transitory and in itself unsubstantial semblance, comparable to the optical illusion and the dream, of which it is equally false to say that it is, or that it is not.[60]

We can see, therefore, not only that Fry stopped on the edge of a vast and possibly disturbing gulf, but also that those who follow him need considerable courage to venture into it for themselves.

Further Study

Although it was written in the first part of the last century, Roger Fry's *Vision and Design* remains the best introduction to the concept and importance of form in visual culture. It is written in a very approachable style and is divided into free-standing, individual essays. From a theoretical perspective, the most important chapters are 'An Essay in Aesthetics' and 'Retrospect'. His important (but considerably less well-known) final essay, 'The Double Nature of Painting', was published posthumously in the art journal *Apollo* in 1969. It is nowadays available in edited collections, including *The Roger Fry Reader*. For more on Fry himself, Virginia Woolf's somewhat quirky biography *Roger Fry* sets him and his thought in a personal and cultural context.

Clive Bell's monograph *Art* was originally published in 1914, then republished variously since. An extract from *Art* is also reproduced in Harrison and Wood's very useful 1992 anthology *Art in Theory*. This collection, which takes a Modernist perspective, also includes extracts from the works of other early formalist theorists, such as the philosopher Benedetto Croce. Formalist analysis, of course, is particularly important when there is no apparent subject-matter at all. This development, prevalent from the 1950s in movements such as the Abstract Expressionism of Mark Rothko and Jackson Pollock, was taken up by theorists following Fry and Bell, who had concentrated on Post-Impressionism. Prominent among these new Modernist critics were the Americans Clement Greenberg and Michael Fried. Greenberg's aesthetic can be found in books such as *Art and Culture* and *Homemade Aesthetics: Observations on Art and Taste*. His collected essays and criticism are edited by John O'Brian in a four-volume set published by the University of Chicago. A collection of Michael Fried's essays and reviews, *Art and Objecthood*, is also published by Chicago.[61]

The question of form in visual culture has also been approached from a psychological perspective. Gyorgy Kepes believed that people had a 'dynamic tendency to create order' which transformed 'the basic sense impressions of light

signals into meaningful forms'.[62] In *The Hidden Order of Art*, Anton Ehrenzweig argued that art had a 'deceptive chaos' which obscured a 'hidden order'. It was an order that 'only a properly attuned reader or art lover' could grasp. The understanding of the hidden order was achieved by a scanning process which was 'far superior to discursive reason and logic'.[63] In this way, psychologists writing some fifty years after Fry and Bell give support to the seemingly abstract notions both of 'form' and even of 'aesthetic ecstasy'. If you wish to grapple with Kant, of course, feel free to do so in the original: his *Critique of Pure Reason* (originally 1781) and *Critique of Judgment* (1790) are both milestones of great philosophical import. However, both make for very demanding reading, for which prior knowledge is more or less essential. A more gentle introduction is provided by Roger Scruton and published by Oxford University Press in 2001.

This chapter has concentrated on Formalism in painting. However, many of the same arguments can also be applied to other areas of visual culture. In chapter 8, for example, we will see to what extent photography might be able to transcend its apparent subject-matter and benefit from a more formal analysis. We will see how Aaron Siskind, who began as a socially committed documentarian, became hailed as a founder of 'abstract' photography who gained the respect of the Abstract Expressionist painters championed by Greenberg and Fried.

When approaching the theme of abstraction and the issues concerning the complex relation between visual arts and nature, the reading of Worringer's work we have used as the main source for the Key Debate in this chapter can be fruitfully complemented by the contact with the views expressed by Wassily Kandinsky. Like Fry, Kandinsky was both an artist and an art thinker. The implications of abstract painting were at the centre of the philosophical reflections we find in his book *Concerning the Spiritual in Art*, originally published in 1911. If, as we hope, this discussion has stimulated your interest regarding more recent developments in abstract art, *Pictures of Nothing: Abstract Art since Pollock*, by the former MoMA curator Kirk Varnedoe will not frustrate your curiosity.

3

ART HISTORY

This chapter focuses upon traditional art history. We will see that it is an essentially conventional approach that concerns itself with the placement of art and artists within the unfolding story of art. Initially, this chapter will give a potted version of that familiar story; it will then go on to discuss the conventional art-historical concerns of context, attribution and provenance. It will do so using the work of Ernst Gombrich as a typical example of this kind of approach, and conclude with an art-historical case study of Picasso's celebrated painting *Guernica*. Along the way, however, it will question many of the underlying assumptions and preoccupations of traditional art history, drawing attention to what is left out as well as to what is included. It will consider the benefits and the disadvantages of placing visual texts within a chronological narrative, while at the same time questioning the advantages of an obsession with great works and great painters. In this way, it will argue for both the usefulness and the irrelevance of the history of art in the analysis of visual culture.

We are now going to look at visual texts in a way that probably feels both familiar and comfortable. By the end of it, it should be an approach that will feel very uncomfortable indeed. Traditional art history is that approach to the understanding of visual texts that is typically taken by undergraduate survey courses on fine art. Its preoccupations, assumptions and techniques, however, continue well into advanced study, and are still the mainstay of the majority of museums and art galleries. It is, in many ways, the 'standard issue' approach to the analysis of painting, drawing and associated techniques. In reality, however, it remains only one way to investigate a visual text, and, like the others, carries both advantages and disadvantages.

Chapters 1 and 2 saw us taking intellectual 'guides' in the guise of Panofsky and Fry. For this chapter, we will be in the company of Professor Sir Ernst Gombrich. As with his predecessors, however, it is his *approach* rather than his conclusions that we will be examining. It is an approach that is shared by innumerable other traditional art historians (such as Kenneth Clark and H. W. Janson), and so we will be taking Gombrich as a good example of someone working and thinking in this conventional way. His example is more than just typical, however. His big-selling textbook *The Story of Art* has sold over six million copies, been translated into thirty-two languages and runs (at the last count) into one 'compact' and sixteen full editions. Whether or not we agree with Gombrich's approach, therefore, there is no doubting his influence. He deserves to be taken seriously.

Ernst Gombrich was born in Austria in 1909, but came to England in 1936. He became established as a hugely respected scholar, working at London, Oxford and Cambridge universities, and was knighted in 1972. *The Story of Art* was first published in 1950. If anyone has taken any art history as an undergraduate, it is a fair bet that they still have a well-thumbed copy of this book. What is particularly admirable about Gombrich is that while he was indeed a dedicated, rigorous and accomplished scholar, he nevertheless understood the importance of writing clearly and interestingly for a non-specialist audience. He had little time for those who used specialist language 'not to enlighten but to impress' the reader.[1] He also had a sense of fun. He is an example who should be more frequently followed. Productive long after his official retirement, he died in November 2001 at the age of ninety-two.

Gombrich begins *The Story of Art* by explaining exactly what he means to do in the book. His stated objective is to help the new reader to bring 'intelligible order' to the often confusing history of art. It is a book for those 'who look for bearings' in a new field, a field that would be illustrated by 'welcome landmarks' of famous and familiar works of art. That is how he would get on with 'telling the story of art' and thus enable the reader to see 'how it hangs together'. This involved placing his chosen works of art in their historical setting. His focus is mainly on painting.[2]

Gombrich's story of art is populated by inspired and gifted individuals. Putting the featured works in their historical setting, he says, will lead to an understanding of the artists' artistic aims. He goes further: 'There really is no such thing as Art. There are only artists.' Indeed, he continues, rising to something of a romantic crescendo, that the great painters 'have given their all in these works, they have suffered for them, sweated blood over them, and the least they have a right to ask of us is that we try to understand what they wanted to do'.[3]

All this requires judgement. Gombrich states that all the examples he has chosen to illustrate the book are limited to 'real works of art'. Many of these 'landmarks' rate among 'the greatest' by many standards, and so carry a great deal of 'artistic merit'. Above all else, however, Gombrich's story of art is narrative. He declares: 'this book is to be enjoyed as a story.' He speaks of 'episodes' within that story, and it is a story that both hangs together and 'unfolds'. In the familiar tradition of fireside storytelling, he concludes his introduction to

the fifteenth edition by warmly assuring his readers that his book is aimed at those 'who would like to be told from the very beginning how it all happened'.[4] This is, after all, the *story* of art. We will now proceed to summarize the story as Gombrich so famously tells it. Our aim is not to save you the trouble of reading Gombrich (or any similar traditional art historian) for yourself. Rather, we want to alert you to some of the underlying assumptions behind this narrative and so we suggest you take a few mental notes for yourself as we proceed.

Gombrich's story of art (and he is not alone here) begins with 'prehistoric and primitive peoples' who formed the 'strange beginnings' of art. We are introduced to the prehistoric cave paintings of Lascaux in southern France, and to some 'native' work from around the world. Gombrich explains, however, that the real, continuous story of art 'handed down from master to pupil' in a direct tradition to the present day begins in the Nile valley of Egypt some 5,000 years ago. This was the art of the pyramids, tombs and temples of the Pharaohs, including the famous Tutankhamen. From the Egyptians, the tradition passed to the Greeks in the seventh century BC and continued to the first century AD. Here, Gombrich sees a 'great awakening' of architecture, sculpture and decorated pottery. Greek art became much more natural and realistic than Egyptian, and constituted a 'great revolution' at a time 'which is altogether the most amazing period of human history'. This was the era of the Parthenon and the sculptor Praxiteles, one of the first artists to be remembered by name. Greek traditions formed the basis of Roman art and architecture, and it is with the Roman Empire that Gombrich's story of art continues. From the first to the fourth centuries AD, we are introduced to the Colosseum and the triumphal arches of the emperors, together with their 'outstanding' achievements in civil engineering. As the Roman Empire spread, so did Roman art.[5]

It was the formal adoption of Christianity by Rome in AD 311 that brings about the next chapter in Gombrich's traditional story of art. The new religion required new places of worship and new works of art to adorn them. Pope Gregory in the sixth century AD is credited with pronouncing that painting could do for the illiterate what books could do for the literate. Gombrich notes, however, that the lifelike naturalness that was 'awakened' in Greece around 500 BC was 'put to sleep again' from about AD 500. The classical origin was lost. During this period of dormancy in Western art, Gombrich feels that we 'must at least cast a glimpse at what happened in other parts of the world' during this period. He swiftly returns, however, to Europe after the fall of the Roman Empire, and introduces us to the Dark Ages, a depressing and confusing period from around AD 500 to AD 1000. Gombrich finds relatively little to be said of the art of that period, but he brightens visibly with the arrival of the Normans in England in 1066. They brought with them a distinct style of religious architecture, which still owed much to the early churches of Christian Rome. This Romanesque or Norman style was also used to decorate the churches, but the artwork continued in the non-realistic tradition. The artist, explains Gombrich 'was not concerned with an imitation of natural forms, but rather with the arrangement of traditional sacred symbols'. By gaining freedom from the need to imitate the natural world, they were better able to communicate the supernatural.[6]

Gombrich sees Western art as restless and in perpetual search of new ideas.

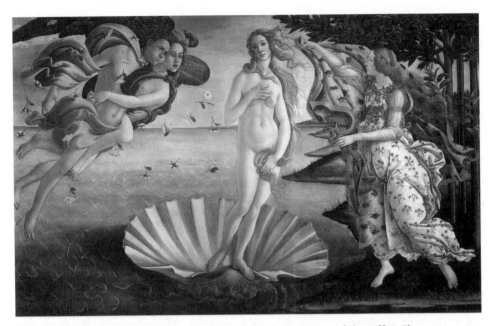

10. Sandro Botticelli, *The Birth of Venus*, circa 1480, courtesy of the Uffizi, Florence

This is why the Romanesque style was overtaken by the Gothic, which originated in northern France in the second half of the twelfth century. It was a style that had its basis in new architectural techniques, typified by the large windows, lofty ceilings and flying buttresses of Notre Dame in Paris.[7] The new style was slow to travel to Italy, but towards the end of the thirteenth century, Italian artists were able not only to catch up with the French but also 'to revolutionize the whole art of painting'.[8] Gombrich is now able to introduce us to the first of his great painters: Giotto. Giotto worked by painting on fresh plaster ('fresco') and found once again the secrets of natural representation. 'Nothing like this had been done for a thousand years. Giotto had rediscovered the art of creating the illusion of depth on a flat surface.' It enabled him to 'change the whole conception of painting'. He helped create the illusion, in other words, of being there. Such was his fame in his native Italy that Giotto became one of the first artist celebrities. According to Gombrich, 'this begins an entirely new chapter in the history of art'. From that day, the history of art became 'the history of great artists'.[9]

The history of great artists really came into its own with the Renaissance, a period that saw the 'rebirth' of classical Greek and Roman approaches to art in early fifteenth-century Europe. The Italians, in particular, cast back nostalgic eyes to the glories of the former Roman Empire, whose standards were held up as models to which contemporary artists should aspire. This was not just a matter of technique: classical subject-matter, too, was rediscovered, as exemplified by Sandro Botticelli's *The Birth of Venus* of circa 1480 (figure 10). Painting became an extremely serious business. For the new artists of the Renaissance, art 'ceased to be an occupation like any other and became a calling set apart'.[10] Classical accomplishments became the model for the future after centuries in

the artistic wilderness, and the city of Florence emerged as the centre of this new activity. It was here that artists vigorously pursued what Gombrich describes as 'the conquest of reality'. Fundamental to this was a mathematical system of perspective, the invention of which is attributed to the architect Brunelleschi. This enabled painters in particular to create the effect that spectators were looking at a scene through a 'hole in the wall' rather than at a flat, two-dimensional plane. The Renaissance was not limited to Italy, however. In Northern Europe, Gombrich singles out Jan van Eyck as another artist whose intent it was to hold up 'the mirror to reality in all its details'. He also credits van Eyck with no less an accomplishment than the invention of oil painting. It was with portraiture that van Eyck's art reached perhaps 'its greatest triumph' with the Arnolfini portrait of 1434 (which we studied with the help of Panofsky in chapter 1). Here, 'a simple corner of the real world had suddenly been fixed on a panel as if by magic. Here it all was . . . as if we could pay a visit to the Arnolfini in their own house.'[11]

The later fifteenth century continued as a period of 'tradition and innovation' in both Italy and the North. Artists not only built upon the techniques of the ancients, but also strove to surpass them. It was early sixteenth-century Italy, however, that provided what Gombrich describes as 'one of the greatest periods of all time'. Artists such as Leonardo, Michelangelo, Raphael and Titian combined to make this period – known to art historians as the High Renaissance – an 'efflorescence of genius' (see figure 11). It was a period around 1500 which 'produced so many of the world's greatest artists'. To them, says Gombrich, 'nothing seemed impossible'. By 1520, it appeared that they 'had done everything that former generations had tried to do'. They had 'shown how to combine beauty with harmony and correctness' and painting had reached 'the peak of perfection'.[12]

This, it can be imagined, left subsequent artists in something of a pickle. How could they improve upon all that? They responded, according to Gombrich, with 'restless and hectic attempts' to surpass them with interest and novelty. It provided a period known as 'Mannerist' in Italy, and this led to 'a crisis of art'. From Italy, the action moved to Northern Europe in the seventeenth century, with attention focusing on both Catholic and Protestant countries. Catholic taste favoured the somewhat florid Baroque style, while Protestant taste in Holland preferred an approach that 'had learned to reproduce nature as faithfully as a mirror'. There were many Dutch masters, but 'the greatest painter of Holland' and 'one of the greatest painters who ever lived' was Rembrandt. His portraits brought us 'face to face with real people' and his 'keen and steady eyes' were able to look 'straight into the human heart'. Indeed, 'no other painter of the period can bear comparison with him'. In addition to Rembrandt, Dutch painting produced still lives and domestic scenes whose beauty transcended their seemingly ordinary subject-matter.[13]

The Baroque style continued (especially in architecture) in the seventeenth and early eighteenth centuries, and developed in France into an ornate style known as Rococo. The Baroque, says Gombrich, culminated in Catholic Europe around 1700, and in the eighteenth century English style became predominant under what Gombrich describes as the age and rule of 'reason'.[14] Pre-eminent

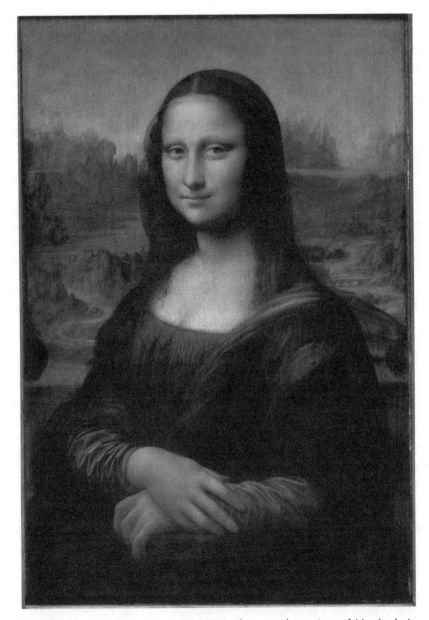

11. Leonardo da Vinci, *Mona Lisa*, circa 1502, oil on panel; courtesy of Musée du Louvre, Paris; photo: RMN

were portraitists such as Gainsborough and Sir Joshua Reynolds, who became the first president of the Royal Academy of Art in 1768. Reynolds, in particular, set about his work with a great seriousness of purpose. Such seriousness was also evident in the art of revolutionary America and France, with Copley in Boston and David in Paris painting inspiring political scenes.

It is during this period, however, that Gombrich notes a 'break with

tradition', with 'outstanding' effects. Artists now began to create a very personal art, an art in which they 'felt free to put their private visions on paper as hitherto only the poets had done'. An outstanding example of this was the Englishman William Blake, who 'lived in a world of his own'. Artists now had freedom in their choice of subject-matter, and this, says Gombrich, led to an elevation in the prestige of landscape painting. Here we can place, for example, Constable's *The Haywain*, which we examined in chapter 1, together with the romantic seascapes and blizzards of Turner. Although their subject-matter was ostensibly similar, Gombrich contrasts their personal styles and sides, incidentally, with Constable.[15]

If the emergence of personal style had brought about a break in tradition, the nineteenth century was, for Gombrich, one of 'permanent revolution'. The foundations of art were being 'undermined' by the new industrial age. Although the new British Parliament buildings turned out to be 'not too bad' (especially when viewed from a distance and partly obscured by mists), Gombrich has little that is good to say about nineteenth-century architecture. In painting, he notes that on the one hand, the artists had a newfound creative freedom, but that on the other hand, there was 'a deterioration in public taste'. This led to a mutual distrust between the two. 'Artists began to see themselves as a race apart, they grew long hair and beards' and shocking the bourgeois became 'an acknowledged pastime'. All was not lost, however, because 'for the first time, perhaps, it became true that art was a perfect means of expressing individuality' and the history of art in the nineteenth century became 'the history of a handful of lonely men who had the courage and persistence to think for themselves, to examine convention fearlessly and critically and thus to create new possibilities for their art'.[16]

This, Gombrich tells us, happened most dramatically in Paris, which now became the art capital of the world. Here, the purpose of art was vigorously debated by artists and critics alike. Some favoured colour to draftsmanship, others the heroic to the everyday. Each new style was thought shocking when it first appeared, culminating, says Gombrich, in the work of Manet, whose revolutionary use of colour was 'almost comparable with the revolution in the representation of forms brought about by the Greeks'. Manet gained followers, including Monet, who championed painting from life in the outdoors, and believed that overall feel was more important than intricate detail in a work of art. This became the Impressionist movement and Gombrich reminds us that in this state of 'permanent revolution', 'impressionism' was originally a derogatory term coined by a hostile critic. Gombrich is much more complimentary. In Impressionism, he states, 'the conquest of nature had become complete'. In language that echoes his summing-up of the High Renaissance, he concludes: 'It seemed, for a moment, as if all the problems of an art aiming at the imitation of the visual impression had been solved, and as if nothing was to be gained by pursuing these aims any further.'[17]

Art, of course, did not stand still. And we know from chapter 2 that the Post-Impressionists followed on from the Impressionists, and that they went on to receive as much abuse from public and critics as did their naturalistic predecessors. Like Roger Fry, Gombrich picks out Cézanne, whom Gombrich calls 'the

father of "modern art"'. Cézanne set out to combine order with nature, and was not afraid to distort nature in order to get the desired result. His indifference to 'correct drawing' started 'a landslide in art'. Seurat experimented with 'pointillism', and van Gogh set to work in a 'frenzy of creation'. Like the other Post-Impressionists, he was 'not mainly concerned with correct representation' and did not seek a photographic imitation of nature. Gauguin left for the South Seas in search of a new kind of inspiration 'among the primitives'. Each, in his own way, was dissatisfied with the artistic status quo, and 'what we call modern art grew out of these feelings of dissatisfaction'. Cézanne led to Cubism, van Gogh to Expressionism and Gauguin to Primitivism. Each was a consistent attempt 'to escape from a deadlock in which artists found themselves'.[18]

The period which follows this 'deadlock' is one that Gombrich describes as 'experimental' and makes up the first half of the twentieth century. He traces developments in architecture, sculpture and painting; developments that 'ultimately led to a rejection of the whole Western tradition'. Artists, according to Gombrich, became increasingly inspired by 'primitive' art in their search for 'expressiveness, structure and simplicity'. It was hardly surprising, then, that they began to ask whether art could be done by 'doing away with all subject-matter and relying exclusively on the effects of tones and shapes'. The first to do this, according to Gombrich, was Wassily Kandinsky, a Russian painter living in Munich. Kandinsky believed that pure colours could be used with psychological effect – like music – and this 'inaugurated what came to be known as "abstract art"'. Gombrich believes, however, that Cubism, which originated in Paris, 'led to much more radical departures from the Western tradition of painting' than even Kandinsky's colour music.[19] Artists such as Picasso began by 'rebuilding' familiar objects such as violins so that they could be seen from many angles at once, represented on the flat plane of the canvas. This meant discarding traditional notions of the illusion of three dimensions in painting. It also meant the prioritization of form over content.[20] Ultimately, artists wanted to abandon works that looked like something else or were merely decorative, and to create instead new things 'which had no existence before'.[21]

As Gombrich's *The Story of Art* was first published in 1950, his coverage of the second half of the twentieth century is less complete. An additional section was added in 1966, under the title 'The Triumph of Modernism'. Here, we were introduced to Abstract Expressionist painters such as the Americans Jackson Pollock and Franz Kline. Gombrich considered Pop Art to be too current (in 1966) for meaningful, art-historical analysis.

Gombrich concludes thoughtfully. Where the history of art thus far had been shown to be the history of revolutions, reactions and brave new initiatives (which the art historian had sought both to explain and to defend), the problem today was that 'the shock has worn off'. To be experimental had become conventional. If anyone needed a champion today, he says, 'it is the artist who shuns rebellious gestures'. That was the transformation that represented 'the most important event in the history of art which I have witnessed since this book was first published in 1950'.[22]

Our attempt to distil the history of art into the past few pages is, of course, little short of an outrage. There is method, however, in our apparent madness.

What we have attempted to do is demonstrate not the detail and complexity of the entire history of art, but to give a working overview of its traditional shape, scope and direction. Again: what concerns us in this chapter is not the minutiae but the approach, together with those underlying assumptions of which we recommended you took note. Similarly, we have not intended to suggest that Gombrich alone is responsible for the history of art. We have used him, simply, as a very good example of the traditional approach. And, once again, we have not provided this summary of *The Story of Art* in order to spare people the trouble of reading it for themselves. Rather, we have done so to provide a brief foundation on which to base the real point of this chapter.

The traditional history of art is a narrative history. It's a point that is underlined by the title of Gombrich's book: *The* (his)*Story of Art*. Stories have beginnings, middles and ends, and the storyline progresses from one end to the other, the past serving as the pre-history of the present. Stories have a need for continuity, with traceable consequences, causes and effects. Everything is, ultimately, explained. Life, however, isn't always like that and neither – arguably – is history. Gombrich – unwittingly, perhaps – betrays something of this when he explains (we recall) that his aim is to help the reader to 'bring some intelligible order' to all the names, periods and styles of art history.[23] If order has to be brought to something, it suggests that it is not originally there. Could it be, therefore, that the traditional history of art actually *imposes* order upon the events that it so colourfully describes? And if this is true of the history of art, might it not also be true of history as a whole? How much does our logical, consequential and narrative story of the past reveal not so much the realities of history but, rather, our psychological need to create the illusion of order in the present?

Stories need colourful characters and charismatic heroes. The history of art provides them in profusion. No matter how much we recognize the importance of schools, styles and movements, we still seem to prefer the personalities. Gombrich, we remember, says there is really no such thing as art, only artists. These are the individuals who 'suffered' and 'sweated blood' for their work. The history of art is therefore populated by gifted characters whose names we are happy to recognize. There is Praxiteles ('the greatest artist of the century', praise for whose 'most celebrated work' was 'sung in many poems'); Giotto (the 'genius' whose 'greatness' enabled him to change 'the whole conception of painting'); Leonardo (the 'genius' whose 'powerful mind will always remain an object of wonder and admiration to ordinary mortals'; Rembrandt ('one of the greatest painters who ever lived') and van Gogh (the tortured and suicidal artist whose letters 'are among the most moving and exciting in all literature' and whose paintings 'give joy and consolation to every human being').[24] It makes great narrative sense to tell the story this way. Not only does traditional art history seek to place works of art within the context of the story of art, it also seeks to place them within the biographies of the individual artists who made them. It is hardly surprising that these individuals are so colourfully described. Who, after all, wants to listen to a story populated with unremarkable characters? This emphasis on artists over art, however, betrays a somewhat questionable assumption: the assumption that history is made by individuals.

Sociologically, however, it is possible to argue that it works the other way round. Artists do not work in cultural or social vacuums. Sociologically, therefore, we have to consider that they, just like the works of art that they produce, are the products of their time. In this way, perhaps it is the Renaissance that produced Giotto, just as the 1960s produced The Beatles, rather than vice versa. If this is so, then perhaps the 'great' artists are simply the fortunate individuals whom the greater social and cultural forces happened to turn up. This is not to say, of course, that Giotto's Paduan frescoes or The Beatles' *Sergeant Pepper's Lonely Hearts Club Band* are not admirable works in their own right. It prompts us to wonder, however, whether such great works of art might really be social as much as individual documents. If this is so, then we need to question one of the underlying assumptions of any history of art; an assumption which has individual artists not only at centre stage, but also directing the action.[25]

Such is the enduring cult of the individual in the traditional history of art that the artist still seems to eclipse the artwork, even today. How often do we unthinkingly refer to a painting as 'a Rubens' or 'a Hockney', as though its authorship were automatically its most important quality? Art historians, experts, collectors, dealers and connoisseurs add to this with their obsession with 'attribution' – the act of authoritatively deciding who was the author of a particular work. Nowadays, the majority of artists sign and date their work, and their output is well documented and recorded. This has not always been the case, however. Artists only started to sign their work in the fifteenth century, about the same time that the identities of artists as individuals (as opposed to anonymous craftsmen) began to matter to the people who bought and commissioned their work. Not all works were signed, however, and it was only a gradual process. This infuriates traditional art historians in their search for attribution. Originally, attributions were made on the basis of style and anecdotal or documentary evidence. More recently, laboratory techniques such as X-ray, pigment analysis and digital verification technology have been added to the quest for attribution – a quest that becomes all the more significant given the vast amounts of money for which art is bought and sold in the commercial market. Art historians are now able to reconsider quantities of works traditionally attributed to celebrated artists. A suspiciously large number of works, for example, has been attributed to Rembrandt. In recent years, art historians have been re-evaluating this, and the number of works originally attributed to Rembrandt has now been reduced from more than 600 to nearer half that figure.[26] His *Landscape with an Obelisk* in Boston's Isabella Stuart Gardner Museum was once described as a work in which 'Rembrandt imposes his brilliant Baroque imagination upon nature',[27] but it has now been re-attributed to his talented pupil Govert Flinck. More famously, his *Man Wearing a Gilt Helmet* (sometimes thought to be of Rembrandt's brother) of 1654, once a prime exhibit in the Staatliche Museen in Berlin, has now been disattributed altogether (see figure 12).[28] This was once thought to have been one of the master's finest works. Yet, although not one fleck of pigment has changed on the canvas itself, art-historically it has now fallen completely apart. And that is just one of the problems of the traditional history of art.

The traditional history of art tends to be the history of men. This is a complex and, indeed, controversial issue, but there is no doubting the overwhelming

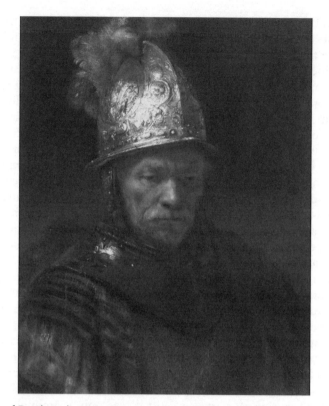

12. Follower of Rembrandt, *Man Wearing a Gilt Helmet*, circa 1650–2, oil on canvas; courtesy of Staatliche Museen, Berlin, SMPK, Gemaldegalerie; photo: BPK/Jorg P. Andres

number of men, as opposed to women, who appear in traditional histories of art. We have all heard of the 'Old Masters'. Why do we not speak of the 'Old Mistresses'?[29] Throughout his history of art, Gombrich refers to artists as men. It was the 'great masters', we recall, who sweated all that blood over art. Remarkably, not one of the 411 works illustrated in *The Story of Art* is attributed to a female artist. Why is this? The most obvious answer would be to say that the vast majority of famous artists were indeed men. Traditional histories of art are therefore merely reflecting reality. A simple parlour game may serve to underline the point: let's make a list of all the famous women painters we can think of. This will probably not take long.[30] Now start making a list of all the famous men. We will soon get bored. So why are there so many men and so very few women? It is important to remember that Western culture has traditionally assigned very different roles to men and women. Women have typically been involved with domestic and child-raising tasks, while business, the professions, the church and the military (to say nothing of the arts and sciences) have been the domain of men. In the early days of art, it was only boys who would be apprenticed to a 'master' and slowly taught their trade. The academies and art schools are considerably more recent innovations, and only recently were

women admitted to them. It was not until the twentieth century that women were permitted to vote in both the United Kingdom and the United States, and only in relatively recent history have they been admitted to universities and colleges. As the traditional history of art goes back to around 13,000 BC, it is hardly surprising that it appears to reflect millennia of opportunities afforded to men but denied to women. More recently, however, feminist art historians have offered an alternative explanation: women have always been active in art, but their contributions have been undervalued or overlooked by traditionally male art historians. These male historians have automatically assumed that art history is a history made by men. Gombrich's story of art embraces such assumptions. Understandably, he refers to the named artists in his book as men. They all are. But his apparent assumption that artists must automatically be men is betrayed by the first paragraph of his introduction. Here, he states, we recall, that there is no such thing as art, only artists. He continues: 'Once these were men who took coloured earth and roughed out the forms of a bison on the wall of a cave . . .'[31] How does Gombrich *know* these were men?

These are complex and controversial issues. We need to understand, for example, that Gombrich was writing (for the most part) more than fifty years ago, and that gender roles, politics and attitudes have changed considerably since then. The aim of this section is not to pillory Ernst Gombrich whose ideas we are using, after all, only as an example of the traditional art-historical approach. The aim of this section is, rather, to suggest that the underlying assumptions to the traditional history of art are open to question. Whenever we look at a theory or even a history, we should always be critically alert to what it assumes and not simply what it states. It is the assumptions that are often considerably more revealing.

Traditional histories of art tend to be remarkably similar to one another. They usually feature much the same periods, schools, artists and artworks. They are stories, in other words, that always seem to contain entirely familiar episodes, characters and examples. What we are left with, then, is a consistent and predictable canon of works of art; a canon with which everyone is expected to be familiar. To an extent, this is very useful. At its best, an established canon provides us with a common body of knowledge upon which discussion can be reasonably based without everyone always having to start from scratch. How difficult it would be, for example, for anyone to talk, lecture, write about or even refer to (say) Leonardo, the Renaissance or the *Mona Lisa* without being able to presume that his or her audience already had a pretty good idea of these 'basics' already. Traditional histories of art, therefore, tend both to work within and to contribute to the art-historical canon.

The canon also works in (possibly) unexpected ways. To be what we might call 'cultured' nowadays, it is expected that we are familiar with a more or less accepted canon of books, authors, plays, composers, artists and artworks. Who could be considered 'cultured', for example, if they could not hum the opening bars of Beethoven's fifth symphony? Our knowledge of certain agreed constituents of the canon therefore serves as a kind of membership card, pin or badge that other members of our 'club' can recognize and possess. Perhaps it doesn't matter so much what these actually are just as long as everyone agrees that these

are the ones that everyone will be expected to know. This goes on to suggest
two things about the canon: first, it may be arbitrary; second, it is certainly
self-perpetuating.

What started out as being convenient, therefore, can end up being very
problematic. How do we know that the canonical art and artists which popu-
late traditional histories of art are indeed the best or even the most important?
Should we select a work for inclusion because it is outstanding (and therefore
hardly typical) or typical (and therefore unlikely to be outstanding)? How and
when might the canon be re-evaluated? Who has been left out, and why? One
thing seems very probable: works are often canonical simply because they are
canonical. Gombrich, we remember, aims to illustrate *The Story of Art* with
'familiar landmarks'.[32] On the one hand, this is reassuring and helpful. On the
other, it betrays the fact that they are included simply because it is understood
that we will know them already. Thus, the canon of traditional art history
entrenches and perpetuates itself.

Gombrich's book is called *The Story of Art*. If we look carefully, though,
isn't it essentially the story of Western European art? We begin the story in
the prehistoric caves in France and Spain before moving to Egypt, Greece,
Italy, Holland and then back to France. We conclude by seeing things start to
happen in the United States, but the point is that ancient Egypt is the only non-
European country that is described as having made a significant contribution to
the continuous, linear tradition of art. Only one chapter of the twenty-eight in
The Story of Art is dedicated exclusively to non-European art, and within this
eleven centuries of Islamic and Chinese art are rolled into one episode, which
comes across as a very condensed subplot to the central narrative. To be fair,
examples from non-European cultures do appear from time to time through-
out the book, but these – again – seem mainly to serve as interesting footnotes
to the real story. It is important, of course, not to become too po-faced here:
Gombrich's *The Story of Art* was written by a Western European for (origi-
nally) a Western European readership. His focus is therefore understandable.
Western European art is also extremely well preserved and well documented, so
it is also a story that it is relatively easy to tell at length and in detail. We must
also remind ourselves (again!) that Gombrich is not alone here, but is typical
of so many traditional approaches to the history of art. Just like the question
of male and female contributions to the history of art we discussed earlier, this
is a complex and controversial issue which cannot be fairly covered (let alone
resolved) in this brief summary. The central point of this discussion remains,
however, that any history of art can only be a partial history. *The Story of Art*,
then, is more accurately *A* Story of Art. So, within this story, we should look for
what is left out as well as that which is included. We can then proceed to ask the
simple but intelligent question: 'Why?'

The history of art is, as we have seen, a narrative history. In terms of classi-
cal narrative structure, however, it seems deeply flawed: it appears to have two
narrative climaxes but no conclusion. The ending is the easiest to deal with.
Gombrich describes the story of art as, in the title of his final chapter, 'a story
without end'. We can understand this; we end with the present but realize (or
at very best, hope!) that there is more to come. Gombrich has taken this into

account not by revising the whole text in subsequent editions, but by tacking on extra sections to the original ending. The present is the moment at which history stops, so we have to keep on bringing history up to date even if it does not end with a rousing, symphonic conclusion. The two 'false endings' are more problematic. The history of art's first false ending comes with the High Renaissance, the period which Gombrich said 'produced so many of the world's greatest artists' and was, indeed, 'one of the greatest periods of all time'. Here, artists combined their final mastery of the illusion of reality with a harmonious and beautiful aesthetic sense. Painting had reached 'the peak of perfection'. If painting had reached the peak of perfection by the start of the sixteenth century, where was there left for it to go? In terms of sheer storytelling, this is akin to telling the reader 'whodunit' before the detective has even arrived at the scene of the crime. The next 350 years is, consequently, tricky in terms of narrative. It is only then that the traditional history of art is able to reach its second climax with Manet and the Impressionists, who brought about that 'revolution' that Gombrich described as 'almost comparable with the revolution in the representation of forms brought about by the Greeks'. These new artists succeeded in creating paintings which portrayed reality not simply as it existed in nature, but rather as the sight of it reached the human eye or mind. Theirs was the art, therefore, not of accurate, objective detail, but of genuine human experience. In this way, the art of the Impressionists in France was even more 'realistic' than the 'perfection' reached by the great artists of the High Renaissance in Italy.[33]

Our aim here is not to try and show that the story of art has been badly told in terms of narrative tension. Certainly, we could use this as evidence in support of our earlier reservations about trying to 'shoehorn' history into a narrative form. What we really want to point out here is that the two traditional 'climaxes' in the history of art are reached at points when painting is thought to have achieved (in two different ways) the perfect illusion of reality. This, in turn, betrays an assumption that it is the illusion of reality that painting is really all about.

The history of art tends to be the history of painting. Gombrich's book admits to being mostly about painting, even though it is titled *The Story of Art*. To be sure, architecture and some sculpture do feature, as do the occasional prints and drawings, but for the most part, and in common with many other accounts of this type, *The Story of Art* is essentially the story of the application of coloured pigments to two-dimensional surfaces. This is not the place to get embroiled in the inevitable 'what is art?' discussion. We can be sure, however, that even within traditionally accepted categories, there is more to art than just painting. This is a point that has become all the more salient with the arrival of new media such as photography, film and television. We might even wish to include video, information technology and advertising. To be sure, all these developments are so relatively recent in comparison with (say) the pyramids of Giza that it could be argued that we so far lack the historical distance to make any meaningful kind of evaluation. The fact remains, however, that considerably many more people are nowadays choosing both to record and to express their world using these new media than through painting. Indeed, even among professional artists, painting is finding itself increasingly further from the cutting edge. Damien Hurst and Tracey Emin, for example, have become household names as

contemporary artists in Britain, yet neither is primarily famed for their work in paint.

Finally, we need to question Gombrich's assumption that what we are trying to do in the history of art is figure out what it was that the artist was trying to achieve. When, in his preface, we read that Gombrich will place works in their historical setting 'and thus lead to an understanding of the master's artistic aims', we may take it as read that the 'master's artistic aims' are what we really need to know. As they sweated all that blood for us, 'the least they have a right to ask of us is that we try and understand what they wanted to do'.[34] Perhaps we should attempt to try and understand this. Traditional histories of art, however, often display a kind of myopia when it comes to insights into the artist's aims and intentions. Typically, they see their aims as purely artistic, and forget that artists, like everyone, need to eat and pay their bills. The 'master's aim', therefore, might be simply to sell pictures in order to make a living. In order to do so, even successful artists may court controversy in pursuit of recognition. Art does not take place in an economic vacuum. Not all artists sweat blood, and not all do so simply for their art.

Even if we expand our conception of the artist's aims to include the grimly commercial, we must still remember that there is considerably more to any work of art than simply that which the artist intended. Intent is conscious. So much of the meaning of a work of art, however, may not be deliberately intended by the artist at all. Artists have feelings, needs and emotions which they did not rationally calculate to include in a work but which are nevertheless there. Our own handwriting or our childish doodling (to say nothing of our dreams), for example, reveal something about us even though we may not deliberately wish it or even understand it ourselves. We may speak our native language without being aware of the declensions and conjugations which structure it, and we may unconsciously use synecdoche, litotes and metonymy in everyday speech without having studied rhetoric or even knowing what they mean. Some of the finest popular songs of the twentieth century have been written by people who cannot read a note of music. More than that, whether we wish it or not, we have only limited autonomy in any cultural field, and especially the arts. We cannot help but be creatures of our own culture. This is how we can speak of *Zeitgeist* or 'the spirit of the age', because no matter how much we intend it or otherwise, any cultural text that we individually produce unwittingly articulates the world vision of our social group as much as it does ourselves. To understand art as part of a greater visual culture, therefore, we must understand that the 'master's aims' are only one part of the picture.

The traditional history of art, finally, is very much tied up with the commercial art market. Its emphasis on context and attribution leads to particular works and particular artists being considered especially 'important' and, therefore, expensive. It follows, then, that a painting (for example) can have a commercial value apart from its aesthetic value. This means that paintings by certain artists will be 'worth' more than those by others even if they are not actually as 'good'. We remember, for instance, how Rembrandt's *Man Wearing a Gilt Helmet* 'fell apart' art-historically when it was discovered that it was not, in fact, 'a Rembrandt' at all. Imagine the horror if one had bought (for the price of a

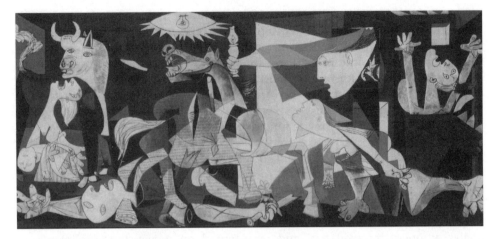

13. Pablo Picasso, *Guernica*, 1937, oil on canvas; courtesy of Mueso National Centro de Arte Reina Sofia, Madrid. © Succession Picasso/DACS 2002

public building) such a painting only to have it disattributed. What would our investment be worth now? Imagine our delight, on the other hand, if we had bought a painting simply because we liked it, and then an expert, finding it hanging in our bathroom, attributed it to Botticelli? In both cases, just as with the Berlin Rembrandt, not a jot of either of our paintings would have changed either aesthetically or physically, but our bank balance would have changed beyond all recognition.

On such niceties does the commercial art market hang. So lucrative can those niceties be, however, that a whole industry of experts, connoisseurs, dealers and auction houses has grown up around them. It is even possible to speculate in the future of new and contemporary artists in much the same way as City and Wall Street traders do in cocoa and pork bellies. Art as history and art as commodity appear, therefore, to be inextricably linked.

This chapter has taken a deliberately dim view of traditional art history – all the more so because it is a view that runs contrary to many people's preconceptions of what visual culture is all about. There is something very cosy about art history, and that cosiness needs to be exposed to an icy blast of interrogation. On the other hand, there are occasions in which placing a work within both its historical and biographical context can genuinely add to our understanding of it. This brings us nicely to our case study: Picasso's *Guernica* (see figure 13).

Pablo Picasso was born in 1881. While still a teenager, he mastered 'realism' in painting, and the rest of his life was spent going beyond the merely realistic. Born in Spain, he made his first trip to Paris (then, as we have seen, a centre of artistic excitement) in 1900, and spent the next four years alternating between there and Barcelona. It is this that is generally known as Picasso's 'blue period', a period in which he painted many melancholic works of poor and down-and-out people, predominantly in shades of blue. In 1904 he settled in Paris, and his subject-matter become more upbeat, with harlequins and entertainers featuring more in his work. These were painted predominantly in shades of pink, and

so the period from around 1905 to 1908 is known as Picasso's 'rose period'. The growing interest in non-Western art is reflected in what traditionalists call Picasso's 'Negro period' from around 1906 to 1909 (the periods begin to overlap). He became particularly interested in African art, and drew from it a simplification of forms that led him still further from 'realistic' painting. It is during this period that he produced his famous *Les Demoiselles d'Avignon* (1907), a painting that caused such a storm that it was not exhibited publicly until 1937. The painting is now one of the prime exhibits in New York's Museum of Modern Art, and reminds us that what many people still consider to be 'modern art' is, in fact, over 100 years old.

Picasso's schematic reduction in forms led to his Cubist period, which continued into the 1920s. This is a group of works in which (and in common with work by other Cubist artists of the period) familiar subjects looked as though they were reflected in a shattered mirror and/or seen from various different angles at once, 'pressed flat' and represented on a two-dimensional plane. Cubism provided a very analytical way of painting, but from around 1925 Picasso's art became much more emotional in both its subject-matter and its technique. The bullfight, for example, was a typical motif, and his works of this period look as though they were created much more rapidly and much more passionately. It is during this time that Picasso painted *Guernica*, to which we shall shortly return. In 1946, Picasso moved to the south of France, where his painting and drawing became yet more fluid. Later works were produced within the day, his *Cavalier with Pipe*, for example, bearing the date 17 October 1970. He died in 1974, leaving behind him a prodigious output, a tempestuous love life and a phenomenal reputation.

The creation of *Guernica* took place within a particularly grim episode in Spanish history: the Spanish Civil War of 1936–9. Picasso's sympathies lay with the left-wing Republicans, while the right-wing Nationalists were led by General Franco and supported by the German Nazis and Italian Fascists. On 6 January 1937, Hitler issued an ultimatum to the Basque population in the north-west of Spain: surrender, or face the consequences. The Nazis were looking for an opportunity to test the Luftwaffe (German air force) under combat conditions, and when no surrender was received, on 26 April 1937 they launched a saturation bombing raid on the small Basque town of Guernica. Guernica was undefended, and the raid lasted three and a quarter hours. It was a massacre, in which 70 per cent of the town was destroyed.

Picasso had been essentially non-political up to this point, but he was so horrified by what had happened that he was stirred into action. He agreed to paint a huge mural for the Republican exhibit at the 1937 World Fair in Paris, which was due to open just three weeks later. The mural was to be over 11 feet high and 25 feet long. Fortunately for art historians, Picasso's work on this project was recorded in detail from his own preliminary sketches to photographs of the artist at work. The first sketches were made on 1 May, Picasso jotting down his initial ideas for both composition and detail on paper. Many of these (such as a seemingly childish horse) make no attempt to be finished drawings, but are equivalent more to an artist 'thinking out loud on paper'. The studies became more complete as the week wore on, with Picasso also sketching in oil. Work on

the canvas itself began on 11 May, and the whole work was complete the following month – slightly behind schedule, but so was the World Fair itself. The completed canvas is all in shades of black, white and grey. It depicts not the act of bombing but the effects on the town from the people's point of view. We see opened windows with people screaming from within, a horse with its tongue distended in a cry of pain and a fallen soldier with his sword broken in two. This is not, of course, to suggest that the people of Guernica defended themselves with swords. Rather, it forms part of a painting that merges symbolism with action to speak not only of Guernica, but also of war as a whole.

The painting itself soon achieved celebrity status. After the World Fair closed, it was exhibited in Scandinavia and Britain, and then went on tour in the United States, where it was exhibited at Harvard University. From 1931 to 1981, it was a major exhibit at the Museum of Modern Art in New York City, where it remained – officially – on extended loan. This caused considerable controversy, as to many this was such a quintessentially Spanish painting that in their view it belonged only to Spain. Less officially, it was thought the painting was in safer hands in New York while the victorious and authoritarian General Franco was still in power in Spain. When Franco died in 1975, King Juan Carlos I ascended the throne and Spain became a constitutional monarchy. As successive reforms led to an increasingly democratic Spain, America's claim on *Guernica* became correspondingly less convincing. Eventually, pressure became such that the work was returned to Spain. In September 1981, crowds applauded as the painting was finally delivered to the Prado in Madrid. The painting is now housed in the more modern Reina Sofia Art Centre, but its celebrity – and indeed controversy – is by no means complete. *Guernica* has spent much of its recent life behind bulletproof glass, protected by armed guards. Many in the Basque region believe that the painting belongs with them and not in Madrid. The Basques have a long separatist tradition, and the movement has often been violently supported by the terrorist group ETA. This is a painting, then, the possession of which is of immense cultural and political value. It shows that in addition to the history of art and of artists, artworks themselves can have a history, and this traceable history of ownership (known as 'provenance') is also of great interest to art historians. Typically, provenance is important in establishing the authenticity of a work of art, but here the authenticity is never in dispute. In the case of *Guernica* it reminds us that art can be something not of just financial or even aesthetic value, but also a symbol of matters of life, of death and of cultural identity.

Key Debate

Art history, a global story?

This chapter has shown that the traditional approach to art history is subject to fierce attack on several fronts. The conventional perspectives exemplified by the influential work of Gombrich have been under heavy critical fire. The long list of accusations includes claims that traditional art history imposes an

artificial narrative coherence on to the complex and often confusing set of events it aims to describe; that it focuses upon individual artists and does not adequately consider the greater social environment in which they worked; that it overlooks female artists, privileges painting over other artistic forms, and that it takes Euro-American art production and art theory as its exclusive fields of interest. It is as if the Western tradition demonstrated all that needed to be said about both artistic production and theoretical approaches to the understanding of art.

In the rich and intense debate over art history, everything is open to critical scrutiny. Even criticism can be criticized. That is what we are going to continue doing in this section, paying particular attention to the idea that the conventional art historical approach (mis)takes Western art and Western ways of looking at art as equal to the whole of global art and theory. Hence our title for this chapter's Key Debate.

In this section we will follow a set of arguments developed by the Czech-based Chinese art specialist Ladislav Kesner.[35] The fact that Kesner is a Western expert known for his work on a non-Western artistic tradition grants him particular legitimacy to address our question. In so doing, Kesner draws upon his combination of background and experience to acknowledge art history's 'deeply entrenched antiglobal shape'.[36] As an example, he refers to the Czech National Gallery, where he himself worked as the curator of Chinese Art. He shows that the gallery allocates only 3 per cent of its floor space to Asian art. To this he adds various other examples, showing the striking imbalance between Western and non-Western art perpetuated in all manner of institutional settings, from university art history departments to curatorial practices; from the editorial boards of influential publications to grant-awarding committees.

Kesner's view of this imbalanced status quo could not be more critical: 'A near total ignorance of world art', he writes, 'is proudly displayed by members of the art historical community as a badge of their professional status.'[37] So far he is in line with many other critics of conventional art history and could easily be taken for a typical advocate of postcolonial criticism against traditional Eurocentric views. However, as he points out, the critical discourses of postcolonialism and multiculturalism do not stop at the exposure of art history's resistance to the study of non-European art: they go so far as to attack the whole hegemony of Western concepts, values and methods in the interpretation of any work of art, regardless of its geographic and cultural origin. This is the point at which Kesner's position diverges from the mainstream non-Western critical perspective to which he partly subscribes. And it is at this point that his view becomes especially controversial.

Drawing upon the 'conceptual scaffolding' offered by James Elkins[38] to address the challenge of world art, Kesner selects two initiatives which have allegedly marked art history's response to the challenge for several decades now. The first and less radical response consists of an attempt to redefine and adjust art history's habitual working concepts to better fit non-Western art. The second and more radical attitude favours the search for indigenous critical concepts to interpret non-Western art. Kesner believes that these initiatives have contributed to a change in the shape of art history, but it is his emphasis on the

differences between the first and the second attitudes that we wish to underline, to better understand his argument.

With the first and less radical initiative, Kesner says that the incorporation of culturally specific notions and categories into the study of non-Western art is hardly a novelty. This importation has been a practice in scholarship on world art for a long time, and Kesner does not see any problem in the necessary adjustments it has brought about: 'This has undoubtedly changed the shape of art history without, however, altering its basic structure, which remains essentially Western.'[39]

The statement about the preservation of an 'essentially Western basic structure' in art history, and upon which Kesner's benign evaluation of the first initiative is based, does not apply to the second. Here, the search for indigenous critical concepts for the interpretation of non-Western art translates into the complete abandonment of the Western matrix – as suggested by Elkins in his view of a 'consistently non-Eurocentric art history'. Kesner argues, however, that taking this path would be suicidal: if the conceptual tools of Western art history are considered inadequate and abandoned in favour of other culturally specific methods, values and judgements, the very object of interest of art history disappears. Why? Because 'it was precisely on account of such (Western) intellectual and cultural equipment that works of other traditions have been discovered as objects worthy of preservation, care, aesthetic mediation and scholarly investigation in the first place'.[40] However, Kesner insists that a careful distinction should be made. It is one thing is to argue that art history does not accommodate non-Western traditions as it should. But it is another thing to assume that the prevailing concepts and methods of Western art history prevent the enjoyment and the understanding of other artistic traditions. His agreement with the first statement is as strong as his disagreement with the second. As Kesner sees it, Western working concepts may and should be enriched through the incorporation of elements imported from non-Western traditions, but the Western art-historical discourse must be kept at the centre of the discipline, for it provides 'the most viable, user-friendly platform from which to address works of art of any tradition'.[41] In fact, it is this discourse – and only this discourse – he claims, that enables the questions that ultimately define the very purpose of art history: Why does an art object look the way it does? Why was it produced? What special meaning does it have for the people who made it? At the centre of Kesner's argument is the belief that such questions can only be meaningfully understood and answered (and even formulated, for that matter) if a range of concepts developed and refined within the long Western philosophical and art-historical tradition (representation, naturalism, empathy, abstraction, intentionality, ideology, culture, and so on) is mobilized and actually put to use.

Kesner presents two interconnected reasons why he thinks Western inspired mediation is indispensable to the interpretation of any work of art. These reasons, which we will briefly describe in the following paragraphs, are rooted in the circumstance that only the Western tradition – unlike any other culturally specific discourse on art – 'has been in a position to continually develop and be enriched by contact with other cultures and non-European art'.[42] Given such historical circumstance, Western art history has developed a 'way of looking' at

any art object that, through the gradual construction of a complex theoretical apparatus, enables understandings and interpretations that surpass the radical spatiotemporal uniqueness of a given artwork, extracting from that uniqueness values and principles which can be used to address work coming from different socio-cultural environments.

The problem, as Kesner sees it, is that a truly multicultural art history would be based in the opposite principle, that is, its purpose must be precisely to approach art objects in the strict respect of the local and specific spatiotemporal horizon of their production. Art history based upon that orientation would 'resemble a network or a dense mosaic of narrowly defined cultural groups, or local and particular cognitive styles',[43] irreconcilable with 'the need to meaningfully organize this diversity into larger plots and narratives, for the general purposes of presenting, publishing and teaching about visual arts'.[44] Apart from the purely practical implications, the abandonment of Western art history's theoretical apparatus in favour of culturally specific conceptual frameworks would also translate into the impossibility of what Kesner designates 'a humanist study of art', which is sustained by the belief that there are 'universal elements of embodied experience that provide the possibility of understanding worlds of art of different cultures'.[45]

The 'humanist study of art' is exactly what Kesner wants to preserve from the postcolonial and multicultural critique of Western art history. In order to maintain that humanist study, and without throwing the proverbial baby out with the postcolonial bathwater, he insists upon the need to engage both the dedication to what is unique in diverse art traditions and the 'faith in certain universal dispositions of human consciousness'[46] that only the Western tradition is in a position to articulate when it comes to the understanding of art, regardless of whether we are talking about Renaissance painting, Yoruba carving or Haida sculpture.

This debate, therefore, has taken an interesting course. We began this chapter by describing the received wisdoms of traditional art history, we then challenged them, and then proceeded to challenge the challenge. This does not strike us as at all problematic. Indeed, as we said at the start of this Key Debate, in the rich and intense debate over art history, everything is open to critical scrutiny.

Further Study

Books tend to be very much concerned with books. In addition to traditional study, however, it is important to stress the value of looking at original works of art when discussing art history. To be sure, books nowadays contain very good reproductions, but this is still not the same as looking at a real painting in its actual dimensions, colours and textures. Going to a gallery can lead to additional surprises. Traditional histories of art tend to concentrate on similar works by similar artists. Going to a gallery, however, can lead to unexpected pleasures when confronted by an artist or a painting one has not seen before. Whether a work is famous or under-appreciated, gallery-going is a great habit to get into so that you can look at works of art for yourself. It helps that many of the world's

great galleries have either free admission or student concessions. Some have specially reduced or free admission times. Looking at the works themselves, whether they are in London, New York or Paris, helps train one's visual literacy.

As regards books, this chapter has drawn especially on the work of Ernst Gombrich as an exemplar of a traditional, narrative approach to the history of art. Although Gombrich provides a particularly good case study for this, it is important to stress that he is not the only example. His approach is, in fact, typical of the style and assumptions embraced by many others. While Gombrich's *The Story of Art* is standard reading in the UK, H. W. Janson's *History of Art* holds a similar position in North America. The broad sweep of Janson's approach is indicated by the subtitle: *A Survey of the Visual Arts from the Dawn of History to the Present Day*.[47] Kenneth Clark (later Baron Clark) provided a book and a television series called simply *Civilization*.[48]

Not all histories of art attempt to be so all-encompassing. Some concentrate on specific periods and locations; others on particular movements or artists. Seymour Slive, for example, is an expert on Dutch painting of the seventeenth century, while Panofsky provided a standard work on Albrecht Dürer.[49] There is no shortage of art-historical books on seemingly any conceivable subject, while exhibition catalogues often contain scholarly articles by specialists in the field – in addition to usually high-quality illustrations. Academic, art-historical journals provide an invaluable source for still more focused study; books that seem more at home on the coffee table than the library shelf may be higher on style than on substance.

Traditional art-historical books, catalogues and journals may differ in their subject-matter, but they tend to share many common approaches and assumptions. Recent years have heard, however, dissenting voices from the mainstream. The concern of traditional art historians with 'old masters', together with the assumption that artists must be men, has led some to question the absence of women in traditional histories of art. The American scholar Linda Nochlin, for example, published in 1971 an article entitled 'Why Have There been No Great Women Artists?' Here, Nochlin argues that women have always been capable of greatness in painting, but have been prevented from achieving it in a male-dominated world. The essay can be found in her collection: *Women, Art, and Power and Other Essays*. This is not to say that there have been no women artists (great or not), as Nochlin shows in *Women Artists 1550–1959*, which she published together with Ann Sutherland Harris. The concept is further explored by Rozsika Parker and Griselda Pollock in their appropriately titled *Old Mistresses: Women, Art and Ideology* of 1981.[50]

Traditional histories of art tend to be populated by great characters and individual geniuses. It is possible to argue, however, that art is ultimately a societal rather than an individual expression. Thinkers from a number of disciplines have argued this, such as the anthropologist Ruth Benedict in *Patterns of Culture* and literary theorists such as Lucien Goldmann in *Towards a Sociology of the Novel*.[51]

Historians, critics and curators from different national and cultural backgrounds discuss the (im)possibility of global art in *Art and Globalization*,[52] a book edited by James Elkins, Zhiva Valiavicharska and Alice Kim in 2010, in

which you will find various approaches to the topic we have selected for the Key Debate in this chapter. To make sure you know what is actually being talked about when world art is the subject, the impressive *Art Atlas*[53] edited by John Onians is a useful resource, covering an extensive range of artistic manifestations, from early Ice Age works produced more than 30,000 years ago to contemporary experiments in different parts of the world. An overview of other controversial issues in the field can be found in Keith Moxey's *The Practice of Theory: Poststructuralism, Cultural Politics, and Art History*.[54]

More direct attacks on traditional notions are provided by writers such as John Roberts in *Art Has No History!* and Donald Preziosi in *Rethinking Art History*.[55] Perhaps the best-known introductory assault on traditional notions of art, however, is provided by John Berger's controversial *Ways of Seeing*.[56] It is with this that we begin the next chapter.

4

IDEOLOGY

This chapter investigates ideological approaches to the analysis of visual culture. It demonstrates how texts may be examined in order to expose the underlying ideas, values and beliefs they embody about society and politics. Fundamental to this approach is the assumption that cultural texts inevitably betray the values of the cultures in which they were created. This kind of analysis, then, can be used to reveal social attitudes, both past and present. This is particularly significant if one believes that current social and political assumptions have historical rather than simply natural roots. We begin with a focus on John Berger's controversial *Ways of Seeing*, in which he claims that art experts deliberately obscure the visual evidence of the past in order to justify the politics of the present. He begins by claiming a relationship between painting, property and social class, but moves on to contend that the way in which women are represented in painting is indicative of the unequal way in which they are treated in society as a whole. This moves us on to a discussion of Laura Mulvey's feminist approach to the study of film. We conclude with an explanation of Pierre Bourdieu's model of how cultural texts are produced in a social context.

The traditional history of art can be a beguiling one. It is an approach that seems to employ such *civilized* values. It is populated by geniuses and guarded by connoisseurs. Its repository consists of the museums and the great aristocratic houses of the world. We can almost hear the Vivaldi as we think about it. But now the stage is set for a dramatic change of tone. An evangelist is about to emerge from the wilderness. His name is John Berger.

John Berger arrived with a mission to overturn the way people looked at art.

He came to prominence with a book and a television series that called for a completely new way of looking at 'the entire art of the past'.[1] *Ways of Seeing*, published in 1972, caused a furore at the time and continues to be controversial today. Although Berger is by no means the only ideological analyst of visual culture, he deserves special attention from us because he was one of the first to gain recognition from the wider public. Additionally, he is clear and simple to understand, and he backs his arguments with examples that we can examine (and, indeed, re-examine) for ourselves. More than thirty years after the event, *Ways of Seeing* is still in print and a staple ingredient of student reading lists. It is polemical, certainly, but it is both a work and an approach that deserve to be taken seriously.

Berger certainly took seeing seriously. Like us, he realized that we live in a visual world. He opened *Ways of Seeing* with the simple sentence: 'Seeing comes before words.' A child, he reasoned, sees even before it learns to speak, and it is seeing that establishes our own place in the world. More than that: Berger claims that images (and especially paintings) give us an unrivalled insight into the past. They give us a 'direct testimony' about the world, and in this respect 'images are more precise and richer than literature'. It is a huge claim, and there is more to come. Berger claims that our ability to see (or to read or to interpret) these important images clearly has been adversely affected by all manner of assumptions about art. These are assumptions that no longer tie in with the world as it is; rather than revealing the past, they obscure it: 'They mystify rather than clarify.' This is doubly unfortunate because not only does it obscure our understanding of the past, but this misunderstanding of the past consequently obscures our understanding of the present. According to Berger, however, this mystification of the past is not accidental. Indeed, 'the art of the past is being mystified because a privileged minority is striving to invent a history which can retrospectively justify the role of the ruling classes'. In other words, rather than falsifying the evidence itself, someone is instead trying to prevent us from seeing it clearly and from drawing our own conclusions.[2] To use a contemporary example (and not one of Berger's), if we are shown a video of the police beating a criminal suspect, lawyers for the police may not deny that the footage is genuine, but argue, rather, that we are interpreting it incorrectly. It is our way of seeing, therefore, that is really at issue.

Berger's way of seeing is an ideological one. Ideology is a complex, shifting and frequently misunderstood term which is often invested with negative connotations. In its most straightforward sense, however, ideology is simply the study of ideas, systems of thought and systems of belief.[3] In practice, this tends to focus on the way these ideas, thoughts and beliefs influence the way we organize and lead our lives, especially at a social and political level. Because politics are so frequently concerned with the distribution of power, an ideological approach often involves a critical investigation of power relations within society. Indeed, according to John B. Thompson, ideology can ultimately be defined as 'meaning in the service of power'. Hence, 'the study of ideology requires us to investigate the ways in which meaning is constructed and conveyed by symbolic forms of various kinds, from everyday linguistic utterances to complex images and texts'.[4]

Ideology questions not only how power is organized now, but also how it might be organized in the future. In this way, an ideological approach can be both descriptive and prescriptive.[5] In the former case, an ideological approach to the study of visual culture seeks to reveal the social and political ideas and assumptions embedded within visual texts. It aims to be even-handed, to expose rather than to evaluate. A prescriptive approach, on the other hand, does involve judgement of the ideas revealed within a text. Frequently, it does so by comparison with the preferred and pre-existing ideological views of the analyst. Typically (though by no means inevitably) the comparison is unfavourable.

John Berger's ideological approach to the study of visual culture leans heavily towards the left. Politically, he subscribes to Marxian theories of struggle between the ruling and the working classes. History, according to this view, should be interpreted as the history of class struggles, and it is history that explains the way things are today. The present is neither natural nor inevitable, but the result of history. We need, therefore, to re-understand the past in order to understand the present. As the old order cannot be justified, and as the damning evidence is there for all to see, argues Berger, 'experts' have deliberately obscured our understanding of the past not so much with jargon but more by 'explaining away' the clear, political visual evidence of the paintings themselves and by mis-directing our attention to other things instead. A 'total' approach to art would relate it to every aspect of ordinary people's real lives. Instead, we have been left with the 'esoteric approach' of a few specialized experts who act as 'clerks' to the interest of the ruling class. This 'cultural hierarchy' of specialists have hijacked the meaning of art and so the meaning of the past. That is why 'the entire art of the past has now become a political issue'.[6]

Marxian views of the past are unfashionable with students nowadays, especially since the fall of the former Soviet Union and the disintegration of communism as a world force. One does not have to be a Marxist, however, to go along with much of what Berger has to say. We have already agreed, for example, that visual culture is extremely important, and that we live in a visual world. Many of us will also agree that reading what the 'experts' have to say about a painting has sometimes confused rather than enlightened us. There has also been an undeniable connection between art and the ruling classes. Art, certainly by famous artists, is expensive. In the case of the 'greats' it is extraordinarily so. It is the ruling classes who have been typically able to commission and to buy art. It is for this reason that many of the great ancestral homes are sometimes referred to as 'treasure houses'.[7] And if anyone wants to make a case for a friendly relationship between the aristocracy and the experts, they only have to point out that Kenneth Clark, the author and presenter of *Civilization*, catalogued the Leonardo drawings at the royal residence Windsor Castle and was given the title Lord Clark, while Ernst Gombrich was knighted by the Queen for his services to art.

We may also agree with Berger when he writes that many famous works of art have today achieved the cultural status of 'holy relics'. This, says Berger, is how works of art are discussed and presented. When we stand before the original of a painting we have seen reproduced many times, we are in awe of its authenticity. The Leonardo cartoon of the *Virgin and Child with St Anne and St John the*

Baptist in London's National Gallery (see figure 28, p. 158) is in a room of its own and protected by bulletproof glass. Somehow, these works are treasured and preserved just like the sacred relics of holy saints that formed the centrepieces of medieval shrines. That is how Berger comes to speak of the 'bogus religiosity' which surrounds them.[8] Those of us who have seen (or attempted to see) the *Mona Lisa* in the Louvre in Paris will understand something of what he means. First, it is hard to get close to the painting because of the crowds that surround it. Many break gallery rules by photographing it with their flash cameras, despite the fact that far better reproductions can be had in the souvenir shop. The point of the photograph, of course, is not the quality of its reproduction but that it serves as irrefutable proof that the photographer has 'seen the original'. Many of those gathered around the painting do not spend time studying the work that they have gone to so much trouble to see. It is enough, somehow, simply to have 'seen' it, to have been in its presence, just as we might touch the foot of a carved Madonna before calmly and devoutly moving on.

Berger produces statistics to show that most people think that a museum reminds them more of a church than anything else. Again, we can see what he means. Not only do people go there to commune with the 'holy relics', but also we often find ourselves behaving much as we would when looking round a church. We walk with a respectful gait, we move politely aside to let others see the work and we speak in hushed tones. The experience is permeated with an atmosphere of respect. We may have noticed, also, how much our traditional museums and galleries *look* like temples. If we approach, say, the Philadelphia Museum of Art, we do so via a long flight of stone steps, as if we were climbing to a sacred place.[9] In front of us is a building in the classical style, with all the columns, decorations and entablature of an ancient place of worship.

The wide availability of reproductions might have reduced the awe and reverence in which original works of art are held. We can, after all, see them depicted in postcards, posters, on the Internet and in books such as this. Berger argues, however, that the profusion of reproductions has only added to the status of the original by emphasizing its 'uniqueness'. We want to see 'the real one' and marvel at its 'authenticity'. Thanks to reproduction, the image is no longer unique and exclusive. As a compensation, then, the original itself 'must be made mysteriously so'. What Berger prefers to the museums and galleries are the pinboards that ordinary people may have in their rooms, and upon which they can stick the images of their choice: 'Logically, these boards should replace museums.' He does not claim that original works of art are useless, but that the pinboard of reproductions offers a new approach to images which bypasses their status as 'holy relics'.[10]

By changing our approach, Berger wants to change 'what we expect of art'. Art, as it is currently interpreted, stands for a nostalgia for an age of inequalities and hierarchies. That, in turn, serves to 'glorify the present social system and its priorities'. This new way of seeing involves a loss of innocence but also, argues Berger, a loss of ignorance. He wants to reappropriate the meaning of the art of the past. 'The art of the past no longer exists as it once did,' he concludes. 'Its authority is lost.'[11]

Oil painting not only has a special relationship with the ruling class, says

Berger, it also has a special relationship with property. This is not just because paintings are property, but also because property is often what they show. Painting, therefore, is propaganda for capitalism and the things it will buy.[12] 'The art of any period', he declares, 'tends to serve the interests of the ruling class.'[13] The ruling classes during the period 1500–1900 depended on the new power of capital. Oil painting during that period articulated a new way of seeing the world, a way entrenched in the concept of property. More than that, oil painting was particularly suited to the task because of its particular and technical ability to depict property deliciously.

Again, it is possible to agree with much of what Berger has to say. We know that oil paintings are often bought and sold for fantastic prices, and the flourishing existence of the art market – to say nothing of the prominence of the great auction houses in the world's capital cities – makes it very hard to argue against the idea of painting as property. More than that, many paintings do indeed suggest a lust for the material world. Perhaps the best examples of these are the Dutch still lives of the seventeenth century. Here, immaculate compositions of expensive commodities such as lobsters, porcelain, handmade glass, tropical fruits, Persian carpets, golden goblets, musical instruments and exotic animals are depicted with almost photo-realistic accuracy. It was a hugely popular style of painting, which betrayed what Simon Schama has described as 'an embarrassment of riches'.[14]

Berger claims that the connection between painting and property has usually been ignored by art experts and historians.[15] It was less easy to overlook his own controversial interpretation of Thomas Gainsborough's eighteenth-century painting *Mr and Mrs Andrews*. This is a portrait of an English couple, set against a rural scene of their own land. It is a very popular exhibit at London's National Gallery, and one that Kenneth Clark described as an 'enchanting' work, painted with 'love and mastery'.[16] Berger thinks differently. This is no idyllic scene, and as for Mr and Mrs Andrews: 'They are landowners and their proprietary attitude towards what surrounds them is visible in their stance and their expressions.' Berger then reproduces two detailed close-ups of their faces as if to prove the point, before waxing lyrical about the deportations and public whippings that would have been handed down to poachers and thieves caught on their land. The Andrews, meanwhile, gained the pleasure of seeing themselves depicted as landowners, and their land is enhanced 'in all its substantiality' by the particular properties of oil paint. These are observations that Berger feels the need to make because they run contrary to the cultural history we are normally taught. Painting is usually compared to 'an imaginary window open on to the world'. We should not be fooled, however, because if we lay aside its claims for itself, 'its model is not so much a framed window open on to the world as a safe let into a wall, a safe in which the visible has been deposited'.[17]

But is he right? There are two ways in which we could challenge John Berger's new way of seeing. First, we could simply question his politics. As his approach is essentially Marxian, if we could show that Marxian theories of history and culture are wrong, then we would consequently be able to pull the rug from under Berger's theories of art and painting. This first approach might prove problematic in three ways, however. First, a critique of Marx and Marxism

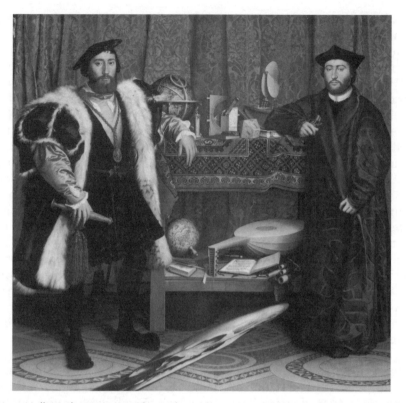

14. Hans Holbein the Younger, *The Ambassadors*, 1533, oil on canvas; courtesy of the
National Gallery, London

would be a huge undertaking beyond the parameters of this book. Second, a
blanket denial of Berger's underlying philosophy would make it difficult for us
to agree, even if we wanted to, with other parts of what he had to say. Third,
this focus on political theory would, in turn, distract our attention from looking
at the paintings themselves. Let us therefore take an alternative approach. We
shall tackle Berger on the evidence presented by two of his own chosen exam-
ples: Holbein's *The Ambassadors* and Hals's companion group portraits of the
Regents and Regentesses of the old people's almshouses at Haarlem.

The Ambassadors was painted by Hans Holbein the Younger in 1533 (see
figure 14). It is a huge work, which has been carefully restored and hangs in the
National Gallery in London. Holbein was a German-born portrait artist who
worked in Switzerland and in England, including at the court of King Henry
VIII. *The Ambassadors* was painted to commemorate the visit of French scholar
and Bishop of Lavaur, Georges de Selve (on the right) to his friend Jean de
Dinteville, the French Ambassador to London. They are standing (with casual
confidence) on either side of a piece of furniture on which all manner of things
is assembled. On the top shelf we see a Turkish rug, a celestial globe and various
astronomical instruments. On the bottom there is a terrestrial globe, a book
called *Arithmetic for Merchants*, a hymn book, a lute and a set of flutes. They are

depicted as young, educated, cultured and successful. The inscription on the sheath of his dagger reveals that Dinteville is twenty-nine; Selve leans on a book inscribed to show that he is twenty-five.

Berger writes that *The Ambassadors* has been painted with great skill to show the tactile qualities of all the textures it represents, from fur to metal to marble. Although many of the objects symbolize ideas, Berger argues that it is the material 'stuff' that dominates this painting. It is 'stuff' immaculately rendered in oil in order to 'demonstrate the desirability of what money could buy'. He goes further: the scientific instruments in the painting were for navigation by sea, necessary for the slave trade and 'to siphon off the riches from other continents into Europe'. The globe shows the location of Dinteville's chateau. The hymnal and the book on accounting were necessary as part of the project of colonization, 'to convert its people to Christianity and accounting'. What we have in *The Ambassadors*, claims Berger, is a stance towards the world that was typical of a whole class: 'a class who were convinced that the world was there to furnish their place in it'.[18]

This is both powerful and – to an extent – persuasive. Who could deny, for example, the obvious wealth and self-confidence of Selve and Dinteville? And who could deny the existence of both a colonial system and a lucrative trade in human beings? However, it is possible to make an entirely contrary interpretation of *The Ambassadors*; an interpretation in which the painting has a sophisticated – and opposite – double meaning.

Holbein's painting provides us with an iconographical feast.[19] The cylindrical calendar next to the celestial globe by Dinteville's left elbow shows the date as 11 April. The polyhedral clock next to Selve's shows the time as precisely 10.30 a.m. The painting seems to be stressing, then, that this is just one moment in time. Wealth and life are transient. A string on the lute on the bottom shelf is broken: the music might stop – suddenly and unexpectedly – at any time. For all their wealth, pride, power, taste, education and vitality, all that these two men possess could be gone in the snapping of a string. But Selve and Dinteville do not see these signs: they are looking directly at us. Behind them, and almost hidden in the top left-hand corner of the painting, is a simple crucifix. What does this tell us? That Christ was the son of God, yet that he still lived in poverty and died for others? That salvation may only come after death?

There is another symbol of which the two men seem unaware: the distorted image of a human skull at the bottom centre of the painting. This is an anamorphic image, painted with remarkable skill, which only appears to assume its proper shape when viewed from one yard to the right of the painting. The two friends cannot see it and neither, unless we work very hard, can we. But once we have seen it, what greater reminder could we have of human mortality, that we will all, one day, be reduced to bones? The skull is, in fact, a recurring motif in the history of art. It serves as a *memento mori*, a Latin term which means 'remember that you have to die'. Entire paintings could be built up around this theme. This was particularly prevalent in Dutch still-life painting of the seventeenth century, and gave rise to a whole genre of art known as the 'vanitas', the point of which was to encourage the viewer to reflect upon the inevitability of death. Earthly pride and pleasures were merely vanity.

15. Frans Hals, *Regents of the Old Men's Alms House*, 1664, oil on canvas; courtesy of
Frans Hals Museum, Haarlem; photo: Margareta Svensson

Interpreted in this way, the meaning of *The Ambassadors* is exactly opposite to
that which John Berger says it is. Instead of celebrating worldly wealth, it draws
attention to its folly. How does Berger explain the skull? It may be anamor-
phic, but it is still very hard to miss. He acknowledges its presence, to be sure.
He even admits to its potential as a *memento mori*. But just as this might seem
to undermine his argument, he swiftly leads the reader away on a tangential
argument about realism and symbolism. Thus, he deftly 'explains away' the evi-
dence of the painting itself, just as he had accused the connoisseurs and experts
of old of cultural mystification in 'explaining away' the visual evidence of the
past. Mystification, one may conclude, is the prerogative of no one particular
political persuasion.

Perhaps the most famous controversy surrounding Berger, though, is the one
concerned with his interpretation of two paintings by the seventeenth-century
Dutch painter Frans Hals (see figures 15 and 16). These were painted in 1664,
and are group portraits of the people who oversaw the running of a charitable
institution in the town. The two paintings, the *Regents of the Old Men's Alms
House* and the *Regentesses of the Old Men's Alms House*, are among his most
famous, and are still on show in Haarlem today in the Frans Hals Museum.
According to Berger, these paintings were commissioned from Hals while the
artist was himself a penniless old man. During the winter of 1664, he received
three loads of peat through public charity, 'otherwise he would have frozen to
death'. The people whom he was now painting were those responsible for hand-
outs such as these. And, according to Berger, Hals would obviously have been

16. Frans Hals, *Regentesses of the Old Men's Alms House*, 1664, oil on canvas; courtesy of Frans Hals Museum, Haarlem; photo: Margareta Svensson

very bitter about the situation. The painting, he says, is a 'confrontation'. Here was Hals, 'a destitute old painter who had lost his reputation and lives off public charity', examining the Regents and Regentesses through the 'eyes of a pauper'. We can see this through 'the evidence of the paintings themselves'. They still work today because, politically, so little has changed.[20]

Berger claims that traditional art historians have mystified the obvious political meaning of these paintings, so that no such interpretation is found in the canonical books. He produces a 'typical example' of such mystification from Seymour Slive's two-volume study, *Frans Hals*, which he describes as 'the authoritative work to date on this painter'.[21] According to Slive, it would be wrong to interpret the paintings as criticism of the sitters; there is no evidence that Hals painted them in a spirit of bitterness. Instead, Slive writes lovingly about the formal rhythms, patterns, colours, contrasts, power, strength and 'harmonious fusion' of the Regentesses painting.[22] Berger admits that the composition of the painting is indeed relevant, but argues that by focusing our attention on the form, Slive has distracted our attention from the much more important subject-matter. In this way, 'art appreciation' is allowed to detract from 'lived experience', and all the conflict 'disappears'.[23]

Berger calls our particular attention to the man who is third from the right in the painting of the Regents. He appears to be drunk: his eyes seem to have trouble focusing and his hat is slouched at a very odd angle. Slive counters this, says Berger, by claiming that it was fashionable at the time to wear hats on the side of the head. His unusual expression could be the result of paralysis. Berger

does not go into detail. Any more discussion would take us even further, he says, from the issues that matter and that Slive is trying to evade through mystification. The issues that matter, of course, are the obvious confrontation in Hals's paintings and the fact that, in reality, we still live in a society with the same hierarchies and class tensions as existed in Haarlem in 1664.[24]

This is a controversy that did not go away. Indeed, it continued for decades and, with the entry of editor and art historian Peter Fuller, became one of the most enjoyable art-historical spats of the twentieth century. Peter Fuller himself began as a Marxian, follower and even friend of John Berger. But then he changed his mind. Marxian theories of art, he decided, left an 'art-shaped hole' in our understanding of art. It was a hole into which notions of beauty seemed to disappear.[25] This was unfortunate, because ultimately, he came to decide, it was the human aesthetic experience that really mattered in art. Fuller first voiced his concerns in a lecture called 'Seeing Berger' at the Maidstone College of Art and then at the (unofficial) Communist University of London 'where, to the best of my recollection, it was not well received'. For Fuller, this represented the beginning of a 'personal rehabilitation of the beautiful and the transcendent'. It also represented the beginning of the end of his relationship with John Berger.[26] His equation of Berger's theories with the 'philistine' policies of former Conservative British Prime Minister Margaret Thatcher surely put an end to it completely, as did the title of his counter-attack, *Seeing Through Berger*.[27] What resulted was a 'noisy, indeed, at times almost hysterical' response from Fuller's critics, 'including Berger himself'.[28]

The row between Fuller and Berger began gently enough. *Ways of Seeing*, wrote Fuller in 1980, had a 'decisive and continuing effect' on his own work as a critic and had 'a greater influence than any other art critical project of the last decade'. He continued in his praise: 'I respect Berger'; he had consciously offered an alternative to Kenneth Clark's traditional art history, and *Ways of Seeing* had been 'eminently readable'. Furthermore, Berger's argument about the special relationship between art and property had been established 'beyond question'. Indeed, it was now practically 'self evident'. Fuller remained convinced of the 'central argument' of *Ways of Seeing*.[29]

Rather than make any fundamental criticism of *Ways of Seeing*, Fuller started by chipping away at a few of Berger's arguments and drew attention to some internal inconsistencies. It was certainly not a full-scale attack. Fuller felt that much more art was in the public domain than Berger admitted. Certainly, Fuller certainly did not look forward to a world in which museums were replaced by pinboards full of reproductions. More importantly, he thought that the political-economic dimension was not 'the only, or even the most rewarding, avenue of approach to works of art of the past'. On the contrary, the greater the work of art, the less it was reducible to the ideology of its own time. This led to his major criticism that Berger was 'unwittingly guilty' of an approach in which 'images have no existence apart from an ideological existence'. There was much more to it than that, wrote Fuller, just as there was 'no simple or necessary correlation between materialism, oil painting, and bourgeois attitudes towards property'.[30]

Fuller's original criticism of *Ways of Seeing*, then, was essentially one of degree rather than of essence. He still described himself, for example, as a 'socialist'.

Berger's book, he agreed, was deliberately polemical.[31] Polemics involved deliberately ruffling feathers in order to make a provocative impression. What Fuller began by saying, therefore, was that Berger had simply overstated his case. Berger, apparently, agreed. He wrote to Fuller, complimenting him on *Seeing Berger*, which he described as '*very good*'. Its arguments were 'just and clear'. *Ways of Seeing* had, after all, intentionally been '*partial* and polemical'.[32]

Suddenly, however, the concord and the friendship fell apart. As the decade continued, the gulf between Fuller and Berger (together with their supporters) became wider and wider. Perhaps the seeds had already been sown in *Seeing Berger*. Here, Fuller had opined that there was a 'kernel of truth within "bourgeois" aesthetics'.[33] This may seem like slight criticism today, but within the charged and committed atmosphere of Marxian theory, this was little short of incendiary. It all blew up in 1988 when Fuller wrote an article, 'The Value of Art', for the British magazine *New Society*, in which he claimed that Berger had been 'ethically and intellectually dishonest' in his treatment of Kenneth Clark. Worse than that, the anti-aesthetic philosophy behind *Ways of Seeing* was 'almost identical to the philistine attitudes to the arts espoused by Margaret Thatcher's governments'.[34] These governments, Fuller argued, had no belief in the value of aesthetics. They had transformed fine art education into courses on technology, design and mechanical processes, and appeared to share Berger's views on the redundancy of museums, which they starved of resources. Fuller now found himself much more aligned with the formerly derided Kenneth Clark: 'for Berger would appear to have been, unwittingly, the clerk to the new ruling philistines'.[35] Marxism was thus equated with conservatism and John Berger with Margaret Thatcher. The cat ran rampant among the ideological pigeons.

The first reaction came not from Berger himself, but from Mike Dibb, the director of the television version of *Ways of Seeing*. Dibb described Fuller's article as an 'assault' which he blamed on the 'bitter breakdown' of his relationship with Berger. The connection of *Ways of Seeing* with Thatcherism was 'ludicrous' and it was about time Fuller 'grew out' of his need to have heroes and villains. Some of what he had said was 'hurtful' and surely written 'in a spirit of revenge'.[36]

The hostility spread. Fuller launched a glossy quarterly publication called *Modern Painters*. Its declared aim was to stand up for aesthetic values in an intellectual climate in which Berger's once radical 'way of seeing' had become the new orthodoxy.[37] Not surprisingly, it was not universally welcomed. *New Society*, *Time Out* and the *New Statesman* all published stories that Fuller described as 'not only hostile but inaccurate'. Indeed, some were 'downright malicious'.[38] Writing in *Art Monthly*, Fuller sought to explain his position. Politics certainly mattered, 'but they are not the only things that matter'. He also grew tired of people who expressed their political opinions as facts. As for Berger, Fuller 'grew out of his ideas'. He had never denounced Berger as a Thatcherite, but did believe that his *Ways of Seeing* 'in many ways anticipated the anti-aesthetic policies of Margaret Thatcher's governments *despite their political differences*'. The result was that *Ways of Seeing* helped forge an 'unholy, anti-aesthetic alliance' between certain intellectuals of both left and right. In conclusion, Fuller

came to believe that Berger's book was 'really a dated and dangerous tract which provides the justification for philistinism of whatever political colour'.[39]

Fuller could hardly have expected relations to improve, and they didn't. The 'contretemps' continued. Fuller began to lament, publicly, that *Ways of Seeing* had an overwhelming influence on 'generation after generation' of students. These were students who had been taught to 'despise aesthetic experience' and believe that there was nothing they could learn from a museum that they could not pick up from a newspaper magazine. Fuller, on the other hand, wanted to get back to the beautiful and to concentrate on painting '*as art*'.[40]

It is difficult to know how much of the growing antipathy between the two men was personal and how much was intellectual.[41] But grow it certainly did. Fuller had begun almost as a disciple of Berger, then began to question him in *Seeing Berger* and finally moved to *Seeing Through* his former friend.

The increasingly venomous feud between Fuller and Berger and their supporters brings us back to Hals's *Regents* and *Regentesses*, the paintings around which much of the argument began. It also gives us a chance to reconsider the paintings for ourselves, using a mixture of visual evidence and logical thought experiments. Let's think about it: if Frans Hals was an eighty-year-old pauper who, thanks to the charity of the townspeople, had been saved from 'freezing to death', is it not possible that he might have actually quite *liked* the people who had saved his life? Might he not therefore have painted them from a position of gratitude rather than hostility? More than that, the Regents and Regentesses had commissioned him to paint two enormous works, for which he was surely financially rewarded. Again, might he not consequently have been rather favourably disposed to the subjects of the paintings? Let us look at them again. If we study the expressions of (say) the three women on the right of the *Regentesses*, might we not suspect that, beneath their starchy exteriors, they were actually rather kindly old souls? And what of the 'drunken' man in the *Regents* painting? He does look a little 'squiffy' to be sure, but might not the theory of the neurological problem have some credibility? A condition known as Bell's Palsy (a type of minor stroke), for example, does cause minor paralysis to parts of the face. If this unfortunate man was so afflicted, would it have been fair to have removed him from the picture altogether simply because he was ill? As for his hat, the theory that it was fashionable to wear large hats in that way is supported by other paintings of fashionable characters of the period. Hals's *Man in a Slouch Hat* of exactly the same period (1660–6) shows a man in precisely such headgear. It may seem an odd sort of fashion to us, but fashion makes us all do odd sorts of things from time to time. In the late twentieth century, for example, it became fashionable for young men in Britain and the United States to wear baseball and other peaked caps back-to-front. Perhaps, in future centuries, art historians will decide that they, too, must have been drunk.

At this stage, a very good art-historical question might arise: what did the Regents and Regentesses themselves think of the paintings? If they felt they had been portrayed unfavourably, they would surely have been the first to have said so. And as Hals was commissioned to paint a pair, it would have been unlikely that they would have allowed him to proceed with the second if they had taken exception to what he had to say about them in the first. Unfortunately, we

cannot be sure. There is no remaining documentary evidence about what they or their contemporaries thought about them.[42] Again, we can only deduce their reaction from the circumstantial evidence. The provenance of these two paintings can be traced directly from the artist's studio to the old men's almshouse, where they hung until 1862. Only then were they removed to the safety of the Frans Hals Museum. Surely, the original Regents and Regentesses, to say nothing of their successors, would not have accepted the paintings and hung them in the almshouse for 200 years if they had thought that Hals had depicted them in a spirit of hostility for all to see?[43]

This brings us back, finally, to the dispute between Fuller and Berger. It seemed as though the exchange of hostile articles had come to a natural conclusion in 1988. The following year, however, the National Gallery in Washington and the Royal Academy in London staged a major exhibition of work by Frans Hals, including the star exhibits: the much-debated paintings of the Regents and Regentesses of the Haarlem almshouse. To make it even more interesting, Seymour Slive wrote the accompanying catalogue article. Fuller jumped upon this gleefully, stating that Slive had cleared up 'once and for all' the theory that Hals was a vengeful pauper, and had established 'conclusively' that 'like most of what Berger has to say about Hals, this is not true'.[44] Hals was actually comfortably well off at the time of the commission,[45] and Berger's theory of 'confrontation' in *Ways of Seeing* should therefore be 'demolished'. The problem was, continued Fuller, that Berger assumed that Hals must have painted the Regents and Regentesses as he himself would have done.[46] But Berger's interpretation was based on out-of-date art-history books that happened to coincide with his own political preconceptions. Berger's interpretation just did not stand up. The result was (in Fuller's wonderfully non-academic phrase) 'sentimental baloney'. Berger, he declared, should have the grace to admit that he was wrong, apologize to Slive, and amend the erroneous passages in *Ways of Seeing*. Fuller concluded: 'I have no doubt that *Ways of Seeing* will continue to blind first year students of the fine arts to the truth about Hals, and much else besides, for year after year.'[47]

Where does all this leave us? First of all, it is important to stress that our focus on the two paintings by Hals has been an illuminating case study. The world will continue to turn without scholars coming to a consensus over a pair of group portraits by a seventeenth-century Dutch artist. As a case study, however, this is a really enjoyable one because it lends itself so well to debate – and because it was disputed in such colourfully antagonistic terms by the parties concerned. It shows, moreover, that a political approach to visual culture is one that can both reveal and obscure the meaning of a work of art. On the one hand, Berger advocated a new 'way of seeing' which really did open up a new approach to art for generations of students. On the other hand, it could also be argued that it was a way of seeing in which Berger saw exactly (and only) what he wanted to see himself.

Our aim here has not been to come down in favour of any particular interpretation of Frans Hals, but to argue instead that whether or not Berger was right about the particular cases of the Regents and Regentesses, there is still something to be said for his approach. Of course, he overstated his case about art,

experts, property and class struggle. He admitted this himself. What he aimed to do was produce a polemical counterpoint to traditional art history with all its connoisseurs and treasure houses. This technique of 'provocative exaggeration' is well known among cultural critics of the left. In doing this, they deliberately overstate their case in order to provoke a reaction from the audience. The audience may not agree, but at least they have been provoked into actively thinking about the concepts under dispute, even if they don't end up actually being convinced by them. It is exactly the same with John Berger. We may not agree with his conclusions, but by being provoked into even considering his way of seeing, at least a part of his work has been done. We can be sure that, once we have read Berger, we will never look at these two paintings by Hals in quite the same way again.[48]

When Berger first published *Ways of Seeing* in 1972, it caused something of an outrage. This was especially so because the book was published alongside a BBC television series, and so Berger's radical ideas were broadcast to a large audience that was much more wrapped up in cosy, unquestioned assumptions about the glories of painting. We have focused on Berger's polemic about the relationship between painting and property not only because it proved so controversial at the time, but also because much of it is argued with specific examples over which we were able to weigh up conflicting evidence for ourselves. Of course, *Ways of Seeing* was not condemned by everyone when it first came out. Certainly, it was taken as an affront by many traditionalists and vested interests – along with those who simply disputed the facts. Yet at the same time that the book met with outrage in some quarters, it also found a sympathetic audience among many students and academic faculty members. The political atmosphere in colleges and universities was much more radical in the 1960s and 1970s than it is today. Set against the background of student and intellectual unrest in both Europe and North America, Berger's art-theoretical attack on capitalism was very much of its time. A problem for ideas that were once very much up to date, however, is that they run the risk of becoming out of date with equal speed. Berger's convictions about painting and property, together with the Marxian ideology that inspired them, have not weathered well in more conservative times.[49]

Not all of *Ways of Seeing*, however, was concerned with painting and property. Berger's third chapter (together with additional groups of illustrations) deals with something that has become a much more widely accepted part of visual culture today: the politics of gender. Just as painting articulated a history of class struggles, Berger argued that it also betrayed social inequalities between men and women. Traditionally, he says, women have been born 'into the keeping of men'. Men take the lead in the world, while women are treated as sights and objects. They are watched by men and conditioned at the same time to watch themselves – always to be vigilant about the way they act and how they look. In other words, 'men act and women appear'. This, claims Berger, is as true in reality as it is in painting. He proceeds to argue his point with copious examples taken from European paintings of nudes.

It is an odd thing, when we come to think of it, how public nakedness is so unusual in everyday life, yet so common in fine art and galleries. As soon as we enter the art school or the museum, nudity is everywhere (on the walls, at least).

17. Ellen Harvey, *The Nudist Museum*, 2010, fifty-four paintings in oil, second-hand frames, tape, collaged wallpaper; courtesy of the artist

In 2010, for example, Ellen Harvey copied every nude in the Bass Museum of Art in Florida. There were fifty-four of them, which she converted into a work of art herself (figure 17). In addition to the various and playful other points she was making, Harvey's project underlined both how many and what a variety of nudes could be found in even a relatively small municipal museum today.

Berger reminds us how many of the nudes so common in the history of art are women. More than that, he shows how many of these naked women are pictured watching themselves (frequently with a mirror), or depicted in a passive pose, pleasurably aware that they are being observed. That is why Berger is able to claim that in the typical European nude 'the principal protagonist is never painted. He is the spectator in front of the picture and he is presumed to be a man.' Indeed, the presence of the presumed male viewer (who still has his clothes on) is the whole reason why the woman in the picture is naked in the first place. The woman, on the other hand, is not depicted because of her own sexuality. Indeed, she is not supposed to be a sexual person herself – and Berger claims that this explains why women were so often painted without pubic hair, because hair represented sexual power, which women were not supposed to have. 'Women are there to feed an appetite, not to have any of their own.' The

naked woman is designed to flatter the man. The man, meanwhile, is not only the ideal spectator of the painting; he is probably also its owner. Again, this 'unequal relationship' is not limited to the visual arts. It is, rather, a relationship that is 'deeply embedded in our culture'.[50]

Berger does not support his arguments on gender with focused case studies, as he does with painting and property. We cannot, therefore, enter into specific debates as we did with Hals's paintings of the Regents and Regentesses. We can, however, marshal some general support for Berger from traditional art history. Studies of provenance, for example, do show that the vast majority of traditional oil paintings were commissioned and subsequently owned by men rather than by women. Similarly, studies of attribution demonstrate that the majority of works in oil were indeed painted by men. This comes as little surprise, given the historical facts of economic life. The best way to assess Berger's general theory on gender, however, is to look for ourselves. We can do this by wandering through galleries in person, or by leafing through art-historical catalogues and books. How many of the paintings we see are of women, and how many of these women are no longer in possession of their clothes? The paintings may be of domestic life, illustrations of classical stories or even political allegories. What may strike us as remarkable is the number of excuses that painting has found to portray women in the nude. And what are these women actually doing while they are naked? Is it true, as Berger suggests, that they are simply (and decoratively) enjoying the pleasure of being regarded? Compare these with scenes of men. How are they portrayed? Is it true – as Berger claimed – that 'men act and women appear'? Berger himself suggests a revealing little game that we can play for ourselves as we look at traditional nudes: each time we see a picture of a naked woman, imagine a naked man in exactly the same circumstance and pose. If the result appears ludicrous, he contends, his point is made.[51]

This is a game we can play not only in galleries and art-historical libraries, but also in advertisements and magazines. It is a point which Berger begins to make in *Ways of Seeing* but which we can develop for ourselves. When we come to think of it, what is the difference between the way women are represented in traditional paintings and how they are portrayed in glossy advertisements and even pornographic magazines? Sometimes the similarities are greater than traditionalists would care to admit. Jean-Auguste-Dominique Ingres' *La Grande Odalisque* of 1814, for example, is a finely executed piece of technical painting, to be sure. Had the same scene been photographed rather than painted, however, would this amount to very much more than a high-class Parisian pin-up? An odalisque is, after all, a female slave or concubine, even though this painting hangs in the Louvre.

If we want to take this point even further, it is instructive to compare the pictures and poses that can be found in 'top-shelf' magazines with some of those in the leading art galleries of the world. If this strikes some people as an offensive thing to do, the point is all the better made. The fact is that the majority of 'pin-ups' in *Playboy* are actually quite mild in comparison with some of the things we can see under the category of 'respectable' art. We may not be too taken aback by bathing pictures by Ingres or Courbet in a museum of art, but many a parent would be dismayed to find similar magazine photographs under a teenager's bed.

18. François Boucher, *L'Odalisque Brune*, 1745, oil on canvas; courtesy of Musée du Louvre, Paris; photo:RMN/Arnaudet

The eighteenth-century French painter François Boucher presents stronger stuff. In *L'Odalisque Brune* of 1745, we can see a naked woman lying down across a bed with her thighs apart and her backside presented towards the (presumed) viewer (see figure 18). Her face, too, is turned back to the viewer as if the woman is clearly pleased to be offering such a fine prospect. Some authorities suggest that the odalisque is in fact the artist's wife. We do know that Boucher was appointed King's Painter twenty years later, and that this paint-ing still hangs in the Louvre, which frequently echoes to the chatter of school parties. Boucher and other painters of the Rococo were famed for their frivolity, but 'serious' artists, too, were capable of creating works that varied from the suggestive to the explicit. Gustave Courbet, for example, was one of the giants of realist painting, famed for great works such as *The Burial at Ornans* (1849–50) and *The Artist's Studio* (1854–5). It was also possible to commission somewhat more private paintings from Courbet, as did the wealthy diplomat Khalil Bey. *The Sleepers* (1866) shows two women enjoying each other's company (but not much sleep) in bed, while *The Origin of the World* (also 1866) is a graphic (and carefully painted) representation of a naked woman's body from breast to a little above the knee (see figure 19). She is lying on her back with her thighs apart, presenting her pubic zone unreservedly to the viewer. The 'point of view' leaves

19. Gustave Courbet, *The Origin of the World*, 1866, oil on canvas; courtesy of Musée
d'Orsay, Paris; photo: RMN/Arnaudet

little to the imagination. The painting is on public view today at Paris's prestigious Musée d'Orsay.

It is interesting to note that it is nowadays very difficult to obtain images such as these in magazines from news-stands in and around colleges and universities. Such publications are thought to be too offensive. They are widely available, however, in campus libraries under the category of 'art'. This may lead us to wonder if much of what we have come to think of as art is in fact pornography. Conversely (and controversially), some might even be so bold as to argue that much of what people have come to think of as pornography might indeed be art.

Debates such as this will be much more familiar to contemporary readers than are Berger's discussions over class struggle and property. This is because feminist scholarship is nowadays much more prominent than Marxist. Indeed, Berger's ideas about men serving as the 'ideal' viewers of a nude painting will be familiar to students of many other aspects of visual culture. Film theorists, in particular, will see Berger's writing on painting echoed in feminism's famous assertion about the cinema: 'the gaze is male'. Publishing three years after Berger, Laura Mulvey wrote a now canonical essay, which investigated what she described as 'ways of seeing' in the cinema. In 'Visual Pleasure and Narrative

Cinema', she argued that women have a central role in the cinema, and that this is fundamental to the medium's erotic pleasure. The viewer enjoys an almost voyeuristic experience because the conventions of narrative cinema have it that those on screen are unaware of the fact that they are being observed. The women are nevertheless there to be looked at, and the watching men project their fantasies on to the females on screen. The on-screen male (again, there are echoes of Berger here) is, by contrast, a man of action and command. The cinema, therefore, mirrors the underlying social assumptions of a 'phallocentric' and 'patriarchal' society.[52]

As with Berger, there is something deliberately polemical about Mulvey's famous article. By today's standard, it (along with other pieces of radical writing from the same period) may even seem to lack sophistication. Linda Williams, writing twenty years later, feared that such a 'totalizing' approach oversimplified the position and reduced the male spectator to the role of 'a popular villain whose specter has haunted the field of visual representation ever since'. Williams agrees, however, that Berger's original insight remains deeply relevant: spectators are somehow 'in' the work. This is a proposition that is shared by Mulvey, along with nearly all sociologists of visual culture: even in 'the most seemingly natural or beautiful images, there is an invisible ideology'.[53]

We may not (and some certainly do not) find ourselves in total agreement with Berger and Mulvey. Some consider their arguments to be too simplistic or too polemical. Others contend that in common with many analysts of their ilk, they have a habit of always finding just what they are looking for in their chosen texts. The selected examples always seem to support their particular ideological stance. Their approach is considerably more prescriptive than descriptive, and in cases such as this, an ideological approach to visual culture can end up revealing more about the analyst than it does about the text purportedly under examination. A more comprehensive challenge to the Berger/Mulvey approach, though, is based not upon the validity of their results, but upon the efficacy of their methods. It suggests that they are looking at the wrong thing, blinded to aesthetics by the bright light of ideology.

The majority of the theories described in this book concern themselves with the analysis of actual visual texts. We have been making practice out of theory; trying to find out not only how but also what texts 'mean'. In this way, the ideological approaches taken by analysts such as Berger and Mulvey seek our same general goal (even though their findings may end up being very different). This kind of ideological approach takes as its basic assumption the belief that a visual text is not simply the product of an individual author, but more a 'fictionalized portrait' of society at the time a particular text was made.[54] This is a concept supported, we may recall, by Panofsky at his 'intrinsic' level of iconological interpretation: the intrinsic content of the text disclosed the *Weltanschauung* or world-view of the society in which it was produced.

Some analysts, however, consider this to be rather too sweeping an approach: not everyone in society holds the same view of the world around them. Lucien Goldmann, for example, similarly subscribed to the idea that cultural texts articulated a 'world-vision' – which he defined as 'the whole complex of ideas, aspirations and feelings'. However, he also stressed that a particular world

vision was common only to members of a particular social group (often in the form of a social class). This, in turn, marked out their differences from – and often their opposition to – other groups.[55] In other words, individual cultural texts should be seen as products of (and therefore articulations of) individual social groups and not the broad sweep of 'society' as a whole.

Whether or not we subscribe to Panofsky's general or Goldmann's more specific version of the 'society/text' model, we still have a very helpful concept. It helps us to see visual texts in their social rather than simply their individual context, and it helps us to move away from the traditional, art-historical, great works and 'lone genius' approach to the analysis of visual culture. For some thinkers, though, this methodological emphasis on the visual text itself is still far too narrow. Sociologist John B. Thompson has described this as 'the fallacy of internalism'. He argues that in order fully to understand the ideology of mass media texts, we must look further than the internal content of the texts themselves. Thompson argues for a broader, three-part analysis which incorporates an understanding of all of (a) the social and historical conditions in which texts are produced; (b) the way they are received by real people; and (c) our familiar, close analysis of the text under discussion. For Thompson, our understanding is incomplete without the whole of this tripartite approach. To concentrate on the internal qualities of the text alone constitutes the interpretational 'fallacy'.[56]

The question of how audiences view, interpret or 'receive' visual texts is a good one. Some theorists believe that once a text has been completed by an individual author, it takes on a new 'life of its own' in the hands of the viewer, each of whom contributes to its ultimate meaning with his or her unique interpretation of it. According to Roland Barthes, for example, once the text leaves the author, the author is essentially 'dead'.[57]

The sociology of reception lies outside the parameters of this book. This is not to say that it is not a good question; it is simply a different one. Our focus is deliberately upon the texts themselves. The question of the social and historical conditions in which visual texts are produced, however, merits more consideration here. We have already dedicated a chapter to the *history* of art, while the issue of context is one of the most important criticisms that can be levelled at ideologically grounded, text-based theorists. How, though, can we consider context without returning to the familiar yet problematic arena of traditional art history?

Pierre Bourdieu was a French sociologist who dedicated himself to just such an issue. Born in 1930, he established himself as one of the leading social theorists of the late twentieth century before dying of cancer in January 2002. As a sociologist, he focused not upon the historical specifics but rather upon the broad, underlying sociological conditions that influenced the creation of cultural texts as a whole. His work is therefore much more theoretical than empirical. Bourdieu's thinking on this topic is most fully set out in *The Field of Cultural Production*, a collection of his essays first published together in 1993.[58] Here, Bourdieu explains how he believes texts are produced with the help of the twin concepts of 'habitus' and 'field'.[59] Habitus is a Latin term which in English translates directly as 'bodily constitution'. In Bourdieu's hands, however, habitus means a set of attitudes or 'systems of dispositions'

that an individual absorbs over time as part of his or her social background.[60] We can think of it almost zoologically as resulting from an individual's 'social habitat'.[61] These dispositions are usually unconsciously absorbed and operated; the individual is not deliberately obeying any consciously learned set of 'rules'.[62] They are long-lasting, learned in childhood and usually held for a lifetime. The habitus becomes a 'second sense' or 'second nature',[63] and because these dispositions are common to people sharing a similar habitus, they can be 'collectively orchestrated without being the product of the organizing action of a conductor'.[64] So far, then, we find no fundamental disagreement with thinkers such as Goldmann: people assume and articulate the world vision of their particular and respective social groups.

Bourdieu is much more distinctive, however, in his concept of 'field'.[65] Where habitus explains the acquired attitudes or dispositions of the individual, field describes the particular social conditions in which he or she operates and, for our purposes, produces cultural texts. If habitus is essentially personal, field is ultimately institutional, with its own particular structures, rules and relationships. The individual takes his or her habitus into the field, which becomes what Bourdieu describes as 'a space of possibilities'.[66] Much of his work in *The Field of Cultural Production* is concerned with both the structure and operation of the field.

According to Bourdieu, the field of cultural production contains three component fields: the literary and artistic field, the field of political power, and the field of economy and class relations.[67] This constitutes his model of the circumstances within which cultural texts are produced. Bourdieu even provides a diagrammatic representation of it: mapped out on paper, it looks like a cross between a Venn Diagram and a complex force-field – the sort of thing we may be more familiar with in the study of physics rather than visual culture.[68] The field of literature and the arts is wholly contained within the field of political power, while this itself is contained within the greatest of the three: the field of economy and class relations.

Although each of Bourdieu's fields is indeed contained within the other, its relative position with the space of the larger field is not static. Each field has both positive and negative poles, which represent the degree to which the field within it is dominated by the greater force. The position of political power, for example, may vary depending on the force within the greater field of economic and class relations. In this way, Bourdieu acknowledges that the influence of the fields will change with circumstances, including the relation between one and the other. Taken together, the various influences of habitus and field combine to explain the practice of cultural production.

An important effect of the way in which cultural texts are produced, argues Bourdieu, is that the field of cultural production is an inversion of the regular world of economic production. Indeed, his opening essay 'The Field of Cultural Production' in his 1993 collection is subtitled: 'The Economic World Reversed'. Art, he says, became increasingly autonomous from the Renaissance until the nineteenth century. We can support Bourdieu's argument here with our recollections from the previous chapter on traditional art history. From the nineteenth century, however, a division developed between

mass cultural production, which was aimed at wide consumption by people who did not themselves produce cultural or 'symbolic goods', and a restricted production, which was aimed towards the approval of fellow producers. So, on the one hand, we had a mass production of cultural goods churned out for consumption by the 'general public' similar to any other industrial product – success here was measured by the volume of sales or even fame among non-producers. On the other hand, we also had a restricted production for a small, discriminating band of fellow artist/producers, described by Bourdieu as 'the peer competitor group'.[69] What really counted here was their approval and critical acclaim rather than financial reward: the artist valued his or her reputation (Bourdieu calls this 'symbolic profit'[70]) more than their bank balance. As a result, this kind of art became increasingly autonomous ('art for art's sake'); it became much freer from political power and developed its own set of values, legitimated and granted by fellow producers (and, to an extent, intellectuals and critics). Indeed, this kind of critical value was opposed to traditional commodity value; a form's popular, economic success was inversely related to its artistic quality. It never became completely free from political power, however, because it was still embedded in the greater, all-embracing field of economy and class relations.

Bourdieu's thinking is valuable for us because it reminds us again that cultural texts are not produced in a cultural vacuum. This takes us back to our first chapter, in which Panofsky argued that a work of art articulated the 'basic attitude of a nation, a period, a class, a religious or philosophical persuasion'.[71] Were a work not produced in a social context, it would not be able to articulate the 'basic attitude' of such a social context as Panofsky claims. Bourdieu helps us go further, though. Panofsky, we recall, felt that all of a nation, period, class, religion and philosophy could be 'qualified by one personality and condensed into one work'.[72] Bourdieu contends that such an approach would constitute a huge oversimplification. He emphasizes, rather, the complex and fluid influences of both habitus and field within the production of cultural texts or 'symbolic goods'. It helps us understand how an artist can be at once an individual and yet still be representative of a greater group culture. In this way, Bourdieu's theory does not seek to remove the individual producer completely from the scene. At the same time, however, it prevents us from fixating with the 'glorification of "great individuals", unique creators irreducible to any condition or conditioning'.[73] We cannot, after all, usefully speak of the 'sociology' of culture while at the same time believing the producers of cultural texts to be isolated individuals, no matter how impressive their individual works may undoubtedly be. Consequently, Bourdieu's work helps us prepare for our discussion of the 'anthropology' of culture and symbolic representation in chapter 6.

Bourdieu's theory is not invulnerable to criticism, however. His model is at the same time both complex and imprecise; there are many diagrams and sophisticated models, yet the important notion of habitus is never tied down with the same 'scientific' precision as field. Further, the more comprehensive a model or theory seeks to be, the greater its vulnerability to perceived omissions. Bourdieu makes a great deal of the influences of social class, for example, but he has considerably less to say about the significance of gender.

There are two further problems with Bourdieu's outlook for us. First, we are mostly concerned in this book with the 'hands-on' analysis of actual examples of visual culture. We are attempting to arm ourselves with strategies that will enable us to interpret the meaning of real visual texts for ourselves. By focusing so sharply on the social conditions in which works in general are produced, Bourdieu has little to say about the content of works themselves. His approach is enlightening for matters of context, but less illuminating for questions of meaning.

Second, Bourdieu's theory of cultural production serves primarily to use context to explain the text. Panofsky, on the other hand, believed that the intrinsic meaning of the text could be used to elucidate its context. Put another way, the study of a work of art can lead us to a deeper appreciation of the nation, class, culture (and so on) in which it was produced. If we use the text simply as visual confirmation of our pre-existing notions of the conditions of its production, we run the familiar risk of finding only that which we expect to see. What we have elsewhere called a 'text-first' approach to visual culture, on the other hand, can help us use the text to shed light upon society, rather than just the other way round.[74]

By giving priority to social context over visual text, we could expose ourselves to just the same criticisms that we earlier levelled at the likes of John Berger and Laura Mulvey. They have firm (and indeed controversial) views about social conditions, but by prioritizing (some sociologists like to say 'foregrounding') these within cultural analysis, their chosen texts always seem to serve as confirmation of their pre-existing socio-political convictions.

Socio-political interpretations of visual texts tend – as we have seen – to be contentious. The better known the text, the more controversial any ideological interpretation of it is likely to be. Just as politics are always a matter of dispute, so is any approach that has politics at its heart. That is because a political approach can extend the argument from a debate over a single canvas to an entire political arena inhabited by people's most passionately held beliefs.

When we take the sociological approach to meaning in visual culture, it is therefore crucial to guard against that prescient danger of always finding precisely what we are looking for. John Berger may in practice be guilty of this, but we should remember that at the same time he urged us to study the evidence and 'judge for yourself'. Even Peter Fuller agreed that it was Berger who had taught him to 'see'.[75] This exhortation to 'look for yourself' is not limited to socially committed theorists of art. Ernst Gombrich, who actively opposed the sociological approach, wrote that he wanted to help to 'open eyes'. If we became impatient with the critics, he wrote, 'the best advice here and always is "go and look at the pictures in the original"'.[76] Even Seymour Slive, so derided by Berger for his writing on Hals, used repeatedly to urge his students: 'And I ask you to *look* at this, people . . .'[77] Critics, scholars and theorists of all persuasions, then, urge us to 'look for ourselves'. What we have to decide is whether they really want us to find our own 'ways of seeing' or whether they just want us, in reality, to see the world through their own particular eyes. Perhaps we should remind both them and ourselves that 'ways of seeing' is not singular but plural.

Key Debate

Images, power and control:
What happens when the viewer is also the viewed?

This chapter has emphasized the way in which visual texts 'embody' ideology. The polemical work of John Berger was used to show how the analysis of images can discover the traces left by the values, ideas and beliefs that such images necessarily betray. Berger's *Ways of Seeing* certainly made an articulate case for the links between ideology and visual culture. But Berger's is not the only possible point of view. A different perspective will emerge if we accept that visual texts can be more than just passive indicators of the dominant ideological assumptions of the time in which they were produced. Indeed, they may actively function as symbolic devices involved in the very production of ideological positions and identities. Engaging with this different approach involves a dislocation, or rather a broadening, of our focus on observation, and this is achieved by adding the crucial figure of the 'spectator' to our analysis. And this sets us up nicely for our key question: what happens when the viewer is also the viewed?

In addition to the familiar concepts of the image-maker, the made image and the socio-cultural context that regulates making practices, we now expand our scope to include the image viewer, the viewed image and the socio-cultural context that regulates viewing practices. And instead of analyzing an image in search of what it can tell us about the ideological circumstances of its production, we will follow a different question posed by Sturken and Cartwright: as 'how images give those who look at them a sense of themselves as individual human subjects in the world in a particular historical moment and cultural context'.[78] We could call this field of analysis a 'field of vision' or a 'field of gaze', constituted by the complex web of articulations between images and subjects who are either represented or observing. It becomes still more complex if we consider that the spectator may in turn become an image available for (self)-appropriation. This is an important notion for the understanding of the role of images in so-called disciplinary societies, which we will address later on. For the moment, though, it is important to clarify the implications of giving the spectator centre stage in the study of images and ideology. To help us do this, we turn to the influential concept of ideology developed by Louis Althusser (1918–99).[79]

Althusser rejects the idea that ideology manipulates and misguides human subjects, and so he accordingly distances himself from the presupposition that the subject is a given upon whom ideology acts. In his view, what ideology actually does is nothing less than produce human subjectivity itself. Ideology, he contends, performs the subjectivity building process by interpelling ('hailing') the individual, who is offered a position regarding ideological formations, a position he or she is urged to identify with, and from which he or she will be able to make sense of the surrounding world. In highly visual societies such as ours, ideological interpellation frequently takes place through exposure to images – all kinds of images. Interpellation, therefore, is about situating the individual/viewer in a 'field of meaning production (organized around looking practices)

that involves recognition of oneself as a member of that world of meaning'.[80] The 'field of gaze' we previously mentioned can now be more clearly understood as a 'field of meaning production', indispensable for the transformation of individuals into subjects. This view highlights the active performative and productive character of ideology and raises notably different questions about the relationship between ideology and the visual.

One of these questions surrounds the role of the visual in processes of social organization and social control. In other words: the relation between images and power. Once again, we may approach the issue using the more static notion of ideology we saw in the work of John Berger, for whom the relation is clarified just as long as visual texts are taken as 'fictionalized portraits' of the socio-cultural conditions of their production. As a result, these texts carry the ideological marks – ideas, beliefs, attitudes – of such conditions, and which ultimately are the product of historically determined power relations that can be deciphered through the interpretation of images. If we privilege a notion of ideology that emphasizes its productive role in the very constitution of subjectivity, however, the idea that visual texts constitute vehicles for the transmission of the ideological principles that prevailed at the time they were produced proves insufficient to illuminate the connections between images and ideology.

To help us understand these connections in the light of a notion of ideology that highlights its role in the production of subjectivity, we will use the concept of the 'visual subject', defined by Nicholas Mirzoeff as 'the person who is both constituted as an agent of sight and as the effect of a series of categories of visual subjectivity'.[81] What this definition implies is that the visual subject is not only the one who sees – the 'agent of sight' – but also the one who is seen – the 'effect of visual subjectivity'. To make it still more complex, the way in which the agent and the effect 'sides' of the visual subject are articulated in the field of gaze does not allow us to take them as separate dimensions. Still, according to Mirzoeff, the situation is described in what he designates the 'mantra' of visual subjectivity: 'I am seen and I see that I am seen.'[82] The 'mantra' can also be used for the understanding of the relations between images and power in so-called disciplinary societies, that is, societies organized to produce subjects actively involved in the self-regulation of their own behaviour. Social control is in part achieved when the individual functions as a 'viewer', given the subject positioning processes that take place when individuals respond to images which 'address' them, providing the identification with a realm of meaning that the subject recognizes as his or her symbolic habitat. But the social control cycle is in fact completed when the individual functions as a 'viewed': someone whose sense of being constantly watched – at least potentially constantly watched – leads him or her to internalize a perceived omnipresent surveillance, and to behave according to that perception.

This notion that discipline is maintained through a system of visibility may seem a little abstract, but it gains tangible meaning if we think of the remarkable number of technical devices that permanently capture images of individuals as they move around the public space. Closed-Circuit Television (CCTV) cameras (and the more recently introduced Closed-Circuit Digital Photography (CCDP) and Internet Protocol (IP) cameras) allow the constant surveillance of

millions of individuals, whose images are recorded, stored and circulated at an unprecedented scale. And even before the introduction of today's increasingly sophisticated surveillance technology, we can think of cruder yet psychologically effective systems that have been used – and continue to be used by disciplinary states and authoritarian regimes worldwide.

Although high-technology gadgets have created the realistic possibility of an environment of virtually total visibility, the role of the image in disciplinary processes was perceived a long time before such sophisticated cameras were invented. The apparatus which epitomizes omnipresent visual surveillance by a hidden surveillor is the Panopticon, a building proposed in 1787 by the English philosopher and social reformer Jeremy Bentham, and described by Michel Foucault as the ultimate means with which to transform the whole social body into 'a field of perception'.[83] Bentham envisaged a building – designed to be a prison, but also applicable to factories or schools – constituted by concentric rings of cells around a central guard tower (figure 20). From the central observation point, everything that goes on in each cell can be watched. However, a set of optical devices makes it impossible for the individuals in the cells (prisoners, workers, schoolchildren . . .) to see who – if anyone – is in the tower, watching. Although the Panopticon was never built (the scheme was published in 1791), it remains the symbol of a physical structure designed to promote the internalization of the 'inspecting gaze' that Foucault sees as the basis of contemporary disciplinary societies. Since the Panopticon prisoners internalize the potential observer and adjust their acts accordingly, there is no need of an actual guard in the tower . . . Just like the CCTV camera that does not really have to be turned on to exercise its disciplinary function. Accordingly, we self-censor and self-regulate our actions so effectively that the need for detection and even punishment is no longer so necessary.

If we accept that something approaching total visibility – in which visual systems play the central role in the internalization of rules and in the enhancing of self-regulating discipline – is now a crucial feature of contemporary societies, we must acknowledge that something has changed. We have used the classic example of the Panopticon to support the argument that the importance of 'total' visual systems in disciplinary processes was not dependent on the invention of modern, technologically sophisticated surveillance equipment. That does not mean, however, that this particular relation between image and power, enacted through the internalization of the inspecting gaze and the corresponding emphasis upon self-regulation, has always been there. In fact, it is a relative novelty – it is associated with the emergence of modernity – and took the place of a different way of understanding and using the visual as a medium of social control. The previously prevailing relationship between power and the visual can be designated 'spectacular' and, although it has not been eradicated in societies with which we are familiar, it seems to have lost relative weight to the predominant surveillance character we have just described.

By the 'spectacular' relationship between power and the visual, we mean the overt displays of power made visible to ordinary people. Heavily ritualized power structures, such as monarchies, totalitarian political regimes or religious institutions, tend to privilege this kind of use of images as a means to secure

20. Plan for Jeremy Bentham's Panopticon of 1791; courtesy of University College London Special Collections

discipline and control. The images displayed may correspond to the pure ostentation of power (the crown, orb and sceptre used in a coronation ceremony, for instance) or function as a powerful warning against any potential attempts to subvert the status quo (the public execution of criminals, for example). The common link is the ostensive and explicit display of 'spectacular' images of power, carefully staged to impress passive viewers and discourage any potential attempts to break or even question the norm. Examples of this can still be seen

worldwide today, but the function of power in its visual dimension became less overt from the moment surveillance became more central than the spectacular. Less overt, perhaps, but not less ideologically determinant.

Further Study

The sociology of visual culture is a fast and still expanding field. It is impossible to recommend everything that should be read, but a few suggestions will help the reader with both groundings and bearings. An ideal place to start is, of course, with John Berger's *Ways of Seeing*. It is, as we have seen, deliberately provocative and doubtless controversial. For many years, though, it has worked as a lively introduction to what is for many people a new approach to the study of the visual arts – even if they still find themselves unable to agree with it. Two further basic readings will help locate Berger. Karl Marx and Friedrich Engels' *The Communist Manifesto* provides a brief, readable and rhetorical introduction to the Marxism from which Berger's way of seeing is drawn.[84] Many people today are happy to pronounce upon Marxism without actually having read any Marx; reading this introduction would at least start to put that right. Berger acknowledges a further debt: Walter Benjamin's famous essay, 'The Work of Art in the Age of Mechanical Reproduction'.[85] Benjamin was one of a number of scholars who built upon Marxian theory to take greater account of the importance of culture within society. This important essay can be found in Benjamin's *Illuminations*, and is also reprinted in various other readers and compilations. For a personal and contrary response to *Ways of Seeing*, Peter Fuller's *Seeing Through Berger* makes for lively and thought-provoking reading. Fuller went on to found the journal *Modern Painters*, which includes intelligent, albeit more traditional, articles on art and art theory. Berger, however, was not alone in taking a Marxian stance on art history: Nicos Hadjinicolaou's *Art History and Class Struggle* was published in France the year after *Ways of Seeing*. The English translation was published in London five years later, underlining the fact that Berger's polemic was by no means an isolated outburst.[86]

Laura Mulvey's important 'Visual Pleasure and Narrative Cinema' was originally published in the journal *Screen*, but has been widely reprinted since, including in Mulvey's own *Visual and Other Pleasures*.[87] This is now a canonical essay, although it is at the same time in danger of becoming more widely referred to than read. Mulvey herself draws from the psychoanalytical works of Sigmund Freud and Jacques Lacan. Feminist approaches to the understanding of visual culture are considerable and diverse. It is a mistake to think that there is only one kind of feminism, or that Mulvey had the last word on 'gaze theory'. Judith Butler, for example, goes beyond what some people refer to as 'first-generation feminism' in books such as *Gender Trouble: Feminism and the Subversion of Identity*.[88] Linda Williams, meanwhile, has provided an excellent introduction to her edited volume *Viewing Positions: Ways of Seeing Film*. She begins with a quotation from Berger and moves on to Mulvey, seeking to revise gaze theory without destroying it. A series of contributed articles follows, emphasizing the plurality of ways in which people view film.

Of course, sociological approaches to visual culture are not limited to class, property and gender. Recent studies have ranged from sexuality to race, religion, national identity and the environment. Edward W. Said, for example, produced the now classic *Orientalism,* in which he argued that Western representations of the East said more about the West than they did about the places and cultures they purported to depict.[89]

For a focus on the social circumstances in which cultural texts are produced, Pierre Bourdieu's *The Field of Cultural Production* brings together much of his thinking on these issues over a ten-year period.[90] For a broader overview of the theoretical relationship between media, culture and society (together with a solid evaluation of other contributors to the field), the work of John B. Thompson is particularly recommended. His *Ideology and Modern Culture: Critical Social Theory in the Era of Mass Communication* and *The Media and Modernity: A Social Theory of the Media* take us well beyond the study of painting and into areas considered in later chapters of this book.[91]

The connection between ideology and the visual is among the main issues addressed by Mirzoeff in *An Introduction to Visual Culture,*[92] whose second edition, published in 2009, contains references to images such as the controversial photographs from the Abu Ghraib prison in Iraq, and a 2006 poster from Al Gore's film *An Inconvenient Truth.* A detailed analysis of the power of a vast collection of contemporary images can also be found in *Practices of Looking – An Introduction to Visual Culture,* by Marita Sturken and Susan Cartwright. There is a wide range of material focusing on the ideological dimension of images in specific historical settings (from Victorian England to Nazi Germany), while other books, such as Elizabeth Chaplin's *Sociology and Visual Representation,*[93] trace the evolution of critical writing on the visual and discuss its current – and arguably increasing – presence in the fields of sociology and anthropology.

The scope of the social analysis of visual culture is indeed broad. However, nearly all the works suggested for further study here are united in the common assumption that visual culture is not produced in a social vacuum. An analysis of visual culture, therefore, can introduce us to an analysis of society itself.

5

SEMIOTICS

This chapter provides both an introduction to semiotic theory and a discussion of its usefulness in the analysis of visual culture. It begins with the early linguistic work of Ferdinand de Saussure and an explanation of the basic terms and concepts of semiotics. The key principles of the *sign*, the *signifier* and the *signified* are demonstrated with everyday examples, and the arbitrary nature of the sign is emphasized. We then proceed to discuss the applicability of semiotic analysis to the visual and not just the linguistic world. This involves paying particular attention to the semiotician Roland Barthes and his classic *Mythologies*, in which he uses semiotics to take a new look at French popular culture and daily life. We critique Barthes' approach and conclusions before embarking on our own case study of a series of Renault car commercials. We conclude with a discussion of the value of Barthes' ideological concept of *what-goes-without-saying*, in which a semiotic approach to visual culture is used to provoke us into questioning fundamental assumptions and beliefs we may previously have taken for granted.

So far in this book, we have looked at four different approaches to figuring out the meaning of a visual text. This fifth chapter aims to be a little different. Here, we will be asking not simply *what* a visual text means, but rather *how* it means. We are going to explore, in other words, how communication of meaning is made possible in the visual world. This is going to involve taking a much more theoretical approach than we have so far pursued. There is no need for alarm, however. Theory can be a great deal of fun because it enables us to ask the big questions which go to the very heart of meaning in visual culture. It is all the more enjoyable when we apply it to everyday and familiar examples. In this

chapter, we will be using the theory of semiotics, illustrated with examples from advertising and popular culture.

Semiotics can be frightening. A lot of people assume that it has to be very difficult because it is so often written about in such a difficult way. Actually, semiotics is a way of putting into words something that many of us already know, at least intuitively. By exploring it in academic language, we are simply trying to structure and to clarify exactly what it is that is going on. At its most basic, semiotics will help us understand how people are able to sell us particular brands of cars, perfume or hamburgers. At its most challenging, it may even provoke us to contemplate the meaning of life. But we are getting ahead of ourselves.

Let us start at the beginning. Semiotics (also known as semiology)[1] originated with the Swiss linguistic analyst Ferdinand de Saussure. Saussure wanted to know how language worked, and he was still working on his theories when he died in 1913. His *Course in General Linguistics* was published posthumously in 1916, with considerable help from his former students, who contributed their lecture notes to the project. Saussure showed that language was a system of signs or signals which enabled people to communicate with each other. To help explain this, he used the 'lexicon of signification': a group of terms that comprised the 'sign', the 'signifier' and the 'signified'. Much of semiotics concerns the relationship between the three. Briefly, the 'signifier' is something that stands for something else; the 'signified' is the idea of the thing it stands for; and the 'sign' is the union of the two. Conventionally, it can be written as 's/S'. Let's take an example. In English-speaking countries, the signifier 'D-O-G' is taken to mean a certain kind of furry quadruped with a cold, wet nose that can clear a coffee table with one sweep of its tail. The signifier, in this case, is that combination of those three letters on a printed page. If we think about it, it is really a signifier made out of a series of recognizable shapes, printed in a recognizable order. The signified is the idea we get in our head as a result of reading the signifier 'D-O-G'. The signified isn't an actual furry quadruped. But that is how we can communicate the *idea* of one to you without there necessarily being one in the room with you as you read this.

Things would be different if we were in another country. In France, for example, we would use the signifier 'C-H-I-E-N' to signify exactly the same signified. In Spanish-speaking countries, the signifier would be 'P-E-R-R-O'. The signified, however, would remain the same. So far we have only considered written language, but the same is true with spoken language. On the printed page, the signifier 'D-O-G' is a group of shapes. If we say it out loud, however, it is a sound. The sound that we make when we pronounce those letters (and we don't even have to be able to read to say it) is altogether different from the shape of those letters, but the signified (again) remains the same. Let's take this even further. We could, between us, completely make up our own word (as children sometimes do) to signify that now familiar quadruped. We could call it (say) a 'P-H-N-O-B'. The signified would still be the same, but we would have invented an altogether new signifier. This brings us to the crucial point behind semiotics: if we can have many different signifiers for the same signified, and if we can indeed come up with any old signifier we like as long as more than one of us has agreed to it, then there is no inevitable, indelible, intrinsic, God-given

relationship between the signifier and the signified. If this is so, then the 'sign' (the union of the two) is 'arbitrary'.

That the sign is arbitrary is the key point behind the whole of semiotics. It reminds us that nothing inevitably means anything. If this meaning is not natural, then it must be cultural. In other words, words only mean the things they do because we agree that they do. The relationship between a particular signifier and a signified, then, is purely conventional. We have to know French, for example, to know what 'C-H-I-E-N' means. If we don't, then it might as well be signifying a new kind of vacuum cleaner. Similarly, the use of 'P-H-N-O-B' in the private language we have just invented only succeeds in signifying what it does because we have agreed between ourselves that it should. We could have come up with anything we liked. This only works because the relationship between the word for something and the idea of the thing for which it stands is a matter of convention. The sign is arbitrary. If it wasn't (think about it!), there could only be one language in the entire world.

The joy of theory is that once we have mastered it, we can start to have fun with the practical examples. And if we are still having trouble with the theory, a few practical examples can usually help to clear it up. Imagine that we are motor-car executives, and we have to come up with the name for a new car. Semiotics warns us to be very careful because, as the sign is arbitrary, what might be a really good name in one country might be a really bad one in another. Take the case of the Chevrolet 'Nova' for example. In English, a 'nova' is a bright, new star – seemingly, a great name for a new car. In Spanish, however, 'no va' means 'doesn't go'. This is a very bad name for a car that we hope to sell to millions of Spanish-speaking people around the world. Ford, meanwhile, produced a car called the 'Pinto'. This seems like another great name for a runabout. A 'pinto' is a kind of horse, and appears all the more appropriate if one of our other models is the famous 'Mustang'. Unfortunately, 'pinto' is also Portuguese slang for 'penis', namely in Brazil. As Portuguese is one of the most widely spoken languages in the world, it is a very bad idea to name what one hopes will be a big-selling small car with a word that would cause such widespread hilarity. This brings us to one of our favourite examples: the Mitsubishi Pajero. In the 1980s, the Japanese motor manufacturer Mitsubishi brought out a new sport utility vehicle called the Pajero. This seemed like a very good name: the word alone seemed full of adventuresome, off-road swagger, especially when one discovers that zoologically, the *Leopardus pajeros* is a South American wild cat. For the UK market, the same car is marketed as the Shogun (as in Japanese warlord), where in Spain and the USA it is sold as the Montero (as in mountain warrior). You get the picture: you can almost smell the testosterone. Unfortunately, 'pajero' has another meaning in Spanish: it is a slang term for 'wanker' or 'one who masturbates'. No wonder the car is sold as the Montero in Spain. We took this picture (figure 21) in Lisbon, Portugal, where the driver was doubtless blissfully unaware that the registration plate could have hilarious consequences just a few hundred miles across the border in neighbouring Spain. Such embarrassment is only possible because the sign is arbitrary.

So far, we have only looked at the semiotics of written and spoken language. This is where Saussure began. Crucially for us, however, Saussure's early work

21. Mitsubishi Pajero, Lisbon, 2010; photo: O. Nan

on semiotics – and especially his 'lexicon of signification' – sowed the seeds for a whole intellectual movement that sought to investigate and to explain cultural life well beyond the merely literary. The resulting 'structuralist' movement was a group of mainly French intellectuals who advanced Saussure's early linguistic theory into areas as seemingly diverse as anthropology and psychoanalysis.[2] Not all of the structuralists are famed for the clarity of their expository writing. Many of their ideas, however, are extremely valuable, and for this reason we shall pay particular attention in this chapter to the work of Roland Barthes. What Barthes did for us is extend semiotics to the analysis of visual and popular culture. More than that, he used semiotics to reveal not only the text but also to expose the underlying ideological assumptions of the society in which it was created. In so doing, he provides both a useful link with and development of the ideas we discussed in the previous chapter.

Before we examine Barthes in any detail, let us first spend a few moments considering how semiotic a world we live in – even if we have not formally recognized it as such. Let's start with clothes. To say that clothes perform a purely practical function (to keep us warm, dry and decent) is to miss the key point of dress in contemporary culture. Our clothes are a major means of visual communication. When we dress for an interview, a date, a wedding, to go to work or even just to meet our friends, we are making semiotic decisions. Our choice of clothes 'says something' not only of who we are but also of how we would like to be seen. We all consciously select our clothing to create 'the right impression' for the right occasion. If a man wears a tie for a job interview, for example, it would be hard to argue that the tie served any sort of practical function in terms of warmth or protection from the rain. On the contrary, the tie is a markedly impractical item of clothing whose only real contribution is to find its way into soup with disturbing regularity. The tie is not worn for practical reasons. Its function, rather, is entirely semiotic. It is a signifier par excellence. A tie 'says' that we are serious about the interview and serious about the job. It shows that

we are treating the occasion and the company with respect. It shows that we are a respectable, dependable person who knows how to live by the rules. But as every man knows, it is not enough just to wear a tie. It has to be the *right* tie. Will it be a dark tie for gravitas, or a bright one for energy? How about a cartoon character to show that we have a sense of fun, or a sports design to show that we are athletic? Maybe a club, school or college tie will show that we have the 'right' connections? A logo, crest or combination of colours act as a semiotic code, but as with all signifiers, it will need to be decoded by another person in order for the intended communication to take place. Then again, if we are interviewing with a software or a 'dot.com' company, it might be equally important not to wear a tie at all.

Ties, of course, are only one example of semiotics at work in the things we wear. Everything from a T-shirt to a camel coat can make a statement of varying and deliberate degrees of subtlety. The American lifestyle magazine *Gentlemen's Quarterly* used to recognize this with a regular column called 'The Semiotics of Dress'. Needless to say, menswear is only an example here. It would be absurd to suggest semiotics are not feverishly at work in women's choice of clothing too. But menswear provides a particularly good example because the greater conformity of men's dress (all those grey suits!) means that small differences become all the more semiotically significant. The tie, in particular, distils significance into a most potent semiotic space.

In a visual world, the possibilities for non-verbal communication are legion, and so are the examples we could choose. Take gesture, for example. We know what is communicated by a nod or a shake of the head, but what if the convention were the other way round: a nod for 'no' and a shake for 'yes'? In North America, one finger constitutes an obscene gesture. In Britain it takes two. In Shakespeare, biting one's thumb was enough to incur bloodshed between the Montagues and the Capulets, but would hardly cause a riot today. In Leonardo da Vinci's painting of Saint John the Baptist (1513–16), someone appears by today's standards to be 'getting the finger', but we can be sure that such a meaning was never intended in a religious work of the Italian High Renaissance.

Think of the logos used by prestigious automobile manufacturers. We all recognize the famous 'propeller' badge from the front of a BMW. Somehow, it oozes expense and sophistication. But what if exactly the same logo had long been used by a far less exclusive manufacturer? We can think of our own example to show that the sign is arbitrary. There is nothing intrinsically classy about the BMW logo. It only connotes by convention. Mercedes Benz, meanwhile, is instantly recognizable by its three-pointed star on the radiator, the hub caps, the steering wheel and anywhere else where motoring sophistication can be communicated. But if we add just one stroke of the pen to the Mercedes Benz logo (see figure 22), it becomes the sign for the Campaign for Nuclear Disarmament (see figure 23), a radical organization which marched upon air-bases under the slogan 'ban the bomb'. If just one straight line on a signifier can so radically alter the signified, then it provides us with all the more evidence that the sign is arbitrary. We can continue to make our own examples: could not the symbol adopted by 'The Artist Formerly Known as Prince' just as easily stand for Little Jimmy Osmond, or red on a traffic light mean 'go'?

22. Mercedes Benz logo; photo: Richard Howells

23 Campaign for Nuclear Disarmament (CND) logo; photo: Richard Howells

Because the sign is arbitrary, it follows that the relationship between a signi-
fier and a signified can change over time. A good example of this is the Eiffel
Tower. Today, the Eiffel Tower signifies all that is Paris. It carries with it con-
notations of pavement cafés, accordion music, haute couture, artists, bookstalls
by the river, and so on. For many people, a trip to Paris without seeing the Eiffel
Tower would hardly be a trip to Paris at all. Yet when the tower was originally
built in 1889, it was condemned as an eyesore: an ugly, wrought-iron advertis-
ing hoarding which blighted the elegant skyline of the 'city of light'. Nowadays,
it is difficult to imagine Paris without it. A four-footed, iron tower does not
necessarily and intrinsically signify Gallic sophistication, however. Five years
after the Eiffel Tower was built in Paris, a similarly shaped edifice was erected in
the coastal resort town of Blackpool, England. Although only slightly over half
the height of Eiffel's version, the Blackpool Tower was consciously modelled
on its Parisian predecessor. The connotations today, however, are entirely dif-
ferent. Blackpool has proved extremely popular as an easily accessible vacation
spot for working-class families from the industrial north of England, but it has
never sought or claimed the cosmopolitan sophistication of Paris. In silhouette,
it would be hard to distinguish the Blackpool from the Eiffel Tower. The mean-
ings they have come to connote, however, could hardly be more different. In
itself, therefore, the signifier is an empty vessel into which cultural meaning is
poured to imbue it with meaning. The sign (at the risk of repeating ourselves)
is arbitrary.

This talk of Paris brings us back conveniently to Roland Barthes. Barthes
(1915–80) was a French writer and critic who, despite his origins in literary
criticism, argued that anything could be treated as a text and decoded semioti-
cally. His classic *Mythologies* (1957) drew gratefully on Saussure and opened up
popular culture to semiotic analysis.[3] It has been essential (and controversial)
reading ever since. Here, Barthes set about 'decoding' cultural texts as seem-
ingly diverse as professional wrestling matches, soap powder commercials,
hairstyles and magazine covers. His aim was not to make high cultural claims for
popular culture but, rather, to take apparently innocuous and everyday things
and dismantle them in such a way as to make us aware of what he thought they
were really saying.

Fundamental to Barthes' analysis was the belief that everything could be a
sign. It was not limited to 'oral speech' or 'written discourse' but also included
'photography, cinema, reporting, shows, publicity' and so forth, because 'any
material can arbitrarily be endowed with meaning'. Pictures, indeed, could be
more potent than writing because 'they impose meaning at one stroke' but semi-
otic communication could extend beyond both the verbal and the visual: even
objects could communicate semiotically 'if they mean something'. Fundamental
to all this, of course, is the basic semiotic concept that things do not mean any-
thing in themselves but are invested with meaning by cultures and societies. In
this way, 'every object in the world can pass from a closed, silent existence to an
oral state' as appropriated by society.[4]

Barthes' analysis is built on Saussurian semiotics and the study of sign
systems as 'tokens for something else'. He begins by restating that semiotics
is concerned with the relationship between the signifier and the signified, and

takes the example of a bunch of roses, which he uses to signify passion. The roses (the signifier) and the passion (the signified) existed previously and independently of each other, but now the roses were 'passionified'; signifier and signified were united to produce 'the associative total of the first two terms', the sign. But although Barthes is based on Saussure, he takes semiotics well beyond the Saussurian model. He does this in two ways. We have already seen the first: he extends semiotics from Saussure's concern with written and spoken language to an analysis of the visual and the popular cultural. This permits us to 'treat in the same way words and pictures'.[5] Second – and this is a key point – he takes semiotics a stage further into the study of what he calls 'myth'.

When Barthes speaks of 'myth', he does not mean (as we often do in the vernacular) 'a common misconception'. Rather, he speaks of myth as a 'second-order semiological system',[6] a system of which Saussurian semiotics provides only the first stage. It is worth taking a moment to explain this. Under Saussure's linguistic system, the signifier and signified combine (as we know only too well by now) to create the sign. This provides us with the basic unit of the semiological system. Barthes, however, shows that it does not end there. The sign created by the association of the first two parts can then go on to become the signifier of something else. It is here that semiotics enters the 'second order'. Let us go back to our familiar example. Saussurian semiotics shows how the written or spoken signifier 'dog' can be used to signify the idea of a dog. What we can then do, if we wish, is use the resulting sign to go on and signify something further, such as fidelity. So, what was the final term or sign in the (first) linguistic system now becomes first term or signifier in the (second) mythical system. Fidelity becomes the mythical signified, and the mythical sign is, in turn, the union of the two.

A myth, then, according to Barthes, is 'a sum of signs'. It is a 'metalanguage', which is to say, a language made up of component linguistic parts. One of Barthes' favourite examples in *Mythologies* is of a *Paris Match* magazine cover in which a black soldier salutes the French flag. Barthes argues that this signifies French colonialism and imperial power. But the magazine cover is itself an assemblage of component signs (flags, soldiers, text, photography and so on), so we are presented with a sign made up of a variety of component signs. This is a myth: a 'total of linguistic signs'. In this way, a whole book can become the signifier of a single concept.[7]

Barthes goes on to describe some of the characteristics of myth. The relationship between the form of a myth (the black soldier saluting) and the concept (French imperial power) is unequal. The form is the poorer of the two. For example, the concept of imperial power could have been signified by all manner of different signifiers. Barthes claims he could have found 'a thousand images' which would have done the same job. That, however, is a very useful feature to people in the business of making myths, as is the fact that the relationship is never permanently fixed. There is a second way in which the form is impoverished by its relationship with the concept. In the magazine cover, the black soldier becomes simply a form for the communication of the idea. Thus, the individual (presumably a very real human being) is 'robbed' of his history. By becoming a token for something else, he loses his individuality. He remains,

physically, in the picture, to be sure. He is not obliterated from the scene, but he is 'half-amputated' because he is deprived of his memory.[8] We forget, in other words, who he is because the myth is much more concerned with that for which he stands.

This deliberate use of something to stand for something else leads us to another of the features of Barthean myth: it is much more concerned with its intention than its form. The connection between the mythical signifier and signified, unlike its linguistic predecessor, is 'never arbitrary'. It is always in part 'motivated'. Indeed, 'there is no myth without motivated form'. This helps explain the value of the system to a producer of myth such as a journalist who 'starts with a concept and seeks a form for it'. That is why Barthes describes a major purpose of myth as to 'transform a meaning into a form'. Of course, he says, there is always a 'halo of virtualities' floating around the final meaning, and this leads to the importance of interpretation in the reading of myth.[9]

Barthes' use of the term 'myth' makes a great deal of sense in this. To an anthropologist, a myth is a repository of value.[10] It is in myths that societies, both ancient and modern, encode their hopes, dreams, needs, fears and cultural values, even though they may take the overt form of other things, such as stories about dragons, heroes or wings made of wax. To a semiotician, a sign has much the same function. It is, we remember, a token for something. What Barthes' semiology seeks to do (at least in the first instance) is to separate the 'tokens' from the 'something else'.

The idea of things standing for something else is not a new one. The artists of the early Renaissance knew this when they included all manner of symbols in their religious paintings. The procedure was formalized (as we saw in the first chapter) in the emblem books of later centuries. Herman Melville understood it (in a different fashion) in *Moby Dick*. Writing a full sixty-five years before Saussure, Melville has Captain Ahab nail a gold doubloon to the mainmast of his ship as an incentive to his crew to kill the great white whale. Passing the coin one day, Ahab becomes fascinated by the figures and inscriptions stamped upon it, for the first time beginning to 'interpret' for himself 'whatever significance may lurk in them. And some certain significance lurks in all things, else all things are little worth, and the round world itself but an empty cipher.'[11] That is exactly what semiotics tells us.

There is something of code-breaking involved in semiotics. In a code, after all, the form and the content are conspicuously different. The letters, words or numbers chosen are consciously 'tokens for something else'. A crucial feature of a code, of course, is that it can be understood not only by the sender but also by the recipient. Indeed, semiotic codes are usually understood by entire groups of people who have learned, through convention, what is signified by a particular signifier. Teenagers have long understood this, as exemplified by a wonderfully illustrative incident from the American TV situation comedy *Sabrina, the Teenage Witch* (1996–2003). Here, Sabrina Spellman has transformed her aunts into teenagers so that they can chaperone her at a late-night record-signing event in Boston without her losing 'street credibility' in front of her friends. Unfortunately, the aunts, while taking on the physical appearance of teenagers, are less well acquainted with the finer points of contemporary teenage semiotics.

It is winter in Boston, and one of the aunts complains about the cold. One of Sabrina's schoolfriends, Gordy, gives her his scarf. Sabrina is appalled:

Sabrina: May I speak to you a moment? What are you thinking? You just took Gordy's scarf!

Aunt: So? I'll give it back.

Sabrina: No! That means he likes you and by accepting it, it means you like him. It's the teenage code!

Aunt: It's just a scarf.

Sabrina: You are so naive!

Sabrina and her teenage friends know that by lending a scarf, someone is semiotically expressing attraction to someone else. By accepting the scarf, the recipient communicates that the attraction is reciprocated. As the horrified Sabrina tells her aunt: 'It's the teenage code!' In this way, her aunt's innocent protestation that 'it's just a scarf!' is as naive as suggesting to a patriot that the stars and stripes is 'just a flag'. In Sabrina's teenage culture, the scarf is the signifier, and physical attraction is the signified. Only by being culturally able to connect the two is it possible to interpret the sign and fully participate in the teenage semiotic universe. The unfortunate aunt fails to make the connection and embarrassment (the greatest of all teenage horrors) ensues.

We are not, of course, using this example to suggest that *Sabrina the Teenage Witch* should be added to the scholarly canon alongside Barthes and Saussure. Nor are we suggesting that Sabrina and her friends (or even her scriptwriters) were consciously discussing semiotic theory on that cold Boston sidewalk. We are simply underlining the point that although semiotics is something that many people think is unapproachably difficult, it is actually perfectly simple to understand with the help of the right examples. We are all semioticians even though we may not use semiotic terms in everyday speech.

There is an important point that separates the three examples we have just been discussing. The artists of the early Renaissance simply got on with the job of using recognizable icons in their painting. They were not, as far as we are aware, troubled by the semiotic theory of it all. Sabrina took it further by explaining the relationship between a particular signifier and a particular signified. Melville, however, took us far deeper into the concept of signification itself. It is this that brings us back to Roland Barthes.

Thus far, Barthes has appeared fairly uncontroversial. He has seen semiotics at work in everyday life, and so have we. Barthes in the original is by no means light reading, but his argument about myths being built up of component signs in order to signify themselves makes sense, just as we understand tunes to be made out of notes and elements out of atoms. We can see how a magazine cover is indeed an assemblage of signs, and yet still goes on to signify for itself. When Barthes says that a journalist or other maker of myths frequently finds a form to fit a pre-existing concept, we understand what he means. A reporter in a famine area, for example, will deliberately seek images that articulate suffering. We probably do a similar sort of thing ourselves: if, on vacation, we are impressed by a town that strikes us as 'quaint' or historic, we will probably seek those photographic opportunities that can be made to communicate that impression;

an impression we have already formed. There may be a thoroughly modern supermarket close at hand, but we won't photograph that because it doesn't fit with what we want to say. Barthes' idea of the impoverished signifier makes sense too. Not only are there lots of different ways to signify (say) sex appeal, but it is also true that the scantily clad model usually loses his or her real-life history and individuality when becoming simply a form for the articulation of something else. The signifier is empty until signification is poured into it, but then the force of the signification ends up eclipsing the signifier him or herself. Advertisers understand the consequences of this. If they choose a model who is already known to the audience, then the potential for signification is more focused, but, at the same time, more limited.

As we read Barthes on mythology, it becomes clear that he thinks that myth-making is a very bad thing. Need we automatically agree with him, though? Fred Inglis makes the point that the unequal imbalance between the form and the concept need not always be a matter of regret. It is true that an unknown model on a magazine cover (the black soldier) or in a jeans advertisement (it could be anyone) is deprived of their individual history in the process of signification. But, as Inglis points out, this can have distinct benefits if constructively applied. An emaciated, crying child with flies around his enormous eyes can, thanks to semiotics, be made to stand for famine as a whole, and not just the individual case of one isolated child.[12] It is in this way that charities and relief organizations are able to garner enormous public support. Similarly, the photographers of the American dust bowl of the 1930s effectively used specific cases to speak of the general condition. Dorothea Lange's famous portrait of a migrant mother (see figure 40, p. 198), for example, seeks to speak not of this particular woman (whose name was not known) but of motherhood in poverty as a whole. It was partially as a result of such photographs that aid began to move into the impoverished West.

Perhaps it is time now to look at Barthes more critically. This is all the more important as we move on to the central, ideological argument of *Mythologies* itself. In a nutshell, Barthes contends that the function of myth is to (mis)represent history as nature. It is an argument that will not be unfamiliar following our study of Berger, but it is worth explaining in some detail to show how Barthes sees semiotics playing this deeply ideological part. Like Berger, Barthes believes that contemporary society is the result of historical rather than natural forces. The status quo, therefore, is neither natural nor inevitable. It could have been different, and still could become so. The feeling that underlines *Mythologies*, then, is one of a burning resentment at the confusion between nature and history in contemporary culture. The majority of *Mythologies* is made up of brief case studies on myths that range from professional wrestling to soap powders, haircuts and a new Citroën car. It is in the prefaces and particularly the final article, 'Myth Today,' however, that Barthes lays his theoretical, methodological and ideological cards on the table. Our society, he claims, is still a bourgeois society with particular regimes of ownership, structure and ideology. By 'ideology' he means a set of ideas about how society is and ought to be, and by 'bourgeois' he means a society dominated by owners as opposed to workers.[13] As culture tends to represent the interests of the dominant class, so myth will

represent the ideological interests of the bourgeois. Myth, however, is subtle. It does not lie; it distorts. It is a story 'at once true and unreal'. It does not deny, justify or explain things. It just states them as fact.[14] It has what we might describe as a 'false innocence'[15] which represents the contentious as inevitable. Myths therefore have a false clarity in which 'things appear to mean something by themselves', when, in fact, they are the results of man-made history and could have turned out (as they still might) very differently. That is why myth has the task of 'giving an historical intention a natural justification, making contingency seem eternal'.[16]

Myth, according to Barthes, achieves the representation of the historical as natural by leaving the historical out. It is a kind of amnesia. Similarly, myth is a kind of speech, but with the politics removed. That is how Barthes is able to define myth as 'depoliticized speech'. The magazine cover of the black soldier saluting the flag presents French imperialism as a fact that does not need explaining, when imperialism is, in reality, a deeply political issue with a huge historical background. It is a text, therefore, with the politics taken out. Imperialism, therefore, is a fact. It 'goes without saying'. This concept of 'what goes without saying' is the most important of all mythologies to the student of visual culture. It inspires us to seek out the underlying cultural assumptions contained within a visual text; assumptions that seem so given, so natural, so inevitable, that they seem to 'go without saying' when in fact they don't. They are 'falsely obvious'.[17]

Although 'Myth Today' contains the important theoretical portion of *Mythologies*, the majority of the book is taken up with short case studies of Barthean mythology in which examples from everyday French life and popular culture are held up to semiological analysis. They were written between 1954 and 1956, but it is surprising how many of them reach well beyond both France and the 1950s. In 'The World of Wrestling', for example, Barthes is able to state: 'Wrestling is not a sport, it is a spectacle.' And although he uses examples of personalities from French wrestling of some fifty years ago, his overall analysis is instantly recognizable to viewers of the grandiloquent events of both British and North American television. Not only is wrestling a spectacle, says Barthes, it is a spectacle of excess. Although some wax indignant that it is 'stage managed', the public is in fact 'completely uninterested in knowing whether the contest is rigged or not'. The purpose is not to win, but to go through the expected motions, complete with exaggerated and excessive gestures. Wrestling for Barthes is a theatrical display of roles played out by 'types', the central one of which is the 'bastard'. Others are great comedians, like characters in a Molière play. All the parts, comic or anti-heroic, are played out with passion, but just as with a play, it does not matter whether the passion is genuine or not. What is played out is a public spectacle of suffering, defeat and justice. The public does not wish for real suffering, of course; it is much more concerned with wrestling's ultimate moral concept: justice. The characters deal out compensatory justice ('an eye for an eye, a tooth for a tooth'). There are dramatic and consequential reversals of fortune which, for Barthes' audience, have a sort of 'moral beauty'. The character of 'the bastard', however, accepts the rules only when they are useful to him, an inconsistency that 'sends the audience besides itself with rage',

but what really upsets them is not the breaking of the 'insipid' rules, but the absence of revenge or punishment. Yet although the wrestler may enrage, he never disappoints. Ultimately, concludes Barthes, wrestling plays out justice in the raw, without the ambiguities of everyday situations.[18]

We have spent some time on Barthes' analysis of wrestling not simply because it is so recognizably relevant today, but also because it is an excellent demonstration of semiotics at work in popular culture. Wrestling is not what it seems; the passion may be false but the concepts for which it stands are very real. Some of Barthes' other insights are less ambitious, but are still rewarding. A yacht trip by European royalty elicits the observation that 'to wear for a fortnight clothes from a cheap chain-store is for them a sign of dressing up' just like Marie-Antoinette and her infamous shepherdess costume. Wine, in another essay, is that which extracts things from their opposites: it makes 'a weak man strong or a silent one talkative'. In other countries, they drink to get drunk, but in France, 'drunkenness is a consequence, never an intention'.[19]

Barthes' case studies are much more readable than his theoretical essays. They contain many a bijou insight, which make us smile. Not all of these *pensées*, however, demonstrate all of the theoretical points made in 'Myth Today'. If we look for any one essay that encapsulates all his thinking on myth, we look in vain. Rather, we have to look to the sum of the parts in order to see his theory in practice. The basics of signification in popular culture, for example, are demonstrated in his analysis of the hairstyles in a film version of *Julius Caesar*. Here, the ubiquitous fringe worn by the male actors is revealed as a rather lazy, visual signifier of 'Roman-ness' as though it were a 'little flag displayed on their foreheads'.[20] His essay on a photographic exhibition called 'The Great Family of Man' is much more ambitious, however. This was an exhibition, he says, designed to show that despite apparent diversity, the great 'family of man' was in fact united by common concepts of birth, death, work, play and so on. Barthes argues, however, that the myth of human 'community' and the human 'condition' was based on the familiar mystification in which history was confused with nature. Birth and death were universal experiences to be sure, 'but if one removes History from them, there is nothing more to be said about them'. It is true that children are always born, but the circumstances of their birth, together with their mortality rates and their futures, are historically formed. That is what Barthes believes the exhibition should be telling people, instead of celebrating 'an eternal lyricism of birth'.[21] Similarly, the exhibition depicted work as a universal fact, placed alongside birth and death as a product of fate. But Barthes maintains that although work is an age-old fact, it is still an historical fact because it treats and affects so many different people so differently – and often unfairly. And as for Emmet Till (the young black killed by whites in the Southern United States at the time of these essays[22]), Barthes thought his parents should be asked what *they* thought of 'The Great Family of Man'. All this false talk of naturalness, he concluded, was an elaborate excuse for things remaining the same. As Barthes claimed in his essay on criticism, nothing should escape being put into question by history. To fail to do so was to acquiesce to the prevailing – and hidden – interests of 'order'.[23]

In his essay 'The Blue Guide', Barthes begins to pull apart the unspoken

cultural assumptions that permeate a myth. The Blue Guide was a well-known guidebook to tourist destinations around the world, but Barthes found it both partial and blinkered. First, he thought it reflected an attitude to foreigners as 'types', as exemplified by the Blue Guide to Spain. He went on to protest that a reading of the same Blue Guide would have one believe that there was only one kind of art: Christian art (and, in Spain, Roman Catholic art at that). It is as if, he observed, 'one only travels to visit churches'. Tied in with this was a language that described such art in terms of 'riches' and 'treasures' which was really a 'reassuring accumulation of goods', often accumulated in museums. The Blue Guide also betrayed a myopic appreciation of Christian history. The Guide (and presumably its readers) failed to realize that Catholicism in Spain had been a 'barbaric' force that had defaced the earlier achievements of Muslim civilization. People needed to know that, historically, there was a 'reverse side to Christianity'.[24]

There was myopia in the Guide's description of the landscape too. The Guide was obsessed with historical monuments at the expense of the realities of the land and its people today. It became an 'agent of blindness'. Indeed, the Blue Guide gave underlying support to Franco. It spoke of Franco's national-ists 'liberating' the country by 'skilful strategic manoeuvres' and 'heroic feats of resistance'. It did not mention Guernica; it did speak of Spain's new prosperity, 'but does not tell us, of course, how this fine prosperity is shared out'.[25]

In 'The Blue Guide', the values that, Barthes notes, 'go without saying' are bourgeois values. The separation of foreigners into 'types' was part of a 'bour-geois mythology of man', and the conflation of art with Christianity was art from a 'bourgeois point of view'. History was removed from the Blue Guide because 'History is not a good bourgeois'.[26] This obsession with 'bourgeois' values is something which runs throughout both the case studies and the theoretical section, and which deserves to be discussed in greater depth.

The 'bourgeois' or 'bourgeoisie' is, we recall, the Marxian term for the social class of owners as opposed to workers. By the time Barthes published *Mythologies* in the late 1950s, the term had expanded to embrace conventional middle-class respectability as a whole, but it was still a middle class that subscribed to material and capitalist values. To left-wing intellectuals such as Barthes, it was a term of contempt, frequently invested with connotations of smug, reactionary unthink-ingness. In the case studies, we can almost hear him spit each time he uses the term, which he does frequently. His contempt is made especially clear in the theoretical section, for he argues that it is bourgeois values that are falsely repre-sented as natural and inevitable by the process of mythology. If something 'goes without saying', it is always an unthinking bourgeois assumption; the product of history as opposed to nature. His aim in *Mythologies* is to expose these assump-tions and to ask us, not unlike Berger, to look again and to reconsider that which we had previously taken for granted.

Sometimes, Barthes appears to be praising something to the point of rapture. In his essay 'The New Citroën', he begins by claiming that cars are 'almost the exact equivalent of the great Gothic cathedrals: I mean the supreme crea-tion of an era, conceived with passion by unknown artists'. The new DS19, indeed, was an 'exultation of glass' and could lead to a 'relish of driving'. On

the exhibition stand, it is viewed with 'an intense, amorous studiousness' before 'visual wonder' gives over to the tactile experience: 'The bodywork, the lines of union are touched, the upholstery palpated, the seats tried, the doors caressed, the cushions fondled.' But just as we feel ready to drive off in one ourselves, Barthes concludes that the object here 'is totally prostituted' and becomes the very essence of 'petit-bourgeois advancement'.[27] Beneath every stone, no matter how seemingly attractive, Barthes finds bourgeois ideology lurking.

For Barthes, mythology is essentially a right-wing phenomenon. It is 'well-fed, expansive, garrulous, it invents itself ceaselessly. It takes hold of everything, all aspects of the law, of morality, of aesthetics, of diplomacy, of household equipment, of Literature, of entertainment.' Revolutionary language, on the other hand, cannot be mythical, because it has nothing to hide. It is overtly political. Myth exists on the softer left, but 'it is a myth suited to a convenience, not a necessity'. There are no left-wing myths concerning human relationships, and they do not touch everyday life. Left-wing myth does not proliferate and 'the speech of the oppressed is real'.[28] Left-wing myth can therefore be clumsy, but, according to Barthes, can never be as virulent as the myth of the right.

From an early twenty-first-century perspective, Barthes' argument on this has not weathered well. Stalin, for example, has become famous for an approach to propaganda that 'purged' people from history, including the photographic record. Examples abound of Stalinist 'before and after' shots from which people have been physically removed following their fall from political favour.[29] Following the communist revolution in China, meanwhile, the personality cult of Chairman Mao Zedong was deliberately fostered. In Cuba, the myth of Che Guevara, today represented as a clear-eyed, good-looking, revolutionary hero, shows no sign of abating. Indeed, his is an image that was adopted by many young people outside Cuba; people who were more often than not unaware of his actual history, some of which is considerably less than glorious. Che has become, in many instances, a consumer icon (figure 24) and fashion statement from which history has been removed. This, it may be argued, is a left-wing myth par excellence.

Barthes' approach, therefore, seems to present us with two significant problems. First, although he speaks boldly of a 'science' of semiotics, his methodology is in fact far from scientific. His approach is selective, subjective and interpretive. It does not appear to be structured; some might well argue that his approach is not even rigorous. His *pensées* contain occasionally brilliant insights rather than sustained analyses. Second, and not unlike John Berger, Barthes sees exactly what he wants to see. The bourgeoisie appear at every turn; their values are to be found at the murky bottom of every myth. We always know in advance exactly what he will find there, but it is the way in which he finds it that holds our attention and provokes our admiration.

Does that mean, then, that we should dispense with Barthes in our investigation of visual culture? Far from it, for although Barthes – just like our other theorists – has flaws, he still has a great deal to offer. First of all, we should remember that his theory of myth is founded on semiotics, a theory that makes a sound and sensible basis for visual analysis. It is a system that gets to the heart of how the communication of meaning is made possible between two or more people. Second, Barthes extended Saussure's linguistic model to visual culture,

24 Making a Mug Out of Che: the shifting semiotic of a revolutionary icon; photo: Richard Howells

so opening up to us the popular and everyday world to semiotic analysis. Third, his theory that myths are made up of component sign systems not only makes a great deal of sense; it also opens up much more complex visual texts for semiotic analysis. Saussure's system is equivalent to showing how notes combine to make up a tune, but in Barthes' hands we are able to get to work on a whole semiotic symphony.

This concept of semiotic layerings is best demonstrated by an example. Inspired by Barthes, we shall use a series of Renault television advertisements as our case study, but it would be even better if you were to think up your own examples as we go along. The case studies are interchangeable, but the theory remains the same and can be applied to pretty well any new campaign as it comes up. The campaigns are usually more interesting than the cars. We think our example is a classic. And with car commercials, we can be comfortably sure that we will not run out of new material.

In the 1990s, the French-based Renault car company wanted to relaunch its restyled Renault 19 in the British market. It had something of an image problem, though: British customers had come to think of the Renault 19 as worthy, but dull. It was not thought to be particularly desirable. Renault's London advertising agency, Publicis, came up with a campaign to try and change that perception, and set about it with a series of four interlinked TV advertisements designed to turn the 19 into an object of desire. In their hands, indeed, the Renault 19 would become the ultimate temptation: a temptation too strong even for a young and handsome Catholic priest (see figure 25). Immediately, we can see a semiotic web under construction here. Roman Catholic priests, it is well known, take

25. Still from Renault 19 car commercial (UK TV, 1994); photo: courtesy of Publicis, London/ Renault/ Rebecca Agency, Paris

vows of celibacy. For them, sex is popularly thought to be the ultimate tempta-
tion. If the car is then made to signify the ultimate in sexual allure, we are left
with a product so desirable that even a priest would be tempted. And he is. In
the first advertisement in the series, we see the car being driven through a south-
ern European town. It is so visibly sexual that people cover their lover's and
their children's eyes as it swishes past. In the second, the progression is from
seeing to touching. The tactile qualities of the car are stressed: curves are stroked
and upholstery caressed. In the third, someone gets to drive it: the gear-shift
is fondled and breathtaking performance results. The seduction is complete.
Underlying this progression is the storyline of the dashing young priest, who
sees the car, buys it (in an assignation with a suitcase full of cash), drives it and
becomes the envy of all his friends at the seminary. In the final instalment, they
all buy one – including the abbot, who gets a convertible.

We have seen so far how a combination of a priest and sex has been used to
make a dull car appear sinfully and irresistibly desirable. The campaign contains
greater complexities, for this is a series that is heavily loaded with deliberate
signifiers, all of which have work to do. For example, the commercials are shot
and set in Italy. To a British audience, this not only signifies continental sophis-
tication, but also reminds potential customers of the sort of place in which they

take – or would like to take – their summer holiday.[30] This is a long way from the daily commute into central Nottingham. The musical background is an orchestral version of an early 1980s hit, *Johnny and Mary*, by Robert Palmer, a jauntier version of which was also used in television advertisements for the compact Renault Clio. By referring to the 1980s hit, the advertisers aimed to appeal to consumers then aged between twenty-five and forty-four; by using the same tune in different campaigns they are able instantly to register this car as one of the Renault 'family';[31] and, by using a 'classical' arrangement, they are able to signify the car's more expensive, 'upmarket' image. The vocal on the Renault 19 commercial was sung by the lead soprano from the English National Opera. The voice-over for all four commercials is cultured, male and refined. The typeface used for the captions is classically understated, and the Renault logo, just like the 'Renault' tune, serves to set up a new product as one of an established and reliable brand. To the target audience of British consumers who buy their own cars (rather than drive 'fleet' vehicles supplied by their employers), the Renault marque also carries connotations of individuality and 'Frenchness' as opposed to company 'standard issue'. In a Western society in which many people still believe 'you are what you drive', this is an important consideration. Finally, there are three significant things we should note about the priest. First, when he decides to buy the Renault 19, he is seen putting on sunglasses. In the semiotics of popular culture, we all know that 'shades' signify 'cool'. Second, the young priest is undeniably good-looking. This is a car, then, for the young and attractive (or people who would like to be). Finally, once 'our' priest has bought and driven the Renault 19, his visibly less good-looking friends all follow suit. If you buy a Renault 19, then, people will want to be like you.

When we consider the semiotic effect of the whole range of signifiers used in this (or any other) campaign, it is often helpful to consider the effect that even slight changes have made. Imagine, for example, that we had taken exactly the same car, but shot the campaign in Nevada or Milton Keynes. Perhaps the central character could have been a middle-aged accountant or a professional athlete. The theme tune could have been something from Meatloaf or Doris Day, played on a distorted lead guitar or a home organ, and the typeface for the caption could have been gothic script or Comic Sans. Advertisers take a great deal of care over all these differences because they are practising and accomplished semioticians.

The one thing we don't see much of in this series is the car itself. This may, at first, seem strange, but if we think about it, it is typical of many car advertisements. Why is this? Semiotics reminds us of the answer. A signifier is an empty vessel until it is filled with meaning in order to signify. The less specific we are about the signifier, therefore, the greater its potential to signify exactly as we wish. If we want people to think again about the Renault 19, therefore, it is far better to start with a clean slate than with something that is already partly invested with value. This is true of advertising for many products. Whatever the advertisers may claim, much of advertising tells us very little about the product itself. One reason for this is that many products are, to all extents and purposes, remarkably similar. What advertisers have to do is differentiate between them in the public mind. One of the world's greatest marketing rivalries, for example,

is that between Coke and Pepsi. Vast amounts of money are spent trying to persuade the public that one brown, fizzy liquid is superior to the other. In the 1990s, Pepsi took the seemingly radical step of changing its packaging from its former red to blue in order to differentiate between the two products. Perhaps the greatest difference between the two, therefore, is actually the colour of the can. Cars, too, are remarkably similar. Although we like to think of cars as hugely individual things, they are in fact distinguished by only slight differences. They all tend to have four wheels on the outside and a steering wheel at the front. They tend to have an engine and an exhaust. Zero to sixty times may differ by a fraction of a second, but all are, pretty much, similarly reliable. Advertisers therefore have the choice between making the most of these slight differences (wow! cup-holders! and an electric sunroof!) or, more typically, selling the car on a combination of its image and its implied benefits as opposed to the actual features of the product itself. Semiotics is ideal for this, because a sign works by connotation as much as it does by denotation. Put more simply, it implies as much (and possibly more) than it states. This is precisely the case with advertising. To prove this point, take a flick through another glossy magazine and pull out the perfume and after-shave advertisements. How many of them tell us what the product smells like or actually state what its specific benefits will be? They work, rather, by a combination of implication and association. As Barthes reminds us, myths do not lie, they simply distort. The implication in a typical scent advertisement is that this product will make the wearer more sexually attractive. Legally, this cannot be stated, but the typical shot of gorgeous people in intimate situations studiously implies otherwise. Even if the 'proposition' is not directly sexual, scent advertisements are usually associated with a glamorous lifestyle. This may be implied by the setting for the photo shoot, the design of the bottle, the colours, the graphics and the wording used. We notice, for example, that the word 'scent' rarely appears in these advertisements. Typically, the product-related words are given in French, which implies sophistication even to a non-francophone audience. 'Perfume' for example, often becomes 'parfum', and 'eau de toilette' sounds considerably better than 'toilet water', even if the product has never been anywhere near continental Europe. What these kinds of advertisement do, therefore, is imbue an essentially generic product with implied and seemingly unique benefits that become available to the purchaser by association. If you buy this, it is implied, your life will be like this. What many advertisements really do, then, is sell lifestyles, which they imply are available by association with the product they happen to have for sale.

This is a concept that is not limited to luxury goods. Major fast-food outlets sell similar products at similar prices in similar surroundings. It is understandable, therefore, that in the 1980s the McDonald's chain took the policy decision no longer to focus on food in its advertising, but to stress the experience of eating at a McDonald's outlet. These were portrayed as happy, hand-clapping places where families and all sorts of well-adjusted people from all manner of different backgrounds could come together and enjoy a thoroughly good time. As James Helmer explained: 'McDonald's moved its primary marketing emphasis off the food it sells and turned instead to marketing love, a sense of community and good feelings.'[32] In this way, McDonald's could be made to signify happiness

– a concept we can still see today, supported by the 'Happy Meal'. It was a strategy, argues Helmer, which helped McDonald's win the 'burger wars' with its remarkably similar rivals.

This can all be remarkably useful to analysts of visual culture. Because advertisements so often work by associating a random product with a desirable lifestyle, we can use our analysis of the advertisement to tell us not about the product, but about the things to which so many of us aspire. Barthes understood this when he wrote that soap powder commercials were something to which 'the various types of psycho-analysis would do well to pay some attention if they wish to keep up to date'.[33] They may not tell us much about laundry, but they do reveal a great deal about our dreams. These dreams may be for sex, power, friendship, status or popularity: things we want even more than burgers, cars or soap, and things that tell us a great deal about ourselves.

It is Barthes' notion of 'what goes without saying', however, that is perhaps *Mythologies'* most useful contribution to the analysis of visual culture. It teaches us to peer behind the scenes of our own society and to question anew things that we had previously taken for granted. By separating the natural from the historical, we interrogate our own fundamental assumptions as if we were looking in the mirror with fresh eyes. We do not always need to see what Barthes sees, however. What we need to take from him is his method, but not necessarily his conclusions. What we find for ourselves is entirely up to us.

We are still left, though, with the problem of Barthes' specific methodology. Panofsky made it easy for us, with a simple three-part analytical technique, clearly explained. Barthes is much less formulaic. It is still possible, however, to suggest a methodology for the visual analysis of advertising based on Barthes but which also takes into account some of the conclusions we have gathered during our investigation into the semiotics of popular culture in this chapter. We recommend a three-stage approach which progresses from the overt to the covert and finally to the underlying meaning of an advertisement. Let us do this with an example: a (made-up) TV commercial for microwave pizza. The scene is a suburban dining room in which a handsome father and two good-looking children are seated at an informal but well-presented table. There is good-natured expectation in the air, which is affably rewarded as an attractive mother appears in the doorway with a tray full of hot and appetizing microwave pizza. The family dig in: this pizza is clearly delicious. The kids smile at each other, father smiles at mother, and mother smiles at us, knowingly. She has made a wise consumer decision, and she is rewarded with domestic bliss. The commercial closes with a close-up of the box and the slogan: 'Potterton's Pizza Puts the Mmmm in the Microwave'. At the first level, the commercial openly tells us something about the product: it's made by Potterton's, you cook it in the microwave, here's what the packaging looks like and it tastes good, too. But at the second level, we discover that what this commercial is really selling is a happy family life, and it suggests, covertly, that the way to obtain it is by buying this particular brand of pizza. It does this by the association of the two. Who would not want the lifestyle that Potterton's Pizza implies? The family are all healthy and attractive, and they eat together as a wholesome domestic unit. The children are not fighting or wandering the streets, and father is neither philandering nor spending

his nights in bars. What's more, they all appreciate mother for her loving care in feeding them so wisely and deliciously. The signifier that is Potterton's Pizza has now been made to signify the family idyll. But what, at the third level, 'goes without saying' here? Does it go without saying that all happy families comprise a mother, a father and two children? Does it go without saying that happiness and material comfort are inseparable? And does it go without saying that in the ideal family, it is the mother who should buy, cook, serve and (presumably) clear away the family meal? What about dad? This is not the place to try and reach any conclusions over nature versus history in gender roles in twenty-first-century culture. All this seeks to accomplish is to call into question that which contemporary visual culture seems to present as natural. It reminds us, further, that even the most seemingly trivial visual text may have a deep yet unintended ideological content that structured and intelligent analysis will help to expose.

Key Debate

Can images be more real than reality?

The different semiotic approaches described in this chapter, from the original linguistic model created by Saussure to the Barthesian extension of the basic framework to the wider realms of the visual and of popular culture, are built upon a fundamental shared concept: the sign. The sign, of course, constitutes the operative unit of language, and is defined by the (arbitrary) relation between the signifier and the signified. This initial semiotic view of language went on to open up more complex possibilities, including the identification of different levels or 'orders' of signification, and the concept of myth. But, in spite of all this elaboration, the centrality of the signifier–signified relation for the description of the sign and of its function in representation and the meaning construction processes were not questioned. That fundamental acceptance explains why the new approach presented in the 1980s by Jean Baudrillard (1929–2007) had such a disturbing effect. In his view, the signifier–signified relation upon which semiotics was ultimately built has been broken and has ceased to provide an adequate basis for defining the working of the contemporary sign. This is clearly something that this further debate on semiotics needs to take very seriously.

Baudrillard's perception touches the very heart of the representation model – the idea that signs clearly stand for something recognizable in the 'real' world. In fact, he claims that it does not make sense to talk about representation at all when we analyse the contemporary sign. That, he argues, is because the signifier–signified relation fundamental to that concept is now lost, having given way to sequences of simulation models which bear no relation to 'reality' and which combine exclusively among themselves in a dizzying 'orbital recurrence' where referentiality, objectivity and, ultimately, truth, have become meaningless notions. In their place, Baudrillard speaks of simulacra, simulation, and above all the 'hyperreal' – which takes representation beyond reality. It is, indeed, more 'real' than reality itself.

The disturbing idea that representation has been substituted by simulation

can perhaps be better grasped using an allegory created by the Argentinean writer Jorge Luis Borges and used by Baudrillard in *Simulacra and Simulations*, one of his most influential texts.[34] Borges tells the story of a map which is so obsessively accurate that it covers the exact territory of an empire, containing its every conceivable detail. Indeed, it is so obsessively accurate that the scale of the map and the empire are identical: they match each other point for point. The map turns out, of course, to be useless. It begins to fray before eventually falling into ruin, good only for crude shelter for animals and beggars in the empire's western deserts. No other remnant of the empire's former obsession with geography remains. In Borges' allegory, the final fusion of the signifier (the map, the double) and the signified (the territory, the origin, the substance) is complete when 'the aging double is confused with the real thing'.[35]

To explain how he perceives the present situation, Baudrillard inverts the tale. In his view, the kind of simulation that characterizes our society is one in which, contrary to Borges' tale, 'the territory does not precede the map, nor does it survive it'. On the contrary, it is just the other way around: it is the map that engenders the territory 'whose shreds are slowly rotting across the map'. In Borges' story, the signifier is engulfed by the signified; in Baudrillard's perspective, the signifier engulfs the signified, creating '*the desert of the real itself*' (the emphasis is Baudrillard's).[36]

It is not surprising that Baudrillard's approach is often considered exaggerated or, at least, uncompromising. What he is proclaiming, after all, is the death of the real – or at least the death of reality as we used to conceive it – and its substitution by 'hyperreality'. Despite the admittedly hyperbolic flavour of the claim, it remains a prescient idea for our study of visual culture, since the simulations that have allegedly taken the place of representations are often operated through images. In the age of simulation and hyperreality, images are everywhere. And although they can no longer be regarded as simple representational devices and sites of plain meaning, they retain and even improve their fascination 'because they are sites of the disappearance of meaning and representation, sites in which we are caught quite apart from any judgement of reality'.[37] When Baudrillard first presented his thesis on simulation and hyperreality, the digital technologies that have recently – and vividly – brought the universe of 'virtual reality' into the core of our daily lives were not yet available. But that circumstance did not prevent him from finding examples of images that had become 'more real than reality'.

One of Baudrillard's most useful examples is provided by Disneyland. From a Barthesian perspective, Disneyland can be interpreted as an ideological construction, an idealized vision of American society. In Baudrillard's view, however, it is much more than that. Disneyland, he claims, is not just a false (ideological) representation of reality; its aim is to save the reality principle. What Baudrillard means is that the imaginary character of Disneyland, which is neither true nor false, convinces us that 'the rest is real'. In other words, it simulates the reality of the surrounding city of Los Angeles and country of America, concealing the fact that Los Angeles and America – or anything else, for that matter – are no longer real.

The obliteration of the criteria that make it possible to distinguish between

visual appearances and reality is further underlined by Baudrillard in a notorious series of articles published in the British and French press (*Guardian* and *Libération*).[38] Here, Baudrillard argued that the (first) Gulf War did not actually take place. Rather than the substantive event, it was a hyperreal simulation created through sophisticated technologies of information mastered by the American political, military and media apparatuses. The article might sound like part of a science fiction plot, but the argument behind it – the idea that appearances and substances are increasingly difficult to be clearly told apart – cannot be lightly discarded. Indeed, the overwhelming development of information technologies and the way they are avidly appropriated into the daily experience of a significant part of the human population has made the claim more tangible. The online construction of personal identities constituted by images which, despite the absence of referents outside the language where they are generated, are perceived as 'real' has become commonplace to the point of banality. Today, we casually interact within simulated environments without asking ourselves about the 'truth' of such environments and our interactions.

The controversial views presented by Baudrillard are based upon an equally radical version of postmodernity. Here it is contended (to put it very briefly) that the production of things has become secondary to the production of desire. Baudrillard can sound excessive, especially when his emphatic views on the impact of postmodern style and culture upon our lives are not considered alongside the forces that resist them. This may be especially so when he proclaims that the real is dead, and that referentiality has become an anachronism. But his perspectives still offer a provocative insight into the nature of the images which, with growing intensity and increasingly complex functions, fill up our daily lives.

We will close this debate with not one but two related ironies. The first involves Borges' fable of the map, with which we began this section. This is taken from a very short piece, titled 'On Exactitude in Science'. Although nowadays attributed to Borges, it was originally published under the pseudonym Suarez Miranda, purporting to be from 1658. Neither the name nor the date was true.

Second, Baudrillard's famous *Simulacra and Simulation* begins with a quotation from the Old Testament book of Ecclesiastes:

> The simulacrum is never what hides the truth – it is truth that hides the fact that there is none.
> The simulacrum is true.[39]

There is, in fact, no such quotation in the book of Ecclesiastes. Baudrillard, it seems, made it up.

Further Study

Semiotics has come a long way since de Saussure's *Course in General Linguistics*. His original lectures of 1907 are available today, reconstructed from the notes

of Albert Riedlinger. They are published, annotated and translated in *Cours de Linguistique Générale*, and are certainly of scholarly interest.[40] Semiotics were also investigated by the American philosopher, mathematician and all-round scholar, Charles S. Peirce. A contemporary of de Saussure, Peirce was interested in the difference between arbitrary and non-arbitrary signs. *Peirce on Signs*, a collection of Peirce's writings on semiotics, has been edited by James Hoopes. Peirce's *Semiotic and Significs* is a collection of his correspondence on this topic with Lady Victoria Welby, while a more general account can be found in Douglas Greenlee's *Peirce's Concept of Sign*.[41] Peirce understood that all things could be communicated semiotically, and it is here that Barthes' significant contribution to the understanding of visual culture is located. Such is its importance that it has taken up the major part of this chapter. His *Elements of Semiology/Writing Degree Zero* takes a more literary approach, but the scope of *Image, Music, Text* is considerably wider. Further important semiotic studies by Barthes include *The Semiotic Challenge* and *S/Z*.[42] Barthes did not have the last or the only word on semiotics, however. Umberto Eco, writing some twenty years later, delved deep into the theoretical structure of meaning in *A Theory of Semiotics*.[43] He likens semiotics to a structural system of particle physics, but at the same time stresses that meaning is both cultural and historical. In this way, meaning can change with time. We can see this for ourselves: words that were once in common use, for example, might now be considered offensive because their connotations have changed – even if the word itself has remained exactly the same. You can think of your own examples.

Saussure, Peirce and Eco do not make for easy reading; semiotic theory can be daunting for beginner and expert alike. Judith Williamson, on the other hand, provides a much more approachable avenue for further study in her *Decoding Advertisements*, in which she uses semiotics to help discover ideology and meaning in this ubiquitous area of popular visual culture. Her approach owes much to Barthes, but her focus is more specific and the language is clear – which makes a welcome change from some semiotic theory. Those who enjoy Williamson's work might also be interested in her later publication *Consuming Passions*.[44]

Semiotics has also made inroads into film theory. As can be imagined, there has been much debate about whether the image on film is a signifier, a signified or even a whole sign. How much does it denote something specific and how much does it also connote something much more general or subtle? Prominent among film semioticians has been Christian Metz, who, in *Film Language: A Semiotics of the Cinema*, explored film's ability to tell stories using non-verbal means. The language of cinema, he concluded, was simple in practice yet hugely complex in theory.[45] Peter Wollen, meanwhile, drew specifically on Peirce in his influential *Signs and Meaning in the Cinema*. Originally published in 1969, this has been revised and republished on numerous occasions since.[46] Film's relationship with reality, together with its unusual capacity with both time and space, will be considered in the ninth chapter of this book.

Jean Baudrillard, whose ideas provided the material for this chapter's Key Debate, was a prolific writer. Apart from articles and short essays, you can choose from among more than forty books by the thinker who introduced the

concept of hyperreality. The works about Baudrillard are equally abundant and can provide a useful entrance to his complex and often disturbing thought. We suggest two completely different books of this kind: *The Baudrillard Dictionary*, where one can easily and quickly find synthetic explanations for key words and concepts,[47] and the less orthodox *Introducing Baudrillard: A Graphic Guide*, that presents the life and work of the French semiotician through a series of intriguing cartoons.[48]

6

HERMENEUTICS

This chapter begins with an attempt to define exactly what we mean by 'culture'. Once we have tried to define it, we move on to the still more difficult question of how to interpret it. The methodology advanced here is that of hermeneutics: an interpretative approach that acknowledges the potential differences between literal and intended meaning. We explain this with the help of suitable examples, together with the work of the American anthropologist Clifford Geertz. In addition to examining his wider theory, we pay specific attention to Geertz's famous study of cockfighting in Bali. This leads us to an appreciation of culture as a compilation of symbolic texts, and invites us to question the connections between culture and identity. We follow Geertz's argument while at the same time listening to a spirited denouncement of his method. We consider both the strengths and the admitted limitations of hermeneutics. The chapter concludes by arguing that we should be prepared to analyse our own culture with the same insight that we use to interpret the cultures of others.

It is time now to try and reach some conclusions about the interpretation of our visual culture. This will take us all the way from a discussion about nods and winks to an investigation of cockfighting in Bali. First, however, we should decide what exactly it is we mean by 'culture'.

Culture is a word whose meaning has changed over the years.[1] If we go back to the sixteenth through to the eighteenth century, we see that the concept of culture was closely connected with the idea of the cultivation of the mind. Culture was progressive: it grew. In this way, the mind could be cultivated to higher and grander things, and to more sublime levels of appreciation. This

'classical' conception of culture understood that education and culture went hand in hand. One had to be educated to be cultured, and one needed knowledge to understand it and to benefit from it.

The nineteenth century saw the emergence of the discipline of anthropology: the study of humankind. Anthropologists began to write about 'primitive culture' in which culture was a whole, complex system of customs and beliefs – the way of life, in other words, of an entire people. So, while one had to be educated to be part of the classical conception of culture, one had only to be a member of society to be part of the second. It is a concept of culture, also, that embraces the popular as well as the elite, for even the humblest tribal artefact could be seen as evidence of tribal culture.

This 'descriptive' conception of culture is clearly much broader than the classical, and its influence spread. It was useful, too, in that it could be applied not only to 'primitive' but also to 'developed' societies such as our own. T. S. Eliot embraced this wider notion when he wrote in 1948:

> [H]ow much here is embraced by the term culture. It includes all the characteristic activities of a people: Derby Day, Henley Regatta, Cowes, the twelfth of August, a cup final, the dog races, the pin table. The dart board, Wensleydale cheese, broiled cabbage cut into sections, beetroot in vinegar, nineteenth century Gothic churches and the music of Elgar. The reader can make his own list.[2]

This is all very heartening for us, as we have essentially been making our own list as this book has progressed. Our list has included all manner of things, from the paintings of John Constable to CD covers, car advertisements and *Sabrina, the Teenage Witch*. Eliot observed: 'To understand the culture is to understand the people',[3] and so we begin to discern one of the major benefits of the analysis of visual culture: it helps us to understand ourselves. To approach that degree of understanding, however, we need to go further than simply agreeing that 'everything is culture'. We need to ask more probing questions, such as: Why do we make the cultural texts we do? What do they mean? How do they mean? How do they communicate? And how do we read them for ourselves?

Our intellectual guide for this investigation is the American anthropologist Clifford Geertz (1926–2006). According to Fred Inglis, Geertz was 'the foremost anthropologist of our day'.[4] It may seem a little odd (initially) to enrol an anthropologist as one of the key thinkers in a book about visual culture. It may seem especially odd to focus on a cockfight in Bali in a book that began with a case study on English landscape painting. There is method in this apparent madness, however. Geertz was, like us, concerned with culture, and the way in which our cultural values and concerns are articulated in symbolic texts. His examples may be both unfamiliar and from distant parts of the world, but Geertz argued that despite our superficial differences, different peoples have similar needs in creating 'culture'. By looking at others, we may be able better to reflect upon ourselves. In addition, Geertz is useful to us as a guide because of the way in which he combined both theory and practice in his work. Finally, he writes with great style and exemplary clarity, while persuading us of the benefits of a multidisciplinary approach to the analysis of visual culture.

Clifford Geertz was born in San Francisco; he gained his PhD at Harvard and his reputation at Princeton. As an anthropologist, he conducted fieldwork in such seemingly exotic places as Java, Bali and Morocco, yet his approach sits comfortably within this book in the company of art theorists, sociologists and semioticians. He died at the age of eighty while still associated with the Institute of Advanced Study at Princeton.

Geertz wanted to know what culture means and how it can be interpreted. Indeed, it is the concept of interpretation that is key to his methodology. In the opening essay to his *The Interpretation of Cultures*, Geertz set out his theory of 'thin' and 'thick' description. He used the everyday example of a wink. If we describe a wink as simply the rapid closing and opening of the lid of one eye, then we are indulging only in 'thin' description. It describes what physically happens, but does not attempt to explain what a wink may *mean*. 'Thick' description, on the other hand, understands that a wink might (among other things) be a sign of attraction or conspiracy.[5] This is something that we both know from experience and, thanks to Barthes and Saussure, are also able now to recognize as an approach that – essentially – seeks to separate the signifiers from the signifieds. That is why Geertz himself was able to state that he has 'a semiotic concept of culture and an interpretive approach to the study of it'.[6] It is the project of interpretation to separate the twitches from the winks.

Culture, according to Geertz, is 'an assemblage of texts'. The component texts are symbolic forms, so it is important not to read them literally, just like the difference between twitches and winks. They are texts that say something of something. For example, Geertz put a great deal of work into the analysis of ritual sheep-stealing in Morocco. Everyone knew what physically went on (it had been going on for years), but Geertz wanted to understand what it meant; what it was that was being acted out. He was later to describe his whole approach to the interpretation of culture as 'figuring out what the rigmarole with the sheep is all about'. Cultural texts, therefore, should never be taken at face value, because we need to 'ferret out the unapparent import of things'. Doing so is like penetrating a literary text: penetrating beneath the cosmetic, formal surface in order to discover 'what it is (that is) getting said'.[7]

This is all very good so far, but how do we actually do this? Geertz was the first to admit that his methodology was not scientific. This did not concern him, however, as scientific approaches can only (thinly) describe the wink as a physical event. Cultural meaning, he argued, could not be discovered experimentally, scientifically or numerically, as is often attempted in the 'harder' social sciences. To Geertz this made no sense at all: it was not worth going round the world to count the cats in Zanzibar.[8] Culture did not conform to unified patterns; nor could it be reduced to a formula. That is why the analysis of culture could not be 'an experimental science in search of law, but an interpretive one in search of meaning'. The search for meaning, of course, was an arduous one, and not one in which undisputed conclusions could be guaranteed. A lot of this was, inevitably, guesswork: 'guessing at meanings, assessing the guesses, and drawing explanatory conclusions from the better guesses'.[9]

The interpretive methodology is not unique to Geertz, especially when applied to other fields. To scholars of biblical and other sacred texts, the theory of

interpretation has long been known as hermeneutics. The term comes from the Greek *hermeneuein*, which means to make something clear, to announce or unveil a message. *Hermeneus* is an interpreter. Hermeneutic scholarship proceeds under the assumption that sacred texts should not be taken at face value. It seeks to elucidate what scholars believe to be real but hidden meanings. They perceive these texts as conduits, in other words, for spiritual rather than historical truth. What is stated in a biblical text is rarely disputed. What it *means*, on the other hand, is usually the real issue of contention. Christians, for example, will recognize the famous 'sermon on the mount' in which Christ (according to the gospel of Saint Matthew) gives a long list of aphorisms by which to live, including: 'If thy right hand offend thee, cut it off.'[10] We know what it says, but what does it mean? Similarly, at the Last Supper, before Christ's arrest and execution, Matthew describes Christ blessing and offering bread to his disciples, and saying: 'Take, eat; this is my body.' He then gives them wine and says: 'Drink ye all of it; For this is my blood.'[11] Again, we know exactly what it says, but arguments over precisely what it means have led to people being burned to death.

Hermeneutics is not limited to religious study, and – not unlike semiotics – is often practised by people who are not even aware of the term. For example, in 1995 the Manchester United and French international soccer star Eric Cantona successfully appealed against a jail sentence for assaulting a spectator during a game in England. Afterwards, he enigmatically informed the world's media: 'When seagulls follow the trawler, it is because they think that sardines will be thrown into the sea.' No one disputed what he said (it was recorded verbatim at the time), but what on earth did he mean? Was it an unflattering reference to the media? Or did it mean that Cantona was not an unsophisticated athlete but a sage and a philosopher whom we were too simple to understand? Or did it mean . . . ? The media speculated for weeks. The term 'hermeneutics' is not a word that appeared in the British tabloids, but that is exactly what they were doing. Remarkably, Cantona and his hermeneutic seagulls remained a much-loved part of British popular culture. So much so, indeed, that in 2010, the Sky Sports television channel used the long-retired Cantona to front a series of TV commercials in which – thanks to digital imaging technology – he magically appeared to walk though a variety of classic TV sporting moments (figure 26). The theme was 'Anything can happen in sport'. In the final vignette, our hero is watching from the green at a golf competition, only to see his favourite seabird take the ball in its beak and fly away. He turns to camera in Gallic resignation with just one word: 'Seagulls'.

Whether we are sports fans, tabloid journalists or biblical scholars, hermeneutics is riddled with ambiguity. This is how a text is able to mean several things at once – and why computers can't understand jokes. There is no such thing as a hermeneutical computer. The ambiguity also underlines how a hermeneutic interpretation is necessarily partial and provisional. As the social theorist Anthony Giddens has said: 'Imperfect understanding is central to hermeneutics.'[12]

Imperfect or not, Geertz still believed that the interpretive approach was the best way to try and figure out the meaning of a cultural text – even if that text was a cockfight in Bali (see figure 27). 'Deep Play: Notes on the Balinese Cockfight'

26. Eric Cantona revisits seagull analogy in a television advertisement for Sky Sports; photo: courtesy of BrothersandSisters, London

27. A cockfight in Bali. Photo: Howard S. Axelrod

is one of Geertz's most famous essays. It is famous not so much because of what it reveals about cockfighting in Bali, but as an articulate and thought-provoking case study that vividly demonstrates the interpretive approach in action. It is also fun.

Geertz explains how he and his wife arrived to conduct anthropological fieldwork in Bali in 1958. They discovered that a cockfight was to be held in the village square to raise money for a new school. The village square seemed a curious venue, as cockfights were actually illegal in Bali. Sure enough, the police raided the event during the third match. Everyone ran and hid – including the Geertz couple. Initially, their reception by the villagers had

been one of studied indifference. Now, they were part of the community, and privileged access to further cockfights was their reward. Geertz argues that cockfighting is as much a part of leisure activity in Bali as baseball, golf or poker in America. Indeed, 'the deep psychological identification of Balinese men with their cocks is unmistakable'.[13] His double entendre is deliberate: he maintains that the metaphor works just as well in Balinese as it does in English. Geertz describes the attention that is lavished upon these fighting birds, and the importance that is invested in their performance. The fight itself is then described in detail, complete with steel spurs and the bloody death of the loser, which the winning owner takes home to eat with 'moral satisfaction'.[14] Geertz's account of the fight itself is both gripping and grimly enthralling, but he goes on to show that it is in fact gambling around which all other aspects of cock-fighting pivot.

The gambling is both serious and complex, and Geertz describes the process in full. He concludes, however, that what is at stake is not money so much as pride; not the prospect of financial gain, but, rather, one's reputation within the village. The Balinese cockfight is a dramatization of status concerns. Geertz stresses, however, that it is only a dramatization because nobody's social status is actually changed by the outcome of the fight. It is like an 'art form' because although it changes nothing in itself, it nevertheless 'renders ordinary, everyday experience comprehensible by presenting it in terms of acts and objects which have had their practical consequences removed'.[15] As W. H. Auden said, 'poetry makes nothing happen',[16] and Geertz draws the parallel with the cockfight. The cockfight is 'an image, fiction, a model, a metaphor . . . a means of expression'. What it does for the Balinese is what *King Lear* or *Crime and Punishment* do for us: it catches up important themes, issues and concerns in our lives and orders them into 'an encompassing structure' which presents 'a particular view of their essential nature'. Barthes concludes: 'Its function, if you want to call it that, is interpretive: it is a Balinese reading of Balinese experience, a story they tell themselves about themselves.'[17]

It is crucial that we are able to build upon Geertz to make a bold intellectual leap here. If the Balinese cockfight is their version of *King Lear* or *Crime and Punishment*, might not our own canonical works of drama and literature equally be our versions of their cockfight? Put another way, is it not possible to view our cultural texts as performing the same functions as the cultural texts of people who, by reasons of distance and development, we may previously have referred to as 'primitive'? If this is so, the real value of Geertz's analysis of the Balinese cockfight might be to invite us to look afresh at our own visual culture and inter-pret these as stories we tell ourselves about ourselves.

Despite his reputation, Geertz and his avowedly interpretive approach are not without their critics. Vincent Crapanzano, for example, has rounded upon Geertz and especially his essay on the Balinese cockfight, which he finds practically subversive. According to Crapanzano, the ethnographer is akin to Hermes, the messenger of classical mythology. The ethnographer carries and interprets messages. He 'clarifies the opaque, renders the foreign familiar, and gives meaning to the message. He interprets.'[18] But, continues Crapanzano, Hermes was also a trickster who promised Zeus that he would not lie, but did

not promise that he would tell the whole truth. The ethnographer, like Hermes, has to make his message convincing, and this can lead to rhetorical trickery and cunning along the way, for he needs to 'convince his readers of *the* truth of his message'. Crapanzano then embarks on a detailed and almost surgical dissection of Geertz's essay, from which two major criticisms emerge. First, he contends that Geertz uses 'stylistic virtuosity' to make his interpretation more convincing than it ought to be. Second, he castigates Geertz (and others of his ilk) for placing himself at the top of the 'hierarchy of understanding' – above even the Balinese themselves. It is this attitude that sees Geertz attributing his own meanings to Balinese culture, and consequently assuming that he under-stands their culture better than they do themselves. Crapanzano counters: 'Cockfights are surely cockfights to the Balinese – and not images, fictions, models and metaphors.' It is Geertz who makes all the grand interpretations, but, demands Crapanzano, 'Who told Geertz?' To Crapanzano, Geertz is an outsider who arrives from his university, imposes meaning on someone else's culture, and then returns to Princeton. Complains Crapanzano: 'there is no understanding of the native from the native's point of view' and we end up with a subjective construction of the native and his world.[19]

What we have here is not so much a disagreement about Geertz's conclu-sions, but about his methodology. It demonstrates that in the interpretation of cultures, the techniques we use can be controversial. We can imagine the disputes that would take place if we were to leave Panofsky and Fry, Gombrich and Berger and Geertz and Crapanzano together in a restaurant. Others might even join in. Fred Inglis (the author of Geertz's intellectual biography) describes Crapanzano's attack as full of 'personal animus'. Crapanzano, he says, takes the famous cockfight essay and seems to want to 'tear it up and cover it with spleen'. Inglis concludes: 'The clear purpose is to belittle Geertz' and yet the 'vividness and authenticity' of Geertz's original essay still speaks for itself.[20] Such disputes are clearly passionate. This is not, we suggest, simply a matter of academic infighting. Rather, it is the inevitable result of the clash of radically different ways of looking at our visual world. The way we look, after all, can often deter-mine what it is that we see.

It is true that Geertz wrote with style, but it does seem very odd to chas-tise him for it. Academia, it seems to us, needs more and not less of writing such as this. Crapanzano's second criticism, however, does need to be taken more seriously, for it revolves around the controversial 'claim to know better'. According to Crapanzano (and he is by no means alone here), the critic or analyst should not claim to know better about people than the people them-selves. There are many who would agree that such an attitude is patronizing, condescending and paternalistic. This is a danger indeed, but sometimes it is not only valid but also important to claim to know better. If Geertz did not claim to know better, why would we bother reading him at all? It is just as if we were consulting a medical specialist who felt that it was patronizing, conde-scending or paternalistic to tell us what was wrong with us and how we ought to set it right. The patient doesn't usually know. The specialist is supposed to. As Graham McCann has said: 'Critics claim to know better. That is what they do.' He argues that academics lead relatively privileged lives 'and for them to

say that they hold as partial a view as the next person is, at best, tactless, and, at worst, hypocritical'.[21]

This is not to say, of course, that the hermeneuticist is always right. He or she needs both the confidence to pronounce and yet the humility to accept the possibility of error. This may come as something of a shock for people – and possibly even readers of this book – who had hoped to find some cast-iron, guaranteed theory or methodology which would reveal, fully and infallibly, the complete meaning of a visual text. The political theorist John Dunn understood this. Hermeneutics, he argued, was 'an admirable name for the good intention of trying to understand one another'. However, there were 'no cheap ways' to deep knowledge, and no guarantees of success.[22] Part of the difficulty in the discernment of meaning in visual culture is that the texts do not give up their meanings easily. This makes sense: if the relationship between meaning and text were such a simple one, there would be no need to draw, paint, photograph, advertise or make films or TV programmes. To an extent, visual culture, from Cézanne to cockfighting, helps us to articulate the inarticulable. If we could have just stood up and said it, we would not have needed to encode it in visual form.

Writing some two hundred years ago, Jane Austen wrote in her novel *Emma*: 'Seldom, very seldom, does complete truth belong to any human disclosure; seldom can it happen that something is not a little disguised, or a little mistaken.'[23] This is something that is understood not only by artists but also by the better analysts. Literary theorists Susan Suleiman and Inge Crossman admit that we need to be more humble about what we can ever know.[24] Even Roger Fry, who was rarely short of a well-expressed opinion, was prepared to admit: 'I have never believed that I knew what was the ultimate nature of art.'[25] It is important to stress, however, that neither our intellectual humility nor the complexity of the task should be an excuse for resignation. Dunn admitted that 'success is not guaranteed', but urged that lack of guarantee should not persuade us from trying. The fact that we cannot guarantee to discover the whole truth about something does not mean that there is no truth at all to be discovered.[26] As Geertz says, we still need 'to penetrate this tangle of hermeneutical involvements'. We cannot guarantee complete success, but until someone actually does solve the Riddle of the Sphinx, he declares, 'that will have to do'.[27]

Geertz's approach is rather like that of a literary critic getting to grips with a literary text. This makes sense because culture is 'an assemblage of texts' itself. What we have to do is give them a close reading.[28] This comparison of literary criticism with ethnography is valid because 'they are the same activity differently pursued'. To a traditionalist, different academic fields need to be pursued differently, but Geertz advocates a multi and interdisciplinary approach to understanding in which 'supposed universes of learning' should not be kept distinct.[29]

Geertz's approach leads him to speak of the 'intellectual armoury' and this is a hugely important concept for us.[30] So far in this book, we have examined iconographic, formal, art-historical, sociological, semiotic and now hermeneutic approaches to the discovery of meaning in visual culture. We have discovered huge differences between them: iconography looks at content, while formalism

privileges the 'elements of design'. Art history seeks order, while sociology seeks to pick this order apart. Semiology – in its structural excesses – sees the discovery of meaning as a 'science', while hermeneutics stresses the interpretive and provisional nature of what we may find. We noticed, as we made our way through the different approaches, theories and conclusions, that each had its own strengths and weaknesses. We also began to notice that some were more appropriate to the examination of certain texts than others. Iconology, for example, was ideal for the analysis of a work by Dürer, but not for one by Rothko. In some cases, the differences seemed so extreme (Berger versus the art historians!) that we almost feared violence should the protagonists meet. In this context, Geertz's idea of the 'intellectual armoury' is surely a very good one. Not all texts communicate meaning in the same way, and no one methodology appears to have the monopoly on revelation in all cases. That is why we need to use the armoury which is a collection of all manner of different 'weapons' with which to attack the issue of meaning. We should not be limited to one, but feel free to choose whichever seems best for the particular job in hand. Our successful choice of weapon is dependent upon our knowledge of the usefulness (or otherwise) of each. That is what Geertz means by the intellectual armoury which should, by now, be well stocked.

If you have been reading interrogatively, however, you may well already have suspected that the 'distinct methodological universes' we have so far explored actually have more things in common than we originally suspected. We laughed at the prospect of leaving the protagonists together in a restaurant, but once the food has stopped flying and the wine has led to companionship, we may find that our adversaries begin to discover a little common ground.

Erwin Panofsky, we remember, said that content and meaning in a visual text were one and the same thing. We would expect him and the formalist Fry to disagree on everything. But if we think carefully about what Panofsky had to say about the first level of iconographic analysis, we will remember that the primary or natural level was understood 'by identifying pure forms' such as configurations of line and colour. It also worked at an 'expressional' level, in which we could identify the character of a pose or gesture. This expressional meaning is apprehended by 'empathy'. To understand this (such as a man raising his hat), he says: 'I need a certain sensitivity.'[31] Now we know that this is only a small part of Panofsky's thinking, and that he is really much more concerned with content, symbols and the cracking of codes. However, we have to admit that in this one small area, there is some common ground with Roger Fry, who – we recall – championed Post-Impressionist painting as 'the direct expression of feeling' and argued that to understand a Matisse 'required only a certain sensibility'. We remember, also, that Fry finally came to the conclusion that painting had a 'double nature' and that content really did have a part to play after all.[32] Fry did not present us with a theory of content; for that we have to look to Panofsky. Let us be clear: Panofsky and Fry are still not one and the same, but there is sufficient agreement between them that we would be unwise to reject either one of them altogether.

Let us remind ourselves now of Panofsky's second layer of iconographical meaning. This 'conventional' stratum consisted of symbolic or 'coded' meanings

that communicated by convention. We have to be a part of the appropriate culture to recognize them. An ancient Greek or an Australian bushman, he argued, would not recognize or, therefore, be able to interpret the signs. Now, Panofsky would never have described himself as a structuralist or even a semiotician. We cannot fail to notice, however, similarities between the iconography of Panofsky, the linguistic structuralism of Ferdinand de Saussure and the radical semiotics of Roland Barthes. Saussure's linguistic semiotics, we remember, revolved around the concept that signifiers were only able to signify by convention. The sign was arbitrary. Therefore, one had to be a part of the appropriate culture to recognize and understand it. Iconography, of course, concerns itself with a far more focused and deliberate way of coding, but the similarities with semiotics are clear. The connection continues at Panofsky's third level. Here, the iconologist believed that the 'intrinsic' level of meaning reveals something of the spirit of the age in which a text is produced, 'unconsciously qualified by one personality and condensed into one work'.[33] How similar is this to Barthes' concept of 'what goes without saying' as the ultimate (and contentious) goal of the mythologist? In both cases, the underlying cultural assumptions of a social group are encoded in visual form. In both cases, the encodement is so unconscious as to be particularly revealing. Both Panofsky and Barthes were – to be sure – concerned with very different kinds of text and would surely have come to very different conclusions, but again there are sufficient similarities between their theories to suggest that they are by no means mutually exclusive.

Panofsky's third or intrinsic level also has something in common with the interpretive anthropology of Geertz. Panofsky argues that at this level the underlying attitudes of a cultural group are unconsciously condensed into one text. To interpret this, he says, we need 'intuition'.[34] Essentially, this is the technique that Geertz advocates; a hermeneutic approach which relies on intuition on the part of the interpreter. And just as Panofsky argues that the world-view or *Weltanschauung* of a period or social group is unconsciously embedded in painting, Geertz argues that a people's sense of themselves is encoded in cultural texts of a much wider order. Both are articulate 'stories they tell themselves about themselves'.[35]

Roger Fry was an aesthete and a curator. To John Berger, he would surely have been another of those dreadful 'clerks' to the ruling class in decline. We recall how much Berger despised all that talk of beauty and form, which he saw as part of a deliberate process of 'mystification' – the explaining away of the real meaning of a work of art.[36] Yet, if we think about it, there are still connections and some unexpected common ground between the two. Fry, we remember, stressed that form *was* the meaning, but he also argued that this actually had a democratizing effect on the interpretation of paintings. It was this that meant that maids could probably appreciate Matisse better than their masters. Their purity of aesthetic vision took them direct to the aesthetic and emotional heart of the painting, while those with 'knowledge' and 'social assets' succeeded only in mystifying Post-Impressionist art for themselves.[37] John Berger was not the first to cause a furore by talking about class interest and painting. Roger Fry had beaten him to it by sixty years.

Berger is a polemical art critic. In *Ways of Seeing,* he goaded the art-historical

establishment and attacked the traditional connoisseurship of specialists such as Seymour Slive and Ernst Gombrich. Yet these battles were still fought on art-historical grounds, and he was easily prepared to admit art-historical evidence (for example, the Hals paintings) when it suited him. Unwittingly, perhaps, he also shares something with Panofsky: the distinguished Professor's talk of *Weltanschauung* and intrinsic meaning. Panofsky, we remember, said that the intrinsic meaning of a work revealed 'the basic attitude of a nation, a period, a class',[38] and this seems strikingly familiar when we recall Berger declaring that '[t]he art of any period tends to serve the ideological interests of the ruling class'.[39] This is not, of course, to claim that the two are in intellectual harmony; far from it. But again, we see two very much opposed theorists sharing at least some commonality of view. Both were prepared, to a lesser or greater extent, to see a visual text as containing social meaning and to interpret it as (if only partially) an emissary of the culture from which it came.

The connection between Berger and Barthes is, of course, much clearer. Both had a loathing of bourgeois values, which they saw lurking in visual texts. Berger provoked us to look afresh at familiar paintings, while Barthes beguiled us into looking at familiar items of popular culture in unfamiliar ways. Both sought to reveal the ideological values and assumptions contained within. In both cases, their methodology was interpretive. Although Barthes spoke (misleadingly, in our opinion) of the science of signs, he joined with Berger and Geertz in taking an essentially interpretive view of the analysis of visual culture. Berger, like Barthes, therefore shares not only methodological but also theoretical ground with Geertz, who wrote that all texts are saying 'something of something'.[40] They may disagree on what it is that the texts actually say, but that they say something, and that it is worth the trouble of finding out, is one thing upon which both undoubtedly agree. It also seems to reveal that it is the traditional, art-historical approach that has the least in common with all the rest. This is because it is this approach that has the least interest in the meaning of visual culture. To be sure, it concerns itself with context, attribution and provenance in a very scholarly manner, but it is mostly concerned with where and how the image fits rather than how and what it communicates. On the other hand, it is the anthropologist Geertz with whom all the rest seem most commonly and thematically connected. This would please Geertz, the theorist who urged us not to keep our intellectual universes distinct, and who wanted us to use a whole intellectual armoury rather than just one simple tool for every job. This leads us to a further conclusion. If we need a whole battery of different devices to penetrate the meaning of a visual text, then it strongly suggests that visual texts have more than one meaning. They are 'polysemic' in that they have many meanings, be they layered above each other like strata in the earth, or wrapped around each other like rings of an onion. Polysemic texts call for polysemic methodologies. We got wind of this when we spoke of the 'semiotic orchestra' in the previous chapter and suggested that a television advertisement (for example) communicates all manner of different things in all manner of different ways. In that chapter, we were speaking of semiotics, but may not any text (and especially a multimedia one) communicate, to lesser or greater extents, at each of the iconographical, formal, historical, sociological

and semiotic levels? We are not sure that we can ever wholly separate them, even if we should wish to do so.

We have ended this theoretical section with Geertz last for four reasons. First, because it is with Geertz, as it turns out, that the other theorists have most in common. Second, because in advocating an interpretive methodology himself, he reminds us that all other methodologies are to some extent interpretive themselves. Third, because the semiotic strain is the one that has run most consistently through the different approaches we have considered. Our fourth reason is the most important, however: in a book about visual culture it is Geertz who has most concerned himself with the vital question of not simply how cultural texts communicate but, still more crucially, what culture is and why we create one at all. He says:

> The concept of culture I espouse . . . is essentially a semiotic one. Believing, with Max Weber, that man is an animal suspended in webs of significance which he himself has spun, I take culture to be those webs, and the analysis of it to be therefore not an experimental science in search of law, but an interpretive one in search of meaning.[41]

This is, we suggest, a bravura passage which provokes us to think not only of cockfighting in Bali, but also of every other aspect of our own culture in its widest sense. What if everything were, indeed, semiotic, so that it therefore has no meaning other than that which we give to it ourselves? What if our entire culture were, indeed, a web of significance spun by ourselves in order to try and make the world in which we happen to live make sense?[42] On the edge of that gulf we feel constrained to stop, except, perhaps, to suggest that although our culture may indeed consist of 'webs of significance which we ourselves have spun', they are truly incredible webs.

Key Debate

Has art criticism become anti-visual?

In this chapter on hermeneutics we have introduced an approach to culture within which visual objects are regarded as texts open for interpretation in an almost anthropological sense. This contrasts with our chapter on form, where centre stage was given to an analysis that privileges the viewer's immediate and sensual experience of the image through the elements of design. With hermeneutics, on the other hand, the meaning or meanings, explicit or hidden, can only be grasped when the viewer engages in an active and deliberate process of interpretation. These two contrasting – though not necessarily incompatible – ways of regarding a visual text will now be used as conceptual benchmarks for the discussion of different orientations taken by some other people who share the visual culture experts' professional concern with images: art critics.

There is a distinct feeling of discomfort at large when it comes to contemporary art criticism. We can certainly see it among the general public, who are frequently puzzled by the opaque texts featured in exhibition catalogues or

other 'explanatory' devices. But the unease has also reached the realm of the specialists as demonstrated, for example, in Nigel Whiteley's juicily entitled 'Readers of the Lost Art – Visuality and particularity in art criticism', published in 1999. Whiteley's work provides a clear description of the radical swing that has changed the face of art criticism.[43]

According to Whiteley, a 'new' art criticism has gained predominance following a hermeneutical shift that has redefined its activity. But this new criticism, he argues, has become 'ocularphobic'[44] and is severely limited by what he designates a '"blindness" of intellectualism'.[45] What Whiteley criticizes in such strong terms is the dismissive attitude of 'new' art criticism towards the actual visual features of individual works of art. These, he says, have been abandoned in favour of 'textual' interpretations which are incapable of accounting for the unique visual experience that constitutes an encounter with an artwork. In the face of such weaknesses, Whiteley insists upon the urgent need for a re-evaluation of sensibility that will enable art critics to engage in a *critical looking* (our emphasis) that can only be achieved if the process of 'denigration of the visual'[46] in favour of textuality is interrupted, and the notion that visual artistic elements are nothing more than signifiers of meaning is abandoned.

The argument can be better understood if we contrast the concerns of 'old' and 'new' art criticism. In his own comparative perspective, Whiteley makes it clear that his objections to 'new' art criticism are not inspired by any sort of reactionary nostalgia. He does not tell us that 'new' art criticism is 'worse' than the 'old' paradigm. He uses a text written in 1964 by the well-respected German art critic Werner Haftmann on the work of Henri Matisse as a telling example. Here, Whiteley argues that 'old' criticism offers the reader an 'adoring' prose consisting of 'a series of evaluations that are neither discussed nor explained'.[47] Reading Haftmann's words, we can immediately see Whiteley's point:

> It is his secret of Matisse and his French genius that vigorous, autonomous life of his ornament of colour, line and light is never divorced from the object, but expresses its reality in a springboard for the sensation that touches off the formal play and raises it to the plane of a higher artistic reality.[48]

It is indeed hard to find tangible critical content in this exercise in art criticism.

Despite acknowledging differences among various 'old' critics – Haftmann's text is presented as an example of traditional art criticism at its worst – Whiteley attacks the general attitude shared by conventional writing on art. 'In this scheme of things', he claims, the critic 'is the artist's earthy representative: the priest who officiates the mass worship and who, in so doing, is conferred some of the artist's genius.'[49] The 'new' criticism, says Whiteley, should be regarded as a reaction to the values and assumptions behind such traditional attitudes.

Whiteley sympathizes with the challenge, which he sees as a historical need. However, his overall sympathy with the 'new' critical project still does not prevent him from expressing serious ambivalence towards the 'denigration of the visual' it has brought about, as we will shortly see. First, however, we should clarify what is really 'new' about 'new' art criticism.

Let us start by using the 'old' discourse as a counterpoint for the 'new project'. As Whitely complains of the 'new' criticism:

> The authorial intention and the focus on aesthetic quality is rejected in favour of the artwork as a text to be deciphered by the critic who deconstructs meaning in order to expose values and analyze social relations.[50]

In other words, the critic as 'arbiter of taste and aesthetic judge' is replaced by the critic 'as deconstructer and interpreter'.[51]

Whiteley continues with further examples from writing about Matisse, this time to exemplify the attitude of the 'new' criticism. These include Carol Duncan's discussion on the objectification of women in Matisse's paintings *Carmelina* and *The Red Studio*,[52] together with Gill Perry's text on the representation of colonialism in Matisse's the *Blue Nude*.[53] We will return to Perry's writings on Matisse's work later: this will help us better understand both Whiteley's assessment and his call for a re-evaluation of the sensibility that will lead to the 'critical looking' that he advocates for the analysis of visual objects of art.

For now, we will concentrate on the text selected by Whiteley to epitomize the most radical manifestations of the 'new' project and to elaborate upon his fundamental objections to the rejection of the visual in favour of the textuality privileged by the 'new' criticism. In an essay entitled 'Trouble in the Archives', published in 1993, Griselda Pollock displays what Whiteley describes as: 'some of the hallmarks of the fundamentalist's passion or the puritan public disavowal of visual pleasures'.[54] Pollock argues that the artist produces 'a series of signs that have to be read like hieroglyphs or deciphered like complex codes'.[55] In her case, the codes are deciphered through a feminist 'reading' of art that raises the repressed question of gender. Paintings, which were regarded as instances of visual experience in traditional criticism, are here taken as pure vehicles of meaning. Art criticism becomes a form of social anthropology. 'To someone like Pollock,' Whiteley summarizes, 'the value of an artwork lies in the extent to which it illuminates cultural and political conditions and so, indeed, its quality as a work of art is immaterial.'[56]

This last remark brings us to the central question of judgement on aesthetic quality, a question that divides the territory of art criticism. For 'old' critics, giving judgement on quality is part – probably the defining part – of their job. For 'new' critics, however, value judgements on aesthetic quality belong to the realm of personal preference and so should be totally dismissed. As the 'new' critic Thomas McEvilley bluntly puts it, 'such dicta are finally about as relevant to the rest of the world as what flavour of ice cream the critic prefers'.[57]

Now that works of art are not to be valued in terms of their aesthetic qualities, they tend to become simple pretexts (pre-texts) for ideological discourse. Critics following such a path prefer not to deal with the visual particularities of specific works of art, and this approach accordingly favours the colonization of the visual by the textual. The problem with this form of analysis is that it can easily translate into speculative and often pretentious criticism, sustained by over-generalizations which do not contemplate any connection with any

particular work of art, let alone the visual elements that make each art object unique. Readers probably already recognize the kind of writing we are talking about.[58]

At this point we appear to be confronted by a dichotomy. On the one hand, we adhere to the 'old' paradigm and take artworks in their pure and innocent visual dimension, in which quality is frequently judged by an autocratic specialist. On the other hand, we can take art objects as simple conveyers of social and cultural meaning – to be deciphered this time by another type of specialist.

Whiteley refuses to accept the dichotomy. There is, he thinks, a way out, and he uses Gill Perry's study of the representation of colonialism and gender issues in Matisse's *Blue Nude* as an example. In Perry's analysis, we find passages like this:

> Space is ambiguous, combining a mixture of modelling – or faceting – with flatter areas of colour. This spatial ambiguity is further emphasized by the odd distortions in the woman's body, which frustrates some of the associations of the odalisque pose (. . .) The nude woman also assumes an impossible pose, a dramatic form of contrapposto, which further confuses the conventional sexual connotations of the theme.[59]

In this kind of analysis, Whiteley identifies what he sees as the key elements of an approach to art that avoids the shortcomings of both the 'old' and the 'new' standard perspectives. This involves an attention to particular works of art and to their visual particularities, the awareness of the pluridimensional symbolic complexity of visual forms and, above all, the ability to engage in a 'critical looking'. By this, he means the capacity to conjoin a detailed visual scrutiny of an artwork with the analysis of content, meaning and reception. Only the combination of formal analysis (the looking part of the equation) with interpretation (the critical part of it), enables the understanding of the dialogue between form and meaning. In this way, we are able to combine an analysis of both the text and the context to reveal what Whiteley says art is all about.

Further Study

The notion of culture, with which we began this chapter, is a large and contentious one. However, anyone investigating visual culture would be well advised to question the underlying notion of 'culture' itself in depth. It is, after all, a term that is often used, yet whose complexities and shifting meanings are less frequently understood. Matthew Arnold's *Culture and Anarchy* was first published in 1869, but has been republished and edited frequently since.[60] Here, Arnold (who was also an accomplished poet) argued for the civilizing potential of traditional notions of culture in the face of encroaching 'barbarism'. By contrast, T. S. Eliot's *Notes Towards the Definition of Culture* may appear positively liberal. Eliot establishes, as we have seen, a far broader, embracing and more popular notion of culture than does Arnold. Eliot goes on, however, to argue

that regionalism, religion and a class system are necessary to the existence of proper culture – and that some kinds of culture are definitely superior to others. His argument, then, is much more controversial (and less liberal) than it first appears.

Anthropological notions of culture tend to be less hierarchical and judgemental in approach. In terms of visual analysis, they prompt us to examine our own culture with the same distance and perceptivity that anthropologists use when they examine the cultures of other peoples. Ruth Benedict in *Patterns of Culture*, for example, asks probing questions about the relationship between culture and creativity in tribal New Mexico, Melanesia and British Columbia. The answers to these questions might provoke us to draw similar parallels with ourselves.[61] The debate, of course, revolves around how best this should be done. Methodological disagreements have long been a feature of anthropology, ranging from quantitative and 'scientific' approaches to the human and interpretive. Claude Lévi-Strauss went so far as to produce a structural theory of myth that involved algebraic formulae to which he claimed all myth could be reduced.[62]

It is clear where Clifford Geertz fits in here, and his *The Interpretation of Cultures* together with *Local Knowledge* provide hugely readable and informative compilations of hermeneutical theory and practice. He makes a persuasive case for the hermeneutic approach, but not all anthropologists agree with either this or Geertz. Vincent Crapanzano's essay, 'Hermes' Dilemma', provides an articulate refutation of Geertz's work and method. Indeed, the compilation from which this essay is taken, Clifford and Marcus's *Writing Culture*, underlines the broad range of disagreements about how the work of social anthropology should best be done.[63]

Hermeneutics, of course, is not limited to anthropology. In addition to its use in biblical study, it has been considered by philosophers, notable among whom were Wilhelm Dilthey and Martin Heidegger. Their ideas were taken up in part by the German philosopher Hans-Georg Gadamer, whose *Truth and Method* and *Philosophical Hermeneutics* provided major contributions to the field.[64] In France, Paul Ricoeur offered further insight into interpretation and meaning in his various essays on hermeneutics.[65] Of course, the idea of interpretation in the humanities crosses further disciplinary boundaries. Pierre Maranda combined anthropological, literary and reception theory in his essay 'The Dialectic Metaphor'.[66] A very down-to-earth and persuasive essay on hermeneutics in practice is offered by the political theorist John Dunn, in 'Practising History and Social Science on "Realist" Assumptions'. Although he concentrates on political, historical and even ethical issues, his defence of hermeneutics (for all its admitted shortcomings) is equally applicable to the interpretation of meaning in visual culture.[67]

If you are looking for more radically ideological art criticism – the kind of approach under critical scrutiny in this chapter's Key Debate section – Charles Harrison, Francis Frasciana and Gill Perry's *Primitivism, Cubism, Abstraction: The Early Twentieth Century* provides abundant material.[68] It is at the same time important to place Frasciana's perspective in a wider context, and this can be achieved with the help of historically oriented books such as Charles Harrison

and Paul Wood's *Art in Theory: An Anthology of Changing* Ideas.[69] For a deeper account of the visual as a discursive construct and a philosophical understanding of the latent tension between ocularphobic and ocularcentric positions, Jacques Derrida's *The Truth in Painting* makes an interesting choice.[70]

It is appropriate to end this chapter – and this entire first section – on such an inter- and indeed multidisciplinary note. It should be becoming increasingly clear that visual literacy is not achieved through any sort of 'quick fix' or by one analytical method alone. As visual culture touches so many different aspects of our lives, so should the ways in which we seek to understand it.

PART II

MEDIA

7

FINE ART

This chapter opens the second part of this study of visual culture. In the first part, we examined six different theoretical approaches to the understanding of the meaning of visual texts. These were general approaches, and not directed at specific media. This second part, however, will be turning things around, for here we will take specific media as our starting point, with chapters on each of fine art, photography, film, television and 'new' media. Underpinning our investigation will be the relationship between our visual culture and the 'real' world we inhabit. We will discover that the relationship is by no means as straightforward as we might have thought. In this chapter, we will consider the illusion of reality in the fine arts. We will begin by challenging the fundamental ability of painting, drawing and printmaking to be genuinely 'realistic' at all. Guided by the theories of Ernst Gombrich, we will then argue that the illusion of reality in art is in fact communicated by a series of learned conventions and artistic devices rather than by the faithful reproduction of the natural world itself. This, contends Gombrich, explains why different artists from different periods have represented the same visual reality in so many different ways.

How realistic is Leonardo da Vinci's famous drawing of *Virgin and Child with St Anne and St John the Baptist* (see figure 28)? It was executed around 1500 as a cartoon or full-sized design for a subsequent painting.[1] In many ways, it is very realistic indeed. It is clear: we can certainly see what it is meant to be. It has volume, detail, perspective, proportion, lighting and expression. It is even approximately life-sized. It is a work that ably demonstrates the technical skill of one of the greatest of all artists and explains why Gombrich lavished such

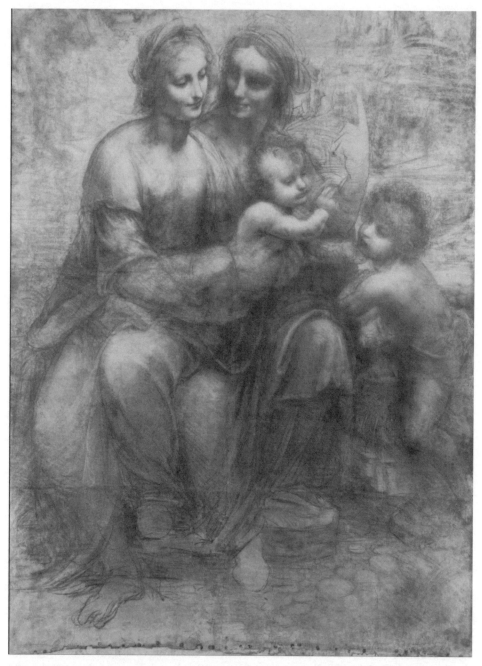

28. Leonardo Da Vinci, *The Virgin and Child with St Anne and St John the Baptist*, circa 1500, charcoal with black-and-white chalk on tinted paper; courtesy of the National Gallery, London

enormous praise on the High Renaissance as a whole. But how realistic is it, really? If we were to walk into London's National Gallery, turn a corner and unexpectedly be confronted with this work, would we even for a moment think that we had stumbled upon two real women and their children? Of course not. Even if we could ignore their old-fashioned clothes (which might form the least of our objections), we notice that nothing moves, that everything is in only two dimensions, that the whole scene is made up of only three colours and that in many places we can see straight through to the paper underneath. No one would for a moment be fooled into thinking that they had seen the real thing, but within the conventions of the fine arts, we would all probably agree that it was very 'realistic'.

We might also agree that paintings from the Dutch golden age are very realistic, too. Painted more than 150 years after Leonardo's cartoon, Jan Vermeer's *The Kitchen Maid* of 1660 is a wonderfully executed study of a quiet Netherlandish interior in which a servant woman gently pours milk into a bowl from a simple jug, as a soft light illuminates the room from the window to her right. Vermeer's painting lacks the life-sized quality of Leonardo's cartoon (it is, in fact, much smaller than life), but unlike the cartoon it appears in full colour, just as (for most of us) the real world does. We would probably agree that Vermeer's work, too, is realistic, even if we would never in practice confuse it with the real thing.

Moving forward another 200 years or so, we reach the French Impressionists, whose concern with realism was such that they said they wanted only to paint scenes from real life, capturing not just the fleeting moment of natural light at a specific time of the day, but to do so also in such a way as to capture how we see things ourselves, with our own eyes, in the real world (usually) outside. Monet's painting *The Gare St-Lazare* of 1877 wonderfully evokes the steam, light and noise of a busy railway station, even though we cannot actually pick out too many of the details. What he realistically gets across to us, however, is the impression that we have been there ourselves and can remember it with the imperfect recollection of our own eyes.

We have, then, three works of art created at different intervals during the last 500 years. Each is, in its own way, realistic – even though the three styles are very different. This leads us to ask ourselves an intriguing question. How is it that three separate artists, from three separate periods in history, can each come up with such a very different style of painting? If people draw or paint 'realistically', shouldn't all their drawings or paintings look pretty much the same? Reality remains, after all, much as it is! How can these three stylistic and very different paintings all be described as realistic? We might reply that everyone sees the world differently, so it can hardly be surprising that there are many different styles of painting. Yet, if everyone actually did see the world differently, shouldn't every artist that ever lived have a remarkably individual and different style from all the others? And would any of those seem 'realistic' to us? The fact is, of course, that not only are we perfectly happy to consider really quite different styles as 'realistic'; we are also aware that these styles are not (mostly) individual but are, in fact, shared by whole groups of artists working in the same sorts of place at the same sorts of time. Leonardo's realism is very similar to

that of Raphael, Vermeer's to that of de Hooch and Monet's to that of Renoir.[2]
To be sure, they exhibit some individual differences, but traditional histories of
art do serve to remind us that artists have nearly always fallen into discernible
stylistic groups, schools or periods. They all have their recognizable place in
the history of art. Indeed, without such stylistic groupings, there would be no
traditional history of art.[3]

So far, we have wondered why there are so many different styles of realism,
while agreeing that (when it comes down to it) none of them is completely
realistic at all. We have proceeded to wonder why it is that although there are
different styles of realism, common views of realism tend to be held by artists
of similar periods, groups and schools. We can now proceed to an even bigger
problem: how come so many earlier groups of artists seemed incapable of
drawing or painting with any kind of realism at all?

When we look at the wall-paintings and relief carvings of ancient Egypt, for
example, we cannot help but notice how everyone seems to inhabit an entirely
two-dimensional world. People appear in exaggerated profile, with heads,
torsos and even both feet presented to the viewer all at once. Was that the
way people looked in ancient Egypt? Is that the way they really sat, stood and
moved? The idea that Egyptians really did behave like that became something
of a vaudevillian joke, as Westerners parodied the 'sand dance' and even the
1980s pop act The Bangles sang: 'All the old paintings on the tombs / They do
the sand dance don't you know' in their 'Walk Like an Egyptian', a song that
is still popular on 'classic hits' radio stations and among people who are old
enough to know better. But beneath the (perfectly understandable) jokes lurk
the thoroughly reasonable questions. Did ancient Egypt really look like that?
Did ancient Egyptians see differently from the way we do? Or is there some-
thing more complex afoot? We face a not dissimilar problem in Europe several
millennia later. Art emerging from the 'dark ages' seems again to suggest a two-
dimensional world of 'flattened' saints and holy people. Even paintings up until
the fifteenth and sixteenth centuries are distinctly perspectively and proportion-
ally challenged. They show (for example) people who are bigger than the houses
they inhabit, and streets populated by people of enormously different sizes. If
we look at Simone Martini's *The Road to Calvary* of around 1340, we wonder
how everyone managed to cram their way into a city that looks so much like a
toy (see figure 29). Again, it is not a world we recognize.

If we take the (reasonable) assumption that Egypt was not a land in profile
and that medieval people could actually fit inside their homes, then we are
much more likely to conclude that what has changed is not reality, but the way
in which we represent it. But that begs another question. If reality has always
been pretty much the same, why did people spend so long painting, drawing and
carving it in a way that was so clearly 'wrong'? And if they got it 'wrong', why
did they get it all so similarly 'wrong' together?

These are all perfectly good questions, questions that we may already have
asked ourselves in some or other way. Now is the time to investigate this much
more methodically with the help of an old friend: Professor Sir Ernst Gombrich.
He, like us, was perplexed by what he called 'the riddle of style'.[4] In 1960 he
published *Art and Illusion* in an attempt to solve this riddle. This is a book that

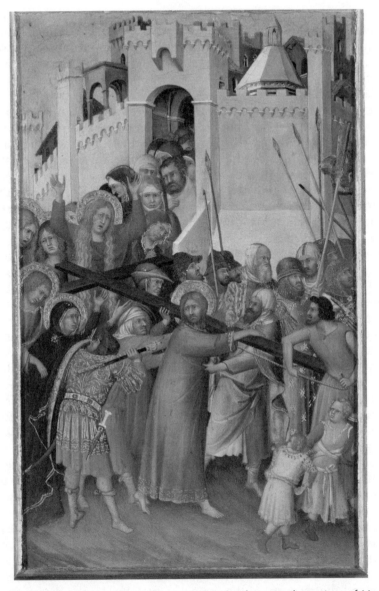

29. Simone Martini, *The Road to Calvary*, circa 1340, oil on panel; courtesy of Musée du Louvre, Paris; photo: RMN

became something of an instant classic. Although *The Story of Art* is perhaps better known among people seeking an introduction to art history, *Art and Illusion* has done much more to maintain his reputation among scholars. It changed the way people had been thinking about these issues since the middle of the previous century.[5]

According to Gombrich, the 'riddle of style' boiled down to the question: 'Why is it that different ages and different nations have represented the visible

world in such different ways?' Art historians, he said, had done their work simply by describing these changes. What was needed was a much broader and more theoretical approach.[6] Gombrich writes at some length in search of a solution to the riddle. His own style in *Art and Illusion* is by no means as structured and concise as it is in *The Story of Art*, but it is possible to summarize his argument relatively briefly.[7]

In *Art and Illusion*, Gombrich seeks to solve the riddle of style by replacing an old theory with a new one. The old theory, he argued, contended that people's ability to see things clearly was clouded by what they knew about the actual world. Knowing, indeed, came before seeing. If we were not careful, we would artistically represent the world cognitively – as we knew or understood it – rather than simply as we saw it. Thus, the ancient Egyptians and the medieval Europeans drew or painted the world they knew rather than the one they saw. What they knew (or what they thought they knew) got in the way. If you wanted to paint a realistic illusion, therefore, you had deliberately to suppress your knowledge of the real world and instead retrieve 'the innocent eye', which saw things afresh and without preconception.[8] You got a closer approximation of nature in art by examining nature itself, not theoretically with your brain and your learning, but practically with your own eyes. In other words, you might *know* that a certain palace contained a thousand rooms, a certain flower so many stamens or a certain boat so many wooden pegs, but you should concentrate instead on what you *saw* from your physical point of view. Not every room, stamen or peg would be visible to you; nor, therefore, should it be to the subsequent viewer of our work of art. The old theory, as summarized by Gombrich, said that as people learned to do this – to concentrate on learning to *see*, regardless of preconceptions – art became progressively more realistic. The Egyptians painted what they *knew* and got it wrong; the Impressionists painted what they *saw* and got it right.

This is an ingenious theory, to be sure, but to Gombrich it remained unsatisfying. It still failed sufficiently to explain 'why it should have taken mankind so long to arrive at a plausible rendering of visual effects that create the illusion of likeness'. Even artists such as Constable (whose seemingly realistic painting *The Haywain* we examined in the first chapter) had to admit that the painting was never free of convention, manner or style. Gombrich, therefore, went on to provide his own, new explanation of the 'riddle of style'. Briefly, he argued that artists learned how to draw and paint realistically not by the careful study of nature and the recovery of the 'innocent eye', but by the discovery of more and more effective artistic conventions or 'schemata', by which the illusion of reality could be more effectively achieved. They gradually discovered, in other words, the tricks of the representational trade. The innocent eye was 'a myth'. After all, you couldn't ever effectively separate what you knew from what you saw. So, the successful development of the illusion of reality in art depended not on the suppression of knowledge but on the successful development of increasingly effective schemata: 'What accounts for the ease or difficulty in rendering a given building or landscape is not so much the intrusion of knowledge as the lack of schemata.' The consequence was that skilled artists actually relied on a 'vocabulary of forms' rather than a 'knowledge of things' when creating convincing works

30. Child's drawing of a cat; drawing: Sarah Howson

of art. Put another way, people learned to paint convincingly not by learning to see, but by learning to paint. They learned the necessary tricks of the trade and in so doing learned to create more and more successful illusions of reality.[9]

We can put this to the test not only by re-examining the history of art, but also by a small experiment using our own experience of learning to draw as a kind of art history in microcosm. When we were young, we very probably learned to draw a cat.[10] We began by drawing a large circle (the body) and then adding part of a smaller circle (the head) on top. To this we added two small triangles for the ears and finally a long crescent (the tail) was appended to the body (see figure 30). Those of us with precocious talent may even have added sets of three straight lines (always three!) for the whiskers.[11] The resulting animal is clearly recognizable to us now, just as it was when we were young. The important point is, however, that we learned to draw this cat not by looking very closely at a real cat (and by suppressing our knowledge of all things feline) but simply by learning from other people the schemata that are necessary to draw a convincing cat. The cat, of course, is only convincing within the recognized conventions of fine art. We would never mistake it for a real one – it is entirely transparent for a start. Real cats don't actually look like that to us, and we have no reason to believe that they look like that to children either. This is why Gombrich warns us against confusing 'the way things are represented with they way things are "seen"'.[12] Again, this is something we had already suspected. As children, we used frequently to draw our homes and our mothers – and we can still smile as

we recollect our early efforts. With scant regard for real-life detail, we would typically draw a stick figure in a triangular skirt outside a square house with four windows and a lollipop tree. The sky would be a single strip of blue across the top of the page. It seems reasonable to assume that we never actually *saw* our mother or our home like this, but that is how we all *represented* them because we had learned the schemata from peering over the shoulders of our classmates and from similar examples on the classroom wall.[13]

The old theory of 'knowing and seeing' is therefore replaced by Gombrich's new theory of 'making and matching'.[14] Briefly, Gombrich argues that the achievement of increasingly successful schemata for the illusion of reality in the fine arts proceeded on an almost experimental basis with 'the invention of pictorial effects'. Gradually, artists would make new schemata and match them against the real world. If the match was a poor one, it failed and was little used again. If it was a good one, it was generally adopted and remained until an even better one took its place. Naturally, the experiment preceded its adoption so, as Gombrich puts it, 'making comes before matching'.[15]

As it was with us, so it was with the history of art. Cultures, like people, learn only gradually to draw realistically. As they grow older and gain more experience, they discover more and more convincing schemata, not by copying nature, but by copying and improving upon previous drawing and painting. In this way, concludes Gombrich, art has a history because it imitates art first and nature second. All paintings, indeed, 'owe more to other paintings than they owe to direct observation'.[16]

If art were simply a matter of learning to see, we would not need to learn how to paint. Originally, painting was taught on a fairly rigid system, in which an aspiring artist was apprenticed to a master. It was understood that painting was a craft that needed to be learned like any other, and the necessary skills were handed down in the practical context of the master's workshop. The training began early in life. Albrecht Dürer, for example, had very little in the way of formal schooling before becoming a boyhood apprentice to his father, a Nuremberg goldsmith. At the age of fifteen, he began a formal apprenticeship as a painter with the master Michael Wolgemut – a situation that lasted more than three years. According to Panofsky, Wolgemut's workshop was typical of its time, being 'a rather large commercial enterprise, with many assistants who treated the apprentices somewhat roughly'.[17] Here, Dürer learned all the necessary practical aspects of his craft, but there is no evidence of him learning 'to see'. The practical nature of art in early Europe is underlined by the fact that the names of the individual artists were not normally recorded. Some of the best artists of the thirteenth to the late fifteenth century, for example, are still only known to art historians as 'The Master of . . .', as in the Master of Flémalle, whose famous Merode altarpiece we studied in the first chapter. The cult of the individual artist (as opposed to the anonymous craftsman) is a later development. Dürer was among the first consistently to sign and date his work, starting in around 1495. The origin of the term 'masterpiece' further underlines the practical nature of artistic training. Nowadays, the term is loosely used to describe any outstanding work, but its origin is in the old apprentice system. Here, a 'masterpiece' was the work by which an apprentice who had finished

31. Demonstration of Alberti's perspectival grid system; drawing: Richard Howells and Sarah Howson

his training was judged to be worthy of admission to the guild and to the title of 'master'. The guilds were commercial craft and trade associations, little interested in the niceties of 'seeing'.

Of course, a decent artist's training did not stop in his master's workshop. The better ones were always in search of improvement and relied, to a lesser or greater extent, upon self-teaching. This was not always easy, however. Today we would seek out the latest books on the subject, but the first book on the art of painting did not appear until 1435–6, in the form of Leon Battista Alberti's *Della Pittura (On Painting)*. Alberti was still advocating a master–apprentice training system, but the most significant aspect of *Della Pittura* is that it is art history's first written theory of perspective.[18]

We know from chapter 3 that the problem of perspective was one of the most challenging of the history of art, and it was one that occupied some of the best minds of the Renaissance. The solution to the problem of perspective was, as is often the case in science, a loosely collaborative one. It is the Florentine architect Filippo Brunelleschi who is credited with the invention of a mathematical system of linear perspective. This was first put into practice by artists such as Donatello with his design for the bronze relief decorations for a baptismal font in Siena in around 1425, and Masaccio with his *Holy Trinity* wall-painting in Florence of about 1427. Alberti's contribution was to publish the 'secret' of perspective for the first time.[19] Instead of painting on what appeared to be the flat surface of a panel, the artist presented himself with 'an open window through which I see what I want to paint'.[20] The theory is expostulated in 'Book One' of *Della Pittura*, and can best be understood if we follow it ourselves.[21] This can even be fun (see figure 31).

Take a letter- or A4-sized piece of plain paper and, with a ruler, draw a rectangle on it. It works best if you do this landscape (as opposed to portrait)

way up. Now draw a horizon about one third of the way down this 'canvas'. In approximately the centre of the horizon, place a small 'x'. This will be the 'vanishing point'. Now, mark the entire baseline of the rectangle at equal intervals – approximately half intervals are about right on a standard piece of paper. Next, join each of the baseline marks (together with both the bottom corners) to the 'x' on the imaginary horizon. The effect should be one of a series of 'railway lines' meeting at the point where they vanish over the horizon. So far, so good. The next parts are slightly more complicated to describe (but actually still quite easy to do). Mark a point towards the top right-hand corner of the rectangle, and connect this with each of the marks on the baseline. You will end up with what looks like two intersecting spider's webs. It is the points of intersection that provide the next (and key) stage. You will find that where both 'webs' meet, there is a series of rows of 'x's beginning on the baseline, and that each row gets smaller as it nears the horizon. Join the top and bottom of each of the 'x's with a horizontal line that stretches across the entire rectangle. If you have done this correctly, each new horizontal line will be parallel to the baseline, but the distance between each line will diminish as it comes nearer to the horizon. You will also notice that each 'x' is now enclosed by its own slightly misshapen rectangle. Think of each as a floor tile, and shade every alternate one in, as though laying a chequered floor. You will now see a perspectively perfect floor, patio or piazza stretching out towards the horizon. If you want, you can now populate the piazza with people who will be in perfect perspectival proportion to each other depending how near or far away they are from the front. The formula is easy: all you have to do is decide how many 'tiles' high you want your average person to be. If you decide (for example) on three, then randomly place several 'stick people' at different points on the piazza. No matter how far to the foreground or background they are, they still need only to be the same number of tiles tall. But because the size of each tile diminishes the nearer it is to the horizon, each person will be perspectively correct. If only medieval artists had known this!

Now that we have made an Alberti-type perspective grid for ourselves, we can look with much more knowing eyes at many Italian Renaissance works. In the light of our new knowledge, we can see how they were constructed and discern that their mastery of perspective is due much more to making and matching than to knowing and seeing. How often there seems to be the telltale tiled floor! Perugino's fresco *The Giving of the Keys to Saint Peter* in the Sistine Chapel in Rome is an excellent example (see figure 32). Commissioned in 1481, we see Christ handing a set of keys to Saint Peter in the middle of a vast Italianate piazza. Conveniently, the piazza is made up of enormous stone flags with the vanishing point right in the middle of the horizon. Of course, not all the grid lines are shown (once the underlying grid is laid down it can be painted over as necessary), but the schema is definitely there. In Donatello's famous baptismal font, Herod's feast takes place on an equally conveniently tiled floor. Of course, one cannot have tiles everywhere, so in Uccello's *The Battle of San Remo* of about 1450, the foreground is strewn with broken lances, which, as luck may have it, both divide the field horizontally and also point towards a distant vanishing point.

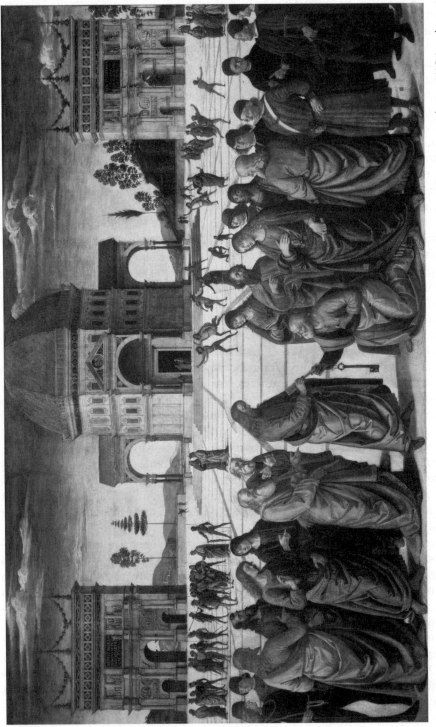

32. Perugino, *The Giving of the Keys to Saint Peter*, circa 1482, fresco; courtesy of the Sistine Chapel, Vatican, Rome; photo: AKG London

Our re-creation of Alberti's system was taken at its simplest. With variation and ingenuity, it can be used as the basis for more advanced effects. If we move the vanishing point from its central position, we can create more unusual views, just as we can by moving the points at the edge of and even beyond the picture frame. Try it! And by working 'upside down' we can create perspectively tiled ceilings, such as in Masaccio's *Holy Trinity* and Mantegna's remarkable 1455 wall-painting of Saint James on his way to his execution.[22]

The theory and examples we have just discussed are all very much Italian-based. This leads us to wonder how artists outside Italy learned the schemata of perspective realism. Alberti's book was, after all, only available in manuscript, and even when printed versions began to appear more than a hundred years later, they were only available in Latin and, later, Italian.

For ambitious young Northern painters such as Albrecht Dürer, the solution was simple: go to Italy. Dürer in fact made two trips to Italy, the second and longest of which lasted from 1505 to 1507. It was in Bologna that he hoped to be taught 'the secret art of perspective' and it was in Italy that, according to Panofsky's biography, he came into contact with the ideas of Alberti. More than that, however, Dürer also discovered the proportional and anatomical studies of Leonardo. This, says Panofsky, made him realize that 'the theory of art might be understood as a scientific pursuit'.[23] As a result, Dürer himself became not only a practitioner but also a theorist of the art of illusion. He published two books on art theory: *Unterweisung der Messung* in 1525 and *Vier Bücher von Menschlicher Proportion* in 1528. The first was a treatise on measurement, while the second was a compilation of four books on proportion. Although there was little in these volumes that had not already been discovered by his Italian predecessors, Dürer's contribution was to publish both in German and in print, so that the new learning could be passed on to Northern artists who did not have the chance of travelling to Italy themselves. In his study on proportion, he added a collection of twenty-six different 'body types' from which artists might choose according to their needs. His own illustrations demonstrated ingenious contraptions and techniques for 'correct' drawing, which included such devices as grids, frames, string, plumblines and viewfinders. Again, however, these studies amount to elaborate schemata, and the emphasis is on learning to draw rather than learning to see.

The traditional belief has it, therefore, that the schemata necessary for the illusion of reality in the fine arts were first invented in Italy, then passed on personally and finally disseminated through publication to a wider European audience. This does lead us to wonder, however, how artists such as Jan van Eyck, working in Northern Europe in the early 1400s, were able to paint so convincingly without the benefit of Alberti and Italian learning. Is it possible that they, unlike their Southern colleagues, really did rediscover the innocent eye?

This is a question we discussed in the summer of 2000 with contemporary artist David Hockney. In addition to his renown as a painter and a draftsman, Hockney had become increasingly interested in optical theory. He claimed that rather than just using mathematically derived grids and systems of perspective, artists had for centuries also used mirrors and lenses to help them to draw with realistic accuracy. He demonstrated this to us at an opening of an exhibition of

his own work in Saltaire, Yorkshire. Theoretically, Hockney was there to meet assembled dignitaries and critics, but once he learned of our mutual interest in art theory, he drew us to one side and, producing a small, concave mirror from his pocket, projected a view from an outside window on to a paper napkin he had purloined from the buffet. It worked! The scene outside the window was reflected on to the paper and, had we wished, we could have traced its outline with a pencil and produced an 'accurate' drawing.[24] Hockney went on to publish his ideas in detail in *Secret Knowledge*. Here, he proceeded to irritate sensibilities among traditional art historians by suggesting that many painters (such as Constable) who are famed for working spontaneously 'from life' had, in fact, considerable assistance from optics. We should listen carefully to David Hockney. Here is an acclaimed artist, who, one might presume, would be keen to perpetuate the romantic notion of the fellow artist's vision and the 'innocent eye', actually adding more credence to Gombrich and his theory of schemata. As another contemporary artist Ellen Harvey observed in the title of a New York exhibition of her work, *Painting is a Low Tech Special Effect*.[25]

So far, we have considered two ways in which artists have learned the techniques necessary for the representation of reality: serving as apprentices to masters in workshops, and then learning, reading and discovering for themselves. We have seen how the education of the individual artist serves as a microcosm for the education of art as a whole. It is now time to consider formal art education.

The idea of an education as opposed to an apprenticeship in art is a relatively recent one. In Britain, it can be traced to the founding of the Royal Academy in 1786. The first president was the celebrated portrait artist Sir Joshua Reynolds, who laid down what he considered to be the essentials of artistic training in a series of 'discourses' that he delivered over a twenty-year period. We find little of the innocent eye here. Rather, Reynolds lays down a strict system in which students are expected to learn to paint by imitating the old masters. Raphael and Michelangelo in particular, he declared, should be considered 'perfect and infallible guides'. Reynolds was a strict taskmaster and demanded 'implicit obedience to the Rules of Art'. As for artistic talent, it was not 'some kind of magick', a gift or an inspiration. Rather, it was the result of training, 'long labour and application'. Yes, a painter should be true to nature, but he must be of necessity 'an imitator of the works of other painters'. Indeed: 'no man can be an artist, whatever he may suppose, on any other terms'.[26]

Reynolds's emphasis on imitation and perspiration over inspiration has not always found favour with critics and art historians – just as David Hockney (like Reynolds, an accomplished artist) offended more romantic sensibilities with his theory of optics. According to traditional art historian H. W. Janson, Reynolds's *Discourses* 'inhibited the visual capacity of generations of students in England and America'.[27] In terms of unfettered creativity, it possibly did. In terms of learning to paint, however, Reynolds, just like Gombrich, believed that the illusion of reality in the fine arts depended not upon learning to see more clearly, but on the imitation of a succession of previous artists who, through a centuries-long process of making and matching, had mastered the necessary schemata.

Our examination of the reproduction of reality in the fine arts has so far been

very supportive of Gombrich's work in *Art and Illusion*. In some ways, he appears to have explained the history of art with a history of optical illusion. There is something appealingly iconoclastic about a theory that replaces inspiration with schemata. In other ways, though, Gombrich's approach still remains deeply rooted in the traditional (and consequently partial) history of art. For a start, his theory is essentially drawn from and applicable to Western art up to around 1900. With the advent of Post-Impressionism, artists ceased to be much interested in the illusion of reality. Roger Fry's controversial London exhibitions of 1910 and 1912 made that perfectly clear: Cézanne, Gaugin, Matisse and their contemporaries seemed only too keen to leave reality behind. Perhaps this was partly due to the advent of photography, which, with the click of a button, could produce 'perfectly realistic' images every time. The Post-Impressionists wanted to take painting elsewhere. Picasso, for example, ably demonstrated that he could paint perfectly 'realistically' by the age of sixteen, but as he grew in maturity and sophistication, he wanted to leave mere imitation behind. In some ways, then, *Art and Illusion* echoes the assumptions of *The Story of Art*, in which the artists of the Italian High Renaissance, together with the French Impressionists, are held up as exemplars of painting at its best. Leonardo, Raphael and their contemporaries perfected reality as it existed, while Monet, Renoir and their colleagues perfected reality as apprehended by the human eye. In both books, Gombrich seems to take it as read that the purpose of art is the accurate presentation of the illusion of reality, and that the history of art is the history of the pursuit of it.

If this is of limited use in an appreciation of Western art, it becomes even less relevant in the art of cultures that have never been interested in mimetic drawing and painting. In Western Europe, the illusion of reality ceased to be of much importance after 1900, but in many other cultures, the illusion of reality had never been on the agenda. We can think of all manner of examples from Africa, aboriginal Australia, Southern America and Polynesia in which issues of symbolic form have always been of much greater importance than 'realism'. They have their own recognizable schemata, to be sure, but not in the pursuit of reality. For example, the native prints and paintings of the Canadian northwest have a common vocabulary of shapes and components, such as the ovoid and the 'S form', which are doubtless learned from the work of other artists. Subtle variations in style and schemata help the connoisseur to attribute works to individual tribes and regions. None of this work, however, seeks the illusion of reality. As we saw in chapter 2, ravens, frogs, eagles and killer whales are all represented in the work, but always in a heavily stylized manner, usually in two dimensions and typically with a palette of just two or three colours – most often red and black. To say that a Haida or a Kwakiutl rendering of a raven (which often contains a human hand for reasons of theological significance) is a poor likeness is seriously to miss the point.

The importance of the symbolic as opposed to the physical truth in fine art is something that is not, of course, limited to non-Western culture. Gombrich himself notes in *The Story of Art* that the Romanesque artists of the twelfth century 'were not concerned with an imitation of natural forms, but with the arrangement of traditional sacred symbols'. Once these artists had 'discarded

all ambition to represent things as we see them', he continues, great possibilities were opened up. When he concludes the chapter by writing of their 'freedom from the need to imitate the natural world', which enabled them 'to convey the idea of the supernatural', we are reminded not only of the Kwakiutl and their ravens, but also of the limitations of Gombrich's own theory of art in pursuit of the illusion of reality.[28]

There is something teleological in Gombrich's argument in *Art and Illusion*. That is to say, it sees the history of art proceeding towards a specific goal – in this case, the illusion of reality. This is, on the surface, both comforting and familiar. It gives us the structure, purpose and outcome we often seek in many other areas of our lives. At the same time, however, Gombrich's teleological approach does view the past (as historians often do) merely as the pre-history of the present. This, we think, can diminish the importance of many of the outstanding works of the past. Surely, it is never a bad thing to appreciate (for example) the Limbourg Brothers' *Les Très Riches Heures du Duc de Berry* of around 1410 as a thing of beauty in its own right and not merely as an heroic but imperfect effort on the march towards realism.

We need also to ask ourselves how completely Gombrich solves what he called 'the riddle of style'. He argues that we can date a picture by its style from its position on the road to realism. He certainly makes a persuasive case for this, but we should not be misled into thinking that all style is a product of schemata created in search of the illusion of reality. Much of style can also be ascribed simply to fashion. We notice how today (although some may try and persuade us otherwise) artists, designers, musicians and others in creative pursuits still work within broadly similar parameters. They know, more or less consciously, that they need to fit in to the general flow if they are to be taken critically seriously and/or become commercially successful. There is no greater sin in the creative arts than being (or being perceived to be) old-fashioned. In this way, even the urge to be innovative, new or perhaps even slightly shocking is a kind of conformity to fashion – a fashion that creates its own kind of style. Even if we do not agree with this last argument, we might agree that abstract or non-mimetic painting can still be attributed to stylistic groups, schools or periods within the history of art, despite its lack of realistic schemata. Cubist painting, for example, actively rejected the pursuit of reality, but we can still date a work by (say) Picasso, Braque or Frank Stella by its style. The more abstract the movement, the less we can connect schemata, reality and style.

Photography is an inherently mimetic medium. Unlike painting, however, it has no need of schemata because the convincing reproduction of reality is guaranteed by the medium itself. If style were simply a product of the continuing search for realism, then there would be no history of style in photography. But there is: we can still usually date a photograph by its style regardless of its lack of illusionistic schemata. Gombrich's theory, therefore, cannot offer a complete solution to the 'riddle of style'.

Perhaps, then, the greatest limitation of Gombrich's theory of realism in the fine arts remains in its underlying assumption that fine art is – or at least ought to be – a realistic medium. We cannot help but be reminded of the words of Roger Fry: 'If imitation is the sole purpose of the graphic arts, it is surprising

that the works of such arts are ever looked upon as more than curiosities or ingenious toys.'[29] There is so much more to fine art than that.

Our focus on fine art and the illusion of reality does not, of course, divorce it from the six theoretical approaches we studied in the first part of this book. Indeed, they all remain relevant whether or not one agrees with Gombrich's argument in *Art and Illusion*. That is not to say, however, that they are all equally relevant regardless of the individual text. Panofsky's iconological approach is certainly of great relevance to the fine arts, but its use is mostly limited to the analysis of figurative or representative texts. After all, analysis at the primary and secondary levels works only if there is subject-matter (overt, symbolic or even disguised-symbolic) to recognize. It loses its importance when the subject-matter is only a secondary consideration (such as in Post-Impressionist painting), and becomes pretty much a lost cause where there is no discernible subject-matter at all. We might, nevertheless, be able to argue that an absence of subject-matter is revealing at the intrinsic level, but there is little else to be said after that. It is important to understand, however, that the usefulness of iconography either way is not affected by Gombrich's theories of schema and schemata. A recognizable image still has iconographic value no matter how the illusion of reality was arrived at.

The usefulness of formal analysis to the fine arts is even greater than that of iconography. All visual images have formal components whether or not they are partly or even wholly figurative. Fry's emotional elements of design can be helpful to textual analysis in every case. With abstract work, the formal analysis becomes, of course, of supreme importance. As for Gombrich's theories of art and illusion, they are of marginal interest to the Formalists who are so little concerned with the veracity of the visual image. To extreme Formalists such as Bell, Gombrich's theories would indeed be 'irrelevant'.

Art history, on the other hand, can be of immense value to the study of the fine arts, especially when taking a traditional approach in placing a visual text within the narrative story of art. Gombrich's schemata become of particular relevance here: as traditional art history is so concerned with the evolution of style, any theory that claims to solve 'the riddle of style' is rendered extremely important. On the other hand, art history has long been able to relate style (and progression towards the successful illusion of reality) to context, attribution and (to a lesser extent) provenance, without having to rethink how such style was technically achieved. Gombrich's work in *Art and Illusion*, then, is more of a part of art history rather than something that necessitates a change in the way in which art history is done.

As with iconology, the ideology of fine art is most apparent in figurative work. The sociology of representation is far easier when something has been clearly represented, and this typically demands recognizable forms. Having said that, though, the degree of technical skill with which something is represented is of little importance to an ideological approach to its interpretation. We are concerned, after all, with the ideas articulated by a visual text far more than we are with its success as an optical illusion. On the other hand, in art produced in periods in which the illusion of reality was not a preoccupation, we must remember that people, objects and events are often represented in a way that

prioritizes their relative importance rather than reproduces their likeness. In circumstances such as this, an obsession with veracity in fine art could impede us from understanding it ideologically.

Text-based ideological analysis becomes much more difficult when form eclipses content and especially when there is no recognizable content at all. It is still possible, however, to claim an ideology of abstract art, and this is an area in which Bourdieu's analysis of the field of cultural production proves especially useful. Here, an understanding of the economic, political and artistic context in which a text is produced helps elucidate the ideology behind the text, even though that information is not drawn from an analysis of the text itself.

A semiotic approach to the understanding of fine art has many similarities with iconology. Each investigates the extent to which the subject-matter of a text has a meaning beyond that of simple appearances, and acknowledges the difference between denotation and connotation. Both agree on the importance of convention to the communication of symbolic meaning, and both see the ultimate level of analysis as concerning the cultural rather than the individual. Again, a semiotic analysis is heavily dependent on recognizable subject-matter and so is more useful to some types of fine art than others. It cares less than iconology about the conscious intent of the artist, but shares with it a concern for meaning over verisimilitude.

Fine art lends itself to a hermeneutic approach. Geertz likened his interpretative methodology in anthropology to penetrating a literary text, and the close reading of visual texts is fundamental to the kind of visual literacy advocated throughout this book. Hermeneutics, in common with iconology and semiotics, acknowledges the difference between literal and symbolic meaning, though it is more humble in acknowledging its capacity for error. Hermeneutics certainly helps us to understand the fine arts as human experience made visual: a story we tell ourselves about ourselves. In this way, Picasso's *Guernica* is not simply a reading of Basque experience: it is also a warning to us all.

Key Debate

Originals, copies, fakes and forgeries: does it really matter?

When a work of art turns out to be not by whom it was thought to have been, the odds are that it will be devalued art-historically. But should it at the same time be devalued aesthetically? What, then, are we to make of copies, fakes and forgeries –and even innocent misattributions?

To begin to answer this question, let's return to the case of the painting *Man Wearing a Gilt Helmet*, which we discussed in our chapter on art history. Once revered as a masterpiece by Rembrandt, *Man Wearing a Gilt Helmet* was once a leading attraction in the Staatliche Museen in Berlin. But no longer. As the *New York Times* reported in 1985, it had once been considered 'the epitome' of Rembrandt. Indeed: 'For many visitors it ranked equal with the bust of Queen Nefertiti as the single most memorable object' in the museum. But then expert opinion, backed by the Rembrandt Research Project, changed. As the *New York*

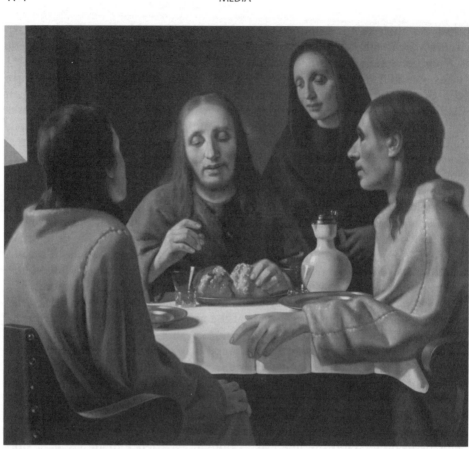

33. *Christ and the Disciples at Emmaus*, originally thought to have been a lost masterpiece by Vermeer, now a famous forgery (1937) by Han Van Meegeren, oil on canvas; courtesy of Stichting Museum Boijmans Van Beuningen, Rotterdam

Times put it: 'it was declared to be not by Rembrandt at all . . . It is a beautiful painting, and it has for generations had an enormous constituency, but it is not by Rembrandt.'[30] The painting is still hanging in the Gemäldegalerie, and visitors can still buy postcards of it. The museum even bravely made it the centrepiece of exhibitions and conferences in 1986 and 2006 when the question of the once iconic painting's (de)attribution was discussed. But the shining helmet has still lost its golden aura. As the Rembrandt Research Project's Ernst van de Wetering admitted in an interview with the German newspaper *Der Tagesspiegel* in 2006: 'The people had the feeling that we took something away from them.'[31]

An even more dashing case study is offered by the painting *Christ and the Disciples at Emmaus* (figure 33), which dramatically came to light in 1937, and was praised by experts as an undiscovered masterpiece by the famed Dutch seventeenth-century painter Johannes Vermeer. Writing excitedly in the prestigious *Burlington Magazine*, art historian and connoisseur Abraham Bredius declared: 'It is a wonderful moment in the life of a lover of art when he finds himself suddenly confronted with a hitherto unknown painting by a great master

. . . And what a picture!' Bredius went on to pronounce: 'we have here a – I am inclined to say – *the* masterpiece of Johannes Vermeer of Delft'. The painting was duly exhibited in Holland and reproduced in the *Burlington Magazine*, care of a 'private collection'.[32] But the new Vermeer was not at all what it seemed.

Although Bredius had waxed poetical about the newly discovered painting in 1937, it was not until the end of the Second World War that things got really exciting. In 1945, another 'Vermeer' painting was found in the collection of Herman Göring, the former Nazi and Commander-in-Chief of Hitler's Luftwaffe. Investigators traced the sale back to one Han Van Meegeren, a little-known Dutch painter and art dealer. The authorities took a dim view of people who had traded Dutch art treasures to the Nazis in occupied Holland, and when Van Meegeren refused to reveal the provenance of the piece, he was sent to jail for treason. But, in a thrilling twist to the story, it turned out that Van Meegeren was entirely innocent of selling Göring a Vermeer: Van Meegeren was in fact a brilliant forger who had painted both this and *Christ and the Disciples at Emmaus* himself. When van Meegeren finally 'confessed' in prison, his status within Holland changed overnight from traitor to hero.[33]

These cases differ, of course, in that one was a misattribution while the other was a forgery, intended to deceive. But they are both very good stories, and they provide an enjoyable hors d'oeuvre for the meat of this section, in which we debate the relevance of the 'genuine' and the 'unique' in art. We will start with a focus on the kinds of misattribution and forgery that have just been described and ask: if the status of a work of art as original, authentic or forged does not alter its intrinsic aesthetic properties, then why should it be demoted from a museum wall when its art-historical status changes? We will then proceed to draw upon the work of the German philosopher Walter Benjamin to illuminate the related (though much broader and deeper) implications of the 'original' versus the technological reproduction of a work of art.

If we think that it makes no aesthetic difference whether a work of art is original, authentic or forged,[34] the decision to demote *Man Wearing a Gilt Helmet* or *Christ and the Disciples at Emmaus* is hardly justifiable.[35] To others, however, that decision does make sense in that forgery is, apart from the moral or legal dimensions of the question, aesthetically significant. Such is the view of Denis Dutton, who argues that even when a forged work of art retains all the formal qualities of the original, they are different aesthetic objects.[36] In what way can the original and its replica be regarded as aesthetically different? This is a challenging notion, but it becomes clearer if we look at the basic argument that sustains it: every work of art should be seen as a performance and an achievement.

Dutton's claim redraws the traditional distinction between the performing and the creative arts. Here, a composer or a choreographer are considered creative artists whereas a piano player or a dancer are thought of only as performing artists. But Dutton argues that that all works of art 'represent the ways in which artists solve problems, overcome obstacles, make do with available materials'.[37] In other words, a work of art necessarily involves human intention and constitutes human achievement. And since the performance and the achievement it represents are intrinsic properties of any work of art, side by side with its purely formal qualities, they must be taken into account in its reception.

An example might help: imagine we are contemplating what we think is a beautiful geological formation when someone tells us that what we have before our eyes is actually a man-made sculpture. Does that information alter our aesthetic appreciation of the object? Dutton thinks it does. He suggests that we would look at the geological formation and at the sculpture with different eyes. In a way, we would be before two different objects. The same applies to the forgery and the original. Forged works of art are a problem not just because they misattribute origin – that is a more relevant aspect within the legal or the ethical realms than an aesthetic matter – but because misattributing origin leads to misrepresenting achievement. And that, Dutton claims, constitutes an aesthetic problem.

In order to see a work of art as an intended, human performance and consequently to understand it as an achievement, one must have some information about the context of its production. One has, so to speak, to place it within a tradition. That provides a point of entry into Walter Benjamin's more complex views on the technological reproduction of works of art.[38] The complexity is grounded in two aspects. First, Benjamin concentrates upon technological reproduction, underlining its distinct character vis-à-vis manual reproduction, which is usually branded as a copy or even a forgery of the original. Second, he is interested not only in the context of the production of works of art, but also in the context of their exhibition and reception. These are in turn linked to the social functions they might fulfil in particular social and historical moments.

Let us begin with the distinction between manual and technological reproduction. According to Benjamin, the technologically produced copy is more autonomous in its relation to the genuine article. It is as if a technological reproduction could have a life of its own, away from the genuine article and free from the original's authority. The technical capacity to bring out aspects which cannot be perceived in the original (via enlargement techniques, slow-motion and so forth) illustrates this 'freedom' of the reproduction vis-à-vis the genuine article. In contrast, the original keeps its authority over the manual copy, which is condemned to live in the shadow of the genuine article.

We might be tempted to associate technological reproduction only with industrial and post-industrial societies, but Benjamin argues that is not the case. The Greeks used casting and embossing to technologically reproduce works of art; wood engraving in the Middle Ages allowed for the reproduction of graphic art, and this was later improved with copperplate, etching, and lithography, and finally photography, which Benjamin designates: 'the first truly revolutionary means of reproduction'.[39] This evolution has increased the distance between the original and the copy, but it has not erased the uniqueness of the genuine work of art. As Benjamin puts it, 'Even with the most perfect reproduction, *one thing* stands out: the here and now of the work of art – its unique existence in the place where it is at this moment' (Benjamin's emphasis).[40] It is on the 'unique existence' of the original work of art that time, duration, and history are played out. The 'here and now' of a work of art, which cannot be reproduced by any technological means (in fact it cannot be reproduced at all), constitutes 'the abstract idea of its genuineness'.[41] And although technological reproduction does not cancel the material duration and the historical witness of the original

work of art, it removes it from perception, makes it invisible. Just as the forgeries discussed in Dutton's work hindered the perception of the work of art as an achievement, the technological reproductions analysed by Benjamin cancel its perception as an historical object.

What happens when duration and history are removed from our perception of the work reproduced by technological means? In a graphic style, Benjamin suggests that something 'starts to wobble' and 'shrinks'. That 'something' that 'wobbles' and 'shrinks' when a reproduction hides the embeddedness of a work of art and its tradition, is what Benjamim famously calls the 'aura'. This fading of the aura is not regarded as an accidental phenomenon. Benjamin relates it to social processes and conditions, especially to 'the increasing significance of the masses in present-day life'.[42] He identifies 'an orientation of reality towards the masses and of the masses towards reality' and underlines that this process has consequences 'not only for thought but also for the way we see things'.[43] And he proceeds by pointing out a tendency of the masses to 'surmount the uniqueness of each circumstance by seeing it in reproduction'.[44]

We can provide our own example of this in action when observing the familiar sight of tourists frantically taking pictures of some famous site they happen to be visiting. The desire to live the unique experience of actually being 'here and now' at the place they are visiting seems to give way to an irresistible impulse to make sure that there will be an available stock of reproduced versions of that circumstance . . .

The eagerness of the typical tourist-photographer might serve as a metaphor for the absolute emphasis upon the display value of images, which, according to Benjamin, regulates their social function in our times. This notion can be better grasped if we consider its polar opposite, the absolute weight of the cultic value of images.

Benjamin argues that the first artistic images served cultic purposes. Created in the service of magical or religious ritual, they were not created to be contemplated by people, but rather to be seen by the spirits or by God. An image of this kind is what Benjamin calls 'a parasite upon ritual'.[45] Reproducing it would be a complete nonsense. At the other extreme of the spectrum we find contemporary images totally emancipated from the ritual context, governed by the principle of total displayability, manifested in technologically reproduced images whose very existence is justified by their visibility, as widely as possible.

This looks like a clean and simple evolutionary line. But things are usually more complicated than that. Benjamin recognizes it, using the example of photographs to illustrate the stubborn persistence of the cultic value of images in modern societies. He refers to photographic portraits of people we love who have died or are far from us. Such portraits are seen as instruments of the cult of recalling those people, thus constituting the 'last refuge' of the cultic value of images.[46] Often in black and white, those portraits remind us that there are many shades of grey to be taken into account in theoretical approaches like the one developed by Walter Benjamin.

Benjamin's views on art, aura and authenticity are famously put forward in his 1936 essay 'The Work of Art in the Age of Mechanical Reproduction'. This is a wide-ranging work, significantly concerned not only with painting but even

more with film and photography, and especially their exhibition value. Further, his agenda is primarily political. It is historically related within the rise of fascism, which he deplores, and intellectually within his advocacy of a revised form of Marxism. But his essay remains hugely important for us here. He reminds us of the perceived importance of the 'original' and of 'authenticity', and how the 'authority' of the original can be deprecated or jeopardized; how the 'aura' of a work of art withers in the age of mechanical reproduction. He shows how much this contrasts with the previous, historically embedded 'cult' value of a work of art – a change which he does not entirely regret. But it seems to us that the 'cult' value or the 'aura' of the authentic, original work of art has not been lost in the age of reproduction. Art-historically we are still – perhaps even more so – obsessed with authenticity. Ours is an age in which forgery is akin to sacrilege, dis-attribution akin to death, and re-attribution to resurrection.

The issue of originals, copies, fakes and forgeries continues to fascinate today. In 2010, the National Gallery in London staged an exhibition, *Close Examination: Fakes, Mistakes and Discoveries*. Much of the accompanying book, *A Closer Look: Deceptions and Discoveries*, detailed the increasingly scientific means available to investigate a painting, from dendochronology to Fourier Transform Infrared Spectroscopy (FTIR). No wonder the exhibition was supported by the British Engineering and Physical Research Council.[47] But no matter how fascinating the investigative techniques and case studies described, a series of deeply embedded cultural assumptions underpins both the exhibition and the book. The author reasonably explains that the purpose of such 'systematic and objective' scientific research[48] is to establish artistic authorship, 'to distinguish between originals and copies, and to identify forgeries',[49] but she does not explain why it is considered so vital to be able to do so. The book never explicitly states or justifies its hierarchies of value. In order to understand these, we need to undertake our own hermeneutic, textual analysis of the exhibition literature, vigilant for what we remember Barthes calling the 'what-goes-without-saying'. As we now come to expect, what is not said is often as articulate as that which is.

A discussion of Raphael's *Madonna of the Pinks* (about 1506–7), for example, shows how this painting was for more than a century considered 'merely a copy' until detailed art-historical and scientific investigation 'proved it was an original'.[50] The painting had been 'dismissed as a copy' and 'hung in a corridor, all but forgotten, for nearly a century', but the painting's rediscovery in 1991 led to the 'reinstatement' of the *Madonna of the Pinks* as 'an original work of art'.[51] A case study of the same artist's *Portrait of Pope Julius II* (1511) culminates with the 'rehabilitation of Raphael's magnificent painting',[52] while additional research concludes with the 're-evaluation' of *The Baptism of Christ* (about 1630–50) by Pietro Perugino.[53] This talk not only of originals and 'mere' copies, but more tellingly of dismissal, 'reinstatement' and 're-evaluation', demonstrates the way in which 'authenticity' is assumed to trump aesthetics at every turn. The real value of a work of art, then, is art-historical. As Frank Wynne puts it in his study of van Meegeren and Vermeer: 'Re-attribution, like a magical incantation, can turn a worthless forgery into a priceless old master,'[54] and the

opposite is equally true. But Nick Groom goes further, introducing a far darker element into the debate:

> Authenticity is the abiding perversion of our times. It is indulged as a vice, worshipped as a fetish, embraced as a virtue . . . Everything it touches turns to gold – or is at least burnished with a scrape of lustre – and in that sense it is the mark of genius, the Midas touch, the apotheosis of capitalism.[55]

If this is so, 'the art-shaped hole' of which Peter Fuller complained in our fourth chapter, is created not by sociology but – ironically – by the history and indeed the business of art.

Further Study

The best place to begin is, naturally enough, with Gombrich's *Art and Illusion*. This is such an important text that discussion of it has been central to this chapter. It lacks, perhaps, the approachability and structural precision of *The Story of Art* (which we examined in chapter 3), but, as with most things, there is no real substitute for getting to grips with the text itself. Although *Art and Illusion* remains Gombrich's best word on the subject, he did go on to collaborate with R. L. Gregory in an edited volume: *Illusion in Nature and Art* in 1973.[56]

Alberti's *Della Pittura*, which is, we remember, held to have been the world's first treatise on painting, is widely available today in edited translations as *On Painting*. The famous system of perspective can be found described (but not demonstrated) towards the end of the first of *Della Pittura*'s three component sections or 'books'. But while Alberti does give practical advice to artists in this volume, he combines it with theoretical and critical passages to reveal both his and the Renaissance's underlying assumptions about painting. Most important among these is the belief that the function of painting is the imitation of reality, as though the viewer were looking though an open window. In order to achieve such verisimilitude, the painter must be knowledgeable about perspectival and other mathematically based techniques. Once these have been learned, the painter must then be taught: 'to follow with his hand what he has learned with his mind'.[57] These fifteenth-century assumptions about painting give grounds for further study and debate – as do apparent inconsistencies revealed by a close reading of Alberti. While arguing for fidelity, for example, he is at the same time able to contend that the artist should selectively improve upon nature in the interests of beauty. Following *Della Pittura*, Alberti wrote *De Re Aedificatoria* (a treatise on architecture in ten books between 1450 and 1472), and *De Statua* (on sculpture) in 1464.[58] Although written some 600 years before *Art and Illusion*, the writings of Alberti share many of the (contestable) assumptions about painting, training and reality as those of the twentieth-century Ernst Gombrich.

The German painter, draftsman, printmaker and writer Albrecht Dürer is credited not only with making Alberti's work on perspective available in printed, vernacular form; he also made his own contributions to fine art technique. He published his *Unterweisung der Messung* (*Treatise on Measurement*) in 1525, while

his four-volume *Vier Bücher von Menschlicher Proportion* (*Four Books on Human Proportion*) was published in 1528, the year of his death.[59] Both are practical works, aimed at helping the practising artist to represent the natural world more realistically. Again, we note the emphasis on learned technique rather than upon 'the innocent eye', together with the continuing assumption that mimetic realism is the true purpose of the fine arts.

Even if they had the education and financial resources to read the few available books on art technique, the artists of Alberti's and Dürer's times still learned to draw and paint in the working studios of fellow artists. The concept of the formal art school is a relatively recent one. London's Royal Academy of Arts was founded in 1768 and sought to establish a rigorous training system for artists. The philosophy of this system was delivered and published by the Academy's first president Sir Joshua Reynolds as his *Discourses on Art*. This highly influential work included a training system for artists that was based not on inspiration but on hard work and disciplined thinking. He called for 'implicit obedience to the Rules of Art' and had little time for concepts such as the 'innocent eye', for it was 'not the eye but the mind, which the painter of genius desires to address'. It is in his sixth discourse, delivered on prize day in 1774, that he famously exalts not the rediscovery of the innocent eye nor even the close study of nature, but the importance of the imitation of other artists in learning to paint.[60] John Ruskin's original concept of the 'innocent eye' is discussed in his *The Elements of Drawing*, which was originally published in 1857. Such was his pre-eminence as a Victorian critic that this – along with many others of his works – went into numerous later editions. Although Ruskin is not now as widely read as he once was, *The Elements of Drawing* was most recently published in an illustrated edition in 1991.[61]

The controversy surrounding the extent to which the 'old masters' themselves used simple optical technology to help them achieve convincing perspective and the illusion of reality is explored by David Hockney in *Secret Knowledge*. Here, he claims to have discovered that artists from Renaissance times had secretly used mirrors and lenses to gain remarkably realistic results by projecting reality on to paper or canvas. The artist then marked the support with traditional media. This, Hockney contends, explains the apparently sudden conquest of realism in fine art in Europe between around 1420 and 1430. Devices such as the camera lucida and the camera obscura were subsequently and frequently used as drawing tools by artists, but then 'this knowledge was lost'. Hockney 'rediscovers' such learning through a practitioner's analysis of the works themselves and by reconstructing and using the optical devices for himself. He concludes that optics were not only used by celebrated artists, but also that the whole history of painting was influenced by their results. Once the extent of the use of optics by artists is realized, 'you begin to look at painting in a new way. You see striking similarities between artists you wouldn't normally associate; you notice big differences between painters who are normally grouped together.' The suggestion that such 'trickery' rather than the innocent eye has been responsible for some of the great masterpieces of Western art is unlikely to be well received by those with a more traditional and reverential attitude towards the old masters and the fine arts. Hockney, however, maintains that great skill was still needed

both to discover and indeed to use these devices successfully: 'To suggest that artists used optical devices . . . is not to diminish their achievements. For me, it makes them all the more astounding.' In addition, he hopes that his study will help people to understand that, in reality, artists have always used available tools in a very practical and pragmatic manner if it helps to improve the quality and therefore saleability of their work.[62] Whether or not Hockney has made his case convincingly will be a matter of debate in the years to come. For our purposes, though, such a theory need not necessarily have to turn the history of art and illusion on its head. It may ruffle traditional notions about artistic genius, but it certainly does not signal a return to the old theory of the 'innocent eye'. Indeed, we may be able to argue that such optical devices are just another kind of 'Gombrichian' schemata.

So much for disputes about painting in the Renaissance. Perhaps one of the best ways to see to how people nowadays learn to draw and paint is to browse through the appropriate section of a modern bookshop or art-supply store. The publications there range from those aimed at the 'serious' to those for the amateur artist. Among the former, we can find such examples as *Human Anatomy for Artists*, which is a detailed compendium of drawings of the human body, including both the visible and the underlying structures. It is telling that this book for practitioners contains *drawings* of human anatomy rather than photographs of the anatomy itself. Presumably, artists learn to draw anatomy by studying drawings of anatomy – an approach that would have made Reynolds proud. At the more recreational end of the scale, we can find such helpful books as *The One-Hour Watercolourist*. The subtitle of this publication, *Time-saving Tips and Exercises to Make the Most of Your Painting Sessions*, betrays the fact that this is an approach that leans far more heavily on Gombrich's schemata than it does on the innocent observation of nature.[63]

The political dimension of this chapter's topic is certainly not among Gombrich's priorities. We cannot say the same about the reflections of Walter Benjamin that we discussed in the Key Debate section. Benjamin makes a major contribution to the socio-political analysis of artistic production and consumption under the conditions of industrial capitalism. For those who wish to deepen their understanding of this, an excellent point of entry is provided by *Aesthetics and Politics*, a book in which Benjamin 'talks' with some of the most important Marxian cultural thinkers of the twentieth century (Theodor Adorno, Ernst Bloch, Bertolt Brecht and Georg Lukács). The conclusion by Fredric Jameson is highly recommended.[64]

An alternative emphasis on the political implications of art and the image in modern consumer society is offered by Guy Debord in his *Society of the Spectacle*, published in 1967 and made famous during the events that shook Paris in May the following year.[65] But now, 1968 is more than forty years ago. Are the theses formulated in such texts still relevant in the so-called post-industrial societies in which we live today? How far has the aesthetic debate developed concerning changes in socio-cultural conditions since Benjamin and Debord? *The Postmodern Arts: An Introduction*, edited by Nigel Wheale, provides potential answers to those questions.[66]

All these suggested further readings link the topic of the present chapter

with other parts of this book, especially the chapter on ideology. There is also a clear connection between what has been discussed in this section and in chapter 2 on form. The very idea, of course, that fine art even *ought* to be concerned with the realistic representation of the real world was challenged by Fry, Bell and many of the other theorists we met in chapter 2. The same concept has also been challenged in practice by painters from the Post-Impressionists to the present day. And, finally, the decline in the importance of mimetic fine art has coincided with the rise of photography, whose relationship with reality – together with its claims to be considered art – forms the basis of the next chapter.

8

PHOTOGRAPHY

This chapter considers the complex relationship between photography and reality. It begins with a brief history and technology of the medium. It shows how it works, and how it is able to represent the real world itself in fixed, two-dimensional form. We will see how the early pioneers succeeded in capturing the image in the early nineteenth century, and how the technology of photography was developed in France, Britain and the United States. We will then see the various uses to which the new medium was put. The ease and mechanical accuracy with which photography is able to reproduce reality, however, leads us to question whether it can therefore be considered an artistic medium. In support of this argument, we will discuss the objections of Roger Scruton, who claims that photography is unable to transcend its subject-matter and so cannot be considered art. In contrast, we will then consider the role of authorship in photography; the extent to which the attitude, creative choices and technical skill of the photographer suggest that photography cannot be considered an objective reproduction of reality at all. We will use a famous depression-era photograph by Dorothea Lange to demonstrate the role of subjectivity in photography, while the work of Aaron Siskind will be used to show the creative potential of form over content. We will conclude with André Bazin's theory of the ontology of the photographic image and its special relationship with reality.

With the fine arts, people struggled long and hard to achieve the illusion of reality. With photography, the illusion is guaranteed by the process. The relationship between the photograph and reality, however, is considerably less than simple.

To understand the medium of photography, together with its relationship with reality, it is necessary first to understand how it came into being. This history of painting goes back to prehistoric times. The history of photography, however, is little more than 150 years old. Rock painting in southern Africa can be dated to around 25,000 BC, while the first surviving photograph (painting with light) was made only in about 1827. Yet to arrive at Niépce's *View from Balcony Window*, we do have to go back a little further, for it took several hundred years for the constituent parts of photography to come together and produce the first photograph. The invention of photography depended upon the confluence of physics and chemistry. Physics was required to create an image; chemistry was needed to preserve it. Of the two, the physics proved considerably easier. Indeed, the basic idea of the camera obscura had been known for centuries. Camera obscura means 'darkened room' and explains where the modern word 'camera' comes from. As early as the tenth century, it was noted that a darkened room with a small hole open to daylight would result in a 'real-time' colour image of the scene outside appearing on the wall opposite the opening. The image was, admittedly, fairly crude and appeared upside down. By Renaissance times, however, lenses were added which not only improved the image, but which also made it appear the right way up. With these improvements in optics, it was discovered that a suitably constructed box could replace the darkened room. The result was recommended as a device to help people draw and paint. The trouble was that the resulting image was still entirely ephemeral. If only it could be fixed or made somehow permanent.

The chemistry of photography goes back to the early eighteenth century, when German scientist Johann Heinrich Schulze discovered in 1727 that certain kinds of silver chemicals were photosensitive – they turned dark when exposed to light. This was a key discovery to the invention of photography, and was seized upon by people such as Thomas Wedgwood (son of the great British potter Josiah Wedgwood). Wedgwood experimented with ways to record images photographically, but although he succeeded in getting primitive, negative silhouettes of objects such as leaves, the resulting image continued to darken until everything was so dark that no discernible image remained. He was unable, in other words, to fix the photographic image, and his experiments got no further.

It is generally held that it was the Frenchman Joseph Nicéphore Niépce who produced the first real photograph in about 1827.[1] This he did by coating a metal plate with a tarry substance called bitumen of Judea and exposing it for eight hours in a camera obscura. Where the light hit, it hardened the bitumen. Where it did not, the bitumen remained soft. The result he called a 'heliograph' (a 'sun drawing'), and he discovered that he could obtain better results by using glass instead of metal as his base. The results were increasingly good, but still not brilliant. The quality was far less than what we expect today, and eight-hour exposures in outdoor sunshine made the process only vaguely practical. What really set photography alight was Niépce's subsequent collaboration with countryman Louis Jacques Mandé Daguerre. They signed a partnership together, following which Niépce died. Daguerre not only ended up a very rich man, but also gave his name to the resulting photographic process: the daguerreotype. It was a hugely effective system, which was formally unveiled to the French Academy

of Sciences on 7 January 1839. The daguerreotype took the form of a highly polished layer of silver on top of a copper plate. It was sensitized with iodine to create a silver iodide surface. The plate was exposed in a camera, developed in mercury vapour and fixed in a salt solution before the whole thing was dried. The resulting image had a number of advantages over Niépce's heliograph. First, the resolution was much better – especially as the process was perfected over time. Second, Daguerre's plates could be exposed in less than a minute, compared with Niépce's eight hours. This also meant that, with appropriate lighting, daguerreotypes could not only be made indoors, but could also be used to photograph people, who, unlike objects, could not be expected to hold still for hours on end. Finally, where the heliograph had presented a negative image (that is to say, it was dark where reality was light – and vice versa), the daguerreotype (when viewed at the correct angle against the light) presented a positive, 'natural' image.

Such was the technical and commercial success of Daguerre's process that by 1853 three million daguerreotypes had been produced in the USA alone. The process could be used by small-town photographers, and those who had not previously been able to afford to commission paintings were now able to own chosen views and portraits for themselves. More than that, of course, they believed in the genuine authenticity of the photographic image. It was like owning a little piece of reality itself. Despite its enormous success, however, the daguerreotype system had a number of drawbacks. It was viewable in positive (as we have seen) only at certain angles. It was an expensive process in terms of both materials and time. The resulting image was also fragile (to say nothing of heavy – it was hardly suitable for a wallet or purse). Most importantly, though, the daguerreotype was a one-off process in which no copies could be made. This was a major drawback – especially when we think of the importance of mechanical reproduction in photography today. What we want, whether we are proud parents or commercial enterprises, is unlimited numbers of identical copies for distribution to family or customers. This the daguerreotype was unable to provide.

The solution was provided by an Englishman, William Henry Fox Talbot. Talbot had been working independently of Daguerre, and was dismayed to hear of the Frenchman's presentation to the French Academy. Talbot, too, had succeeded in fixing the photographic image, and announced his process to the Royal Academy in London just two weeks later. But instead of working on copper, Talbot had been working on paper. This he sensitized with silver chloride, exposed in sunlight and fixed with sodium chloride. By placing items such as leaves and lace against the sensitized paper, Talbot was able to make delicately intricate contact prints of the objects in question, which he called 'photogenic drawings'. The use of paper was helpful enough, but Talbot went on to make two further important developments. First, he began to use a camera instead of contact prints. In this, he matched Daguerre. But, second, he went on to invent the positive–negative process, and in so doing advanced photography where Daguerre had stopped. Talbot had turned photography into a reproducible medium.

What Talbot realized was that by placing one of his finished negative photographs over a second piece of sensitized, but as yet unexposed, piece of photographic paper and passing light through the former to the latter, the

resulting print would become dark where the negative had been light, and light where the negative had been dark. So, while the negative had been the opposite (in terms of light and shade) of the original scene, this second exposure produced a consequent, positive image in which the original relations were restored. More than that, once the original negative was in place, an almost unlimited number of positive prints could be produced from a single negative.

Talbot worked at refining the process, and improved chemistry helped him reduce exposure times still further. He patented the process in 1841, and called it the 'calotype' (from the Greek *kales* (beautiful) and *typos* (impression)). He then took a crucial step for mass media by publishing the first photographic book, *The Pencil of Nature*, in six instalments from 1844 to 1846. Not only did the book contain photographs, but it also served as a seminal exploration of what photography could achieve and where it might be headed.

It is tempting to say that, with Talbot, modern photography was born. This is a somewhat dangerous claim, however, because it involves entering into what is often called the 'primacy debate'. Here, historians, often with nationalist agendas, vigorously dispute who was the first, sole and original inventor of photography (or any other new 'discovery' for that matter). It is amazing how the French tend to champion Daguerre, and the British Talbot! National agendas aside, though, it is a debate that doesn't really get us anywhere because, in reality, technological advances (and much else besides) tend to be simultaneous and the result of collaboration, if not directly between individuals, then as a result of building upon the work of common 'ancestors' such as Niépce, Wedgwood and Schulze.

Further advances in the history of photography were also built upon previous discoveries. The processes developed by Daguerre and Talbot were indeed seminal, but with them photography remained in the hands of experts and specialist commercial practitioners. Photography did not become available to the general public until the introduction by George Eastman of the Kodak camera in 1888. Now the camera was bought ready-loaded with enough roll film for 100 exposures, and it was designed for use with the minimum of fuss. Once the film was all used up, the whole camera was returned to Kodak headquarters in Rochester, New York, for processing.

The production of roll film was significant not only for the enthusiastic amateur, but also for the serious professional.[2] Previously, photography had depended on the use of photographic plates of varying sizes and degrees of fragility. Such was the chemistry required to prepare and to process them that practitioners were either confined to the studio or had to take vast quantities of equipment (often including a tent for use as a darkroom) on location with them. The whole thing was normally accomplished with the help of numerous assistants. Roll film, however, led to the manufacture of smaller, hand-held cameras which could be taken out pre-loaded with enough film for multiple exposures, and which would not need to be processed until the role was complete and the opportunity presented itself. This meant that photographers were not only liberated in terms of location and subject-matter, but were also able to work much more spontaneously, responding to the things that they saw instead of having to construct them.

34. Alfred Stieglitz, *The Steerage*, 1907, photograph; courtesy of the Library of Congress, Washington, DC

This is just what happened with the celebrated photograph, *The Steerage*, taken by American photographer Alfred Stieglitz (see figure 34). In 1907, he was on board a steamer called the *Kaiser Wilhelm II* when he saw an excellent photo opportunity.[3] He raced back to his cabin, found his portable camera and got the shot, which he later published in *291* magazine. The result is a

confluence of form and content presented not from the imagination but from real life. On the upper deck, we see mostly male passengers in bowler hats and straw boaters looking curiously over the railings. Below are mostly women and children, the most prominent in headscarf and shawl. They have assembled a makeshift washing line on deck: for them the journey is not one of adventure or excitement, but one in which the drudgery of domestic life goes on. The class divisions that provide both the physical and metaphorical content of the photograph also create its major compositional element. The photograph (not unlike Raphael's *Transfiguration*) is divided into two separate yet balanced sections, one upper and one lower. Railings, booms and decking divide and frame the composition horizontally, giving it an almost 'flat' composition. Yet the panel-like construction is enhanced by three strong diagonals (a pipe, a stairway and a gangplank), which not only break up the ordered flatness, but which introduce depth into the composition. The result is one of ordered disorder in which the eye, while never quite agitated, can at the same time never settle. It is an image that was praised by Picasso in the same year that he was working on *Les Demoiselles d'Avignon*.

Technical advancements in photography did not, of course, end with the invention of roll film. In 1925, the first 35 mm camera was produced by Leica in Germany, and this convenient format remained something of an industry standard into the twenty-first century. Kodak introduced the first colour film in 1935,[4] while the 'instant' Polaroid camera and film were invented by Edwin Land in Cambridge, Massachusetts, in 1947. The most important recent developments involved electronic as opposed to chemical means of storing the image, and have led to a much-trumpeted 'digital revolution' in photography. Sony produced the first video still camera (the MAVICA) in 1982, while Kodak launched a photo CD storage system in 1990. The same company claimed the first high-quality digital camera (the DCS 460) in 1994, and the mass marketing of digital cameras for consumers began in 1996. By the early years of the twenty-first century, steady increases in image quality led to digital eclipsing chemical technology and traditional film cameras in both the professional and domestic markets.

With the proliferation of cameras and consumer photography today, it may be difficult to imagine a world without photographs. We have grown up with it, and the taking and viewing of photographs has become a part of everyday life. It is important to stress, however, that in the early days photography was something wonderful and new. Once the technology had been perfected, what was this thrilling new medium going to be used for? The technology, it seemed, preceded the purpose. For the early pioneers, it was enough to demonstrate that it worked, and that the natural world could be 'frozen'. Niépce's rooftops and Talbot's leaves were more remarkable in their existence than in their subject-matter. They didn't tell us much new about the world, other than that it could now be photographed. Once the novelty wore off, however, photography began to open up a visual world as never before.

Photography was able to show people places they would not otherwise have been able to see. Maxine du Camp, for example, photographed the colossus of Abu-Simbel in 1850. Few people were able to travel to Nubia themselves

(even fewer than today), but thanks to photography, they were now able to see the wonders of the world for themselves.[5] To be sure, there had been drawings and other 'artist's impressions' of remarkable sites before, but the photograph had an authenticity that was lacking in fine art. Du Camp even included a man standing by the colossus to give the photograph a genuine sense of scale. In painting, scale could be exaggerated for effect, but, with photography, people thought they could see the genuine vastness of the colossus 'with their own eyes'.

In addition to places, people could now see people. Nowadays, we are entirely used to seeing photographic images of the politicians and the celebrities of the day. This is, of course, only recently the case. Until photography, most Americans had never seen a 'true likeness' of their president. James Knox Polk was the first sitting president to be photographed in 1849, although more people are familiar with Scots-born Alexander Gardner's famous portrait of Abraham Lincoln in 1865.[6] The British, meanwhile, were delighted to see the great engineer Isambard Kingdom Brunel, resplendent in his enormous hat and with a cigar clamped between his teeth, photographed against the launching chains of his ship *The Great Eastern* in 1857. In the sixteenth century, Henry VIII had felt deceived into marriage by an overly flattering painted portrait of Anne of Cleves. The photograph, it was believed, could now show people as they really were.

Photography brought people closer not only to people and places but also to the world of events. Again, there had been a tradition of drawing, painting and printmaking to show people both national and international events of importance. In times of conflict, for example, official 'war artists' would travel with armies to record battles and army life for the newspapers and magazines back home. War tended to look very exciting and glamorous when represented in fine art, but photography – even when not directly concerned with the harrowing details – managed to make it look, at least, slightly squalid. The Englishman Roger Fenton is thought to have been the first real war photographer, and he returned to London in 1855 with pictures of Balaclava and the Crimea, including his famous *Valley of the Shadow of Death*.[7] Fenton recorded that for the taking of this shot, it 'was plain that the line of fire was upon the very spot I had chosen', so he had, reluctantly, to move his camera 100 yards away.[8] In North America, Matthew B. Brady organized a team of photographers to document the Civil War. According to Beaumont Newhall, he was 'almost killed' at Bull Run.[9] Among his assistants was Alexander Gardner, who published *Gardner's Photographic Sketch Book of the War* in 1865–6. These photographs are very static by today's standards, but for many people they provided their first real glimpse of warfare – including the dead.[10] Gardner went on to photograph Lincoln's second inaugural address in 1865, together with his funeral procession that same year.

Photography was not only concerned with wonder, celebrity and world events, however. From its early days, the medium was also used to document social conditions and to agitate, visually, for social change. The Scottish photographer Thomas Annan documented slum housing conditions in Glasgow from 1868, while in New York, Jacob A. Riis sought to expose crime and poverty in

the tenements of the Lower East Side from 1888. These were conditions that the well-to-do would never have seen until photography provided them with the visual evidence.

These examples of the early photography of places, people, events and social conditions have all deliberately been taken from the nineteenth century not only to demonstrate the uses to which the new medium could be put, but also to show that photography represented a new way of seeing the world. It was a way of seeing based upon the unique relationship between the photograph and the thing photographed, and it had an authenticity that fine art could never accomplish. Photography, indeed, had a special relationship with reality, which persuaded people that when they looked at a photograph, they were looking at reality itself. They could say, 'this is Abraham Lincoln', when actually they were looking not at the man but at a photograph. They knew that the camera, the lens and even the original plate had been in the presence of the president, and that the resulting image had not been drawn by hand. They believed, rather, that it had appeared on the plate and then the paper without human intervention. It is in this way that Talbot, the author of *The Pencil of Nature*, was able to describe Lacock Abbey (which he photographed in 1835) as the first building 'that was ever yet known to have drawn its own picture'.[11] It is an attitude that suggests that a photograph is an unmediated medium with a direct, uncomplicated authenticity and which provides straightforward evidence of the thing photographed. As it is a mechanical recording device, it can only record the truth.

It is this argument for the mechanical authenticity of photography that, at the same time, argues against claims for photography as art. Photography, so the argument goes, is easy: so easy, indeed, that with an auto-focus, auto-exposure, auto-everything camera, even a well-trained gibbon could produce satisfactory results. If it isn't difficult, it cannot be art. This is not, of course, a terribly sophisticated argument. A more intelligent objection would be based upon photography's umbilical relationship with its subject-matter. Here, we would contend that photography is simply a mechanical record of what is already out there. It is like a photocopying machine or a security camera, which simply duplicate that which is already in front of us or point a reprographic finger at something that is already out there. In both cases, we respond not to the photograph itself, but – simply – what it's *of*. In about 1852, for example, the British photographers Albert Southworth and Josiah Hawes produced a daguerreotype of a man undergoing an operation under ether (see figure 35). It is an excellent record of what took place: we can see the surgeons in their frock-coats, a gruesome collection of bowls and knives, and the patient himself, stretched out with a happily vacant expression and a pair of woolly socks. It would provide excellent illustrative material for a lecture on mid-nineteenth-century anaesthetic practices. Moving forward to the period just before the Second World War, we find that American press photographer Sam Sphere caught a spectacular shot of the airship *Hindenburg* exploding at Lakehurst, New Jersey, in 1937. The *Hindenburg* was an 800-foot-long, German-built Zeppelin, which carried passengers by air across the Atlantic Ocean. Unfortunately, it relied on highly inflammable hydrogen for its buoyancy, and shortly before landing in the USA it exploded in spectacular style, killing thirty-six of its passengers and crew.

35. Albert Southworth and Josiah Hawes, *Early Operation Using Ether for Anesthesia*, 1847, daguerreotype, 14.6 x 20 cm (5 3/4 x 7 7/8 in.); courtesy of The J. Paul Getty Museum, Los Angeles

Sphere got the shot at the moment it first burst into flame. It is a remarkable and dramatic photograph: we cannot help but be impressed by it. It is as though we were there ourselves at exactly the right moment. What impresses us, though (it might be argued), is its subject-matter – a subject-matter that would have been impressive in its own right if only we had been there to witness it. The photograph does not create the drama; it just reports it. That cannot be art.

Photography, according to this argument, is simply a medium through which we observe the natural or real world. If it only reproduces what is already out there, it follows that a photograph cannot transcend its subject-matter; it can only be beautiful if it is of a beautiful thing. Certainly, early photography was concerned with beauty as well as with the recording of remarkable places, people and events. Nineteenth-century photography saw an active 'pictorialist' movement, when practitioners of the new medium competed with painters in an attempt to capture 'pictorial' scenes. Peter Emerson and Thomas Goodhall, for example, produced soft and sumptuous images of rural life in the waterlands of England in the 1880s. *Rowing Home the Schoof-Stuff* (1886) shows a solitary man at twilight with a boatload of reeds, his oars hardly stirring the water in which he and the Norfolk sky are reflected with a painterly tranquillity. This is an undeniably beautiful photograph. However, it could at the same time be argued that it takes its beauty entirely from what was already a beautiful scene (see figure 36).

36. Peter Emerson and Thomas Goodhall, *Rowing Home the School-Stuff*, 1886, platinum photographic print; courtesy of George Eastman House, International Museum of Photography and Film

This is very much the view of the British philosopher and theorist Roger Scruton, who wrote: 'If one finds a photograph beautiful, it is because one finds something beautiful in its subject. A painting may be beautiful, on the other hand, even when it represents an ugly thing.'[12] Scruton's argument is articulate, but flawed. Certainly, we have to admit the close relationship between a photograph and its subject-matter. That much is understood. It should be clear, however, that there is much more to a photograph than just its subject-matter. Most obviously, a beautiful subject-matter does not guarantee a beautiful photograph. In order to render a beautiful scene beautifully, it is necessary for the photographer to make a number of both technical and creative choices. The Norfolk scene witnessed by Emerson and Goodhall, for example, existed independently of them and would have been beautiful whether or not they had been there to witness, let alone record, it. But being there was not, on its own, enough. They began by recognizing the aesthetic potential of a photograph of a man rowing a boat full of reeds home over still water against a sunset. They could have chosen many other scenes (a tree, a gate, a heron or a rat-catcher), but they selected this. Selective choices are creative choices. They then proceeded to decide how to photograph this particular scene in terms of composition. Where would they set up their equipment in relation to the bank, the boat and – crucially – the sunset? Having agreed upon that, how would they frame the subject from their chosen point of view? What would be the proportion, for example, of water to sky? And would the boat be placed in the centre or to one side? Compositional choices are (as Roger Fry would have had no trouble reminding us) aesthetic choices and affect the form – and therefore the meaning – of the final photograph. Then there would be the vital decision about precisely when to press the shutter. How far should they allow the sun to go down before making the exposure, for example? And should (again, for example) the oars

be in the water or raised slightly above it at the decisive moment of the shutter release? Technically, they had to make sure that their subject was in focus – but how sharp did they want the overall focus to be? Did they want 'scientific' precision, or were they aiming for a 'softer', more romantic effect all round? The exposure needed properly to be calculated not just to obtain a recognizable result, but also to allow for the required range of shadows and highlights. Was the man in the boat to be in detail or in silhouette? The shutter speed had to be calculated in relation not only to the movement inherent in the scene, but also in consideration of the amount of light admitted when calculating the exposure and, consequently, when opening or closing the iris in the lens. As every (decent) photographer knows, these technical decisions all have creative consequences and directly affect the final result. A dozen of us, all standing on the bank in the fading English light, could have photographed the same scene, resulting in a dozen different results from that of Emerson and Goodhall.

The photograph is by no means completed at the scene. Once the traditional plate or film has been exposed, it is necessary to make the photographic print, and here a plethora of choices (again a combination of the technical and the artistic) influences the eventual image. Emerson and Goodhall, for instance, chose to print *Rowing Home the School-Stuff* using expensive platinum rather than the more usual silver-based chemistry. Platinum results in a softer, more subtle scale of greys than did traditional techniques, which can be used for greater contrast and more graphic impact. Emerson and Goodhall made the choice they considered most appropriate to this tranquil, pastoral scene. The printing stage offers additional choices for framing, cropping and enlargement, gradations of contrast and lighter or darker prints. A skilled practitioner can make selective changes to individual parts of the final print – even before more drastic special effects might be introduced. The eventual photograph, then, is the result of creative choices that began at the very setting up of the tripod.

We have concentrated thus far on traditional methods of photography. This is not only because our particular case study is an analogue image, but also because even in the second decade of the twenty-first century, the number of traditionally made images available for analysis still considerably outnumbers those made by digital technology. That said, the vital ingredients of both technical and creative choice apply to both traditional and digital techniques. When Scruton says: '[t]he camera is not essential to that process: a gesturing finger would have served just as well', his argument is equally hard-hitting.[13] And either way, we need only a limited knowledge of the most basic photographic technique to understand that Emerson and Goodhall's idyllic scene did not, whatever Scruton says, photograph itself.

Our objection to Scruton's assertion that photography can only be about its subject-matter echoes Fry's contention that it is the emotional elements of design that carry the meaning of a work of art, and that this meaning is communicated not so much by content as by form. Indeed, it would be informative to reread Fry, substituting the word 'photograph' at every instance of the word 'painting'. The resulting argument might be much the same: what we respond to is not so much what a photograph shows, but how it shows it. We do not, we remember, respond to Impressionist paintings as a result of our fascination

with water lilies or haystacks, but because of our emotional response to form. In photography should we not, as Fry said of painting: 'give up the attempt to judge the work of art by its reaction on life, and consider it as an expression of emotions regarded as ends in themselves'?[14] A photograph, after all, has formal properties that transcend its subject-matter. This is true even of the most seemingly mundane image. Talbot's 1844 calotype of articles of china may, on the one hand, seem like the sort of photograph we might take in order to record our property in case of theft. Here, Talbot, has laid out four horizontal rows of china on vertically aligned shelves. The arrangement is not haphazard, however. It is deliberately balanced and symmetrical, and diverse individual pieces are arranged to create an ordered and balanced whole. Important pieces occupy the compositional centres of attention. Scruton might argue that the subject itself was arranged in this way, and it is that to which we are responding. He has a point, of course, but only inasmuch as he would have had a point with Emerson and Goodhall – to say nothing of Cézanne or Matisse. Fry would argue that we relegate the subject-matter, and concentrate instead on the elements of design – many of which apply to photography as much as they do to painting. The composition in Talbot's photograph depends as much on the position of the camera (and, therefore, of us the viewer) as it does on the arrangement of the china itself. We are placed dead centre, and our field of vision is almost filled. There is no attempt to create the illusion of depth. What appeals to us is not only the mass of the objects themselves, but the space between them – the 'negative space' created by the absence as much as by the presence of things. The china appears in a creamy, evenly lit hue, which almost makes it pop out from the even and indistinguishable background. Yet it is the rich mahogany brown of the even background that impresses us as much as the china against which it is contrasted, along with the even, solid lines of the shelves that divide the plane with such quiet confidence. More than that, we notice how in this print the brushwork of the hand-applied photographic emulsion has been left in place at the four edges of the photograph, so that the order of the composition emerges from the disorder of the 'outer world'. Fry would have been proud.

These examples show us that photographs are not just about subject-matter. Just like drawing or painting, subject-matter may be more or less important depending on the individual text or artist. The proportional relationship between the two, as in painting, may not always have been premeditated. But, as photography progressed, some photographers – just like certain painters – began deliberately to create images in which form was the more important of the two. Paul Strand, for example, began to photograph everyday objects in unusual ways. His *Shadows, Twin Lakes, Connecticut* of 1916 is a study of diagonals, clean edges, contrasts and strong light, which appear to be based on someone's porch or deck. It tells us very little about the deck itself because that isn't the point at all. Similarly, his *Wire Wheel, New York*, made two years later, is a study of curves and straight lines in which we become slightly disorientated when we try to make out the physical layout of the car itself. Had Strand been hired to illustrate a manual on home improvement or motor-vehicle maintenance, he would clearly have been fired. His objective, however, was never to

get us to respond to the subject-matter or even to point a Scrutonian finger at something that was already beautiful. Rather, he wanted to lend us his eyes and, in so doing, turn an object into a composition. It is an attitude betrayed by the title of his 1916 photograph: *Abstraction, Bowls, Twin Lakes, Connecticut*. Strand, of course, was not alone. Edward Weston photographed clouds in New Mexico in the 1920s, not out of meteorological fascination but because of the shapes they made. The idea was that we should respond not with 'what a great cloud', but 'what a great photograph!' It is a reaction that would have pleased Aaron Siskind, one of the most intellectual of American photographers. Siskind began very much in the documentary tradition in the 1930s, when he was a member of the socially committed Film and Photo League in New York. He joined them in documenting topics such as life in Harlem and the Bowery, but he became increasingly interested in the formal properties of photographs as opposed to their subject-matter. By 1942, he had set out on his own, concentrating on shape, pattern and texture at the expense of factual information. As his early biographer Nathan Lyons put it: 'Subject matter as such ceased to be of primary importance.' This directly echoed Siskind's own conviction that 'the meaning should be in the photograph and not the subject photographed'.[15] Or, as Siskind himself explained, a photograph, like a painting, should be valued 'as a new object to be contemplated for its own meaning and its own beauty'.[16] We have only to look at Siskind's later work to understand this. Here, graffiti, battered enamel signs, discarded gloves, peeling posters and tar-filled cracks in the road are rendered into abstraction by the photographer (see figure 37). The ugly is transposed into the aesthetic, and Scruton's viewpoint becomes untenable.

Scruton, it might be argued, is on stronger ground when it comes to documentary photography. The word 'documentary', after all, implies that it is there to document – to record – rather than to transform into the aesthetic realm. In this context, then, we are far more likely to agree with Scruton that a photograph is 'a representation of how something looked. In some sense, looking at a photograph is a substitute for looking at the thing itself.' He goes further: 'it is neither necessary nor even possible that the photographer's intention should enter as a serious factor in determining how the picture is seen.'[17] But is it? Imagine we are working for a real-estate company that has commissioned us to take photographs of a house it is putting up for sale. It will surely be our intention to make the house look as good as possible. We will probably wait until the sun comes out and, then again, until it is shining on to the most attractive aspect of the house (usually the front). We will probably try to frame our photograph to include any trees or flowers that might be in the foreground, while deftly excluding the slaughterhouse next door. If there are trash cans at the front, we will probably move them to the back before taking the full-colour shot. A judicious use of lenses will even make the property look spacious. Potential customers will almost hear the birdsong as we release the shutter. This may seem like a cynical exaggeration – but consider the real-life case of a house offered for sale in Dungeness, England, in 2009. It was marketed as a charming fisherman's cottage set in half an acre of land within the Dungeness National Nature Reserve. All this was true, as was the picture showing the little white house,

37. Aaron Siskind, *San Luis Potosi 16*, 1961, photograph, Aaron Siskind Foundation;
courtesy of the Center for Creative Photography, University of Arizona

surrounded by grassland and a broad blue sky (see figure 38). What the bro-
chure did not show you was one of Europe's biggest nuclear power stations less
than 100 yards in the opposite direction (see figure 39). It was all a question of
angles. The case caused widespread merriment in the British national press with
the agents previously unaware, no doubt, that their creative use of the camera
was to become, quite literally, a textbook case.

 This is, of course, a fairly extreme example, but not one that we had to invent.
When we take a photograph we all, whether we are working professionally or
simply snapping our friends, have the intention of saying something about
something. Why else would we say 'smile' when we press the button? Serious
documentary photographers are just the same. They, too, have something to
say, and they want people to react to the photographs they produce. The docu-
mentarians of New York and Glasgow housing conditions in the nineteenth
century clearly intended to show how bad they were, and so photographed them
accordingly. Even the initial decision that something is worth documenting is a
subjective one, and, in practice, photographers will always bring something of
their predisposition towards the subject with them. A classic example is that of
the photographers of the Farm Services Administration (FSA), who were sent
to document the terrible farming and living conditions the rural poor were expe-
riencing during the American dust bowl and Depression of the 1930s. Much of

38. Sales brochure shot of a cottage for sale, Dungeness, England, 2009 Copyright Press Association

39. The same cottage (figure 38), photographed from a different angle Copyright Press Association

their work will be familiar to us today, such as Walker Evans's starkly balanced images of impoverished homes and families in Alabama, and Arthur Rothstein's memorable image of a bleached-out animal skull against the parched earth of a formerly productive land. Perhaps the most famous of all is Dorothea Lange's *Migrant Mother, Nipomo, California* of 1936 (see figure 40). Here, we see a poor, worn-out, furrowed-browed woman seated in worried contemplation with

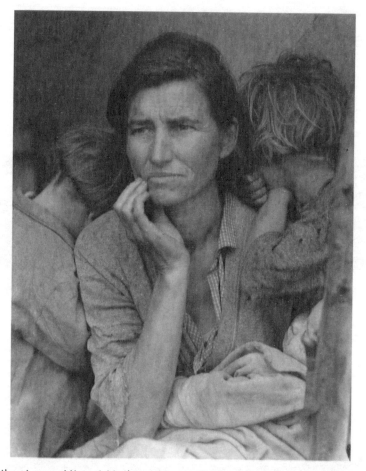

40. Dorothea Lange, *Migrant Mother, Nipomo, California*, 1936, photograph; courtesy of the Library of Congress, Washington, DC

her hand against her chin. Her two ragged children press themselves close on either side of her, their faces deliberately hidden from the camera's view. All is not lost, however, for the image seems to remind us of Renaissance studies of the Madonna and child, and here they are transposed into the American Depression. The woman may be poor, but she is still a mother with her own dignity and her own worth.

This and the many other photographs of the FSA were produced with the deliberate intent of creating support for economic policies to ease the Depression. Just like all the other photographs, Lange's *Migrant Mother* is made with conscious authorial intent. As Susan Sontag (1933–2004), one of America's leading public intellectuals, argued in *On Photography*: '[p]hotographs are as much an interpretation of the world as paintings are'. In this way, the 'immensely gifted' photographers of the FSA 'would take dozens of frontal pictures of one of their sharecropper subjects until satisfied that they had gotten just the right look on film – the precise expression on the subject's face that

supported their own notions about poverty, light, dignity, texture, exploitation and geometry'.[18]

Anyone who has taken photographs with any degree of seriousness will agree with Sontag, who could also be used in support of our previous example of real-estate photography. At the same time, however, we would be very foolish to disregard the importance of subject-matter in any kind of photography – certainly documentary, and even abstract. We have used examples from the early years of photography to show how the new medium enabled people to see places, people and events they had never seen before. People then felt that they had seen Abraham Lincoln (or, today, Diana, Princess of Wales) when they had in fact only seen them in photographs. What they believed – and what we must realistically accept – is that whatever we know about selection, subjectivity, creativity and authorial intent in photography, there is nevertheless an inevitable and special relationship between photography and reality. There remains, as we have already seen, an 'umbilical' connection between the object and the image.

This special relationship between photography and reality is something that famously intrigued the French intellectual and theorist André Bazin (1918–58). Bazin was essentially a film theorist who was the founder and leading light of the influential periodical *Les Cahiers du Cinéma*, which has been described by James Monaco (of whom more in the following chapter) as 'the most influential film journal in history'.[19] Bazin realized that the photographic image was fundamental to the cinema, and so the opening essay of his *What is Cinema?* was dedicated to 'The Ontology of the Photographic Image'. Here, Bazin was determined to get to grips with the ontology (we might also say 'essence') of photography. He realized, however, that this was a very complex issue. On the one hand, he acknowledged the clear, physical relationship between the object photographed and the photograph itself. 'The photographic image is the object itself', he declared, but at the same time 'freed from the conditions of time and space that govern it'. So, a photograph of Abraham Lincoln is, undoubtedly, *of* Abraham Lincoln, but while the photographed Abraham Lincoln was captured in a particular place at one precise moment in 1865, the photograph *of* Abraham Lincoln can be seen anywhere at any time. The photograph, then, is not reality itself (how could it be? Lincoln is long dead) but because of the inherent qualities of the medium, it is at the same time a technologically captured impression of reality. Bazin put it beautifully: the photograph is like a 'fingerprint'. It is not the finger itself, but a record of the thing itself made by the thing itself. So: 'The photograph as such and the object in itself, share a common being.' Yet Bazin goes even further, claiming that: 'Photography can even surpass art in creative power.' There is something surreal, he argues, in photography because, just as in Surrealist painting, 'the logical distinction between what is imaginary and what is real tends to disappear'. That is how the photograph manages to be 'an hallucination which is also a fact'.[20]

What we are left with, then, is a visual medium that has a dual nature. To some, this may be a distinct criticism of photography: it is neither wholly real nor wholly imaginary. To others, though, it is the confluence of the two that is photography's unique strength rather than its particular weakness. This is

something that was well articulated by photographic historian Mike Weaver, speaking at a symposium at the Royal Academy in London, held to celebrate the 150th anniversary of photography. Weaver argued that the photograph was like a novel based on a true story, and used the example of Nathaniel Hawthorne's celebrated novel *The Scarlet Letter* (1850). Here, the narrator claims that the story of the adulterous Hester Prynne is one that actually took place years ago in Puritan Salem, Massachusetts, and explains that his research and rediscovery of the past events in a contemporary town is like seeing a familiar room by candle-light. Here, our imagination may start to take over. A ghost might enter, and we might be forgiven for wondering whether it had returned from the past or had never even left. What we had, therefore, was something 'between the real world and fairy-land, where the Actual and the Imaginary may meet, and each imbue itself with the nature of the other'.[21]

That, it seems to us, is precisely what photography is: a meeting of the actual and the imaginary, where each adds to, rather than detracts from, the power of the other. When we view a photograph, we are stimulated by the hallucination and the fact at the same time – and receive the compounded stimulation of both. The effect is doubled, not halved. The relationship between photography and reality is, therefore, a complex one, but it is a complexity that explains the deep and articulate richness of the photographic image.

Theoretical approaches to photography are complicated by the fact that the photographic image is both reality and representation at the same time. Iconology, for example, is certainly relevant at the primary level, as the vast majority of photographs have subject-matter that can be recognized from experience. The initial stages of the secondary level can be useful, too, especially when subject-matter depends on prior, cultural knowledge for its identification. We get into potential trouble, though, with 'disguised symbolism'. In fine art, everything that is shown has been deliberately included by the artist. We may dispute whether it was intended to be symbolic, but we have to agree that nothing 'puts itself' on to the canvas automatically. With photography, the dangers of iconological over-interpretation are even greater than they are with painting because a photograph's content is often the result of circumstance rather than the artist's premeditated intent: an apple or a Volkswagen might appear in a photograph simply because it happened to be there in reality. The intrinsic level of iconology is more helpful to photography because it acknowledges that this third level is often beyond the conscious intent of the artist. As such, a photograph can be indicative of a wider, cultural way of seeing the world than the photographer had imagined.

Our investigation of 'formal' photography makes it quite clear that formal analysis can provide a useful insight to the medium. We could quite reasonably apply Fry's explanation of Post-Impressionist painting to those photographs whose prime concern is aesthetic rather than reproductive. Clearly, some photographs are more determinedly formal than others, but even the most subject-based photograph still has formal properties, whether or not form was its prime concern. That is not to say, of course, that Fry's elements of design translate literally from one medium to the other. It would be difficult to say much about the 'rhythm of line', for example, in photography. Notwithstanding, the

fact that the same subject can be photographed in many different ways endorses the fact that form is always a relevant factor in the analysis of photography.

It was one of our criticisms of the traditional history of art that it tended to be the traditional history of painting. There is no reason why, however, a narrative history of photography should not be constructed around similar concerns. As with *The Story of Art*, we could structure a chronological 'Story of Photography' around great photographers and great photographs. Such approaches already, of course, exist. Where they tend to differ from stories of painting, however, is that once the 'discovery' and development of photographic technology has been described, the story of photography fragments into parallel, simultaneous and often competing styles. This is partly because, as a reprographic medium, photography is not stylistically influenced by its Gombrichian progression towards the successful illusion of reality. With photography, perspective and proportion, for example, were mechanically achievable from the outset, so a substantial history of photography cannot be another history of verisimilitude. Photographic historians can still, however, occupy themselves with issues of context, attribution and provenance, and, with a growing market for collectable photographs, this kind of approach is likely to increase.

Photographs, just like the fine arts, are profitably open to ideological interpretation. Indeed, parts of Berger's *Ways of Seeing* are dedicated to the meaning of photographic forms. Although Berger and Mulvey were mostly concerned with class, property and gender, we can, in addition, use photographs as visual evidence of social attitudes towards anything from race and national identity to mourning and religion. As with fine art, however, we need to consider how much of the ideological content of a photograph might be the product of the individual photographer, the greater social group or even the particular interpreter. Photography also takes place within a social context, and while it is certainly successful as a commercially driven medium, the same claims for autonomy ('photography for photography's sake') could be made of the newer form.

The semiotics of photography are a far more complicated matter. This is because – unlike with language – it is very hard to argue that the relationship between a photograph and the thing photographed is 'arbitrary'. As Bazin argued, however, the photographic image both is and yet is not 'the object itself', and therein lies the root of the complication.[22] If we were to pursue this issue in depth, we would find ourselves in a metaphysical realm beyond the parameters of this introductory text. For our purposes, it is enough to focus on the difference between the literal and implied meaning of a photograph; the difference between denotation and connotation. This is where Barthes takes us when he talks about the second order of signification in which mythology takes place. A photograph of a black soldier saluting the French flag is, on the one hand, literally that: a reprographic image of a particular soldier doing a particular thing in a particular place on a particular occasion. On the other hand, its semiotic significance is about race, nation and French imperialism as a whole. Thus, we can investigate how a photograph may be semiotically constructed, while at the same time applying Barthes' notion of 'what goes without saying' to its wider interpretation.

The way in which photography can be both actual and imaginary lends itself

to a hermeneutic approach that embraces ambivalence. Just as with a scriptural text, the literal meaning of a photograph may not be its complete and total meaning. As photography becomes much more practised than fine art, both domestically and professionally, it is important that we learn to value it as a reflection of our identity and cultural values. In order to benefit from its value, we must also learn to interpret its complexities. To dismiss photography might be to dismiss our own reflection in the mirror.

Key Debate

Photography, representation and style: is it just about the subject-matter?

The ideas of Roger Scruton were given a central role in our chapter on photography. And justifiably so. The highly provocative character of Scruton's argument – namely, his claim that photography cannot be regarded as an art form since it is intrinsically unable to transcend its subject-matter – explains its long-lasting presence in theoretical debates on the subject. Much of what is said about photography, representation and art today is, to a certain degree, a response to Scruton's controversial view. So, Scruton will retain his pivotal role in this Key Debate section, in which we will look more closely into two distinct critical reactions to his position.

We will begin with the more traditional criticism presented by William King in his analysis of Roger Scruton's perspectives.[23] This relatively conventional line will then lead us to an essay by Nigel Warburton, who claims that King's response to Scruton is 'weak', 'ultimately unconvincing' and based upon a misinterpretation of Scruton's main thesis.[24] Warburton's very critical response to King's views should not, however, be taken as a defence of Scruton's claims about the mechanical, causal and transparent nature of photography and its impossibility as an art form. It is actually a fierce attack on such a view, simply using a different and perhaps more lethal theoretical weaponry.

William King takes issue with Scruton's perspective by asking an apparently very simple question: why do we look at photographs? The apparent simplicity of the question should not obscure the importance of our answer to it. If our reasons for looking at a photograph coincide with our reasons for looking at its subject-matter, then Scruton is right. If, on the other hand, we look at a photograph driven by an interest that does not entirely coincide with our interest in its subject-matter, Scruton is wrong. The first answer suggests that a photograph cannot be taken as more than the transparent reproduction of its subject-matter, as Scruton claims. The second answer implies that our interest in a photograph can be captured not only by *what* the photograph shows us, but also by *how* it shows us. And we can only be attracted by *how* the photograph displays its subject-matter – photograph's 'manner of representation' – if that particular *how* is one among many other possible ones. This in turn means that the photograph is more than just a surrogate of its subject-matter; it is a result of the photographer's intention, a notion that just does not make sense in Scruton's view.

Before taking this argument further, let us return to King's initial question: why do we look at photographs? Using a transcript of reasons given by a survey of actual viewers, King organizes the remarks into five basic types of answer to his driving question.[25] As you will see, the four initial sets of remarks do not contradict Scruton's basic assumption that photographs cannot elicit aesthetic interest. It is the reason manifested in the fifth and final set of remarks that directly challenges Scruton's view.

The first set of viewers quoted by King say they look at photographs because they are interested in the subject shown. Imagine someone asks you why you are interested in (say) your parents' wedding photographs. You would probably give that same reason yourself. If so, your remarks would be obviously consistent with Scruton's perspective. King's second set of remarks highlights the evocative power of photographs. Think of the photographs taken during the trip you made last summer. They are interesting in that they have an emotional impact; they trigger memories and make you relive a situation. It is still all about the subject, which means that Scruton's argument has not been challenged so far. The third set of responses emphasizes the cause of the photograph's formal appearance and expresses interest in technical aspects of the process. Comments about the effects of excessive exposure or of the use of a given lens, for instance, fit this category. Since the remarks of this kind are limited to technical aspects – they do not actually touch the aesthetic dimension of photographs – they too cannot be regarded as a challenge to Scruton's view. What if the remarks are not directed to the technical causes but rather on the effects themselves, that is to say, the actual formal appearance of a photograph? Would that be a challenge to Scruton's perspective? Not really, King claims. Remarks about purely formal features of a photograph – patterns of light or colour, for example – seem to challenge Scruton's argument about the incapacity of photography to transcend its subject-matter. But there is still nothing in such remarks that relates them to the *specific* experience of looking at a photograph. They can be made about anything at all. Anticipating these kinds of remarks as a potential challenge to his ideas, Scruton himself points out that we can have a purely abstract aesthetic interest in any visual object. Photography's alleged *specific* limitations cannot therefore be questioned by evoking the interest of the viewer in abstract formal features.

We have to wait until we are presented with King's fifth set of remarks to see the real challenge emerge. That only happens when and if the attention to the formal features of the photograph is, in the viewer's eyes, merged with an interest in such features as representational devices. Can photographs be the object of that kind of attention; can they 'elicit a second type of aesthetic interest' involving an interest in 'manners of representation'?[26] This is the crucial point where Scruton and King diverge. Clearly opposing Scruton, King claims that photographs can express the photographer's particular 'way of seeing' and that such aesthetic interest in representation might constitute a reason why we look at them, a reason that simultaneously transcends the viewer's simple interest in the subject-matter and in the purely abstract features of a photograph.

But that, according to Nigel Warburton, is a weak response to Roger Scruton's argument.[27] In his essay about the possibility of individual style in

photographic art, Warburton says why he believes King's objections are 'weak' and presents what he considers to be a 'strong', alternative position to Scruton's views. Warburton reminds us that Scruton's essay is about *ideal* photography, about the distinctive optico-chemical process that differentiates photography from other visual media. The weak critical reply, Warburton argues, is sustained by the analysis of *actual* photography, thus missing the target and facilitating Scruton's counter-response. Scruton acknowledges that actual photographers do produce intentional and aesthetically significant actual images. The point, he claims, is that they can only do it insofar as they move away from ideal photography and contaminate it with procedures imported from other visual media, including from painting.[28] A strong response to Scruton should therefore be given within the limits of ideal photography. That is Warburton's ambitious aim. To achieve it, he concentrates upon the matter of individual style.

The notion of individual style usually refers to what is distinctive about an artist's work. Warburton uses the term in a more precise way, referring 'not just to what is distinctive but to those aspects of it that exhibit an aesthetically significant intention'.[29] This brings us back to the decisive idea of intention. As we have seen, the allegedly weak rebuttal of Scruton's position also put forward the intentional nature of photography. We have also seen that the weak reply to Scruton identified human intention with the manner of representation. In other words, intention would be manifested in *how* a given subject is visually represented in a photograph, with that *how* depending on aesthetically relevant choices made by the photographer. Accordingly, a pattern of aesthetic decisions, enabled by the photographer's control over the medium and expressed in a particular manner of representation – a special 'way of seeing' – would constitute individual style.

Warburton does identify a problem in this approach. Although he concedes that new photographic technology has further increased the photographer's control over the medium, he shares with Scruton the sense that intentional control over the photographic image is essentially very limited. Such limited power of selection, which sharply reduces the available manners of representation, becomes clear when contrasted with the much wider spectrum of considerably more sophisticated choices made possible for the painter.

Scruton emphasizes the lack of intentional control to claim that individual style – in the sense of a particular set of aesthetically significant decisions expressed in a particular manner of representation – can never be achieved in photography. Since individual style is the form of intentionality that ultimately defines a work of art, it follows that photography cannot be art. This would seem to be the end of it. And it would be, if Warburton did not raise an additional question: accepting that the limited manners of representation fatally associated with photography leave no room for individual style, can we find it somewhere else within the photographic process? His answer – his affirmative answer – contains the core argument of his strong reply to Scruton's position.

In order to find photographic style within the manner of representation, Warburton suggests we look for it beyond what is visually given in an individual photograph. Unlike painting, where individual style can be achieved and perceived within an individual work, photography does not allow us to identify

individual style in a single image. It requires us to take a panoramic view and consider the *repertoire*: 'It is only in a series of photographs that a photographer's choices can be made clear.'[30] Even if we agree with Scruton and accept that a single photograph cannot be much more than a piece of information about its subject-matter, the situation radically changes when we insert that individual photograph in the context of a photographer's work as a whole. Through that process of contextualization, the stylistic features emerge, the intentions become discernible, and photography achieves the status of 'a medium which has the capacity to embody important and aesthetically relevant intentions'.[31] In other words, the photograph can now be seen as a work of art.

Further Study

Library and bookshop shelves contain no shortage of material on fine art. Photography, on the other hand, is less generously served. This is not to say, however, that further study is made correspondingly difficult, and photography's relatively short history is well served in terms of quality, if not in quantity.

The early history of photography is well covered in volumes such as Newhall's *The Daguerreotype in America* and Mark Haworth-Booth's edited *The Golden Age of British Photography*.[32] That said, a general history of photography is a very good place to begin with a broad grounding. Compared with the histories of fine art, photographic histories tend to be less chronologically structured once the earliest discoveries have been described. Photography falls less easily into successive schools and periods, and developments in this medium are grouped much more into parallel approaches. They are far less dependent upon the milestones, monuments, masterpieces and even masters than traditional histories of fine art. Among the introductory volumes, Beaumont Newhall's *The History of Photography* is something of a classic text; it is well illustrated and clearly explained. The only (understandable) weakness is that while claiming to trace photography up to 'the present day' it in fact stops at the start of the 1980s.[33] Michel Frizot's edited *A New History of Photography* is more up-to-date and takes a less narrative approach – which makes it a useful companion to Newhall.[34] The substantial catalogue printed to accompany the 1989 international touring exhibition *The Art of Photography* comprises some very useful scholarly essays by experts in the field, along with potted biographies and further reading suggestions for all the photographers included. It also has the advantage of first-class reproductions of more than 450 important photographic images.[35] The importance of looking at photographs (and not just reading about them) cannot be over-emphasized.

The social and cultural issues surrounding photography are capably introduced in Jean-Claude Lemagny and André Rouillé's edited *A History of Photography*.[36] Pierre Bourdieu, whom we met in chapter 4, published *Un Art moyen* in 1965; this was translated and published in English in 1990 as *Photography: A Middle-brow Art*.[37] Here, Bourdieu investigates photography as a widespread and everyday social practice. This is important because, of all the media considered

in this book, photography is the one that falls most easily into the hands of the general public. Aaron Siskind's socially committed documentary work with New York's Photo League is featured in *This Was the Photo League*, which also includes the work of photographers such as Arthur Rothstein, Berenice Abbot and Lewis Hine.[38] Siskind's break with the Photo League and his espousal of abstract photography is covered in Richard Howells's 'Order and Fantasy: An Interview with Aaron Siskind' and Carl Chiarenza's *Aaron Siskind: Pleasures and Terrors*, which is the most comprehensive and authoritative biography of Siskind to date.[39] The work of Aaron Siskind has been highlighted in this chapter because of its particular relevance to theories of realism and representation in photography. There remains, however, much scope for the further study of other photographers, just as there is with painters and others in the more traditional fine arts.

Among theoretical works on photography, Susan Sontag's *On Photography* is of course recommended, as is Bazin's hugely important essay, 'The Ontology of the Photographic Image'. Introductions to both have already been made in this chapter, along with Roger Scruton's *The Aesthetic Understanding*. Roland Barthes' *Image, Music, Text* is also recommended, especially along with his compendium of reflections on photography, *Camera Lucida*. John Tagg's *The Burden of Representation* tackles theoretical issues with an emphasis on documentary, while Stuart Hall's edited volume, *Cultural Representations and Signifying Practices*, contains essays on both representation in general and photography in particular. Especially recommended are Hall's own essay: 'The Work of Representation' and Peter Hamilton's 'Representing the Social: France and Frenchness in Post-War Humanist Photography'.[40]

For a sophisticated approach by an author also extensively cited in our iconology chapter, see *The Reconfigured Eye* by W. J. T. Mitchell.[41] Two further recommended introductions to photographic theory – which like Mitchell also have the additional advantage of including digital imaging – are Liz Wells's *Photography: A Critical Introduction* and Terence Wright's *The Photography Handbook*, which is less of a practical guide than its title might suggest.[42] For a clear and approachable guide to photographic practice, see Barbara London and John Upton's *Photography*.[43] This is recommended not because it is suggested that all visual theorists should also be skilled practitioners. Rather, it is because (at least) a working knowledge of photographic practice helps both explain and underline the significance of authorship, mediation and control in photographic representation. Moving from the practical to the much more philosophical, we recommend Nelson Goodman's work on a semantic theory of art. His *Languages of Art: An Approach to a Theory of Symbols*, first published in the 1970s, is now a classic text.[44] This, in turn, can be usefully complemented by 'Photography as a representational art', a concise essay by Robert Wicks published in the *British Journal of Aesthetics*.[45]

9

FILM

This chapter discusses the connection between film and reality, with a special focus on its relationship with time and space. We begin by comparing film with theatre. We see that although film has both a superficial and an historical connection with the theatre, as a medium it has fundamental differences. When we proceed to compare cinema with the novel, however, we discover that these two have much more in common. This is especially the case with the position of the reader/spectator, and in the ability of both forms to overcome the real-world limitations of time and space. To demonstrate this with film, we break the medium down into its most basic grammatical units. We show how editing enables film to break loose from worldly constraints, and how this contributes to its narrative complexity. This was not apparent in the very earliest days of film, but with the help of examples from the Lumière brothers in France and the Hepworth company in England, we will see how cinema rapidly discovered and developed its own grammar and vocabulary, and was thus liberated from temporal and spatial limitation. We conclude with a case study of Stanley Kubrick's horror classic *The Shining*. Here, we confirm that, despite the medium's apparent realism, film is not reality at all.

With film, we are going to enter the fourth dimension: the dimension of time. The graphic arts work mostly in two dimensions, even though they frequently seek to create the illusion of three. Photography creates the illusion of three more or less automatically, but film goes even further by adding the fourth.

Film takes its realism from photography, but because film comprises moving pictures of an intended duration, it adds the fourth dimension to photography's height, width and illusion of depth. Film might appear, then, to be even more

realistic than photography, for it goes beyond still photography's 'frozen' reality by reproducing the movement that is such a recognizable and necessary part of the natural world. However, we will discover in this chapter that because it appears to free the viewer from the constraints of both time and space, which are so fundamental to the physical world, film at the same time appears to free us from reality altogether.

The technology that underpins the cinema is basically the same today as it has been since its introduction at the end of the nineteenth century: a succession of marginally different still images viewed in sufficiently rapid succession (industry standard is nowadays twenty-four frames per second) appear to the human eye to become one single moving image. That is (essentially) all there is to it. More recent innovations such as sound, colour, computer animation and various attempts at 3D have added to, but not altered, this underlying principle. Just as with photography, there is much contention as to who was the 'inventor' of the cinema, and, not surprisingly, the 'primacy debate' here is similarly nationalistic and unproductive. Generally speaking, the French credit the Lumière brothers in Paris in December 1895, while the Americans support Thomas Edison in New York four months later. In reality – and again, as with photography – both teams built on the work of others, and the birth of commercial cinema owes as much to litigation as it does to inspiration. This need not detain us, however, for what really concerns us is the unique way in which film is able to communicate, together with its tantalizingly duplicitous relationship with reality. Both these issues transcend the primacy debate.

As a narrative medium, film is very much a new kid on the block. People have been telling stories orally since prehistoric times, while classical civilizations related them in epic verse. Only later were they written down. The ancient Greeks, in particular, mounted plays for the theatre, as did medieval Europeans and Renaissance Englishmen. The novel, a much more recent innovation, tells its story in prose. So where does film fit in here? Clearly, all these media have significant differences: epic is recited, plays are acted and novels are read. What we are looking for, however, is film's ability to tell stories in ways that other media do not.

We can best begin this investigation by comparing film with theatre. When we watch a play, we usually do so from a fixed space in the auditorium while the action takes place in real time on the stage. The idea is that we 'eavesdrop' on what is taking place in front of us. In most kinds of theatre (and especially the kinds that consider themselves to be naturalistic) the convention is that the characters on stage are unaware of us, the audience. Generally, we do not move from our seat during the action. We have, therefore, a static point of view, which does not vary during the action. Our eyes are free to roam around the set as we wish, but our bodies stay put. We view everything from a fixed point and a fixed angle. We are certainly not permitted to wander around on stage in order to get a better view or to change our perspective. If we did so, not only would we be removed by security, we would also have spoiled the naturalistic illusion for ourselves and everyone else. Of course, not all types of theatre depend on us watching from a fixed point in the audience, but those that seek 'realism' nearly always do. And as we are comparing theatre to the illusion of narrative reality

in film, the comparison is fair. Film, too, can be presentational, but that is not what we are seeking to discuss. Similarly, it is possible for action in the theatre to take place beyond the traditional confines of the stage. If the producers wish it, actors, dressed up as steamtrains, can roller-skate around the back of the auditorium, but again, they do not seek the illusion of reality. The naturalistic theatre keeps its characters on stage, clinging to the efficient and recognized convention of the 'fourth wall' through which we can see in, but the characters cannot see out. If the characters were to break through that wall, the effect would be much as if we had crossed on to the stage. The illusion of reality would be broken. In the naturalistic theatre, we both expect – and are expected – to spectate. Although theatrical convention decrees that the stage and the auditorium are different and mutually impenetrable spaces, they both remain subject to the same physical rules. Neither actor nor spectator can be in two places at once; nor can either move around theatrical space at any speed greater than they could in reality. This is not the case in the novel; nor is it so in the film.

Just as the theatre is rooted in real space, scenes on stage almost always take place in real time. Although the play itself may be set in the past, present or even the future, things take as long to do on stage as they do in real life. If an actor pours a drink, it takes as long to pour it as it would in a real room. The same can be said for the time it takes to cross from one side of a room to another. Within a scene on stage, therefore, time passes only as quickly as it does in reality. We cannot defy physics. In the naturalistic theatre, the narrative is nearly always linear and sequential. Things tend to happen in the order in which they happen with logical cause and effect. Within a scene, time tends to be continuous and non-interrupted, just as it is in reality. Further, there is usually a direct and progressive timeline from the beginning of the play until the end. If we depart from that convention, or even if time is meant to have passed between scenes, we usually need a programme note to tell us so: 'Act Three: Two Years Later'.

The theatre, then, is hugely limited by both spatial and temporal dimensions. Put more practically (perhaps), the theatre has significant problems with 'meanwhile'. Things are very different in the novel: the novel is free from the physical restrictions of both time and space. In the novel, the author can transport us anywhere at any time so that we become – if the author wishes it – omnipresent. In the theatre we are rooted to our fixed spot in the stalls, but in the novel we are free to move without physical constraint. The theatre may depend on the convention of the missing fourth wall, but in the novel we can walk straight through the walls as if, physically, there were no walls at all. It is an interesting experiment to read a section from a novel while at the same time plotting where you, the reader, are spatially situated within the action. When we read, we usually create a 'visual equivalent' in our minds of the words we have seen on the page. We create – in other words – the pictures in our head. But from what point of view do we 'watch' the action described on the page and render it visible in our minds? Do we imagine that we are crouching, unseen, in the corner of the room in the hope that the literary characters will not see us, as we might do in reality? Probably not. Do we watch every scene – motionless – from a fixed distance and a fixed point of view, as we might do in the theatre? Again, this is unlikely. What usually happens when we read is that we are free to float anywhere we wish, like

an all-seeing camera. We are uninhibited by walls or even buildings. We may observe from a point in the ceiling or join (in our imaginations) the characters round a table. If the finer detail of someone's facial expression is described, the whole of our imaginary vision is taken up with it, as if we were watching a cinematic close-up.

Transitions in space can be still more dramatic. So far, we have imagined ourselves sweeping uninhibitedly round a room. In the novel, however, we can be transported through space much more rapidly and spectacularly. If the narrator were to say, for example: 'In what seemed an instant, I found myself at my destination with people and carriages all about me . . .', we would have covered a distance of maybe several hundred miles in a fraction of a second. At the change of a paragraph, we could even be in Mexico or Kathmandu. We cannot (sadly) do this in reality, but in the novel and the cinema it seems so natural as hardly to be noticeable.

The novel is similarly free from the constraints of real time. When we come back, for example, to our imaginary phrase, 'In what seemed an instant, I found myself at my destination . . .', we are aware that a journey of what may have lasted several hours has been contracted to the second or so it took to read the line. Imagine how tedious it would be if it took three hours to read a description of a three-hour journey! The novel is particularly good at cutting out the tedious or unremarkable portions of life and concentrating on the interesting parts – whether that is several generations of a family saga or a simple journey from one place to another. Sometimes, these transitions in time will be clearly signified with phrases such as 'the following day' or 'later that night'. This is not always necessary, however, because the reader is usually aware of the literary conventions that permit real time to be contracted into literary time without an explanatory phrase every time this happens. It is simply understood. Again, we can demonstrate this to ourselves by reading a section from a novel and noting each time there is a 'temporal transition' in the narrative. At the same time, we can observe how, even when there is no marked or 'signposted' transition, at the end of the section there is nevertheless a discrepancy between how long things took in the novel and how long they would have taken in the real world.

Now it is time to conduct the same experiment with film. We can take almost any popular film at random and subject it to the same analysis that we have the novel. We can begin with space. When we watch a film, we are usually at a consistent distance and angle from the screen (be that a TV, computer or cinema screen), just as we are from the stage in the theatre or the printed page in the novel. With film (just like the novel), however, we enjoy the illusion of joining in the action, of being drawn into the 'screen world', rather than watching from outside. This is because of the cinematic convention that equates the camera position with our position: we see what the camera sees and so not only do we become the camera, the camera becomes us. In the cinema, unlike the theatre, we feel that we are participants, not spectators. When we watch a scene on film, then, notice how often 'our' point of view changes even during a relatively simple conversation or action, such as someone leaving a house and getting into a car. If that is true of a simple scene, look at the transitions between scenes, which may transport us from continent to continent with cinematic ease. Next,

examine the same section of a film while noting down contractions and transitions in time. What is the difference between natural time (real time) and film time (reel time)? If you do this well, you will start to perceive afresh conventions that previously you had probably just taken for granted. It is all a part of visual literacy.

The complex grammar of narrative film as we know it today was not instantly arrived at. In its earliest days, film was something of a novelty. Before the introduction of purpose-built cinemas, films were shown in cafés, at fairgrounds, in amusement arcades, music halls, traditional theatres – anywhere in which this new attraction could be exhibited to paying customers. The earliest films were very short and very simple. In 1895, for example, the Lumière brothers filmed workers leaving their film factory in Lyon in central France.[1] They emerge through the factory gates at the end of the day; a bicycle and a dog add to the general excitement. As the last of the employees leaves, the gates are closed. That's it. In another of the early Lumière films, we see a mother and father feeding their baby at a table set up outside their house. That is all. There is nothing, then, remarkable about their subject-matter. There is certainly no attempt at narrative or storyline. What was remarkable for people at the end of the nineteenth century was simply that the pictures moved. This was something of a technological wonder at the time. We live today in a world in which we are almost perpetually surrounded by moving images, but imagine the awe we would feel if we had seen pictures move for the very first time. The first days of film, therefore, are described by media historians as 'the cinema of attractions'. Cinema could be advertised as 'the latest attraction' along with other wonders such as circus freaks, performing animals and daring escapologists. We can understand something of the novelty and excitement of a new visual technology when we remember the first time we saw a hologram. Then, we saw lifelike, virtual images that appeared to hang in three-dimensional space. We passed our hands through them with a childlike curiosity, and looked around us to see how they were 'done'. Now, just a few years later, the initial technology seems primitive, and the novelty has diminished as holograms appear on things as commonplace as credit cards. But just as with the early cinema, that was not always the case. Nor has the cinema of attractions altogether disappeared. Today, it is still considered great fun to visit an Imax or Omnimax cinema in which the screen is so enormous that it fills our entire field of vision. Special films are made for screening in this novelty format, and the producers know that one of its special features is the illusion of movement that it creates. No large-format film seems complete, therefore, without a shot in which the moving camera swoops low over a precipice and audiences literally hold on to their seats for fear of falling over! A more recent attraction has been to add three-dimensional films to the large-format repertoire. Here, the audience excitedly don special spectacles to help create the effect, and can be seen ducking and grinning with pleasure, as objects, wizards, sharks and even dinosaurs appear to break out of the screen and head towards them. In all of these cases, it has to be said that it is the novelty of the new cinematic experience rather than the narrative or educational quality of the films themselves that provides the main attraction.

Now that we have understood the original appeal of the early films, it is pos-
sible to go back and analyse more dispassionately their cinematic form. And, as
we observe its evolution over its formative years, we will see the cinema evolving
a language which leaves the cinema of attractions – and even the theatre – far
behind. Earlier in this chapter, we noticed the term 'grammar' used to describe
the language of film. This may have struck us as slightly odd because grammar
is something we normally associate with the written word. It used to be an exer-
cise in school English classes (and in some Latin too) that students would be
asked to 'parse' a sentence. This meant that a given sentence was to be reduced
to its component parts of speech: subjects, objects, verbs, adjectives, preposi-
tions and so on. This was rarely a popular exercise with the students, but it did
have the advantage of revealing the mechanics of verbal communication. It was
also considered a necessary part of verbal literacy. The same sort of detailed
analysis should be a part of visual literacy. Film-makers are aware of it, and so
should we be.

Most passages of film can be reduced to just two grammatical components: the
shot and the edit. The shot is completed inside the camera and is the most funda-
mental grammatical unit of the cinema. The edit is the order and way the shots
are put together. The edit is completed outside the camera, nearly always after the
photography is complete. The shot, according to James Monaco, is a single piece
of film, no matter how long or short, without any cuts, exposed continuously. As
soon as it is stopped in the camera, or physically cut on the editing table, the shot
comes to an end.[2] Modern films tend to comprise many shots within even a very
short passage (we can try counting the shots for ourselves: we will get very tired
after only a few minutes). This was not always the case, however. The Lumière
brothers' film of workers leaving the factory (*La Sortie des Ouvriers de l'Usine*)
comprises only one shot, making it a very unsophisticated piece of film (see figure
41). Contemporary Hollywood, by comparison, offers a different shot every
one or two seconds, so a typical, ninety-minute commercial picture will contain
something in the region of three to five thousand shots. We need to look at more
than the number of shots, however, for we must also take the type of shot into
account. *La Sortie des Ouvriers de l'Usine* uses a straightforward single shot, made
from a fixed position in the middle distance on the street side of the factory gates.
The camera does not move. As there is only one shot, it follows that there are no
edits. As a piece of cinema, then, this short film is very reprographic. It records,
very simply, what we might have seen had we been standing in exactly the same
spot as the photographer at that particular moment in 1895. No liberties are
taken with physical space or real time. There is no temporal difference between
the time the film took to run through the camera and the time it took us to watch
it. It was enough, as we have seen, that the pictures moved.

The novelty of moving pictures was not enough alone to maintain public
interest in the cinema. Once it had been established that the illusion of move-
ment could be realistically achieved, the novelty was very likely to wear off.
Fortunately for the cinema, however, its practitioners soon discovered that film
had potential far beyond being simply a moving photograph. Five years after
the 1895 Lumières film, the Hepworth Manufacturing Company in England
produced a short film called *How it Feels to be Run Over*.[3] On paper, subject to

41. The Lumière Brothers, *La Sortie des Ouvriers de l'Usine* (France, 1895); photo: British Film Institute/Association frères Lumière

the same criteria of sophistication we used to examine the Lumière film, this Hepworth feature would appear to be exactly the same. There is only one shot, no edits and no camera movement. The cinematic effect, however, is quite different and considerably more advanced. Here, the audience is already primed for excitement by the very title of the piece. *How it Feels to be Run Over* promises much more in the way of anticipation than *Workers Leaving the Factory*. The film begins with a view of an open country road in summer. From around the corner, a horse and cart approach us. Could this be that which is going to kill us? Fortunately, the vehicle passes serenely by to our right and we are safe. No sooner has it passed, however, than something much faster and far less controlled looms into view: a Victorian motor car filled with well-dressed and excitable people waving frantically for us to get out of the way. We are mesmerized, rooted to the spot, as the car gets closer and closer; the passengers gesticulate still more frantically until the speeding car fills our entire view and – blackout! So, this is how it feels to be run over.

What makes this film a much more cinematic experience than the Lumières' effort is a combination of ingredients. First, it is narrative rather then mere reportage. This time, we have a story. It is only a short and simple narrative, to be sure, but it still has build-up, suspense and a dramatic conclusion. Second, it presents an experience that we would not normally gain (let alone survive!) in ordinary life. We could have seen workers leaving a factory pretty well any time we liked, but to experience being run over by one of those new-fangled automobiles would have been something beyond everyday occurrence. Third, and most importantly, the cinema has been used to place us in the action, not merely to permit us to witness it. This is a film, after all, about how it *feels* to be run over, not about what it is like to observe someone else suffering the same experience. We were spectators at the Lumière factory gates, but with the Hepworth film we ourselves are knocked down in the middle of the lane. This is mainly achieved by a shot called the 'point-of-view' shot, in which cinematic convention has it that, through the camera, we see exactly what a character in the film is seeing for him or herself.[4] Here, of course, that character is us.

Although the Hepworth film is, technically, a 'one-shot wonder' like some of the very first attempts, it differs from them by providing a uniquely cinematic experience. When we watch this film, we are at the same time watching the cinema discovering its potential to communicate in new ways. In the theatre, we might (were the producers sufficiently ingenious) just about be able to get an idea of what it looks like to see someone else being run over, but one cannot run over the audience in the same way. Cinema in these early days was facing both a very steep learning curve and also the prospect of teaching itself from a book that had yet to be written. But within only a handful of years, it was discovering a language all its own.

That same year, Hepworth produced another short film on a similar topic: *The Explosion of a Motor Car*.[5] Here, an automobile full of carefree motorists makes its way towards us along a suburban street. Just as it reaches the foreground, it explodes in a puff of smoke. The car is suddenly gone, much to the astonishment of a policeman who is instantly on the scene. He produces a telescope from his pocket, only to see the (comically) dismembered bodies of the car's former

42. The Hepworth Manufacturing Company, *Rescued by Rover* (UK, 1905); photo: British Film Institute

occupants falling back to earth from a great height.[6] This is an early example of a 'special effects' movie, featuring the 'stop–motion' technique. The car is filmed approaching the camera, and then the filming is stopped while the car is taken away. A stage explosion is set in the place where the car was last seen, and the camera is started again from exactly the same position. The smoke effect goes off, the policeman approaches and the off-camera film crew throw comedy body parts into the site of the explosion.[7] In terms of shot-count, then, we now have two – although the producers seek the illusion of only one. This is achieved by the 'invisible edit' between the two shots, creating the effect of continuous action. Just as in our previous examples, however, the camera does not move, and there is no transition of physical space. Here, for the first time among our examples, though, there is a discrepancy between the time covered by the film and the time taken to view it. So, not only do we see an effect that could hardly have been presented so impressively on stage, we also see cinema beginning to experiment with the potential differences between real time and reel time.

The novelty films produced by the Hepworth Manufacturing Company were, to an extent, imaginative continuations of the cinema of attractions. Their *Rescued by Rover* of 1905, however, was a genuine attempt at narrative rather than spectacle (see figure 42).[8] It is also considerably more sophisticated in both grammar and structure. The film begins with a British nanny taking a baby for a walk in a baby carriage. Along the way, she is approached by a beggar woman, who asks for money. The nanny refuses; she is far more interested in the young

soldier with whom she hopes to share her walk. As the courting couple move on, the beggar exacts her revenge by stealing the baby from the pram. Back inside the house, the distraught nanny reports the loss to her employer. There is much general emoting. The family dog, Rover, however, springs into action and we see him leap from a window and bound off in search of the abducted infant. Rover, the intelligent beast that he is, runs along the well-maintained suburban streets and even swims across a river before reaching a rundown street on what is very clearly the wrong side of town. The intrepid Rover tries a number of houses, outside which a variety of very louche characters is loitering with nefarious intent. At the top of one such house, we discover our heartless abductress in a rundown attic, consoling herself with strong drink and the company of the stolen baby. Rover, however, rushes in, only to be beaten away by the drunken hag. But our heroic hound is not dispirited: he rushes back to his home, swimming the river (again) and back through the streets to the room where the master of the house is wracked with both worry and self-recrimination. Is Rover consoling him? No! He is trying to tell him something! The master gathers his silk top hat and runs with Rover all the way back though the streets and over the river, through which Rover swims (yet again . . .), but across which the tail-coated gentleman rows in a small boat. They reach the house and enter the attic, grasping the baby from the iniquitous old woman, who consoles herself with drink and the prospect of selling the remnants of the baby's clothes and blankets. Finally, back at the house, mother and baby are reunited and Rover is the hero of the day.

In terms of plot, this may strike contemporary audiences as (to say the least) a little corny – even though in terms of content and approach it is a format that will not be unfamiliar to devotees of American screen hero Lassie or her antipodean soulmate Skippy the bush kangaroo.[9] What is much more interesting in the context of this chapter is the remarkable advance in cinematic language in the five years since *How it Feels to be Run Over*. Where the Hepworth feature of 1900 contained just one shot, 1905s *Rescued by Rover* comprised more than twenty. This did much more than simply make it a longer film. It also demonstrated that advances in the language of film were made in the editing as much as in the shooting. The editing in *Rescued by Rover* permitted contractions in time so that, interminable though Rover's journeys from house to attic may appear to modern audiences, they nevertheless take considerably less time to accomplish on film than they would have done in reality. Time here is 'concertinaed', in that parts of the action are cut out at the edits and the rest of the action is closed up like a telescope after use. The audience understand, for example, that time has passed between the scene in which the beggar woman steals the baby and the interior scene in which the nanny reports the theft. Similarly, once Rover and the gentleman have recovered the baby from the attic, the journey back to the house is (thank goodness!) taken as read. We are transported directly from attic to drawing room: the time taken to travel through the streets and across the river is simply taken away. Time is not only removed between scenes, it is condensed within scenes. Each time Rover runs between the house and the attic, the film is cut in such a way that we understand that parts of the journey are used to imply the whole of the journey. We see Rover leap from the drawing-room window, then suddenly he is running down a street, approaching a corner

and then, instantly, arriving at another. Suddenly, again, he is at the river and then, having shaken himself dry, he almost magically reappears in the dubious neighbourhood where the missing baby is to be found. The difference between the real time it would have taken to make the whole journey and the reel time it took to show it is especially pronounced. Theatrical and physical constraints of time no longer apply in the new world of cinema.

The technique by which *Rescued by Rover* is able to transcend real time and real space is what we might call 'elliptical editing'.[10] Here, a chunk of real-time action is removed between shots (in reality, it is probably never even photographed at all) and it is connected with the following shot by means of a simple edit in which we simply 'cut' to the next piece of continuous action within the same scene. The audience understands this by narrative and filmic convention. In reality, Rover's journey from house to hovel may have taken twenty minutes, but what we see on film is a selection of brief sections from the real journey, cut and spliced together in such a way that they are understood to stand for the whole. In practice, of course, there is no need to shoot the whole journey: representative sections of it are photographed and the implication of the entire journey is created by cutting on action. This visual ellipsis is not only economical in terms of time and film stock. Done properly, it creates a far more exciting pace than showing the journey in its entirety. At a more intellectual level, it also liberates film from real-life temporal and spatial constriction. The average viewer will be unconcerned by this, but that is not to say that it does not take place.

Hepworth's *Rescued by Rover* incorporates another feature that was not a part of the previous three examples: camera movement. There are two basic categories of camera movement in film. In the first, the camera is moved on its own tripod, such as in a 'pan' (in which the camera moves from side to side) and the 'tilt' (in which the camera moves up or down). In both cases, the camera position itself does not change, but the field of view does, just as if we were moving our heads to watch a train go past or a balloon go up. Much later lens technology permitted the 'zoom in' and the 'zoom out', in which the viewer feels pulled into or out from the action. This is an optical effect in which the camera position, again, does not change. It differs conceptually from the pan and the tilt in that it is an effect that is not possible to create with our own eyes. It became very popular with 1970s TV action dramas, but nowadays appears somewhat stylistically dated. It is used much more rarely in film.

The second kind of basic camera movement is that in which the whole camera position changes during a shot. The most well-known of these is the 'tracking shot' in which the camera keeps up with the action by following it, such as when two people in conversation are followed as they walk along the road. Although they are physically moving through space, the distance between them and the camera remains more or less the same. It is called a 'tracking shot' because in order to keep the camera steady and the photography smooth, it was usually necessary to mount the camera on railway-like tracks and have assistants pull it along as the action progressed. The track, of course, should never be visible in the shot itself. Film is an artificial medium that goes to considerable lengths to conceal its own artifice.

The tracking shot can also be used to move the camera in and out of (as opposed to simply following) the action. As this is sometimes difficult to accomplish without the tracks showing, it is often done with the use of a 'dolly', which is a kind of cart or trolley run on pneumatic tyres. If this is the case, it is known as a 'dolly shot' (although the effect can be pretty much the same). The camera can, of course, instead be hand-held and the operator can simply walk around with it, usually balanced on a shoulder. The problem with this is that the resulting shots can be very jerky, especially when the camera operator is walking along the ground. It is this that led to the invention of the 'Steadicam' in the 1970s. Here, the camera is supported by a complex suspension system worn by a single operator, and results in a remarkably steady shot without the need for tracks, dollies or assistants. The Steadicam can often be seen in use at sporting events today, but it can also be used (as we shall see) in feature film-making.

The moving camera techniques we have just examined all replicate, to some extent, human movement, allowing us to view a scene as if we were there ourselves, on our own two feet. More spectacular techniques go beyond that which we can normally experience in real life. By attaching the camera to a boom or even a hydraulic platform, for example, we can produce the dramatic 'crane shot' in which we seem suddenly to soar above (and sometimes swoop down upon) the action. In this way, we can be watching an incident at street level and then smoothly, within the same shot, rise above it and gain an impressive bird's-eye view. Still more striking effects can be gained by filming from a helicopter, which gives us an almost god-like perspective on events. We rise, fall and hover, but the helicopter, just like the tracks, should never of course be seen. As these techniques get further from the human way of seeing things, they become correspondingly more expensive. They begin to replicate, however, much more the way in which we 'see' when we read a novel. Still more recent advances in technology have permitted cameras to be fixed to moving objects such as sports cars or to be used for comic effect, such as the 'thrill-cam' featured by TV's David Letterman. In these cases, however, the technique usually seeks to draw attention to its artifice, and so is much more rarely seen in the naturalistic, narrative film.

We have now moved on a long way from *Rescued by Rover*, but deliberately so. It serves to emphasize the very limited camera movement used in that early film. Here, only the pan is used. It appears just three times and in ways that seem almost accidental. First, we see the camera pan very slightly to the right as the nanny and her soldier friend move off together down the path in the opening scene of the film. We see another (this time slightly to the left) as Rover arrives at the row of shabby houses in which the baby has been secreted. The most obvious camera movement, however, takes place when Rover's master crosses the river by boat. As he rows away from the bank, the camera pans to the right to keep him and the boat in shot. This is unfortunate (and surely unintended, however), as the pan gradually reveals the bridge by which the man could much more easily have crossed the water had the producers been less determined to have featured the novelty of a boat! We must remember, however, that this was only 1905, and the cinema was still only learning new visual ways of telling a story. As the cinema developed, camera movement would be further exploited

not simply to keep the action on camera, but to provide increasingly cinematic ways of seeing the world.

Advances, too, were made in editing. These, however, were much more conceptual than technical, and were discovered early in the history of film. The most important of these was what we will call 'parallel editing',[11] which enabled the cinema to narrate simultaneous action or, put another way, to say 'meanwhile'. It has become something of a cliché nowadays to say 'meanwhile, back at the ranch . . .'. When it is done properly in cinema, however, it is unnecessary to say this because the conventions of parallel action make it visually understood. With parallel editing, we are able to witness simultaneous events at numerous locations, often switching back and forth between them as the tension mounts. This kind of editing, then, is also useful in the creation of suspense.

The primacy debate about who was the first to use the various techniques does not concern us here. It is sufficient to provide a good, early example of parallel action, and we find one in D. W. Griffiths's *The Lonedale Operator* of 1911.[12] In this, the operator of an isolated railroad telegraph office is taken ill, but his gallant daughter takes control and foils the attempts of a group of desperate outlaws to rob a train carrying the payroll for a local mining company. It is a simple enough tale, but the idea of information being passed by telegraph (which can carry information ahead faster than any train) makes it perfect for cross-cutting and parallel action. In this film, we witness simultaneous action taking place at locations that are miles apart, be they Lonedale Station, the originating telegraph office or the footplate of the train that the desperadoes are trying to rob. Griffith cuts between them all, and the suspense mounts.

Cross-cutting for suspense is a technique that is still widely used today, especially in Hollywood action features. A time bomb is set in a building and we see the clock relentlessly ticking away. The director cuts back and forth between shots of the clock, the hero racing through town to defuse it, a group of nuns evacuating good-looking children from the building, the hero (now minus his shirt) still on his way, the clock, the hero stuck in traffic, the clock, the hero now running along the roofs of stationary cars, the clock, the nuns . . . The cutting rhythms accelerate until we are on the edges of our seats with excitement.

While we are gripped by action such as this, it is understandable that our analytical faculties might be distracted. We might fail to notice, for example, that film here is giving us an experience that is impossible in real life; it allows us to be in several places at once, permitting us to observe the action unfolding at the same time at different locations. This remarkable capacity gives us an almost god-like omniscience, which worldly mortals are unable to attain. Not only do we see more and know more than the characters in the film (our shirtless hero can see neither the nuns nor the clock, for example), we are also granted a kind of omnipresence which permits us to travel instantaneously between disparate locations at something approaching – or even exceeding – the speed of light. Again, this is a facility that real life does not provide.

Parallel editing also permits ellipses in time. The audience understand, for example, that time has passed between the shot of our hero stuck in traffic and the next shot we see of him running across the roofs of the stationary cars. Each edit provides the opportunity for ellipsis should the director desire it.

Additionally, however, parallel editing may be used not just to contract time but also to extend it. This is something we can understand by what we might call the 'time-bomb effect'. In our imaginary (but painfully familiar) Hollywood blockbuster, the clock on the time bomb is set for (say) one hour and begins counting down. If we set our own watches to the clock on the bomb, however, we would not expect them to remain synchronous with that which we see on film. We could wager that the first fifty minutes or so on the time-bomb clock will be elliptically edited so that they take considerably less on screen. Watching fifty minutes of real time would probably strike audiences as boring at this stage, so real time is condensed into reel time. With two minutes – and certainly ten seconds – to go, however, parallel editing will normally be used to prolong and heighten the action at the most exciting point in the film. As the director cuts back and forth between the clock, the hero, the nuns, the children (and, who knows, by now maybe even the President), real time will be padded out into reel time so that the second hand on the time-bomb clock seems hardly to have moved anywhere during the period when the action has cut away. It is this that keeps us on the edge of our seats.[13] In order to do so, this 'realistic' cinema has enabled us to transcend the real-world constraints of time and space. We enter a cinematic reality in which actual physics no longer applies.

If we fail to notice the way in which real-life time and space have been left behind, the director's work has been professionally accomplished. If editing is deftly performed in the naturalistic cinema, then we should hardly be aware of it. The conventions of cinema should strike us as the most natural thing in the world. This is a feature of the classic, Hollywood style, which seeks to persuade us not that we are watching a piece of technically manufactured artifice, but that we are a witness to actual events. The events that we do witness, of course, are rarely actual at all. This is true in two ways. First, and most obviously, the plot is usually fictitious and played out by actors. What we are seeing is not 'true'. The second is less glaring but more intellectually intriguing. Imagine an incident in a play in which one character throws a bottle at another. Just as the bottle is about to hit, the second character ducks and the bottle smashes on the wall behind him. In the naturalistic theatre, this would have physically to take place on the stage. It would not be 'true' in the first of our two ways, because it is a play and, therefore, 'only pretend'. It would, however, be 'true' in the second sense in that what we see does actually physically take place exactly as we see it. This is not usually the case in the cinema. Just like in the theatre, we know (even though we usually choose to suspend our disbelief) that what we are watching is a fiction, which is being acted out for our entertainment. But, unlike in the theatre, what we see on screen most probably never physically take place as we saw it. If we were to film the 'bottle incident' for an action movie, we would probably compose it out of a number of different shots for dramatic effect. We might start with a close-up of the bottle itself, then another of a hand grasping it around the neck. A third might follow of the angry character drawing the bottle back behind his shoulder and then another from a different angle showing the throw as the arm extends and the bottle leaves his hand. Shot five might briefly show the bottle in flight, while the next would probably be a reaction shot of the victim's expression as he sees the bottle flying towards him. In the next we would see

him duck and the bottle explode against the wall. The final shot would be of the spattered wall itself, with the frothy remnants of the beer running down it. Films (for all sorts of reason) are usually shot with only one camera. Consequently, the incident we have just described would have taken eight separate 'set-ups' to complete. What ended up looking like one flowing, continuous action is actually therefore a compilation of eight separate events filmed piecemeal over a considerably longer period of time. They may not even have been filmed in that order, and several different takes (featuring several different bottles) would probably have been necessary to achieve a satisfactory version of each shot. What we end up seeing in the finished movie, therefore, is something that not only never happened in real life but which also never even took place in physical reality.

So far, our examples have been taken either from early or imaginary films. We will conclude this chapter by looking at a much more contemporary film, but before we do so it is necessary to establish just a few more terms in the cinematic vocabulary. Every kind of shot used in cinema can be given a name or term by which it may be verbally described. To an extent, we have already begun to do this by describing camera movement, but some of the most basic terms are applied also to static shots. Generally speaking, these are used to classify the shot in terms of the distance between the action and the camera. Among the most commonly used are the long shot (LS), the medium-long shot (MLS) and the close-up (CU). The close-up can either be on character (to show, for example, an actor's facial expression), or on detail (to show, for example, a murder weapon such as a smoking gun). At the other extreme, the establishing shot is one used typically to introduce a new location, such as a general view of Paris or the exterior of the apartment block in which the subsequent interior scene will take place. Sometimes, the shot is described by the number or even the parts of people it contains: the two-shot, for example, is commonly used to begin a scene in which a conversation takes place. This may be followed by an over-the-shoulder shot, a reverse over-the-shoulder shot and even a close-up before returning to the two-shot to conclude the conversation. In the hands of a competent director, these shots serve not only to reveal the content of the scene but also spatially to orientate the viewer within it.[14] The naming of shots is not an exact science, but it is generally possible to exploit and (if necessary) compound the basic terminology to come up with a recognizable working description of most types of camera work.

In terms of editing, we have only so far dealt with the straightforward 'cut' in which one shot is abruptly followed by another. The term is taken from the physical cut which is made in the exposed film before the end of one shot is spliced directly on to the beginning of another. By far the majority of edits are of this type. However, a number of more complex (and noticeable) types of edit can be noted over the history of film. Sometimes, for example, a shot will emerge from darkness, and this is known as a 'fade-in'. Its exact opposite is, of course, the 'fade-out'. If these were used within a scene they would disturb the free flow of the narrative. For that reason, they are usually used to signal the beginnings and endings of discrete scenes. A more gentle transition between scenes can be achieved by the 'wipe', in which a new shot appears to spread across the screen as if a cinematic hand were being waved across it. This technique is rarely used

nowadays, but the 'dissolve' is still sometimes used to create a smooth and seamless transition between one shot (or scene) and another. Here, the last shot is still fading out as the new one is fading in, so that, halfway through, parts of both can be seen. It is the visual equivalent of the 'cross-fade' used by DJs and radio presenters who want to play two records in succession by merging the end of one with the beginning of another.

The final type of narrative device that needs to be mentioned here is the one in which typography is used as an additional way of communicating information to the viewer. Most commonly, nowadays, we see this used for the opening and closing titles of a film to let us know who is (or has been) in it. We do not normally expect to have to read as well as watch once the film is under way. Sometimes, however, typography is used in a caption in which (for example) the word 'London' appears over an establishing shot of Trafalgar Square. Other information (such as the date) can be added if thought necessary. It is a device that most directors nowadays feel is best used economically. In the early years of film, the 'inter-title' was much more common. Here, words would appear in between rather than superimposed upon shots. Sometimes, this would serve as a substitute for important dialogue in the silent cinema ('You Must Pay The Mortgage!') or again to signal location in time and space ('Meanwhile, Back At The Ranch . . .'). Contemporary film-making has less need for these relatively crude devices, but they can still – as we shall shortly see – be used for narrative and artistic effect.

Stanley Kubrick (1928–99) was one of the most meticulous and accomplished of film-makers of the twentieth century. Born in the United States, he worked both in the USA and the UK, where he eventually settled and, living in publicity-shy seclusion, made many of his most memorable films. He is remembered for such pictures as *Spartacus* (USA, 1960), *2001: A Space Odyssey* (UK/USA, 1968), *Full Metal Jacket* (USA, 1987) and *Eyes Wide Shut* (USA/UK, 1999), to say nothing of the controversial *A Clockwork Orange* (UK, 1971), which the director himself withdrew from distribution in the UK, where it has only become available again since his death.

Every type of shot and edit has an effect on the narrative of film. Each is therefore chosen with care, and often in advance of the start of the physical filming. Some of the basic camera work may appear in the original screenplay, but it is usually planned in detail with the help of 'storyboards' which set out how each scene is expected to look by the end of the picture. Such is the time and expense involved in feature film-making that as little as possible is left to chance. It is all also part of the total control that a director seeks over what we, the viewers, will finally experience. The director hopes to dictate exactly what we will see, how we will see it, for how long we will see it, from what angles we will see it and in what order we will see it. Additionally, the director controls what we will hear in terms not only of dialogue but also of sound effects and incidental music. Film offers the director the potential for total control of our visual, aural and, therefore, emotional experience during the narrative. It is a capacity that a good director will rarely overlook, and it is a capacity that is available in neither the theatre nor the novel. Film provides us with an almost total visual and narrative experience.

Stanley Kubrick's *The Shining* (USA, 1980) is loosely based on a horror story by Stephen King (see figure 43). Horror is not always one of the screen's most

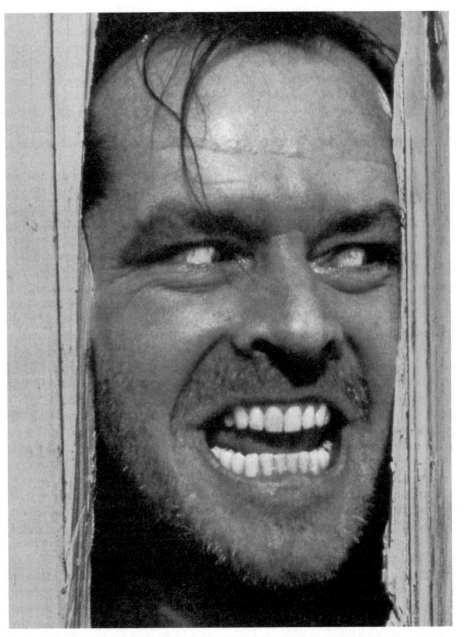

43. Jack Torrance (Jack Nicholson) in Stanley Kubrick's *The Shining* (UK, 1980); photo: Pictorial Press

prestigious or successful genres, but Kubrick's offering is a work of remarkable quality, which, unusually for a horror film, seems to improve the more (and more closely) we see it. This is partly because it relies much more on psychological tension than it does on the element of surprise. There are no monsters

– other than those which lurk within the human mind. It is the story of Jack Torrance (Jack Nicholson) who, accompanied by his wife Wendy (Shelley Duvall) and young son Danny (Danny Lloyd), takes on the job of caretaker of a large and isolated Rocky Mountain hotel during its winter closure. Things start swimmingly enough, but gradually, the isolation, combined with super-natural repercussions of the hotel's gruesome past, begins to take its toll. Young Danny turns out to be psychically sensitive to what has taken place before, while his father Jack becomes increasingly irritable, eccentric and – ultimately – homicidal. It is a film that is available on DVD and is suitable for close analysis at home or in college.

The opening ten minutes of *The Shining* provide an extremely valuable example of contemporary cinematic narrative, in which we can see many of the concepts and techniques we have been discussing in action. It demonstrates an accomplished filmic way of telling a story using visual rather than simply verbal craft. The opening shot is a slow, sweeping helicopter long shot over a mountain lake. A small island comes into prominence as the camera swoops low and then banks off to the right. It dissolves into shot 2, which is a high-angle helicopter shot of a road snaking through the forest; the camera follows a car we can see driving on in the middle distance below. This cuts to a lower-angle helicopter shot which follows the car more closely now, and we see still higher mountains in the approachable distance. We cut to shot 4, another helicopter shot, in which the camera is still following the car.[15] The camera moves closer, and for the first time we are able to recognize the car as a Volkswagen Beetle. The camera advances closer still and then, for the first time, 'overtakes' the car before picking up speed and striking out on its own across the lake. When we cut to shot 5, however, we are again in position behind the car, which now dis-appears into a small tunnel, while the camera flies over the top and rediscovers the Volkswagen on the other side. The countryside has become more mountain-ous still as we cut to shot 6 in which the camera is positioned almost vertically over the car. Cut to shot 7: the car is a little further away this time and snow has appeared on either side of the road. The camera follows, again by way of a helicopter shot. When we cut to shot 8, we get our first view of the hotel, sur-rounded by snow-covered mountains. The camera flies in over the car park to reveal the impressive-looking building in greater detail. We cut to shot 9, which is a simple inter-title: 'The Interview'.

Every shot we have seen so far has been followed by an elliptical edit that has signalled the passage of time and space between shots. In this way, a journey of several hours' duration, several hundred miles in distance and several thousand feet in altitude has been condensed into just eight shots and two minutes, forty seconds. The transition in time and space was indicated fairly explicitly by the dissolve, which constituted the edit between the first two shots. A dissolve is an edit that draws attention to itself and so clearly alerts the audience to the fact that neither the action nor the location is continuous. After the initial dissolve in this case, however, simple edits are enough to transact the ellipses. The clearly differing locations, together with the varying positions of the car relative to the camera, leave the viewers in no doubt that the action is condensed rather than continuous. Between shots 4 and 5, for example, the camera has passed the car

and set off on its own, only to reappear in place behind it again. Snow has suddenly appeared between shots 6 and 7: we do not remark at the discontinuity. Rather, we quietly note that the journey has covered both ground and height and that this has been both concisely and visually conveyed. In the ensuing interview scene (shot 10), Jack tells the hotel manager: 'I made the trip in three and a half hours.' There is, therefore, a discrepancy between real time and reel time of around two hundred to one. Such are the narrative codes and conventions of film, however, that this strikes us as entirely natural.

From the inter-title, we cut to an interior long shot of the hotel lobby, just as Jack is entering from the left and confidently making his way towards us and the reception desk. The camera pans right to keep him in the frame, and this becomes a two-shot as he gets directions to the manager's office. Many directors might have cut here, but as Jack crosses in front of camera, this is revealed as a Steadicam shot because, instead of cutting, we follow him, documentary-style, through one doorway into an anteroom and then through another door into the hotel manager's small office. The two shake hands, Jack sits down and a secretary exits the frame through the door we have just entered to fetch coffee. By following Jack in this way, the Steadicam has given us the impression that we ourselves are tagging along behind him, sticking around for the interview. Just as the interview starts to get under way, however, we dissolve to an exterior establishing shot (shot 11) of an apartment complex. The trees and grass are green and birds are singing. There is no snow and we zoom in towards one of the blocks. We cut to an interior two-shot of Wendy and Danny at the kitchen table. The TV can be heard showing cartoons in the background, as Danny expresses his reluctance to move up to the hotel for the winter; this twelfth shot is the first of the film to be made with no camera movement. Shots 12–19 continue the conversation between the two of them, alternating by straight cuts between close-ups of each. Two further points need to be made about this scene. First, it is understood that this action in the apartment is parallel to the interview taking place at the hotel at the same time. Second, once we have been introduced to the apartment interior and taken up 'our' position in the kitchen, the scene is edited on action rather than elliptically or in parallel. This is to say that, although the conversation between Danny and his mother is shown via eight separate shots, it is understood that what we are witnessing is one single, continuous conversation which is shot from several different angles in the interest of variety and character close-up rather than to imply changes in location or time. 'We' may move back and forth slightly during this scene in order to get a better view of the action, but the characters are constant in both time and space.

The following edit changes this, as we are suddenly back in parallel action in the manager's office at the hotel. This twentieth shot brings us in to an interview that is already well under way, and the third character (the manager's assistant) has joined the meeting. We did not need to see him arrive; he is simply there. Shots 20–32 alternate on action between Jack and the manager, and the dialogue proceeds; shot 33 is a reaction shot of the assistant, whom we see from the front for the first time. Shots 34–41 resume alternating between Jack and the manager, but we dissolve into shot 42, which is a Steadicam, long-shot of the boy Danny, discovered through the open bathroom door. The camera

approaches on Danny's monologue, in which he receives a premonition that the telephone is about to ring with news that his father has been offered the job at the hotel. Sure enough, we cut to Wendy in the kitchen. The camera pans right as she answers the phone. We cut to Jack on the other end of the line in the hotel lobby, telling her of his good news. This is the second of four shots cross-cut between two places several hundred miles apart. The cross-cutting on parallel action allows us to be physically present at both sides of the conversation at once: a facility that reality does not permit.

The next sequence begins conventionally enough. We cut from Jack in the hotel lobby to Danny, who is still in the bathroom where we saw him last time. He is looking at himself in the mirror and continuing his psychic monologue. The camera approaches over his right shoulder until it is the mirror image of the boy's face, which fills the frame in close-up. We then cut to a completely unexpected medium-long shot of an empty hotel interior with two elevator doors on the far wall. Suddenly, torrential quantities of dark-red blood pour in from the left, flooding the lobby. We cut to a very quick shot of another new interior in which two unsmiling and identically dressed girls face the camera. We have hardly had time to take this in when shot 50 cuts back to the bloody lobby. Cut now to a close-up reaction shot of the horrified Danny, then back to the lobby, which is now so filled with blood that it fills the screen and the shot fades to black. Shot 53 is the inter-title 'Closing Day', which introduces us to the next section of the film.

This brief analysis has demonstrated film's exploitation of visual means of telling a story. We have seen how the narrative proceeds in neither real time nor real space, but is a sophisticated amalgam of editing techniques. Elliptical editing brings us up to the hotel while parallel editing lets us alternate from hotel to apartment to get the best of both sets of action. Although we followed the car all the way up into the mountains, we are magically already inside when Jack first strides into the lobby. By contrast, it is in a very human way that we follow him into the interview room, as though we were on foot behind him. When we alternate between locations and witness both sides of the same tele-phone conversation, we feel we have a superhuman freedom to see whatever we want whenever we want. The swooping aerial shots gave us an almost god-like feeling of omniscience. This is all an illusion, however, because in reality we are completely in the grip of the director and, for all our sense of autonomy are, in fact, being completely manipulated. This is one of the great things about film. When we witness Danny's psychic experience of the cascading blood and the spine-chilling twins, we move from a physical state to psychological insight. We are not just in an apartment or a hotel, we have been invited into the horrors of someone else's mind.

What may first appear, then, to be the most realistic of all the media we have so far encountered turns out to be quite the opposite. We are drawn into a fan-tastically crafted construction and, while always intellectually cognizant of its artifice, we are still emotionally manipulated by its apparent realism. We can, therefore, thoroughly understand the words in which the terrified Danny tries to convince himself after his most chilling encounter with the now dismembered twins: 'It's just like pictures in a book . . . it isn't real.' Exactly.

On the face of it, theoretical approaches to film should be very similar to those

of photography. Both, after all, depend on the ontology of the photographic image, and film, in its crudest sense, is photography at twenty-four frames per second. In practice, however, film theory has developed as a discipline in its own right. This confluence between the theory and practice of film analysis, together with the practice of actually creating film, makes for some unexpected complication when we reflect upon the medium from the six theoretical perspectives from the first part of this study.

Fortunately, a good place to begin is with iconology. With photography, we saw how this was a useful approach at both level one and part of level two. Complications set in, however, with the symbolic parts of level two, as objects might be included in a photograph as a result of happenstance rather than the conscious intent of the photographer. With film, the extent to which this might be true varies with the type of film under observation. With a documentary film, the director is *unlikely* to have placed objects within the frame with a view to their symbolic value; more typically, they are there on film because they were there in reality.[16] This does not, however, prevent a director from selecting or reframing a shot with a view to the creative treatment of actuality.[17] With a 'realistic' fiction film, especially one shot on location, the content of the frame is likely to be a mixture of circumstance and intent. Every detail of the characters, however, is likely to be deliberate, down to the last item of jewellery. The higher the budget, and the glossier the production values, the more every detail of a shot is likely to be intentional. Every shot is 'storyboarded' before filming even commences, and an army of artistic designers, costumiers and set dressers attends to the appearance of the film in every detail. Big-budget films can afford – and usually demand – this attention to visual minutiae. The analyst, therefore, needs carefully to consider the type of film under scrutiny before applying second-level iconographic theory. At the intrinsic level, these issues are less important. Intrinsic analysis is still hugely valuable, however, because a film is such a collaborative venture. It is more likely, then, to represent a group than an individual world vision. We will say more about this when we discuss the ideology of film in a few paragraphs' time.

Just as the value of iconographic analysis varies according to the type of film under review, so does the usefulness of a formal approach. Put simply, some films are much more formal in intent than others. This points us towards one of the key disputes within both film theory and practice: realist versus formalist film. According to the realists (originally led by theorists such as Siegfried Kracauer[18]), film both is and ought to be concerned with the representation of reality. It is its relationship with reality, they argue, that constitutes film's greatest strength. Consequently, formal considerations should be kept to a minimum in film, as they create obstacles between the viewer and the reality with which he or she is intended to connect. A contrary argument is put forward by the formalists (originally led by theorists such as Rudolf Arnheim[19]). The formal argument is that if film simply represents the natural world, then it is only a mechanical recording device and cannot claim to be art. Film, therefore, should eschew realist technique and give the viewer a new experience that is clearly creative; we should marvel at the film as an artwork itself and not simply at what it shows. To an extent, of course, this schism represents something of a false

dichotomy. Just like photography, no film is either entirely one or the other: it is a matter of degree. This, again, goes to show that the usefulness of the formal analysis of film varies according to the individual film under consideration. Again, Fry's aesthetic is useful here, even though his elements of design were devised for the analysis of painting and so are of only partial methodological use with film. Here, however, it is not simply a matter of the irrelevance of the 'rhythm of the line', as with photography. With film, the pictures move, and so the order and way in which the individual shots are compiled is fundamental to a formal analysis of film. Editing not only presents us with information in a carefully structured way; the rhythm of the cuts can provide an almost musical experience for the eyes.

Film history has already established itself as a respectable field of study. In general, it follows the narrative, chronological approach of art history, while at the same time permitting additional focus on particular films, directors, actors, studios and genres. It is an approach that helps us to see how a particular text fits within the story of film, and so is very useful for consideration of context, so beloved by art historians. Attribution proves less of a concern for film historians, as everyone concerned with a film is even more eager to append their name to it than painters to a canvas. Additionally, as film is such a modern medium, accurate records are far more readily available than with centuries-old works of fine art. Provenance is even less of an issue to the film historian, for multiple copies of films make the history of ownership of a particular print far less significant than if there were only one 'original'. Straightforward though the historical approach to film may be, however, it frequently forms the foundation of film education, just as art history typically provides the starting point for the study of painting.

The ideological analysis of film has in many ways replaced the realist–formalist debate as the most prominent concern of contemporary film theory. The ideological content of film is not an entirely new consideration, however. It was of great concern to the critical theorists of the middle of the last century: analysts such as T. W. Adorno and Max Horkheimer made broad (and even sweeping) criticisms of mass culture and what they saw as its promotion of the political interests of the ruling classes.[20] Many of these themes were echoed by Berger in *Ways of Seeing*, which also reveals the influence of critical theorist Walter Benjamin.[21] As we saw in our chapter on ideology, Berger's thinking on the ideological position of women in painting connects with early feminist film theory as pioneered by the likes of Laura Mulvey. In addition to class and gender issues, the ideological analysis of film can concern itself with any social value that may be articulated in a given text (or series of texts). Film lends itself easily to this kind of analysis for three main reasons. First, because, as such a pervasive mass medium, film nowadays provides a social education for many people beyond the parameters of formal schooling.[22] There is hardly an issue that has not been covered by film. Second, because the commercial cinema is so deliberately tailored to the tastes of the public at large, it can be hugely representative of public concerns.[23] Third, as a complex narrative medium which includes plot and dialogue in addition to visual content, film has a greater capacity for ideological loading than simpler visual texts. Just as with the ideological analysis of fine art, however, the ideological study of film is a heavily

disputed field. The reader is therefore urged to study the ideology of the analyst in addition to the ideology of the text.

The semiology of the moving image is even more complex than the semiotics of photography. Indeed, film semiotics has become a branch of film theory in itself. Part of the further complication lies in the extra layering of the fiction film. A photograph of President Kennedy, for example, is semiotically complex enough; a moving picture of an actor *representing* President Kennedy is more complicated still. This all goes to show that the semiotic analysis of film is both extremely rich and extremely difficult. Indeed, much of the existing writing on semiotic film theory makes for particularly challenging reading. We have seen in this chapter that film can be compared to language in that it can be reduced to its own 'grammatical' components. This renders it open to semiotic analysis as, we recall, semiotics began as an attempt to figure out how language worked. As with photography, however, the signifier and the signified in film are often indistinguishable, and so their relationship is certainly not arbitrary. But (again, in common with photography), the film image is capable of being connotative as well as simply denotative. An image of John F. Kennedy, for example, can refer not only to a specific human being, but to all that (culturally speaking) John Kennedy has come to represent. And, just as with photography, the way in which an object or a person is depicted adds considerably to its connotational meaning. Among the pioneers of film semiotics are Christian Metz and Peter Wollen, who argued that film communicated with three different types of sign: the icon, the index and the symbol.[24] It is not practical to describe (let alone critique) their approaches in any depth here; appropriate leads will be given in the 'Further Study' section to follow. Suffice it to say that the semiotic analysis of film is hugely stimulating, but is not for the intellectually faint-hearted.

In light of our discussion of semiotics, it should come as no surprise that hermeneutics can be productively applied to the study of film. Indeed, Geertz's interpretive methodology has distinct semiotic foundations. Where film particularly lends itself to Geertzian hermeneutics is in its narrative form. If cultural texts are stories we tell ourselves about ourselves, then explicitly narrative forms (which, like film, benefit from the added dimension of time) are likely to be especially rich in cultural meaning.[25] And because hermeneutics acknowledge ambiguity and layers of meaning beyond the literal, it is possible (for example) to interpret twentieth-century films about an alien invasion of the earth as metaphors (whether intended or not) for Western fears about communism and the former Soviet Union. The content and the meaning are never necessarily the same thing.

Key Debate

Does film just represent time or actually create it?

In this chapter, we have discussed the ability of film to communicate in a way that it does not share with other media. As we have seen, the uniqueness of film is related to the introduction of a new element, one which is absent in images conveyed through all the other media available when cinema was invented: time.

Time is also the central concern in the very particular views about cinema offered by Gilles Deleuze. Published in the 1980s, his two books about cinema have had what Robert Stam calls a 'positively corrosive impact' upon the field of film studies that can still be felt today.[26] The 'corrosive' nature of Deleuze's reflections is due to his overall attitude towards cinema as an object of study. Unlike other critics, who tend to look at film as a means to *represent* concepts, meanings and ideas, Deleuze is concerned with film as a means to *generate* them. In other words, where others regard film as a particular type of language, Deleuze sees it as a special kind of event.

This might at first sound confusing and vague. Certainly, Deleuze's own playful philosophical style is far from an example of systematic precision. He had a phenomenological attitude towards cinema, which saw 'film as an event', and this in turn was linked to a notion of cinema that highlighted its capacity to generate concepts rather than simply reflect them. It all becomes clearer if we look more closely at the concept that, according to Deleuze, is most crucially generated by light and motion in modern film. Yes: time.

We previously used the adjective 'modern' to classify the kind of cinema capable of generating a particular concept of time. This was deliberate, for, in Deleuze's view, the history of cinema is divided into two parts, the classic and the modern periods.[27] Each of these is characterized by a type of image, which, in turn, is defined in terms of the distinct way time (and space, in its relation to time) is articulated on the screen.

During the classic period, which Deleuze locates before the Second World War and is typically (though not exclusively) exemplified in Hollywood genre films, time is spatialized. That is to say, it is determined, measured and perceived through movement and action. Images in such films are images of motion and action – what Deleuze calls image-movement films – that provide a perception of time mediated by our sensor-motor system. Time, in these kinds of images, is subordinated to space, which means that the sense of time in classical image-movement cinema is experienced in an indirect way.

The narrative style of classical image-movement cinema is very familiar to us: it has certainly continued to inform mainstream films since the Second World War, and is still clearly predominant in Hollywood film today. As a result, it may be difficult for us to conceive a cinematographic experience of time different from the one we have just described. But we must ask ourselves: can time be experienced directly, cut off from sensory-motor connections, emancipated from space and movement links? According to Deleuze, film is the communication form that allows for such an experience, made possible through the time-image he associates with modern cinema. The archetype of this second period in the history of film is the European art cinema produced after the Second World War, in whose films Deleuze identifies images that generate a sense of time that no longer depends on its spatialized representation. Time-images, the novelty introduced by modern cinema, provide a 'direct relation with time and thought'.[28] Although European post-war cinema is identified with the generation of this new sense of time, Deleuze mentions the American film *Citizen Kane*, directed by Orson Welles in 1941, as a pioneer example of such 'direct relation with time and thought'.

44. Still from *Last Year at Marienbad* (*L'Année Dernière à Marienbad*, France/Italy, 1961, directed by Alain Resnais); photo: British Film Institute

Deleuze does not offer a clear-cut definition of what a direct image of time might be. But his insights indicate that the character of the time-image, sometimes also designated as the crystal-image, is related to its ability to fuse multiple temporalities. What temporalities are we talking about and how are they brought together through the time-image? The contrast with movement-image may help to answer the question. In classical film, time flows chronologically and is represented through progressions of shots that, in connecting time to sensory-motor references, represent it in a continuous fashion. Time ellipses and flashbacks add a degree of sophistication to this representation of time, but they do not alter the essentially linear nature of movement-image progressions, designed to create spatio-temporal coherence. The real shift occurs when different layers of time are simultaneously implicated, as happens in Alain Resnais' *Last Year in Marienbad*, to use one of the examples invoked by Deleuze to illustrate the 'present/pastness' of modern cinema time-image. In this 1961 film, with a screenplay by *nouveau roman* specialist Alain Robbe-Grillet, unnamed characters relate to each other in a European chateau (see figure 44). The film has become famous for its non-linear narrative structure, characterized by the intensive use of flashbacks and time shifts that are far from obvious and that create the time ambiguity that is the object of Deleuze's particular interest.

The 'present/pastness' emerges when the distinction between an event which is somewhere in the past and the recollection of such event through its actual viewing in the present becomes indiscernible. Past and present, virtual and actual, physical time and psychological time are merged in images where time fluctuates above the sensorial connections that link it to space and movement. Memories, dreams, fantasies and mental processes of all kinds are frequently evoked in images of this new type. The spatial representation of a continuous and coherent timeline gives room to the generation of fragmented time, eased of its links with the sensorial perception of movement, creating a sense of 'out-of-space' fractured time.

Although this is not the place to elaborate on the philosophical presuppositions and implications of the Deleuzian notion of time-image, it is still worth mentioning the influence of Henri Bergson on its formulation. And, if we take into account that the work by Bergson that most influenced Deleuze was *Matter and Memory*,[29] it is hard to resist associating the movement-image of classical film with the territory of matter and the time-image of modern cinema with the field of memory.

In this chapter on film, we have referred to the vocabulary and the grammar that have been gradually developed over the history of cinema. The main elements of this vocabulary and grammar are the same in both classical and modern film: the shot and the editing. Their purpose, however, is not the same when movement-image or time-image is privileged in the narrative. Deleuze sees the shot facing in two directions: on the one hand, it presents relationships among elements within the frame; on the other hand, it relates to a wider 'whole' outside the frame, which is continuously rearranged as the narrative progresses. In classical film, movement-image shots function as parts of the whole, to which they relate so as to engender an organic totality based upon rationality, coherence and continuity. In modern film, however, time-image shots do not serve the same purpose. They gain a new autonomy, enabled by the overall crisis of rational 'wholes' that Deleuze, sharing an overall postmodern perspective on contemporary culture, associates with modern cinema. Since each time-image shot relates to a non-totalized process, it acquires an expressive value *in itself*, and its connection to the previous and to the following shots is no longer guided by concerns of rationality, coherence and continuity.

What about the representation of space on screen? How is space affected by the alleged collapse of totalities that open the way for discontinuous successions of time-image shots that characterize modern film? We have discussed Deleuze's argument that space and the movement within space are used to offer sensory-motor representations of chronological time in classical film, which is not the case in modern cinema. In this case, does modern film present a particular articulation of space? In other words, is there a spatial habitat particularly adequate for time-image shots? According to Deleuze, such habitat can be found in what he designates as 'any-space-whatevers'.

The term 'any-space-whatever' (and we admit its unintended comedy potential) was originally crafted by the French anthropologist Marc Augé (*espaces quelconques*),[30] but Deleuze appropriates it in a very particular way. Augé used it to refer to homogeneous and anonymous spaces (such as airport terminals,

metro stations) that deprive people of their individuality. Deleuze sees these very same places not as de-singularizing loci, but rather as spaces whose apparently homogeneous universality opens them up to the emergence of all sorts of singularities.

Examples of 'any-space-whatevers' can be found in the empty urban spaces so often filmed by Michelangelo Antonioni. In Antonioni's cinematography, pieces of urban waste ground where buildings have been demolished, and rebuilding has not yet taken place, provide the sense of indetermination and openness that is central to the Deleuzian notion of 'any-space-whatever'. Just as the determined spaces of classical cinema allow for an ordered development of the narrative, the sense of indetermination conveyed by 'any-place-whatevers' contributes to put it in crisis, creating an instability that contaminates the identity of the characters and the rational coherence of the plot.

The notion of 'any-space-whatever' also helps in understanding why Deleuze locates the shift from classical to modern cinema in post-Second World War Europe. As he puts it, 'the post war period has greatly increased the situations we no longer know how to react to, in spaces we no longer know how to describe'.[31] It is impossible not to relate that description to the wider sense of indetermination and disconnection that seems to have spread in Western societies over the last half-century. Modern cinema can be seen as a response to that overall feeling. Post-war ruins are no longer part of our daily visual routines. But the proliferation of urban undetermined spaces has simply taken new forms.[32] The same can certainly be said about the crisis of rational totality systems or the instability of identities. All these processes are related to the emergence of a new concept of time that Deleuze associates with the time-image triggered by modern cinema, which makes his writings on the subject much more than just another history of film.

Further Study

There is no shortage of material for further study in film. For the sake of simplicity, we can divide serious reading on film into four separate categories: film history, film theory, the sociology of film and film practice. In addition to serious reading, there is a plethora of publications and websites aimed at the 'fan' or the enthusiast. These are not recommended for scholarly research – unless, of course, one is researching the popular culture surrounding film. They have sociological interest to be sure, but in terms of knowledge about film, they lack *authority*.

Histories of film range from the general to the particular. Narrative histories of film, just like those of other media, provide a convenient way for the reader to gain his or her bearings within the chronology of the cinema. Movements, styles and technological developments are traced, along with the political economy of the movie business. As the cinema is a not inconsiderable commercial enterprise, the latter has a great deal of influence over the films we see. Gerald Mast's *A Short History of the Movies* is widely recommended by teachers of introductory film studies, and is currently in its sixth edition.[33] Inevitably, perhaps,

Hollywood's domination of commercial cinema production is reflected in the literature. David Bordwell, Janet Staiger and Kristin Thompson's *The Classical Hollywood Cinema* provides an overview of style and production during a period of Hollywood's undoubted supremacy.[34] Cinema from the rest of the world is, as yet, less well reflected in literature in English. India and Hong Kong, for example, have flourishing film industries. British films, in comparison, tend to be influential rather than numerous, and the health of the British film industry is a matter of seemingly continual concern.

Studies of stars and directors fall under the heading of film history, focusing as they do upon individual lives and works within an historical context. Care needs to be taken here, however, in separating works of genuine academic merit from the many publications (successfully) aimed at coffee tables and the star-struck. Studies of directors tend to be the more reliable of the two, owing to the presence of '*auteur* theory' in film study: the idea that a director is individually responsible for a film, just as an author or a playwright is responsible for a novel or a play.

Film theory provides both a profitable and a challenging area for further study. Briefly, film theory asks fundamental questions about what film is and how it communicates. It also considers its status as an art form. Film theorists have traditionally fallen into two groups: the 'formalists' who believe that film's strength lies in its transcendence of reality, and the 'realists' who argue that film is intrinsically related to the real and visible world. Among the formalist writings, Rudolf Arnheim's *Film as Art* is a seminal work, while for the realists, Siegfried Kracauer's *Theory of Film: The Redemption of Physical Reality* is a key text.[35] Within the formalist and realist categories, we can also observe both 'prescriptive' and 'deductive' theories of film. The former seek to devise rules to which film should conform if it is to be successful; the latter take film's success as given, and seek, rather, to account for it. André Bazin, for example, is both a realist and a deductive theorist.

More recent theories of film have revolved around semiotic, structural and postmodern analyses, the beginnings of which we observed in chapter 5. Two particularly recommended readings on film semiotics are Christian Metz's *Film Language: A Semiotics of the Cinema* and Peter Wollen's *Signs and Meaning in the Cinema*.[36] For those unfamiliar with film theory, a broad orientation in the fundamental arguments is recommended before striking off into special-ist territory. J. Dudley Andrew's *The Major Film Theories* provides just such a grounding. Bordwell and Thompson's *Film Art: An Introduction* is also fre-quently recommended, along with Gerald Mast and Marshall Cohen's selection of introductory readings in *Film Theory and Criticism*.[37]

Sociological approaches to film, it could be argued, are a branch of film theory. As they concern themselves less with the ontology of the medium and more with its relationship to culture and society, however, they will be consid-ered separately here. Some early and influential writers on this topic considered the relationship between film and society to be an unhealthy one. T. W. Adorno, Max Horkheimer and others of the Frankfurt School argued passionately that 'popular culture' (including film) was not actually 'popular' at all. It was not a culture *of* the people: rather, it was imposed *upon* the people in a class society.

Film, for example, was produced like an industrial product, while also serving two nefarious ends: it sought to distract people's minds from the harsh, political realities of their own lives while at the same time using the surreptitious, ideological content of the movies to persuade the viewer that capitalism was both natural and inevitable.[38] Marxian concerns about capitalism are less widely heard nowadays, but, as we saw in chapter 4, subsequent schools of thought have redirected ideological attention to what they believe are the inequitable, gender-biased assumptions of the commercial cinema. Others have similarly argued that a sociological examination of film texts reveals unhealthy social attitudes towards ethnic and sexual minorities. This in turn has stimulated much sociological debate as to whether the cinema creates, reflects or simply perpetuates societal attitudes. It is an argument that cannot be resolved here. The competing theories are, however, succinctly outlined in publications such as Fred Inglis's *Media Theory*.[39]

The belief that film is indicative of the *Zeitgeist* (spirit of the age) or *Weltanschauung* (world-view) of a particular culture or nation supports sociological investigations of film and national identity. This correlation is psychological rather than literal: as Martha Wolfenstein and Nathan Leites showed, in *Movies: A Psychological History*, life itself isn't like it is on film.[40] What the movies reveal is a set of underlying attitudes – rather like a dream. In this way, for instance, films set in the past tend to reveal more of the present in which they were made. That is how Siegfried Kracauer was able to claim: 'The films of a nation reflect its mentality.' He concluded that an examination of German national cinema from 1920 – and especially of its historical films – explains the rise of Hitler.[41] More recently, cinema in the United States has been examined for its sociological 'mind-set' in books such as Stephen Powers, David J. Rothman and Stanley Rothman's *Hollywood's America*, while, in the UK, Jeffrey Richards covers corresponding ground (albeit with a different approach) in *Films and British National Identity*.[42]

Besides constituting a useful resource for a philosophically informed approach to cinema, *The Philosophy of Film and Motion Pictures: An Anthology*, edited by Noel Carrol and Jinhee Choi,[43] includes as a 'bonus' Roger Scruton's essay 'Representation and Photography', which is the main source of our Key Debate in the photography chapter. The analysis of the link between film and philosophy has to include the work of Gilles Deleuze. For those who find that Deleuze's writing is not easy, Ronald Bogue's *Deleuze on Cinema*[44] may be helpful. This includes a discussion of Bergon's influence upon Deleuze's understanding of time in film. Thomas Elsaesser and Malte Hagener's *Film Theory –An Introduction through the Senses*[45] presents an interesting structure: despite being a book on theory, as the title suggests, each chapter is organized around a particular film, from *Rear Window* to *Persona*, from *Blade Runner* to *Toy Story*.

It has not been the intention of this chapter to explain the complex, skilled and time-consuming process by which films are made. Consequently, there has been no attempt to offer instruction on cinematic practice to the reader. As with photography, however, a practical understanding of how cinema works is a useful area for further study, as it helps an intelligent reading of films themselves. A helpful overview is given by James Monaco in *How to Read a Film*, which has

the added advantage of also including introductory sections on film history and film theory.[46] For fuller consideration, Edward Pincus and Steven Ascher's *The Filmmaker's Handbook* has long been a valuable, practical resource for the student film-maker. Since its original publication in 1984, however, video and new technologies have made considerable inroads into student, small-scale and even feature film production. Writers such as Ascher and Pincus have therefore kept pace with their revised and updated version: *The Filmmaker's Handbook: A Comprehensive Guide for the Digital Age*.[47] The contribution of new media to visual culture in the 'digital age' will be considered in our final chapter.

10

TELEVISION

In this chapter we will investigate the question of realism in television. Already in this section we have discussed the relationship between reality and the graphic, the photographic and the moving image. It is time now to consider the most pervasive of today's mass media – one whose realism is widely assumed but is, in fact, considerably more difficult to demonstrate. We begin by making claims for the value of television as a cultural artefact, a value that is independent of its intellectual content or artistic quality. This leads us to a focus on soap opera, with a case study of the long-running Australian programme *Neighbours*, which we proceed to compare with the teenage drama *Heartbreak High*. We pursue the role of realistic detail in television with the example of British police series *The Bill*, which in turn leads us to an analysis of the hugely successful American situation comedy *The Cosby Show* and its portrayal of race and reality. Our investigation leads us to a concluding discussion about the ideological leanings of popular TV and the extent to which its realistic surface disguises a fantastical inner core.

If aliens from the planet Tharg were to be monitoring the earth by watching our television programmes, how realistic an impression of our lives would they receive?

This may strike us as a preposterous proposition, but actually it isn't. No: this is not a pitch for the existence of extraterrestrial life. Rather, it is a proposition calculated to draw attention to the way in which we ourselves have sought to gain access to the lives of others through an analysis of their visual culture. This, in turn, should entice us to reflect upon the relationship between our televisual culture and us. How realistic is television? What are the similarities and

differences between the world as depicted on TV and the world that we actually inhabit?

The good people of Tharg (let us reasonably presume) are unable to visit earth in the twenty-first century, just as we are unable to visit the ancient Rome or Mayan Mexico of two millennia past. What we can do, though, is try to learn as much as we can about distant cultures by giving close readings to their cultural texts. This is what archaeologists do. We may not be able to participate in Roman or Mayan daily life ourselves, but we feel that we are able to build up an informative picture of their culture and their civilization through an examination of their houses, temples, carvings, mosaics, coins and artwork. Even broken pieces of pottery can be put together to reveal something of their daily lives. The value of broken pottery and even kitchen utensils to archaeologists demonstrates that it is not only great art and 'high' culture that are useful in creating a picture of the lives and times of people from different cultures. Indeed – and especially when we are interested in everyday and not just spectacular lives – the mundane can be even more revealing than the remarkable. Archaeologists researching Dudley Castle in England, for example, gained a great deal of insight into medieval England by excavating the castle dung heap. To be sure, the midden may have lacked the prestige and splendour of the chivalric glories of the Middle Ages, but it both widened and deepened scholars' understanding of what people ate and threw away as part of ordinary domestic life. The lesson for us is that all manner of things can be used to enlighten us, even if they are – quite literally – a pile of manure.

Popular television, with its action dramas, game shows, soap operas and situation comedies, may not showcase the very best in contemporary culture. In terms of sheer quality, it is hard-pushed to rival poetry, the opera, the art gallery or the symphony hall. But the student of contemporary visual culture, just like the archaeologist, must not be blinded by the 'quality threshold' in the search for understanding. We do not have qualitatively to admire something in order to find it informative. The cinema, for example, runs the whole gamut from art to schlock, but as director and writer Andrew Bergman has argued, 'every movie is a cultural artifact' which, just like the 'pottery shards' and 'stone utensils' examined by scholars of other cultures, reflects the 'values, fears, myths and assumptions of the culture that produces it'.[1]

Bergman is a writer, director and analyst of popular movies. This is important because, when he states that 'every movie is a cultural artefact', he is speaking not simply of a few, high-minded art films, but of 'every movie'. His use of the word 'movie' is deliberate, and it is chosen in opposition to the more highly regarded 'film'. If one thinks of cinematic culture, one can be forgiven for thinking automatically of 'film', but here Bergman is able to use the words 'movie' and 'cultural' in the same phrase. His understanding of 'culture', then, is very much in the Geertzian sense.

Scholars of film aesthetics have concentrated, understandably perhaps, on the relatively small number of artistically sophisticated films made by *auteurs*: those film directors whose works receive serious critical attention on the strength of who directed them rather than who starred in them.[2] When we want to look at movies in the cultural sense, however, it is necessary to cast our net

much wider. Indeed, the less artistic a movie's aspirations, the more revealing it is likely to be at a cultural level. James Monaco, for example, is someone who personally much prefers the 'art' film, but who nevertheless recognizes the sociological value of the mass-produced Hollywood product: 'In fact, because these films were turned out on an assembly-line basis in such massive numbers, they are often better indexes of public concerns, shared myths and mores than individually conceived, intentionally artistic ones are.'[3] Robert Warshow, the American critic who was among the first to take popular screen culture seriously, went so far as to describe the movies as a kind of 'pure culture . . . which has not yet altogether fallen into the discipline of art'.[4] Bergman, Monaco and Warshow all serve to remind us not to trip over the 'quality threshold' in search of the cultural value of film. It is a view that extends more widely into the study of popular culture as a whole. Eugene Weber, for example, chose to focus on popular as opposed to avant-garde culture in his study of *fin de siècle* France. No matter how much he admired the products of the avant-garde, they were 'marginal and unrepresentative' and admired only by a 'narrow trendy public'.[5] Even T. S. Eliot, one of the high priests of high culture, was able to concede: 'Even the humblest material artefact . . . is an emissary of the culture out of which it comes.'[6]

Our three-headed aliens from the planet Tharg would, then, demonstrate considerable sagacity by monitoring our television programmes in order to find out who we are and how we live. Television provides one of our most prevalent visual texts. Who does not watch television? All around the world, television can be found in homes, offices, hotels, schools and hospitals. Even in the contemporary gymnasium, we can find ourselves running, peddling or rowing with our eyes fixed not upon the open road or river, but upon the screen in front of us. The television is no longer limited to the family room, even during the working week. TVs go on in the kitchen during breakfast, and they go off in the bedroom last thing before going to sleep. Anyone who doubts the prevalence of television should keep a diary of how much a part of their (or their friends' or families') day is spent, no matter how casually, watching TV.

The aliens from Tharg will have little difficulty in finding a broadcast. All around the world, terrestrial, satellite and cable programming leaves an increasingly bewildering variety of choices to watch. Perhaps the monitoring aliens would pick a country and a programme at random. When we picked a local, British channel at random to prove a point to students, we were treated to a camouflage-painted Arnold Schwarzenegger (even before he became Governor of California) battling supernatural creatures with bows, arrows and flames in a darkened forest. Apparently, a group of commandos in the South American rainforest had found themselves hunted by an extraterrestrial predator. Fortunately, Schwarzenegger was able to save the day.[7] This kind of movie is fairly standard TV fare, and is just the sort of thing our aliens or any other type of cultural archaeologist could dig up from a random scan of our TV channels. We would suggest, however, that the analyst should not jump to the wrong sorts of conclusion. Although this was indeed transmitted one night on a regional British TV channel, it did not provide a reliable picture of British life. We were not living in South America, let alone in the middle of a rainforest. We are not

aware that any of our neighbours has ever been hunted by an extraterrestrial (certainly in our part of town), and neither we nor anyone we know looks even remotely like Arnold Schwarzenegger. So: if friendly aliens had taken TV as typical in this instance, they would have been seriously misled.

We know, of course, that real life isn't like it is in the movies. This is something of which Wolfenstein and Leites articulately remind us in their psychological study of Hollywood: 'We should not expect the relation between movies and real life to be one of simple correspondence. Thus we do not, as foreigners occasionally do, infer from American films that gangster hostilities are the major preoccupation of daily life, or that life-and-death chases in high powered cars constitute the major traffic on the highways.'[8] Their point is amusingly well made, but even within our own time and culture we can sometimes be forgiven for 'learning' much about other countries from the movies. If a film is, indeed, an emissary of the culture from which it comes, in the hands of someone taking such an artefact at face value, a very misleading reading could be the result.

Perhaps we have taken an unfair example. We have just been looking at film (even though it is frequently shown on TV), where really we had meant to look at television. Television, after all, is much more realistic than cinema because that is the medium for which 'gritty', 'down-to-earth' and even 'everyday' drama is most commonly produced. To be fair, therefore, we should look at programming that is specially made for television. Soap opera seems a very good place to start.

Soap opera takes its name from the commercial fact that this form of open-ended serial drama was devised as a vehicle for the advertisement of domestic products to the mainly female viewers who were thought to constitute the majority of the television audience during the day. Women, it was calculated, would be drawn into the human-interest storylines and would at the same time be shown advertisements for the soap powder (and other) commercials for which they were the target audience and intended consumer. Some networks have attempted to euphemize this by insisting that their soaps are nowadays referred to as 'daytime drama', but the public still know a soap when they see one.

Some soaps are more realistic than others. American soaps tend to have everyday titles (*Days of Our Lives, General Hospital*) but usually feature the glamorous lives of wealthy and accomplished people. British and Australian soaps, on the other hand, aim to be more recognizable to their audiences. The long-running *Coronation Street*, for example, is set around a working-class neighbourhood in the north of England, while its BBC rival *EastEnders* takes place around an inner-city square in London. Australian soaps tend to be much more middle class, such as *Neighbours*, which takes place in a residential street in the fictional Melbourne suburb of Erinsborough. In some ways, an intergalactic archaeologist (or even a Londoner or a New Yorker) watching *Neighbours* would get a fairly reasonable impression of Australian daily life. The characters have believable jobs (the most glamorous is a doctor in general practice) and the children attend an ordinary local high school. Their houses are neither grand nor humble, and they wear the sorts of clothes available at a typical mall. In the interests of realism, characters can often be seen wearing the same clothes in

a number of episodes: they have limited budgets, just like everyone else. They tend to eat at home or on the run; restaurants are a treat. The adults drive the sorts of car one would find parked on any suburban drive; the kids ride bikes and play computer games. The premise for *Neighbours*, then, is convincing and the setting is visually realistic.

Life in *Neighbours* tends to revolve around everyday themes: who is dating, making up or breaking up with whom, the success of the local sports teams, rivalry over recipes, boundary disputes between adjacent gardens and even the occasional wedding. In many ways, it is the warm-hearted trivia of daily life that provides the appeal of *Neighbours*. Although made and originally shown in Australia in 1985, it also became very popular in the UK, where it was for a while the country's top-rated programme. It remained part of the BBC's schedule until 2008, moved to Channel 5, and celebrated its twenty-fifth anniversary in 2010.

To an extent, it is the gossip provided by *Neighbours* that has kept the audience interested. 'Ramsay Street' provides something of a surrogate community for its viewers, especially as real communities provide less and less in terms of neighbourly social interaction. Everyday gossip, however, is never quite enough in even the most 'realistic' of soap operas. Even *Neighbours* needs incident beyond real life. After all, if TV were only like real life, there would be no point in watching TV. To remind ourselves that the realism of soap only goes so far, it is informative to count the number of characters who have died – usually in dramatic circumstances. *Neighbours*, for example, is based around just six houses in one ordinary street, but the mortality rate resembles the killing fields more than it does suburbia. It would be amusing to list each former character together with the circumstances of his or her tragic demise (Kerry Bishop: bizarre duck-shooting accident, and so on), but such a compilation would be out of date even before we reach the end of this chapter.

The more we think about *Neighbours* (and many other soaps for that matter), the more we become aware that its typicality is only partial. Ramsay Street turns out to be a neighbourhood in which wrongs are always made right and disputes, no matter how rancorous, are always resolved into amicability. The cast (especially the youngsters) consists of unusually good-looking types, and there is something remarkably well scrubbed and wholesome about the whole environment, socially as well as physically. Surely, the whole of Australia cannot be like suburban Erinsborough?

While *Neighbours* originated in the 1980s, *Heartbreak High* emerged in the 1990s. It ran for seven seasons until 1999, and syndicated in Europe, India, Canada and the USA. Although it was still set in Australia, this was heralded as a much more raw and realistic portrayal of life than *Neighbours*. It was set in a working-class area of Sydney, and revolved around a local, inner-city high school. For the young people in *Heartbreak High*, going to school was only one of the problems that they needed to confront as part of their daily lives. Where *Neighbours* began with a sing-along theme tune about the joys of neighbourliness, coupled with smiling pictures of the cast in their gardens, *Heartbreak High* was introduced by distorted guitar-work and an energetic montage sequence of the multi-ethnic characters out and about on the city streets. Pre-publicity for

the UK screenings included concerns from parents that the *Heartbreak High* teenagers were overtly sexually active, and freely discussed controversial issues such as contraception. Here at last, it might have seemed, was a realistic portrayal of contemporary Australian life.

One typical episode from the first series shows the students returning to class after vacation. As the teacher battles to keep order, it becomes apparent that none of them has done the required reading for English. Their excuses are realistically unimpressive. The girls are much more interested in the arrival of a good-looking new drama teacher, Mr North. In his class, the students behave rowdily and disrespectfully, and the scene is heavy with sexual banter and innuendo. Then they hear that their English teacher is leaving. The real reason is that her fiancé has got a promotion to another city, but they think it is because they have been behaving so badly. Next time she arrives for class, the students in class are already rapt in their reading, and a bunch of flowers is waiting for her on her chair. 'Miss,' says one of the most supposedly streetwise of the students, 'we just wanted to say we like you a lot.' What happens next? Well, after a very socially conscious discussion about whether a woman should quit her own job to follow her intended husband, 'Miss' announces she will stay. The class leap to their feet, cheering, hugging and literally dancing for joy in the aisles. Where is the gritty realism of *Heartbreak High* now?

Heartbreak High, it would seem, is an example of a television series that has only a veneer of 'gritty social realism'. In this and many other programmes from around the world, it seems that what we have is a vigorously shaken mixture of fact and fantasy. It is no wonder that the aliens from planet Tharg are confused: so are we. There is nothing new about this, however, and it is certainly not unique to television. Fiction has long gained narrative conviction from a heady mixture of the actual and the imaginary. Homer's *Odyssey*, for example, can be very helpful in giving us a picture of life in ancient Greece. It is set against a background of the Trojan wars, and we can picture the men, the ships and the palaces as we read. We can also learn a great deal about Achaean culture and customs. On the other hand, the *Odyssey* is also populated with gods, goddesses, sorcerers and one-eyed monsters. We would be unwise to take all of it too literally. If we jump from Greece in the eighth century BC to England in the fifteenth century AD, we can use *Sir Gawain and the Green Knight* to help us create a picture of medieval courtly life. In one part of the story, the Gawain poet describes in gruesome detail how a deer is cut up on site by a hunting party:

> First the throat was slit, and the gullet scraped
> With a sharp knife, and tied; then they cut
> The legs and skinned them; then broke the belly
> Open, and carefully hauled out the intestines,
> Leaving the gullet knotted in place;
> Then taking the throat they quickly separated
> Esophagus and windpipe . . . [9]

It is a sequence that would delight historians of medieval hunting and even butchery techniques, but before we start reading *Gawain* as though it were a textbook, we should remember that Gawain's quest began with the decapitated

green knight retrieving his own head from under a table and, still talking, riding out from the banqueting room on his green horse.

Much more recently, similar techniques have been used by thriller writers such as the creator of James Bond, Ian Fleming. Bond's adventures, both sexual and professional are, of course, preposterous. However, we are able (partially) to suspend disbelief because of the amount of credible detail that Fleming puts into his work. In *Dr No,* for example, we have the customary scene in which Bond receives his equipment for his forthcoming assignment:

'There's only one gun for that, sir,' said Major Boothroyd stolidly. 'Smith and Wesson Centennial Airweight. Revolver . . . 38 calibre . . . With standard loading it has a muzzle velocity of eight hundred and sixty feet per second and muzzle energy of two hundred and sixty foot pounds. There are various barrel lengths, three-and-a-half-inch, five-inch.'[10]

The gun seems so authentic that the rest of the story must be too. Actually, of course, we have to learn how to separate authentic detail from imaginative substance in Homer, Gawain, Fleming and television drama. This is not always easy.

Television's long-running police drama *The Bill* provides another classic example. It ran on British independent television from 1984 to 2010 and its longevity broke British TV records. It was syndicated in Europe and Australasia. It was a show so seemingly authentic that officers of London's actual Metropolitan Police were said to have given it their seal of approval.[11] The police here were not the picturesque, avuncular 'bobbies' of village-green England, but a hardened, up-to-date, urban force of human and sometimes flawed characters trying to do their best in a world of rising crime and falling resources.

In the tenth anniversary special episode of *The Bill,*[12] Detective Inspector Sally Johnson has herself been brought before the court on a charge of the unlawful killing of a suspect (see figure 45). DI Johnson had led a dawn raid on the housing-project home of a suspected drug dealer. As Johnson and her team burst in, the suspect swallows a large quantity of crack cocaine in a bid to dispose of the evidence. Johnson believes that this is likely to kill him, and so attempts forcibly to remove it from his mouth. In the ensuing struggle, the suspect knocks his head against his bedside furniture and dies. Now it is Johnson who faces the judge, despite the efforts of some of her colleagues to protect her by covering up the full circumstances of the death.

The plot strikes us as entirely credible in the modern world. Drugs, and especially crack, are a feature of inner-city life and sometimes the police feel they are fighting a losing battle. Miss Marple may not have approved, but force genuinely is sometimes a part of that battle. We know from reading newspapers from London to Los Angeles that, increasingly, police – and not just criminal – actions can give rise to public concern, and that, on occasion, officers have been known to put their loyalty to each other above their loyalty to the law. This anniversary episode of *The Bill* continues in almost documentary style as the trial is about to begin. Johnson's fellow officers bicker about who is paying for the tea in the cramped and unlovely witness room, and a hand-held

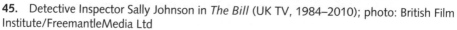

45. Detective Inspector Sally Johnson in *The Bill* (UK TV, 1984–2010); photo: British Film Institute/FreemantleMedia Ltd

camera follows Johnson herself as a sour-faced prison officer leads her from the holding cell and up into the dock. The court is hushed as she firmly pleads 'not guilty'.

This special edition seems to ooze authenticity in everything from its plot to its characterization and even its camera work. We may be seduced into reading it as an historical document; as dependable visual evidence of typical police procedural life in London in the late twentieth century. As the camera cuts to a close-up of Sally Johnson's face as she denies the charge, only the particularly well informed would spot that there is one feature of this situation that was in fact remarkably unrealistic. At the time that this episode was made (1994), there was not one black woman holding the rank of Detective Inspector or above in the whole of the Metropolitan force. As a high-ranking officer, Sally Johnson was a complete fiction. So how should we, let alone anyone else, read this as a social document? And if it doesn't tell us everything about life and law enforcement in London, does it tell us nothing?

Television, agrees John Fiske, is 'an essentially realistic medium'. It is realistic, however, because of its ability to be 'convincing' and not because of its 'fidelity to an empirical reality'.[13] One way to demonstrate the distance between the world of television and that of daily life is to perform a quantitative analysis of the sorts of people and situations we typically find on TV and make a statistical comparison with that which we find in the world outside. Lichter et al. conducted what they describe as a 'scientific' analysis of the content of thirty years of prime-time American television and discovered 'five times as many spies as meat cutters' and '16 times more prostitutes than mineworkers'. They found the murder rate on television to be 1,000 times greater than it was in reality, and that, 'compared to his real life counterpart, the television murderer is more likely to be a wealthy, white mature adult'. Actual homicides, they claimed, were committed much more often by juveniles, non-whites and low-income groups. According to Lichter, Lichter and Rothman, blacks on TV were eighteen times less likely to commit murder than in real life. Asians, on the other hand, committed three times more murders on television than in reality.[14]

These examples from the contentious and controversial arena of racial issues go to show that spotting the differences between life on television and life in reality could become something of a parlour game. But actually, it's more important than that: real social issues are at stake. Even a seemingly heart-warming situation comedy such as *The Cosby Show* can become a political issue.

The Cosby Show was screened by NBC Television in the USA, and syndicated around the world, including Channel 4 in the UK (see figure 46). It ran for eight seasons and 198 episodes, from 1984 to 1992. It was the number one show in the American Nielson ratings from 1985 to 1989, making it one of the most popular and financially successful programmes in the history of American television.[15] *The Cosby Show* was the story of happily married Dr Heathcliff Huxtable (an obstetrician), his wife Clair (a lawyer) and their family, who lived in a smart brownstone house in Brooklyn, New York. They had five children: Sondra was a Princeton graduate who went to medical school and married a fellow medical student. Denise was the wild-child of the family, having dropped out of college. She nevertheless married a serving officer in the US Navy. Son Theo became a student at New York University (from which he graduated in the final series), while daughters Vanessa and Rudy lived at home and went to school. Episodes revolved around the family home, centred on the wit and wisdom of Dr Huxtable, played by Bill Cosby himself.

The Huxtables enjoyed a very good lifestyle. Their house had room for all the family, and was tastefully furnished. Although they lived in New York City, there were trees and on-street parking outside. In one episode from season seven (1991), we see Cliff taking Clair off skiing for the weekend, while Theo takes advantage of their absence by cooking for a prospective girlfriend. The expensive European cookware simmers on the stove as student Theo prepares the appetizer of shrimps in hot sauce, accompanied by a crisp Chardonnay. The family, whether in practice, college or school, are always immaculately dressed; their home is one to which many of us would aspire.

The Huxtables' happiness is not simply material, however. This is a family in which the long-running marriage is strong, and in which the children both

46. The Huxtable Family in *The Cosby Show* (US TV, 1984–92); photo: British Film Institute

respect and seek the advice of their parents. Family love is unconditional, even though strict standards of discipline are maintained. Humour abounds. The cordial family relationships extend beyond those living under the parental roof. Theo may not end up with his hoped-for privacy for his romantic dinner, but as siblings and grandparents appear unannounced (together with the unexpected return of his parents), everyone is welcomed, quite literally, with open arms. This is an extended family in which everyone actively *likes* each other as each new lesson is learned and every obstacle, comic or otherwise, is overcome.

To an extent, the Huxtables follow in the tradition of America's most notoriously happy, successful and entirely functional family of the 1970s: *The Brady Bunch*.[16] This is the story of architect Mike Brady, who, together with his

wife Carol, is bringing up six children in a large and comfortable family home with the invaluable help of their housekeeper, Alice. Just like the Huxtables, the Bradys are well dressed, good-looking and respectful to each other. The pains and adventures of childhood and even adolescence are lovingly aired and resolved within each thirty-minute episode. There are differences, though. For both Mike and Carol, this is their second marriage, and it is Mike alone who is the professional breadwinner. The Bradys are white, and the Huxtables are black.

There is nothing unusual about a sitcom or serial drama revolving around a professional, aspirational, middle-class family. For such a family to be black, however, made *The Cosby Show* significantly different. Prime-time television drama in the UK and the USA is mostly concerned with white families and characters. It is not only the absence of ethnic characters that has proved to be contentious, however: ethnic groups have long complained that when such characters do appear, they are often negatively portrayed. What was needed, they contended, were positive representations so that the characters would not only serve as positive role models to minority people, but they would also combat negative stereotyping by majority groups.

In *Watching Race*, Herman Gray traces the portrayal of black characters and issues in American television. In the early 1950s, programmes such as *Amos 'n' Andy* and *The Jack Benny Show* represented blacks in 'stereotypical and subservient' roles such as domestic servants or 'con artists and deadbeats'. Some of the characters were, to be sure, sympathetically portrayed, but rarely did they show the social competence or civic responsibility that would place them on 'an equal footing with whites'. In 1953, the National Association for the Advancement of Colored People successfully lobbied to get *Amos 'n' Andy* taken off air. The late 1950s and 1960s, says Gray, offered 'more benign and less explicitly stereotypical' images of black people, but, in programmes such as *The Nat 'King' Cole Show*, played down their 'blackness'. In the early 1970s, however, the networks began making programmes that contained 'authentic' and 'relevant' representations of black people. These tended to be set in poor urban communities, 'populated by blacks who were often unemployed or underemployed'. In the late 1970s and early 1980s, programmes such as *The Jeffersons* and *Diff'rent Strokes* broke away from depictions of poverty to scenes of black social mobility but, argues Gray, only to a limited extent. Often, this required putting characters in unusual situations (such as black children in white middle-class homes, as in *Diff'rent Strokes*), and the effect was frequently as 'benign and contained as shows about blacks from earlier decades'.[17]

The Cosby Show is considered by Gray to be so different and so important that he refers to its arrival in 1984 as 'the Cosby moment'. It was a show that 'intentionally presented itself as a corrective to previous generations of television representations of black life'. The Huxtable family is stable, successful and (upper)-middle class. It is 'universally appealing' largely because 'it is a middle-class family that happens to be black'. As the show projected its celebration of the upper-middle-class life, together with an idealization of the family, rather than emphasizing its 'blackness', it was able to attract and maintain large, multiracial audiences. As such, argues Gray, it provided 'a critically important

moment, a transitional point . . . in the development of television representation of blacks'.[18]

What would our aliens from the planet Tharg make of *The Cosby Show*? Would they take it at face value as an authentic representation of the typical black experience in New York City in 1984–92? Would they use it to deduce that law and medicine were the typical occupations of black people? From that, would they extrapolate that the most revered professions in America were held by blacks – and, in the case of law, especially by black women? Would they conclude that the average black teenager went to university, possibly even one of the Ivy League, before studying medicine and marrying another (black) doctor? And would they conclude that the typical black person in New York lived in a single family brownstone house with trees and plentiful parking outside?

If our observing aliens – or anyone else for that matter – were to take *The Cosby Show* as typical of the black experience in America, they would be seriously misled. The statistical picture is starkly different from the television image projected by the Huxtables. Although the Huxtable family lived in aspirational comfort, when *The Cosby Show* was first aired in 1984, the typical black standard of living was actually declining in comparison with whites. Black families had always earned less than white, but in the ten-year period from 1975 to 1984, black family income went down further, from 61 per cent to 56 per cent of white family income. Relative unemployment, meanwhile, increased. From 1980 to 1988 (four years into the *Cosby* run), black poverty actually increased, with 33.1 per cent living below the poverty line by the end of that period. Despite the Huxtable family's affluence, in 1988, only 42.4 per cent of black families owned their own homes, compared with 67.2 per cent of whites. Jhally and Lewis claimed in their 1992 study of *The Cosby Show* that 'the Huxtables' lifestyle reflects the reality of only a small minority of black families'. Indeed, the 1980s had seen not an improvement but a decline in relative well-being of black American families.[19]

Jhally and Lewis went on to draw from William Julius Wilson's 1980s studies, *The Declining Significance of Race* and *The Truly Disadvantaged*, to show that although only one out of every nine people in the United States was black, in 1984 black people accounted for nearly half of all those arrested for murder and non-negligent manslaughter. Homicide was the leading cause of death for black Americans aged twenty-five to thirty-four. Remarkably, the number of black men between the ages of twenty and twenty-nine in prison was greater than the number of black men in college.[20] We can see for ourselves, then, that in the real world Theo Huxtable was more likely to have been in prison than at New York University. The final, two-part conclusion ('And So We Commence') to the last ever series saw Theo graduating from college. In the outside world, its transmission (April 1992) coincided with rioting in Los Angeles: four white policemen had been controversially acquitted of beating block motorist Rodney King. Bill Cosby himself appeared on an affiliate station in LA, urging people to watch the final *Cosby Show* instead.

Despite its apparent 'realism', then, there is a disturbing gap between *The Cosby Show* and reality. If we had been reading it for 'typicality' we would have gained an entirely misleading idea of the life of a typical black family in New

York between 1984 and 1992. Some commentators like to claim that popular culture holds up a mirror to society. George Melly, for example, argued that British popular music of the 1950s and 1960s created an 'exact image' of a society in the grip of feverish social change, while Ernst Mandel used the crime novel to 'reflect, as if in a mirror, the evolution of bourgeois society'.[21] Clearly, *The Cosby Show* does not provide an 'exact image' of the society from which it sprang. This should not be altogether surprising, however. If television were just like real life, there would not be much point in watching it. We would just get on with life for ourselves. But television is not like reality: it is much more exciting and also, somehow, much more satisfactory. On television, the good guys nearly always beat the bad guys and the murder is always solved. Family problems are amicably resolved and virtue triumphs over iniquity. As television critic Richard Bruton observed in his preview of *Beverly Hills 90210*: 'There are romances, misunderstandings and betrayals – but in the end, as everyone gathers around for a hug in the warm Californian sunshine, every knot is tied, every tear is dried.'[22] What *The Cosby Show* does, then, is provide a 'rewrite' of reality in which things are much better than they are in the real world outside. Of course, *The Cosby Show* is not alone here. Lichter et al. argued that television was 'Hollywood's nightly fantasy version of our society', which had taken on a life of its own as a kind of 'artificial reality'. Indeed, what television provided was 'a shared fantasy world that merges with and sometimes replaces the more mundane world of real life for millions of Americans'. In our reading of *The Cosby Show*, we find a world in which marriages are stable, families are happy and race does not matter. If only life were like that! No wonder Lichter et al. were moved to describe television as a 'home movie of America's fantasy life'.[23]

Hollywood's fantasy life is not limited to upbeat and heartwarming programmes such as *Cosby* and *Beverly Hills 90210*. We recall how the allegedly 'gritty' Australian drama *Heartbreak High* has – for example – a distinctly dewy-eyed vision of student–teacher relations in the inner city. It also combined distinct racial groups in harmonious friendship and cooperation. Critic Mark Crispin Miller led a sustained attack on the popular, prime-time, American police procedural *Hill Street Blues*, which ran for 146 episodes between 1981 and 1987. It was set in an unglamorous, inner-city precinct in which the streets were dangerous and everyone had their failings. It was filmed with multiracial characters in a 'documentary' style with moving cameras and constantly ringing telephones. The show was liked by critics, reported Miller, who described it as 'gutsy', 'gritty', 'racy', 'raunchy', 'punchy', 'tough' and 'steamy'. They praised it as 'realistic', at the same time applauding its lack of violence and ethnic stereotyping. Everyone was essentially likeable and got along well despite their dazzling variety of last names. Miller argued that while that was all very 'heartwarming', it was not very 'steamy'. He continued: 'In "real life", it seems, there are no ethnic traits nor any such things as national character, regional identity or class consciousness. And everyone is equally "genuine and worthy". This is gritty realism?' *Hill Street Blues*, he argued was not both true to life and idealized, because such a combination was 'impossible'.[24]

What, then, has become of television as the 'mirror' of reality? Jhally and Lewis detailed a deep 'disparity between the upwardly mobile position of black

people on television and the acutely disadvantaged position of many black people in society'.[25] Gray put it simply: despite the good living so visibly enjoyed by the characters involved in *The Cosby Show*, 'the Cosby era has witnessed a comparative decline in the fortunes of most African American families in the United States'.[26] Television here seems, therefore, to provide a direct opposite of reality, in which wrongs are made right and failure is translated into success.

The dramatic reversal of fortune which even seemingly 'realistic' television provides is something of which we need constantly to be aware. Although television does indeed provide what Lichter et al. describe as 'America's changing image of itself, refracted through the lens of the American dream machine',[27] that image is neither direct nor unmediated. Frequently, it is inverted. There may be something of a mirror about it, to be sure, but when we look at ourselves in the mirror, we need to remember that although we think that what we see is exactly what we are like, the mirror in fact reverses reality. Television works in much the same way: it looks realistic, but television and reality are quite often the other way round. In this way, TV so often provides us with a reflection not of how life is but of how we would rather it might be. It works as a compensatory document, which represents what we lack rather than what we already have. The dreams may be real, but they should not be confused with reality itself.

The upbeat and positive representation of middle-class, black family life in *The Cosby Show* was not accidental. This was a programme designed 'quite intentionally' to work as a 'corrective' to previous representations of black life on television. Bill Cosby himself resented the lingering legacy of shows such as *Amos 'n' Andy*, and actively promoted not only *The Cosby Show* but also the values that it consciously espoused. Gray praises its 'enabling effect' within television.[28] But *The Cosby Show* had aims beyond television and objectives which touched upon reality itself. By providing such a positive representation of a prosperous and harmonious black family, the show could be intended both to promote racial tolerance among white viewers and to generate 'a feeling of intense pride among black viewers'.[29] Instead of the old stereotypes about comedy rustics, inner-city criminals and unemployed people, here were positive, professional role models who could actively encourage black people to believe that they too could participate in the American dream.

So how successful can we conclude that *The Cosby Show* has been? We can probably agree on the basics. In terms of 'realism' (and certainly if we equate realism with typicality), *The Cosby Show* can hardly be argued to have been successful at all. On the other hand, we will probably also agree that, as realism was not high on the *Cosby* agenda, this is a somewhat dubious criterion upon which to judge it. Much more straightforwardly, we will surely agree that in terms of audiences and profits, *The Cosby Show* turned out to be very successful indeed. It was successful, too, in projecting a warm and positive image of black professional and family life. It would be very difficult to watch the show and detect any negative loadings attached to the values espoused by the Huxtable family. This is a programme that celebrates rather than criticizes togetherness and success.

A much more difficult question arises when we come to ask whether or not *The Cosby Show* was successful in terms of effects. We know that Bill Cosby and the producers aimed deliberately to counteract what they perceived as negative

stereotyping of black people on American television. We are also aware that *The Cosby Show* marks a very identifiable sea-change in the representation of black people on TV. It is, after all, what Gray describes as 'the Cosby moment'.[30] A very good question for us, however, is whether *The Cosby Show* created or simply defined that moment. Was one television situation comedy, acting alone, able single-handedly to change the representation of black people on television? It was, declared Gray, 'critical to the development of contemporary television representation of blacks', and has had an 'enabling effect within television'.[31] On the other hand, as Jhally and Lewis point out, the show is 'caught up in cultural assumptions that go well beyond the responsibility of any one program maker, no matter how influential'.[32]

If the direct influence of *The Cosby Show* on television is, at least, debatable, then its influence on the real world outside is yet more contentious. Gray, we remember, saw *The Cosby Show* as critical to the development of the representation of TV, but went on to claim that the show 'opened up to some whites and affirmed for many (though by no means all) blacks a vast and previously unexplored territory and diversity within blackness – that is, upper-middle-class life'.[33] It is a bold claim to say that a television programme has changed attitudes or even lifestyles beyond its thirty-minute slot. It is widely presumed among the public (and even some politicians) that what we see on television has a direct effect on how we behave outside. If this is the case, television can be blamed for real-life violence and sexual profligacy just as much as it can be praised for combating racial stereotypes (although interestingly, television is usually blamed for society's ills much more than it is praised for its virtues). On the other hand, research can be marshalled which demonstrates that, contrary to what many people believe, television actually has very little effect on the real-life actions of its viewers.[34]

We remember that the final episode of *The Cosby Show* coincided with the 'Rodney King' riots in Los Angeles, described by Gray as a 'media spectacle of racialized rage'. The contrast was profound, but how much of this could be put down to cause, correlation or coincidence? Clearly, *The Cosby Show* had not caused the LA riots – but neither had it prevented them. The effect of even the most well-meaning and deliberately positive of television situation comedies clearly had its limits. To Gray, the juxtaposition was entirely coincidental, but nevertheless poignant. No matter how much a television series attempts to smooth things over, he argued, 'conflict, rage and suspicion based on race and class are central elements of contemporary America'. Next to the pictures of Los Angeles in flames, he said, life on *The Cosby Show* 'seemed little more than soothing symbolic props required to affirm America's latest illusion of feel-good multiculturalism and racial cooperation'.[35]

Gray's comments contain echoes of a seminal critique of popular culture that originated in the 1940s. Where Gray has reservations about the efficacy of *The Cosby Show*, T. W. Adorno, Max Horkheimer and others of the Frankfurt School were unrestrained in their condemnation of popular culture as a whole. According to this group of influential thinkers, popular culture was not only rubbish, it was dangerous rubbish. What it did, they argued, was feed the public with false dreams and false promises which took their minds off reality. So, instead of doing anything about social injustice in the real world, people were

happy to lose themselves in a popular cultural fantasy land in which every-
thing turned out right in the end.[36] Frankfurt theory saw this process as quite
deliberate and imposed as part of a class system. One does not necessarily have
to subscribe to this theory, however, to argue that *The Cosby Show* might per-
suade viewers to see race relations and minority inequalities through rose-tinted
glasses: the Huxtables are doing just fine; the show looks realistic and so race
cannot be a problem in reality.

Jhally and Lewis's sophisticated critique of *The Cosby Show* both acknowledges
its merits and condemns what they argue could be its unintended consequences.
They agree (as we have seen) that *The Cosby Show* is not typical of black expe-
rience in the United States in the 1980s and 1990s, but they admit that the
positive representation of the upwardly mobile Huxtable family could have
beneficial effects both on television and beyond. As their analysis continues,
however, they begin to find aspects of this 'distortion' to be 'deeply disturb-
ing'. Indeed, they argue that for African Americans, the increasing numbers of
middle- and upper-middle-class black characters on television in fact represents
'a serious step backward'. They contend that programmes like *The Cosby Show*
do indeed encourage people to see the world through rose-tinted glasses, espe-
cially as viewers are quite capable of confusing television with reality. According
to their research, *The Cosby Show* persuaded (especially) white viewers that
racism was 'no longer a problem in the United States'. Indeed, viewers also
arrived at the belief that if the Huxtable family could achieve such success, then
so could all black people today. This may initially appear to be empowering,
but what it in fact does is create a false sense of opportunity that ignores the
realities of race and social class in the real world beyond television. According
to the authors, the real class barriers that 'confine the majority of black people'
need to be acknowledged rather than overlooked. Without a realistic portrayal
of these obstacles, white viewers were left to assume that 'black people who do
not measure up to their television counterparts have only themselves to blame'.
In this way, the 'enlightened' welcome that white viewers give to the Huxtable
family is, in fact, 'a new, sophisticated form of racism'.[37]

Jhally and Lewis contend that the 'message' of *The Cosby Show* was well
intended but that it unwittingly misfires. Miller, on the other hand, is deeply
suspicious of shows with messages at all. Following on from his criticism of *Hill
Street Blues*, he argues: 'There are still too many shows like this, piously telling us
how to think and "feel" while suggesting a subtle elitism.'[38] Sometimes, people
do complain that television comedies, dramas and even soap operas are so full of
'messages' that they feel they are being preached at by the producers when all they
want is to be entertained. Miller goes further, however, by accusing such shows
of 'liberal bias'. In *Hill Street Blues*, he says, not only do people from all ethnic
groups get along unrealistically well, but the minority characters are all selectively
drawn and well presented. He condemns the show's 'unmistakable smugness, its
air of liberal righteousness, its propagandistic pitch disguised as "gutsy"'.[39]

This may come as something of a surprise. The majority of the politically
committed theorists we have so far encountered in this book – and especially
in this chapter – have approached visual culture from a left-leaning or liberal
perspective. Berger, Barthes and the Frankfurt theorists, in particular, took

the view that, as the ruling classes owned or at very least controlled the media, the media communicated right-leaning or conservative messages, which they sought to challenge. With Miller, suddenly, we have a commentator who claims that the bias is the other way round. Can he be correct?

That prime-time television contains an essentially liberal bias is one of the central claims of Lichter et al.'s study of TV in the USA. They, we remember, carried out a content analysis of thirty years of programming, focusing on how issues ranging from sex, the family, work and law and order were represented on the small screen. They concluded that, generally speaking, prime-time TV reflects the social and political views of the 'television élite' who make the programmes. This élite is liberal, left-of-centre, and tries to guide middle-American tastes in the direction of intellectual trends emanating from the production centres of Los Angeles and New York. This leads to what they describe as a kind of 'Porsche populism', which reflects Hollywood's 'socially liberal and cosmopolitan sensibility'. The resulting programmes therefore contain storylines that take a reformist attitude to the social issues of the day, be they race, crime, poverty, class or sexuality.[40]

If we are politically liberal ourselves, this may strike us as all well and good. Here is television working for enlightened social change by the overt or even latent content of its programming. If we are politically conservative, however, we are much less likely to applaud what we see as the reformist messages of prime-time television. We may argue that its proposed changes are for worse rather than better. This leads us to ask two important questions of ourselves. First, does television really champion a liberal or a conservative attitude to life? Interestingly, each side tends to argue that it is the other that has the upper hand. It is informative (and usually provocative) to watch a TV comedy or drama with a group of friends and then discuss what we believe the programme had to 'say' about the social issues it presented. We can then expand the discussion from one specific show to television as a whole. This may seem trite at first, but we must remember that as a social document, it always has something to say, no matter how unwittingly. As Herbert Gans put it: 'Even the simplest television family comedy, for example, has something to say about the relations between men and women and parents and children, and insofar as these relations involve values and questions of power, they are political.'[41] When we add crucial issues such as race and discrimination, we can agree with Jhally and Lewis that their study of something as seemingly innocuous as *The Cosby Show* in fact deals with issues of 'immense political importance'.[42]

The second question we need to ask ourselves is not whether television is biased to the left or to the right, but whether it ought to be biased at all. Sometimes, people will argue that it is a very good thing for television to take a 'constructive' stance on some or other social issue. What they often end up meaning, though, is that they think it a very good thing if television articulates the views they happen to hold themselves. If we do permit TV to veer from realism in the interests of social change or reform, we are admitting that it has a right – or even an obligation – to be biased. Once we have permitted bias in principle, have we admitted that it is equally permissible for television to argue against the views that we so dearly believe?

This discussion may appear to have come a long way from the aliens from the planet Tharg. They were observing our earth by monitoring our television programmes, and we asked ourselves how realistic an impression of our lives they would receive. At face value, we would have to conclude 'not very'. Life isn't very much like it is on TV. We would hope, however, that the aliens would by now have learned the lesson we have learned ourselves. Television is a cultural artefact, and, just like all other cultural emissaries, it articulates the state of the debate as much as any fixed reality. Read intelligently, television can inform us not just about how we look and what we do, but how we think and even imagine. It is an artefact that articulates society as a work in progress.

The textual analysis of television can have much in common with film. After all, a film shown on television is essentially the same text as it is in the cinema. To be sure, the way in which audiences experience the two forms of media may differ, but that does not alter the content of the text itself. Among the six theoretical approaches discussed in Part I, most are broadly applicable to television as well as to film. The iconology of television, for example, proceeds along much the same lines as does the iconology of the earlier moving picture medium. There remain, however, some important differences of detail in this and other areas, and these merit some attention. We began by making the point that the showing of a film on TV does not alter the text itself from an analytical point of view. In broad theory it need not, but in practice it often does. This, it must be stressed, is a matter of practice and current technology rather than something inherent to the respective media, but as, in reality, it does affect the situation, it is worth taking seriously. From an iconological point of view, many films are edited or simply cut for television transmission. This is often done to remove violent or sexual content, and sometimes simply to reduce running time to fit in with existing programme schedules. Whatever the reason, the text frequently *is* changed in order to facilitate its translation from one medium to another. From an iconological point of view, it is interesting, then, to see what is cut out and why it has been removed. In terms of textual content, the absence of something can be as articulate as its inclusion. In addition to that which is cut out, we should also consider the importance of something that is often put in, for films shown on television frequently contain advertisements, which were definitely not a part of the original text. We might wish to argue, of course, that as these are shown only during designated commercial breaks, they should not be considered as part of the analysis of the film itself at all. On the other hand, we might contend that, much as we try to avoid them, commercials are very much a part of the whole experience of watching films on TV. If we feel that the insertion of commercials into a film affects its rhythm and structure, then we should consider this as part of our formal analysis. If we feel that the content of the advertisements affects our reading of the total film (advertisers like their commercials to be shown during relevant and appropriate programmes), then we might wish to take this into account when we consider not only the iconology but also the semiotics of films shown on commercial television.

Programme forms specific to television carry implications for iconological analysis in that they sometimes rely particularly heavily on prior cultural knowledge in order for the full intended meaning to be understood. This is especially

the case with soap opera, situation comedy and drama series in which the audience is expected to be familiar with previous episodes, characters and storylines in order to get the most from the current broadcast. Here, not all the information necessary to the full understanding of a text is included in the text itself. For example, anyone watching the TV situation comedy *Friends* (1994–2004) for the first time halfway though the seventh series would need considerable help in understanding the situations and even the jokes. Unlike with (say) painting, however, the necessary cultural knowledge for interpretation at level two would be drawn not from culture as a whole, but, rather, from a specific familiarity with previous and related texts from within the same textual 'set'. This is essentially specialist knowledge, no matter what doubts we may harbour about the quality of the texts from which such familiarity has been drawn.

In theory, the formal qualities of a text shown on television should not vary from when it was shown on other media. In practice, however, formal changes do take place. A television screen, for example, is considerably smaller than a cinema screen, and so the resultant visual image is smaller too. We may not think this is the most important problem in the world, but home cinema devotees are nowadays spending increasing amounts of money overcoming it. Certainly, the size of an image is one of its formal properties and should not be discounted from formal analysis. Of more pressing concern is the question of colour. A colour film shown on a monochrome TV undergoes radical formal change, which is of great significance to both the analyst and the casual viewer. This need not only be a matter of aesthetics: colour often carries crucial, factual information, as any TV sports fan will know. Even when we are watching in colour, the manufacture and settings of individual television sets affect the way the colours appear. To demonstrate this, we only have to stand in front of a bank of working TVs at an electrical goods store. The colours vary surprisingly from set to set. When a production team has sweated long and hard over the details of artistic design in a particular film, small but important formal differences can creep in as a result of colour change and alter the intended meaning.

The most provocative formal issue among film connoisseurs, though, is usually the changing of aspect ratios when a film is translated to TV. The aspect ratio is the technical term for the shape of a filmic image, expressed as the relation of its height to its width. Typical aspect ratios range from the almost square 1.2:1 of early sound film to the extremely wide 2.35:1 of Cinemascope. In between, we have the traditional 'Academy' and TV ratio of 1.33:1, the European widescreen of 1.66:1 and the American widescreen of 1.85:1. What this means to the TV viewer is that the average modern film has to be cut off at the sides in order fully to fill a standard television screen. The most obvious consequence of this is that important information can be lost entirely from the TV screen simply because this happened to be off-centre in the original film. In the extreme case of a conversation between two people, therefore, either or both the characters could be removed from the television screen and all we would see was a mystifying gap down the middle. Traditionally, there have been two ways to overcome this. The first option is simply to show the film in its original aspect ratio, with the result that while the film reaches both sides of the TV screen, a space is left at the top and bottom, and this is typically filled with a neutral black band. Unfortunately,

this has usually met with resistance from general television viewers, who feel (wrongly) that they are losing something from the TV and that, anyway, the resulting image is too small for comfortable viewing. A more widespread practice, therefore, is the 'pan and scan', process in which the original film image is rephotographed by a second camera set up for a standard television aspect ratio. This second camera is moved around the original widescreen frame to cover the action no matter where it takes place. In this way, it is argued, the television frame is always fully filled without the loss of important, peripheral action. Of course, both simple cutting down and even 'panning and scanning' are anathema to serious film enthusiasts because it significantly changes the formal properties of the film. It is akin to an art gallery that has only one shape of frame insisting that all the paintings are cut down to fit, regardless of the merits of the original composition. Panning and scanning brings out still more serious formal change, in that it introduces camera movement where none originally existed. Good directors and cinematographers move the camera for a reason; it is a very powerful formal device. Subsequent camera movement compromises the formal integrity of their work. Fortunately, some of the more dedicated film channels have now developed policies to show works in their original ratio wherever possible. The home electronics market, meanwhile, responded with the introduction of widescreen televisions. What the manufacturers tend not to advertise, of course, is the fact that there is still more than one widescreen ratio in common use, so images are often automatically resized to fit the shape of the existing screen. The trouble, of course, remains that as with much else in life, one size does *not* fit all.

The usefulness of art-historical approaches to the analysis of television is not dissimilar to the situation with film: a narrative history can similarly be applied which puts the key inventions, developments and programmes in chronological context. The biggest problem facing television (as opposed to film) historians, however, is a practical but significant one. Many early television programmes were broadcast live, and so no copies exist today. Even when video-taping became a practical proposition, tapes were frequently wiped to make space for new work. The increasing number of programmes being produced, together with the greater numbers of channels on air, meant that there was insufficient shelf space for a comprehensive archive. Film, on the other hand, was produced from the start in fixed form, and because there was (and still is) far less of it, it was much more practical to store for future study.[43] Again, therefore, there is no theoretical reason why television should not be studied historically like film (or even fine art). In practice, it remains much more difficult.

The ideology of the televisual image differs little from the film image in practical, analytical terms. Where the newer medium has an ideological potential to differ is in the way it is produced. Television costs less to produce than film, especially with the introduction of cheaper digital technologies, particularly at what was once the distinctly 'consumer' end of the market. Together with the consequent greater availability of production facilities (some cities even have designated 'public access' channels), the scene is supposedly set for a greater diversity of ideological opinion as a greater variety of people can make programmes. Whether this has actually turned out to be the case is a matter of dispute. In theory, at least, even the greater number of television programmes

should provide a far wider sample size to the ideological analyst of TV as opposed to film. And because this is a practical rather than an ontological issue, it does have the potential for change.

Similar arguments may be made for both the semiotic and hermeneutic analysis of television. In theory, an image (or series of images) has similar semiotic properties no matter what the size or type of the screen. In practice, the still more massive medium of television provides a far greater number of studies for analysis. Much the same can be said for the hermeneutics of the small screen. The variety of stories we tell ourselves about ourselves is greater on television, too. While film today typically takes the form of one-off narrative drama, television also includes series, documentaries, news programmes and game shows, all of which provide varied fertile ground for the text-based analysis of our own cultural values and symbolic way of life.

Key Debate

Is there a post-TV television?

Television, it seems, has always been with us – at least for those of us born since the middle of the last century. At the same time, however, it has gone through vertiginous changes. No matter what particular aspect of television we look at – from technology to modes of production, from programming to reception contexts and experiences – we feel that some kind of mutation is going on, deeply altering the traditional broadcast model established when this powerful medium took its place at the core of social life, some fifty or sixty years ago.[44] Although the various dimensions that contribute to this panorama of accelerated transformations are all interconnected, we will focus our attention here on one particular aspect: the changes that have affected what we can broadly designate as the representational regime of television.

We argued earlier that the strength of television is embedded in its possibilities as 'an essentially realistic medium', in the words of John Fiske.[45] Such realism, as we have also shown, does not mean that what we see on TV objectively reflects reality. It rather means that it is appropriated by the viewers *as if* it represented reality. That is a point also supported by Fiske when he writes that television realism does not correspond to a 'fidelity to an empirical reality', but rather results from television's capacity to be 'convincing'.[46] Drawing upon *The Cosby Show* as our case study, we showed how television *reality* can be far from empirical reality. We observed the gap between the late 1980s, early 1990s black family in New York portrayed in the series and the actual life of black families living in the same city and during the same period. Nevertheless, *The Cosby Show*'s 'rewrite' of reality worked in so far as it was perceived by viewers as 'convincingly' real. Why is that so? How can we explain the power of television to tinge its content – be it news or serial drama – with the unmistakable colours of convincing realism? And, finally, how has this capacity been altered by recent changes affecting the viewing experience of television consumers?

In order to answer these questions, we need to consider the representational

regimes of 'old' and 'new' television. This is taken up in a highly relevant essay by John Hartley, in which he investigates television in what he calls its 'post-broadcast' era.[47] In the traditional broadcast model, Hartley speaks of the medium's unique capacity to create 'imagined communities' formed by large and diverse audiences brought together by 'a simultaneous commonalty of attention that could sometimes aggregate to the billions' of people watching the same programme at the same time.[48] Hartley points out that traditional broadcast TV proved to be unbeatable 'at riveting everyone to the same spot, at the same time – in fear, laughter, wonderment, thrill or desire'.[49] The unmatchable ability of broadcast TV to gather people from across all boundaries (hierarchical, demographic, sometimes even national) in what Hartley calls 'we-dom' moments is supported by the common and generalized nature of what is being represented on screen. In other words, the content of broadcast TV is capable of *saying* something to large and diverse 'imagined communities', by representing what is perceived as a generalized experience, meaningful to each and every viewer. This ability to create a sense of togetherness among viewers, actually coordinating a varied spectrum of public sections 'into a semiotic unity'[50] is an extraordinary achievement of broadcast TV.

On the other hand, if we reflect upon the mechanisms that allowed for the 'we-dom' effect, we may at the same time find a correlated downside. As Hartley puts it, the representation model of broadcast TV generated a situation in which *'everyone was represented'*, but 'simultaneously *no one spoke for themselves*'[51] (Hartley's italics). Hartley points out that ordinary life and the everyday choices which constitute the typical raw material of TV content were traditionally represented on screen by 'professional expert elites' – a category shared by actors and politicians[52] – leading him to conclude that: 'everything was realist but nothing was real'.[53] Broadcast TV togetherness, no matter how impressive it might be, is a passive togetherness.

But there have been some significant changes in the ways in which we watch television over the years. These range from the social to the technological. Socially, the idea of whole families – let alone whole nations – settling down to watch TV together is becoming increasingly outmoded. In the middle of the last century, families will typically have had only one TV set, usually as the focal point of the family or living room. Nowadays, however, there are more usually multiple sets dotted around the house – including in children's bedrooms (which was unheard of in the early days of the medium). Coupled with this has been the proliferation of channels since the early days of severely limited choice. This expansion had been a feature of traditional terrestrial broadcast television even before we add the multiplicity of channels available via cable and satellite delivery systems. Expansion in the numbers of sets per household, coupled with significant increases in the channel and therefore programme choices available, has meant that viewing patterns have become more fractured. Rather than everyone watching together, modern families are much more likely to be enjoying their own shows in their own rooms. This increasingly fractured and therefore targeted television demographic has led to us talking nowadays of 'narrowcasting' rather than the familiar old broadcasting. It's a long way from *Ozzie and Harriet* and *Watch with Mother*.

Along with changes in viewing patterns, television has been transformed by the changing face of technology. Here, the old asymmetry between (a few) powerful producers and (many) powerless consumers is also becoming an anachronism. According to Hartley, this is apparent in new modalities of television. Indeed, he argues that the very model that regulates the relationship between the screen and the consumer is changing. The choice-restricted and expert-made *representational* model of traditional broadcast TV is losing its hegemony, and new viewing experiences suggest the emergence of an alternative *productivity* model of post-broadcast TV. In this sense, the convincingly realistic is becoming the real thing.

The new productivity model is present in non-broadcast instances such as streamed, downloaded, mobile or consumer co-created television. Although there are all manner of new ways to choose and even 'interact' with television today, YouTube provides an especially good example of the new model in action. YouTube can also be used to illustrate Hartley's thinking on the content of new television formats in which 'the increasingly democratic system of viewer choice and participation seems also to require increasing silliness'. The key word, however, is not 'silliness' (of which there is certainly no shortage), but rather 'democratic'. Despite the actual content, which can range from 'girls in the bedroom miming to favourite songs'[54] to online citizen journalism, the democratic potential of the productivity model is the key principle. So, despite the clear increase in 'silliness' in the new model, predominantly optimistic commentators such as Hartley champion the intrinsically democratic character of the interactional possibilities opened up by 'post-broadcast' TV.[55]

Optimism, however, is not always so evident when we look at the way in which other television studies scholars perceive these recent developments. Where some see opportunities, others see disguised threats. Where some identify the consumer's empowerment, others detect his or her increasing vulnerability. In an article about the contemporary experience of the television screen, Mark Andrejevic describes the features of a new device introduced by the NEC Corporation to explain why new forms of television interactivity make him feel more concerned than enthusiastic.[56] The television set proudly presented by NEC during a conference held in Tokyo in 2008 includes a set-top camera through which the age and gender of each viewer is assessed, allowing the content provider to modify the advertisements accordingly. Defining this telescreen's mission as 'surveillance with a commercial face', Andrejevic offers a contrary vision to the optimistic advocates of democratic interactivity. He focuses on the negative consequences of 'television's entrance into the digital enclosure', especially the 'increasingly important role of consumer monitoring'. [57]

Remarkably, the 'digital enclosure' that allows for consumer monitoring is the same technological environment that enables, at least potentially, new forms of active citizenship. Indeed, digital technology brought two crucial novelties to the television system which are as relevant to Hartley's optimistic view as they are to Andrejevic's more sombre concerns: content proliferation and interactivity possibilities. These new features seem to have simultaneously created the prospects both of the viewer's emancipation and the conditions for tight customization. The same technology which greatly enhances the viewer's choices

makes it possible to monitor the viewer's behaviour. And the irony goes on: the monitoring of the viewer's behaviour, which can be used to customize contents and advertisements, is possible in so far as the viewers make traceable choices. The more we choose, the more we are giving away information that can be used to . . . limit our choices.

Both Hartley's and Andrejevic's perspectives indicate that the remarkable proliferation of telescreens that constantly bombard us with all manner of images is not just a *quantitative* phenomenon. They suggest that there are *qualitative* transformations going on, and that these affect how we relate to that never-ending stream of televized images. Will the changes eventually lead to the democratic empowerment of viewers? Or will they make them more vulnerable?

Confronted by both bright and dark sides of the argument, there actually seem to be reasons to consider the two possibilities together, suggesting that the optimistic and pessimistic approaches are complementary, rather than incompatible. One thing is certain, though: television viewing is turning into something very different from that which it used to be when traditional broadcasting defined our relationship with the box that changed the world.

Further Study

Considering the prominent role of television in contemporary life, it is remarkable how relatively little scholarship there is on the subject. This is not to say that there is no good reading available on television, but compare the amount of library space dedicated to the study of painting to that which is given over to TV. Then compare the centrality of television to painting in today's society. This is partly due to the fact that TV is a much newer medium, but it also reflects an academic fear that because it is such a popular medium, it is not a suitable area for serious study. The opposite is, of course, the case, but it nevertheless leaves us in the position of giving a particular welcome to the quality work that does reach our bookshelves.

John Fiske and John Hartley's *Reading Television* was first published in 1978 and has been frequently reprinted since.[58] Its emphasis on *reading* television – that is to say, treating it as a visual text – echoes both Monaco's approach to film and the analytical stance that underpins the whole of this current study. Fiske and Hartley do not seek to provide a narrative history of television, or even a description of how the technology works. Rather, they take a thematic approach – including semiotics. Television realism, the central focus of this chapter, receives a chapter of its own. Their book also contains a useful bibliography – although it does (understandably) grind to a halt after 1978. Writing alone this time, Fiske continued his broad analysis of television in 1987's *Television Culture*. Much reprinted since, this provides a very approachable introduction to the issues, which it illustrates with welcome and familiar examples from both British and North American television. The essay by Hartley upon which we drew in the Key Debate section can be found within Graeme Turner and Jinna Tay's highly relevant edited volume *Television Studies after TV – Understanding Television in the Post-Broadcast Era*, first published in 2009.

That said, Fiske and Hartley are neither the first nor the only people to write about television. Marshall McLuhan's studies of mass media in the 1960s proved seminal in taking the medium seriously. *The Gutenberg Galaxy*, *Understanding Media*, and *The Mechanical Bride* are now less widely read than they were in their day, but nevertheless remain classics in their field.[59] McLuhan's influence can be seen in many subsequent studies, including Neil Postman's provocative and hugely readable *Amusing Ourselves to Death*.[60] Here, Postman argues that it is not trivial TV that poses a threat to society, but, rather, television's doomed attempts to tackle serious content. This, argues Postman, is beyond the intrinsic capabilities of the medium. Raymond Williams is another founder of the field. His *Television: Technology and Cultural Form* is recommended for placing TV within its British cultural context, while his collected essays on television are collected and edited by Alan O'Connor in *Raymond Williams on Television*. David Marc's *Demographic Vistas*, meanwhile, examines the position of TV in American culture.[61]

The relationship between television and reality has been explored by Richard Dyer in *Light Entertainment* and in Roger Silverstone's *The Message of Television*.[62] The former provided a study of television's proclivity for escape and fantasy, while the latter considered its capacity for myth. This current chapter, meanwhile, has made particular use of Lichter et al.'s *Watching America*, which claims a 'scientific' basis for its conclusions, together with Marc Crispin Miller's more subjective *Boxed In*. Both have the advantage of challenging not only TV's supposed 'realism' but also what they perceive as a liberal bias in contemporary television content. This second factor is additionally interesting because it brings a useful counterpoint to the liberal perspective, which, it may be argued, is more prevalent than the conservative in academic studies of the media. For studies of televisual representations of race in general and of *The Cosby Show* in particular, Herman Gray's *Watching Race* and Sut Jhally and Justin Lewis's *Enlightened Racism* are specially recommended. The aliens from planet Tharg are revisited in Máire Messenger Davies's '"What Planet Are We On?" Television Drama's Relationships With Social Reality', in Howells and Matson's *Using Visual Evidence* (2009).

The representation of gender is another main concern in television studies. Lynne Joyrich's *Re-viewing Reception: Television, Gender and Postmodern Culture*[63] is a good example of a close observation of TV (especially 1980s television, in this case), using analytical tools provided by feminism and postmodern studies. *The Age of Television: Experiences and Theories*,[64] a more recent work by the Italian media sociologist Milly Buonanno, is also an interesting option.

This chapter – and therefore this section on further study – has concentrated on narrative television and its relationship with social reality. There remain, of course, many other profitable areas of research in the field of television, such as news and factual coverage, together with audience research. Audience research, indeed, is relevant to many aspects of media theory, but as this book on visual culture has an avowed emphasis on textual analysis, the sociology of reception is respectfully left to others. The technology of television is well explained to the non-specialist in Stephen Lax's *Beyond the Horizon: Communications Technologies, Past, Present and Future*, which also provides clear descriptions of other and 'newer' media systems.[65] It is with 'new media' that we engage in our final chapter.

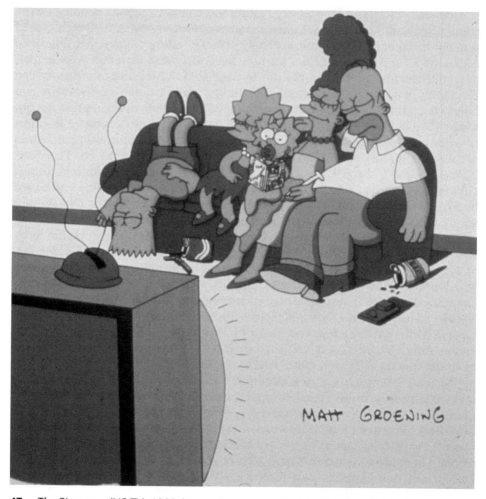

47. *The Simpsons* (US TV, 1989–): a contemporary television family – definitely not the Cosbys; photo: British Film Institute/Twentieth Century Fox

Finally, of course, no further study of the visual culture of television is complete without the close, critical analysis of television programmes themselves. We therefore strongly recommend the re-viewing of some of the examples we have already provided in this chapter in tandem with some that we have not. Compare and contrast, for example, *The Cosby Show* with another famous American TV family *The Simpsons* (see figure 47). We think you will be delighted by their differences – but also surprised (if you look hard enough) by their underlying similarities.

11

NEW MEDIA

This concluding chapter examines new media, and begins by wondering to what extent it is justified to speak of 'new' media at all. It questions the current enthusiasm for declaring media 'revolutions' and contends that many so-called new media are in fact merely different systems of delivery. We look at examples from recorded music to digital photography – the ontology of which, it is contended, is not affected by its partial use of digital technology. The discussion continues with a comparison of cinema and television, combined with video and digital recording and playback facilities. It is argued that while the system of delivery may affect the viewing experience, it does not affect the content of the text itself. We then take a critical look at the claims of computer and Internet technologies to be new media within visual culture. Finally, we undertake an investigation of the music video, with a case study of Aerosmith's 'I Don't Want to Miss a Thing'. Although the cross-media references and connections are complex, it is suggested that the music 'video' really does have some justified claim to be considered a genuinely 'new' medium.

Disasters lie in wait for writers on new media. This chapter will avoid two of the most obvious, but will commit heresy by positively courting a more interesting third. The first disaster befalls the writer who attempts an 'up-to-date' account of the new media today. Inevitably, the new have become old by the time the manuscript reaches print, and the resulting chapter results only in unintended comedy value for the reader. The second lies in wait for the writer who is foolish enough to take a longer-term view and to speculate by predicting the future. This, too, is usually doomed. Visions of the future are nearly always errone-ous. *The Jetsons*, despite all their futuristic intentions, still look positively dated

today. Arthur C. Clarke's *2001*, meanwhile, predicted that by the time you are reading this book, computers will have developed wills and personalities of their own, and will have attempted to take control of their supposed operators. No matter how much we may be tempted to agree with this in moments of frustration, we know that this is not actually the case. Even market research is unable reliably to predict the technological future: the Sony 'Walkman', it was confidently concluded, would never catch on.

Despite all the obvious snares and pitfalls, there remains an incredible amount of talk about the communications and media 'revolutions' through which we are all supposed to be going. The hyperbole seems to increase on a daily basis. If we were to believe everything we read and hear, the future should be unrecognizable by the end of next week. In reality, however, we suspect that it won't be. In a real revolution, there is a sudden, schismatic break with the past in which previous paradigms are rendered invalid and the future proceeds on altogether new assumptions. Talk of 'revolution' today should be used with extreme caution. What we are experiencing is, for the most part, a period of rapid evolution rather than past-erasing revolution.[1]

This is particularly relevant in the area of 'new media'. Although this is a phrase that is widely used and enthusiastically embraced, we need to remember what is actually meant by the word 'media'. A medium (singular) is a delivery system; therefore 'new media' actually means only 'new delivery systems'. These are not new forms of communication, but increasingly convenient and consumer-friendly hardware systems, which deliver similar texts without altering their content, meaning or 'message'. In the chapter that follows, then, we are not going to attempt to provide an 'up-to-the-minute' description of the latest technology. Rather, we are going to consider the (we think) much more interesting ideas which underlie the concept of 'new media' and the relevance of these to an understanding of visual culture.

Let's begin with an example. We can see how changing technology has both affected and yet failed to revolutionize music. The earliest commercial records were available only on vinyl, playable at seventy-eight revolutions per minute. These ranged from orchestral and operatic works to the popular songs of the day. Even some of Elvis Presley's earliest records were issued as '78s'. The seven-inch, 45 rpm 'single' however, became the standard format for popular records during the 1950s, 1960s, 1970s and even for much of the 1980s. 'Albums' or 'long-playing' collections of tracks were issued on twelve-inch vinyl, playable at 33 1/3 rpm. From the 1970s, cassette tapes (and even for a while eight-track tapes, designed for use in cars) were available in parallel with vinyl, offering the listener a choice of formats. In the early 1980s, the digital compact disc was introduced, further adding to consumer choice of delivery systems, and eventually eclipsing (but not entirely eradicating) earlier analogue technologies. The 1990s saw the introduction of the mini disc, which enjoyed partial success with consumers, and by the second decade of the twenty-first century, MP3 technology and computer downloading had again changed the way many people acquired and listened to music. The point here is not to relate a detailed history of music distribution technology, but rather to make the point that, whatever audiophiles may claim to be the merits of the various delivery

systems, they have not really changed the music itself. It is technically possible to buy (or at least to have bought) some well-known recordings in each of these formats, but the format itself has not changed one note of the actual music. The text has in each case remained exactly the same. Changing distribution technologies certainly affect the music industry, especially when they facilitate practices like 'home taping' (which they said was 'killing' music in the 1980s) and its younger sister file sharing. But despite all that, digital or analogue, laser or stylus, mini disc or MP3, legal or illegal, *Heartbreak Hotel* is still *Heartbreak Hotel*.

We began with this example from recorded music technology because it is an area with which every reader will be familiar. We can now move forward to apply the same sort of thinking to visual culture. According to the advertisements we see daily in the press, digital technology has revolutionized photography. We are urged to join the 'digital revolution'. How much, though, has really changed? In traditional photography, physics creates an image of the outside world inside a camera, and this is recorded on light-sensitive film. The film is then chemically developed, and either becomes the photograph itself (in the case of a transparency) or forms the negative for a positive print that is chemically produced on light-sensitive paper. With digital photography, the image is created in precisely the same way (through a lens), but it is then recorded electronically inside the camera. The resulting image is then downloaded to a computer, where it can be manipulated with commercial software before being retained on disk and/or printed out on a simple printer. All this can be accomplished, with varying degrees of sophistication, both professionally and by the amateur at home. From a practical point of view, there is much to be said both for and against digital photography. One thing that is generally agreed upon, however, is that it significantly increases the degree by which even the most amateur photographer is able to manipulate and print his or her own photographs without the need for a chemical darkroom and the training, skill and experience that is required to produce professional results. There is no doubt, then, that digital technology has made advanced techniques much more easily available in the domestic market. These technological advances have certainly facilitated the way we are able to do photography. What they have not done is revolutionize it. Photography still represents the capture of an image with a lens and a camera. What has changed is that where in the past the image had always been recorded chemically, it may now be recorded electronically. The manipulation of that image before it is finally stored or printed out is now much easier than it had been before, but – and this is an important point – what has changed is the ease and possible degree of manipulation, not the act of manipulation itself. The ontology of the photographic image has not been affected by this. The special, complex relationship between reality and the photograph remains fundamentally as it has always been.

We saw in chapter 8 how, despite the protestations of some of its detractors, the photograph is not a simple, straightforward, objective recording of reality. To at least some degree, every photograph is authored – and some very much so. It is just the same with digital photography. Authorship is not simply a matter of 'trick' photography, but a result of subjective choices that

are inevitably made when photographing any subject. This applies just as much to traditional, chemical techniques as it does to the digital. Certainly, domestic software and digital techniques make manipulation easier, but there is nothing at all new about manipulation.

Manipulation is not just about cheating. Every time we bring any change to bear on a photographic image we are manipulating it, no matter how small that change may be. Manipulation is not always designed to mislead the viewer. It may be intended simply to improve the appearance of the photograph. Perhaps we have decided, for example, to crop the image slightly to benefit the composition, or to make a selective enlargement to accentuate some part of the scene. In black-and-white photography, a red filter over the camera lens will darken a sky (which might otherwise be lost) and accentuate the clouds, while in colour a polarizing filter can have much the same effect. A soft filter smoothes away wrinkles in a portrait of an older sitter, while a fast film will provide a documentary-style 'grittiness'. In the darkroom we may selectively darken or lighten areas of the print for aesthetic effect, or print on a higher or lower contrast paper. The list goes on . . . basic examples of benign and everyday manipulation of straightforward photographic images.

Of course, more extreme forms of manipulation can be used significantly to change an image, and sometimes with the deliberate intent of misleading the viewer. Again, however, there is nothing new about this. As early as 1839 (the year many ascribe to the 'invention' of photography), Johann Enslen succeeded in creating a photograph in which the head of Christ appeared on top of an oak leaf. Enslen did not seek to mislead the viewer but, rather, to demonstrate both his skill and the potential of the new medium. Two girls from the Yorkshire village of Cottingley, however, had other ideas. Between 1917 and 1920, cousins Elsie Wright and Frances Griffiths, using nothing more than a domestic camera, photographed each other playing with 'fairies' in the woods near their home (see figure 48). The photographs gained national and international attention, aided by the interest of Sherlock Holmes's creator Sir Arthur Conan Doyle, who appeared to be convinced by the photographs. The case of the Cottingley fairies remains something of a mystery today. In 1993, Elsie admitted that all but one of the photographs had been 'faked', but she still insisted that the two girls really had played with the fairies. Frances maintained to her death in 1986 that the photographs had all been genuine. It is up to us to decide for ourselves whether Elsie and Frances's childhood photographs either reveal the existence of fairies or go to show that one does not need twenty-first-century digital technology to manipulate a photograph.[2]

There is considerably less mystery attached to the manipulation of political photographs in Stalin's Russia. The period from 1929 to 1953 provides us with a range of examples that would be hilarious were it not for the genuine awfulness of the fates that befell many of the people involved. Here, as individuals fell out of favour with Stalin's totalitarian regime, they were systematically removed from official photographs just as if they had never existed. In one notorious example from the Fourteenth Party Congress of 1925, more than half the men who appeared in the original group portrait of nine were expunged from the image by the time it was reproduced in Stalin's official biography.[3] The missing

48. Elsie Wright and Frances Griffiths, *The Cottingley Fairies*, 1917–20, photograph; reproduced with the permission of the Brotherton Collection Leeds University Library, UK

men were magically erased and the remaining group reassembled by the smiling Stalin. Chillingly, only one of the original group (apart from Stalin himself) was to die of natural causes. Again, this manipulation was accomplished years in advance of the so-called 'digital revolution'.

The increased variety of delivery systems for visual texts is no more amply demonstrated than it is with the moving image. For the first part of the twentieth century, if people wanted to see moving pictures, they went to the cinema. The cinema provided news, cartoons and, especially, feature films. The invention of television and its increasing popularity from the 1950s brought moving pictures from the movie theatres and into the home. As television evolved, it offered an increased variety of programming, including some of the same films that people may previously have seen only at the cinema. There is no doubt that television developed (if not completely invented) formats of its own,[4] but in the case of the feature film shown on TV, the text remained the same even though the delivery system had changed. This leads us to suspect that although the medium may have been different, the message remained the same.

It was Marshall McLuhan, of course, who in 1964 coined the famous aphorism 'the medium is the message'.[5] In the case of the feature film on television, however, it seems that even if McLuhan was not entirely wrong, he did, at least, deliberately overstate his case.[6] To be sure (and this is what McLuhan was really getting at), the way we receive a message does, to an extent, influence its meaning. Imagine, for example, the same simple words 'I love you' whispered in

your ear, written in the sky, shouted through a megaphone, attached to a bunch of flowers, tapped out as a text message on a mobile phone or appearing in the subject box of an email spreading a computer virus.

Similarly, there is no doubt that different visual media can create different viewing experiences. When we go to the cinema, we watch the same film in the company of many other people. The majority of these will be strangers, but we will all be focused on the same thing. It helps provide what sociologists call a 'shared experience'. In order to make this work, an understandable etiquette of cinema-going has emerged: do not arrive late, do not talk during the performance, do not use a mobile phone, do not wear a stove-pipe hat in front of the people behind you . . . and so forth. We sit, collectively, in the dark. In a comedy we laugh together, in an adventure we gasp together, and with horror we jump together. For many, the fact that it is a 'shared experience' adds to the pleasure of it. For some people, there is a whole ritual involved in going to the cinema, which can be more important (and enjoyable!) than the particular film itself. This may involve deciding what to wear, the purchase of improbably large quantities of confectionery, and even a meal out as well. There are some people who enjoy the post-film discussion more than they do the film. Going to the cinema is, in other words, an occasion that is about so much more than celluloid. We have only to consider the importance of cinema as part of the 'dating' ritual to underline the point.

Watching television is a rather different experience. With television, we do not go out to see a movie; the movie comes to us. We watch either alone or as part of a small group, all of whom we usually know well. It is a much more personal medium. Partly because of this, there is considerably less social etiquette involved. Not only can we talk while the television is on, we can also have one eye on the screen while doing other things – cooking (or even eating) dinner, fixing the vacuum cleaner, reading a magazine, talking on the phone and so on. People leave and enter the room as they please when the television is on. There is no need to sit in ordered rows in the dark. If it is too loud, we can adjust the volume. If it is too dull, we can simply switch channels. This is something we cannot do at the cinema. Television, on the other hand, lacks the cinema's sense of occasion. We would hardly dress up to watch the small screen, and there is no collective hush of anticipation when the lights go down. We may laugh and gasp our way through a film on TV, but probably not as frequently and intensely as in a packed movie theatre. And when the film is over, a visit to a bar or a restaurant to discuss it is much less likely to be built into the plans for the evening.

The point of this discussion is not to try and show that television is any 'better' or 'worse' a medium than the cinema. It seeks simply to begin to show that, as viewing experiences, they are different. But while watching a film on television will be a different viewing experience than watching it at the cinema, it is still the same film. What has changed is the reception of the text, but not the text itself. To be fair, of course, we have to admit that sometimes the film itself is changed somewhat by being shown on television. Sometimes (and irritatingly) a film may be cut for sexual or violent content, or simply to make it fit the available time slot. On a commercial network, it may be punctuated by advertisements.

Frequently, as we saw in the last chapter, a film shot in a widescreen format will be cut off at the sides (and possibly even 'panned and scanned') to make it fit the television screen.[7] In these instances, the change of medium will affect the text, but the important point is that it is not a fundamental condition of the medium that these changes *have* to be made. These changes are matters of choice decided upon by the programmers. They are not an inevitable consequence of the transition of the same text from one medium to another.[8] Even the size of the screen we watch is a technical rather than an ontological consideration. It is a consequence of practice rather than theoretical principle.

In chapter 9, we looked at the narrative codes and techniques of cinema, together with its relationship with reality. We used a variety of practical examples, ranging from the Hepworth brothers' early efforts to the more contemporary features of Stanley Kubrick. It is fundamental to the argument of this chapter that all of the points we made regarding the grammar of film are just as valid whether that film is shown on screen or on television. Large screen or small screen, a shot is still a shot, an edit is still an edit and a parallel storyline is still a parallel storyline. *Rescued by Rover* and *The Shining* are just as primitive or complex no matter which of the two media is used to show them. Similarly, in chapter 10 we looked at television as a social document and compared a selection of British, Australian and American programmes with reality. Again, every point we made about *Neighbours* or *The Cosby Show* would have been equally valid had the same texts been projected on to a cinema screen. The differences between the social situations they depicted and the world outside would not be altered by the changes in media. In these cases, then, the medium is clearly *not* the message.

From the 1950s, consumers began increasingly to enjoy a choice between film and television for moving pictures.[9] As we have seen, it became possible to see certain programming on both media without significant alteration of the visual text. Starting in the late 1970s and growing in popularity through the 1980s, the video-cassette recorder (VCR) began to take its place alongside the television set. The domestic VCR had two major applications. First, it could be used to record television broadcasts for (sometimes repeated) viewing at a later date. Second, it could be used to show pre-recorded feature films and other programming made commercially available for rental or outright purchase. The VCR has made significant changes to the way in which we watch both television and film.

Before the advent of the domestic VCR, people had very few options about when they watched the television programmes of their choice. If a network decided that a programme should be transmitted on a certain day at a certain time, that is when we had to watch it. Sometimes, this added to the excitement, knowing that a large television event was being simultaneously watched by many other people. In 1953, millions of Americans watched Dwight D. Eisenhower sworn in as the thirty-fourth President of the United States. The same year, the UK experienced a seminal television event with the coronation of Queen Elizabeth II. For both countries, these were the first times such important civic events had been broadcast to the nation's living rooms; coverage of Eisenhower's inauguration has been described as providing a 'national town

meeting'.[10] On 20 July 1969, people all over the world watched live pictures of mankind taking its first steps on the moon.

Not all the programmes people want to watch are of such great importance. Nevertheless, viewers have always gone to a great deal of trouble to catch their favourite programmes, be it *I Love Lucy* or *Morecambe and Wise*. Traditionally, this has meant having to be in front of the set at the specific time designated by the network. If you missed the show then, you missed it completely. Further complications arose because rival networks often deliberately scheduled popular shows against each other in order to compete for the ratings, which brought them increased advertising revenue. For the viewer, this could lead to agonizing choices and family arguments in deciding what to watch. The increase in television channels only exacerbated the problem.

The advent of the VCR meant that people were able increasingly to become their own programme schedulers. It would be possible, for example, to watch one programme while recording another, or to record a variety of programmes without actually having to be at home. The VCR also provided an important second advantage. Television has traditionally been a very ephemeral medium. Once a programme had been broadcast, that was it. With the VCR, it was possible for viewers not only to catch programmes they might otherwise have missed, but they could also return to the tape for repeated viewings. The domestic video tape offered the formerly fleeting TV broadcast a significant degree of permanence.[11] It was now possible for people at home to preserve the television image and to collect programmes for subsequent reference and enjoyment as if they had been books.

There is a second, more subtle way in which the video tape can be likened to a book, and that is in the way that we read it. At the cinema, or when watching broadcast TV, we usually watch the whole film or programme in one sitting. To be sure, some of the older films had intermissions, and commercial TV programmes have commercial breaks, but these are predetermined and we have no choice about when we take them. With a film or programme on video, however, we control not only precisely when we will begin to watch, but we can also stop, start, scan, review and return to the text just as we please. This degree of control is similar to that we enjoy when we read a book, which we rarely seek to complete in one uninterrupted sitting. When we read literature, we may choose to read a chapter or so at a time, but we are also able to put down the book at any moment to answer the telephone, go into the kitchen or even leave for the day, without fearing that the book will go on without us. Similarly, we can reread sections, skip the boring bits and even dip in for reference just as if we were watching a video.

Similar – and possibly even greater – degrees of 'reader' control are possible with newer delivery systems. The 'laser disc' was introduced as a way of getting better image quality from pre-recorded feature films. Despite this, however, it failed significantly to catch on with consumers. Considerably more successful has been the Digital Video Disc (DVD), a smaller and more versatile format, which was introduced at the end of the 1990s.[12] This format permitted pre-recorded films and other programming to be reproduced with high video and audio quality, and the amount of information that may be recorded has

permitted some manufacturers to include extra information and options on DVD which were not available in earlier formats. Recordable and re-recordable disk formats were introduced, and in 2004 Britain's largest electrical retail chain announced that it was to stop selling the once dominant VCR after twenty-six glorious years.

Advances in personal computer technology have introduced further flexibility into the home viewing experience. Traditionally, everything was watched on a conventional television screen, but the turn of the current century saw both television programmes and DVDs available for viewing on a suitably configured personal computer. Alternative applications of this technology have permitted films, television and other visual programming to be available in mobile situations, such as at airline and car seats. Again, the degree of consumer control of the viewing experience is far greater than with conventional cinema screenings and TV broadcasts. This includes the emergence of 'on demand' services such as the BBC's iPlayer, introduced in 2007. Here, people could select and access existing television programmes for viewing on their home computers at times and locations (subject to copyright restrictions) to suit them. The list of options continues to grow.

The list of available and alternative formats for a visual text can be extensive, and we can use a popular Hollywood movie as an example. The big-budget action-adventure *Armageddon* was released in 1998. Its high-profile cast included Bruce Willis, Billy Bob Thornton, Ben Affleck and Liv Tyler, and the director was Michael Bay. Here, an asteroid the size of Texas is heading for planet earth, and the end of the world is, consequently, predicted. The only way to save civilization is to send a team of renegade oil drillers into space. Under the fearless leadership of one Harry S. Stamper (Bruce Willis), they plan to land on the asteroid, drill deep into its core and detonate a nuclear explosion that will split the asteroid in two and save the earth. Needless to say, despite all manner of personal and adventuresome complications, humanity is saved in the nick of time, and the film concludes with a rousing track from the rock band Aerosmith.

Armageddon was first released in movie theatres in North America in July 1998, then at intervals across the rest of the world through to December. Video, laser-disc and DVD versions were released the following year. Various formats were available, as a result of three different television systems having been adopted by countries around the world. National Television Systems Committee (NTSC) versions were produced for the North American and Japanese markets, Système Électronique Couleur Avec Mémoire (SECAM) for France and the former Soviet Union, and Phase Alternate Line (PAL) for the UK and most of Europe. For DVDs, various regional versions were also introduced as part of distributors' (only partially successful) attempts to control marketing across the world. Once the pre-recorded market had been satisfied, *Armageddon* was made available for satellite, cable and, finally, terrestrial broadcasting.

As we can see, there is no shortage of different delivery systems available for people who want to watch *Armageddon*. Hand-in-hand with this goes the even greater variety of locations and situations in which it is possible to view the film. What has not changed is, once again, the film itself.

To say that new media have had no effect on communication is clearly

untrue. But to argue that the new media have had only a limited effect on the visual text and the analysis of it is considerably more persuasive. It is particularly so within the context of this book. Traditionally, there has been a three-way division of labour in the study of media: the political economy of the media, textual analysis and audience reception. More recently, we can add technological approaches. Those who study the political economy of the media tend to focus on patterns of ownership, and ask how the media is affected by its commercial organization.[13] They might investigate, for example, the relationship between media moguls and the content of the newspapers, television and radio stations that they own. They might concern themselves with issues of individual access to the media, or consider the relationship between global media empires and local cultures.

Text-based analysis is the approach with which this book is mainly concerned. It considers, as we have seen, what and how meanings are communicated by the texts themselves. The focus may be aesthetic, theoretical, social or ideological. Some analysts take a 'scientific' or quantitative approach; others (as is the case here) advocate a more qualitative methodology.

Audience reception theory asks how viewers, readers and listeners understand the media, and how it might affect them. Reception study might ask, for example, whether violent films create violent spectators, or how much people are really influenced by political advertisements. A theoretical approach to reception might consider how the particular circumstances in which we receive a message might affect the message itself. Some reception theorists contend that changes in meaning between author and audience are so significant that the audience becomes a kind of second author which creates new (or at least significantly transposed) meanings for itself.[14] Other scholars take a more empirical approach to the sociology of reception. Janice Radway, for example, investigated how a particular group of women readers read romantic fiction, while Ien Ang examined the worldwide popularity of the American television drama series *Dallas*.[15] Understandably, the study of reception is of considerable interest to sociologists, who approach the problem with a variety of methodologies which include surveys, focus groups and statistical analysis, in addition to ideological and theory-based approaches.[16]

Technological approaches to the media fall into three main categories. First, there are those that seek to describe and explain how the various media work. Books and articles in this area range from the introductory to the advanced, and the approach is located very much within the sciences rather than the humanities. Second are the historical approaches, which narrate the invention and assimilation of communications technologies either specifically or in general. Here, we could learn the story of the telephone or of communication from cave painting to email. Finally come the sociological approaches, which seek to understand the relationship between communications technologies and society. Here, for example, we might grapple with concepts such as 'technological determinism' or ask what benefits the Internet and social networking might bring to democracy.[17]

Three of these four approaches are extremely relevant to the study of new media, and vice versa. Mass media and popular culture all take place within

some sort of political economy, and new media are no exception. The commercial interests that control much of cinema and television have, unsurprisingly, extended their interests into new media. Areas that had once seen fierce competition are now typified much more by integration. Again, there is nothing new here. Starting in the classic era of Hollywood, studios sought not only to make films but also to control the distribution of them to cinemas. The studios saw the increasing popularity of television as a threat to cinema attendances, but have since discovered the benefits of cooperation and even mutual ownership. The domestic video was initially seen as a threat to both, but then both film and television companies discovered the ability of video (and later DVD) to extend rather than compete with their own programming. The DVD distribution of a feature film, for example, nowadays constitutes a major component in the economy of film production, which increases rather than reduces revenue. It is understandable, then, that 'vertical integration' has become such a feature of the political economy of the media. In business terms, it can be extremely advantageous for a single company to own or control every stage of the production and consumption of a visual text, from studio to cinema to video and to television. The same company may also be responsible for the soundtrack album, playable on its own home stereo or MP3 systems, alongside the DVD machines and television sets it has also manufactured. In this way, competition is not so much among rival media, but more between competing media corporations, frequently at a multinational level.

The political economy of the media need not flow exclusively in the direction of big business, however. In some areas, new technologies have enabled group and individual access to media and communication in ways that had not previously been so easily available. With photography, for example, home users needed either to build and run their own darkrooms or to send out their work to commercial processing plants. Digital photography, in connection with the personal computer, has enabled consumers to produce and control their own work much more easily and cheaply than before.[18] What is true of still photography is even more so of moving pictures. Hollywood-style film production gets more expensive by the month. Small-scale and especially home video production, on the other hand, becomes comparatively more affordable. Reductions in price (in real terms) have been countered by increases in quality, and these have gone hand-in-hand with improved ease of use. This is especially true of editing, which was originally a highly specialist pursuit in terms of both equipment and expertise. Just as with digital still photography, the personal computer has extended access to the non-specialist. Of course, improved and more affordable consumer technology does not automatically enable the individual to compete with multinational corporations in terms of global mass media. It does, however, enable individuals, smaller groups and organizations far greater access to media than had previously been the case and this – at least in theory – indicates a democratizing potential of the 'new media'.

We need to stress, however, that the political economy of the media is not a new phenomenon, and it is certainly not limited to new or even mass communications. Nobody produces a visual text in a political or economical vacuum. Medieval craftsmen and Renaissance artists may have produced images of great

beauty, but they still needed to eat. In order to eat (and certainly to prosper), they needed to operate within the realities of the political economy of the time. Michael Baxandall, for example, has shown how the pictorial style of painting in fifteenth-century Italy was influenced by social factors and not just by abstract notions of aesthetic value.[19] Similarly, we can see the wealth of style painting in the Dutch 'golden age' as taking place against the social and economical background of Dutch independence, Protestantism and the economic rise of the merchant classes.

We have already touched upon the importance of reception to the understanding of new media. We have seen, for example, how the circumstances in which we view a feature film can affect the way in which we both 'read' and respond to it. Watching a DVD on a laptop computer in an aeroplane is clearly a very different experience from watching a film projected by the Lumière brothers in *fin de siècle* Paris. This serves to remind us, however, that the reception of visual texts is not limited to new media or to the twenty-first century. The prehistoric paintings in the caves of Lascaux must have looked very different to early man in the flickering light of a fire than they do to us in a university lecture hall. How different a painting appears over the altar in an historic place of worship from the way it appears in a civic museum or hanging on the white-painted walls of a commercial gallery. The changes need not always be for the worse. A painting can often be far better studied in a museum than in a church, while mechanical reproduction of the same painting can have further benefits. High-quality photography (whether for books or television) is, for example, excellent for enlargements and the study of detail, while mass reproduction of the image makes it available to far greater numbers of people than was possible before. To be sure, some of the 'aura' of the original may be lost, but, as John Berger has argued, this need not necessarily be a bad thing.[20] For the social critic Walter Benjamin, 'mechanical reproduction emancipates the work of art'.[21]

Walter Benjamin's thinking on reproduction reminds us that the technical efficacy of new media should not been seen in isolation. Technology, as we have seen, has social implications for media old and new. This is not to say, of course, that technology has not brought practical improvements to media. The quality of audio-visual reproduction, for example, has increased as a result of digital technology, as has ease of use. Technology has also brought about improvements in the delivery and storage of material. Digital techniques have increased the amount of material that can be supplied, and storage takes up less physical space. Additionally, digital media suffer less from quality loss as a result of protracted use. A DVD, for example, takes up less space than a traditional video tape, can hold more information and – unlike its magnetic counterpart – does not wear out as a result of continued contact with the heads of the player. Hard drives increase storage capacity still further, and improvements in all areas of visual media technology will doubtless continue apace.

Of all the aspects we have been considering, we have seen that textual analysis is the least affected by new media. This is not to say, however, that there is nothing new in visual culture. By concentrating on visual forms rather than on mere delivery systems, we can (while still remaining vigilant against hyperbole) identify two areas in which something does seem genuinely and significantly

different. One is the relatively recently emerged form of the Internet website; the other is the established form of the music video. These are new kinds of text.

The Internet, of course, is a global network of interconnected computers. It originated in 1969 as a communications system for the US Defense Department. Originally known as the Advanced Research Projects Agency Network (ARPANET), it was joined by universities and other research organizations that wished to exchange information electronically. The system grew in both sophistication and scope, turning into an international communications medium as it was joined by wider organizations, commercial enterprises and private users. The World Wide Web (WWW) is a component feature of the Internet which facilitates the dissemination and retrieval not only of text but also of pictures, sounds and moving images via a network of interlinked sites around the world.[22] It was instigated at the Geneva-based CERN institute in 1989, based upon an internationally recognized system known as the HyperText Transfer Protocol (HTTP). During the following decade, increasingly user-friendly and affordable software was developed which led to the WWW becoming a mass medium accessible widely and domestically by personal computer.

The WWW is not in itself a media text. It is, rather, an interconnected system by means of which information can be both distributed and obtained. As such, it can be used both to access and to make available familiar forms such as photographs, radio programmes, musical tracks, video clips and even 'live action' from web-cameras (web-cams) around the world. Again, however, just because a text is delivered in a new way does not mean that it is therefore a new kind of text. What is new in terms of visual culture is the WWW site. This is not simply an existing image delivered by new means, but a new form that does not exist elsewhere. In its crudest form, the website could simply be (and frequently was) a single image or written text. As the WWW increased in reach, however, so did the presentational sophistication of its component sites and pages. Initially, the content was essentially word-based, but web design evolved increasingly to emphasize the visual. More than that, the website has also developed into an integrated portal to further texts and locations. Fundamental to this is the concept of interactivity, in which the viewer (usually by way of 'point and click' operations with a computer mouse) was able to navigate around the site to reveal new aspects and dimensions of it. By use of the 'hypertext' facility, it became possible directly to move to different sites altogether.

Now that we have (briefly) defined and described the Internet and the WWW, we are able to consider more analytically the status of the website as a new kind of visual text. The Internet website can be thought of as having three important features: integration, interaction and impermanence. We have touched upon integration already, because a sophisticated website acts as a kind of lobby through which we enter and then select further destinations. Each of these destinations may contain a different kind of text. Imagine the (hypothetical) website of a car manufacturer. Our first 'point and click' may reveal a photograph of the car we are interested in. The second may elicit traditional text describing its performance figures. The third might provide a technical drawing of its transmission system. Our fourth 'point and click' could play the 'theme music'

used in the company's current advertising campaign, while the fifth could start a short film or video of the car in action. Sixth, we could begin to 'customize' our chosen model by virtually pre-viewing colour and option choices. Seventh, we might send an email requesting further product information, and, eighth, we may connect to another website belonging to a local dealer. In this way, our website integrates photography, drawing, (written) text, music and video. The email is another (written) text-based system, while, with the hyperlink to the next website, we start all over again.

With all this pointing and clicking, we have demonstrated that not only is the website integrative, it is also interactive. As we make our way around the site, our choices directly affect the way it looks. The more interactive the site, the more we are offered choices within choices with increasingly personal effect. On our imaginary car website, for example, once we had summoned up the picture of the particular model we require, we were then able to interact with a colour chart to see how our chosen specification looked in a variety of trim combinations. We could then interact directly with the manufacturer with bro-chure requests, or even (if we were brave) order an entire car built to our exact requirements online. Perhaps we take this kind of interactivity for granted with websites, but this is not the case with other forms of visual culture. It is very dif-ficult to interact with (as opposed to respond to) a film at the cinema, while, if we were to interact with the *Mona Lisa*, we would swiftly be pinned to the floor by security guards.[23]

The impermanence of the website can itself be considered under three head-ings. First, many sites allow the viewer to see (in addition to hear) events taking place live. This could range from organized concerts to pictures coming direct from remote web-cams at ski resorts or college campuses. Here, the website has the immediacy, yet also the ephemerality, of the traditional broadcast media. Its content is temporal. Second, even when a website does not contain live action, its content can still change frequently. The websites of our favourite sports teams, for example, are updated regularly to keep us in touch with scores and locker-room news. We return to the site on the expectation that its content is going to change. The appeal and value of more traditional visual texts, on the other hand, is that they never change at all. Third, the website is impermanent in that it has no fixed, physical state. At a practical level, this means that any site may suddenly cease to exist. This can cause further complications in that, unlike with (say) a book, a film or even a television programme, it is very difficult to make and keep a 'copy' of a website for viewing (and certainly interaction) once it has been removed from the Internet. At the heart of the website's imperma-nence, of course, is the fact that it is essentially a 'virtual' text in that it does not exist in a physical state.

The impermanence of the website does not detract from its status as a new kind of visual text. On the contrary, it could positively add to it. A more sophis-ticated argument against the website stems from its integrative condition. We saw earlier that entering a website is like entering a lobby from which we choose paths that may lead to a written text, a graphic, a photograph, a piece of audio, or a film or video clip, or a live camera scene. This may be stylishly and indeed innovatively accomplished, but at the same time the website is acting only as

a perpetual transit lounge. The site itself may be new; its final destinations are ultimately traditional.

It is interesting to speculate whether this need necessarily be the case. Perhaps artists (as opposed to motor manufacturers) might create genuinely different kinds of websites. Eva Pariser has studied artists' websites, which she says are a 'natural extension of their artistic output'.[24] She uses a number of examples, which include samples of the artists' work, biographical and personal information and, in some cases, web-cams in the artists' studios so that they can be watched, live, at work. Pariser shows how the artists use the sites both to promote their work and to reveal something of themselves. Yet despite Pariser's enthusiasm and the undeniable sophistication of some of these websites, it would be hard to argue that many of these sites are artworks in themselves. Today, artists frequently use their own websites to display their work, but what we might call the 'ultimate destination' is still the artwork and not the site itself. This can be true even when the ultimate destination is an event rather than an artefact. In the summer of 2000, for example, British artist Andy Goldsworthy transported several giant snowballs into central London, and web-cams were installed so that people around the world – and not just passers-by – could watch them melt (see figure 49). This creative use of the Internet therefore allowed viewers to observe the snowballs metamorphosing over time and not just space. In this way, the use of the Internet not only expanded Goldsworthy's audience; it also enabled people to 'return' to the site virtually many more times than they would in reality. This use of new media thus successfully transformed a local phenomenon into a (potentially) worldwide event. As an event, it was indeed novel, but the heart of it surely remained the actual melting snowballs and not simply the way in which we were able to view them. The snowballs themselves remained the 'paramount' text. The website, then, is clearly a developing medium, but one that – still – appears mostly ancillary to existing forms. Precisely how it will develop, of course, remains to be seen.

While the website is still emerging as a new kind of text, the music video is much more established. The origin of the music video is a matter of dispute. In 1940, Walt Disney produced the animated feature film *Fantasia* in which figures such as dancing mushrooms and hippopotami were set to well-known pieces of orchestral music. Later that same decade, clips were used to promote jazz in the USA, playable on special machines. In France during the 1960s, a predecessor of the video jukebox called the Scopitone showed colour clips of pop performers.[25] Neither system was a major success, however. Much more popular were the feature films of the late 1950s and 1960s, which were produced to appeal to a youth audience with a distinctly different musical taste from their parents. In 1955, Bill Haley and the Comets played 'Rock Around the Clock' over the opening credits for *The Blackboard Jungle*, while two years later, the young Elvis Presley appeared in *Jailhouse Rock* as convict turned teenage rock 'n' roll star Vince Everett. The film featured a highly stylized, choreographed number in which Elvis performed the title number. Two films directed by Richard Lester catered for the vast audiences who wanted to see the Beatles' *A Hard Day's Night* (UK, 1964) and *Help!* (UK, 1965). The first was a documentary-style re-enactment of a day in the life of the Beatles, while the second took a far more

49. Andy Goldsworthy, *Snowballs in Summer*, 2000, installation/web-cam photograph; courtesy of the artist/Michael Hue-Williams Fine Art, London/Eyestorm

fanciful approach by involving the group in a screwball adventure story filmed in exotic locations. Both, of course, featured songs that could be heard on their concurrently released albums.

Television's contribution to the music video began in the 1960s. Starting in 1966, the American-produced series *The Monkees* merged adventures with records in a format not unlike the earlier Beatles movies. The following year, the Beatles themselves produced their *Magical Mystery Tour* TV special, in which they combined narrative with songs in increasingly fanciful settings. Although 'pop' shows such as *American Bandstand* in the USA and *Juke Box Jury* in the UK first appeared in the late 1950s, it was not until the mid-1960s that they began to use clips when bands were unable (or unwilling) to appear in the studio. This was especially the case with international acts such as The Beatles and The Rolling Stones. The former, for example, provided clips for 'We Can Work it Out' and 'Paperback Writer' in 1966. The clips varied in their degree of sophistication, but production values gradually increased into the next decade. The video to Queen's hugely successful 'Bohemian Rhapsody' is widely held to provide a Gombrich-style 'landmark'.[26] Produced in 1975, it was six minutes long, was heavily stylized and used (then) impressive special effects. In addition to the popularity of the song, the video became a thing of wonder in itself. It also had practical advantages: 'Bohemian Rhapsody' spent so long at the top of the charts that it was impossible for Queen to perform it themselves every time it was featured in chart run-down shows such as BBC television's *Top of the Pops*. Additionally, 'Bohemian Rhapsody' was essentially a studio production rather than a live act. As pop relied increasingly on production rather than on concert techniques, the music video became ever more useful.

It was the 1980s, however, that saw the real emergence of the music video. According to Andrew Goodwin, this was because it then became established as the standard way of promoting pop singles. The music video became permanently established within the political economy of the media on 1 August 1981 with the debut of MTV in the USA. Here was a channel dedicated to the broadcast of music videos. Appropriately, the first video screened was The Buggles' 'Video Killed the Radio Star'. Music videos gained an American network slot with NBC's *Friday Night Videos* in 1983, and MTV Europe began in 1987. The new format suited both the record companies and the broadcasters. The former gained free promotional exposure for their products; the latter gained free programme material. Everyone was happy, including increased audiences. But what we need to understand, according to Goodwin, is not its audience figures but its 'intrinsic qualities as a different kind of television'.[27]

There is nothing new about putting pictures to music. Goodwin calls this 'synaesthesia' and claims it is something which composers and audiences do mentally anyway.[28] If we think about it, this has been going on for centuries. Beethoven's Pastoral Symphony, for example, was designed to create 'pictures in the mind' long before MTV. What Disney did in *Fantasia* was to set some of these down and turn them into a shared, visual experience. We can see the connection, then, between Disney and the popular classics and the music videos of contemporary popular culture. What we need to do, though, is think about the music video conceptually as much as historically.

Let us briefly consider the options we may have for turning a musical text such as a pop song into a visual text. We could (1) film the band playing live in concert; (2) film the band playing or lip-synching to a studio audience; (3) film the band performing without a live audience but to an assumed audience on the other side of a television camera; (4) film the band playing or lip-synching in a non-theatrical location, such as in a moving railway carriage; (5) film the band singing or lip-synching in a naturalistic setting with an 'invisible' orchestra, such as in a Hollywood musical; (6) film the band doing things (such as larking about on a ski-slope) other than performing while the song plays anyway; (7) film the 'story' told in the lyrical content of the song without the band having to appear at all; (8) splice together clips from the feature film alongside which the song is being marketed without showing the band or illustrating specific lyrical content. We can think for ourselves of examples of each of these approaches (and will examine a case study shortly). We can see two further things: first, that music videos often combine several of these approaches within one text and, second, that the music video is a form that draws upon the conventions of both film and television.

Music video (like television) takes its fundamental vocabulary from film. The shot and the edit remain the basic grammatical units, and the music video can mostly be 'parsed' by using the terms we encountered in chapter 9. Music video, not unlike the television advertisement, makes great use of editing: the 'montage' techniques advocated by the early film-maker and theorist Sergei Eisenstein and demonstrated in films such as his *The Battleship Potemkin* (USSR, 1925) are familiar to viewers of music video. Sometimes, the music video's filmic qualities are emphasized by the choice of a cinematic rather than televisual aspect ratio, and the project may even be shot on film (as opposed to video), resulting in improved image quality and – possibly – prestige. Music video also takes many of its conventions from film genres, including the concert feature, the rock documentary (such as D. A. Pennebaker's *Don't Look Back* (USA, 1967) about Bob Dylan) and the Hollywood musical.

Other aspects of music video are taken from television. While television, of course, draws much of its language from film, it developed stylistic techniques of its own in photographing pop music performances. These ranged from exaggerated camera movements (designed to communicate the energy and excitement of pop) to special effects (such as starbursts and revolving, multiple images), which could much more easily be developed and accomplished using television technology. There are two further and important differences which television contributed over and above film. First, television (unlike film) did not feel the need to place musical performances within a wider narrative context, such as a 'tour' documentary or a Hollywood musical. Second, television convention (again, unlike film) permitted the performer to acknowledge the presence of the camera and to address it directly. As Goodwin correctly points out, this is a convention of the music video that draws from the television and not the cinema.[29]

We could spend a great deal of time debating the influences of these two media on the music video. Goodwin, however, argues articulately that the music video ultimately derives neither from film nor from television, but from the music itself. For this reason, 'music videos need to be studied primarily in relation to popular music, rather than in relation to television or cinema'.[30]

Goodwin's argument is laid down in detail in *Dancing in the Distraction Factory* and, along with the other important studies cited here, deserves to be read in its own right. Within the context of this chapter, however, we can summarize the key points. A music video, says Goodwin, derives its structure from the song it illustrates. With the feature film, the soundtrack is used to support the visual image. With the music video, therefore, the roles are reversed. Additionally, the music video takes its tempo and cutting rhythms from the music, with which it must be in visual sympathy. Unlike film, the music video is neither narrative nor naturalistic. It breaks (as we have seen) the cinematic conventions of address to the camera and, unlike in film, television or even much of fiction, music video has a 'present storyteller' in the form of the lead singer. The narrative, such as it is, is frequently 'fractured', and lacks both linear and temporal development. The viewer, however, is still able to make sense of it all because he or she is able to understand it within the conventions and culture of pop.[31]

It is, however, an exaggeration to say that the music video is wholly drawn from and is therefore dependent on the music. Goodwin admits that the video can instil the music with extra pleasure,[32] but from our own experience we can see that sometimes a good video can visually surpass the musical content. It may be the images rather than the sounds that we remember, and new meanings can be created by the confluence and juxtaposition of images. Montage theory, it seems, may help explain the music video and not just the music alone. Whether or not we choose to theorize our position, we may sometimes find ourselves nodding in wry agreement with the British television comedy series *Not the Nine O'Clock News* which, during the 1980s, parodied the emerging genre with a spoof music video called 'Nice Video, Shame About the Song'.

It is time for a case study. The Aerosmith video 'I Don't Want to Miss a Thing' (USA, 1998) is something of a classic in its field and illustrates many of the points we have so far been discussing in theory. It begins with a shot of an asteroid hurtling through space towards the earth as the instrumental introduction to the song begins.[33] The camera initially follows the asteroid, but sweepingly overtakes it, rapidly moving in through the lights of a city at night and (by way of what is actually a very swift dissolve) to a close-up of lead vocalist Steve Tyler as he begins the opening line. The opening verse is intercut between Tyler (with his trademark scarf tied around the microphone stand) and shots of lights and a mixing desk being prepared for what looks like a live concert performance – even though it is clear that the 'video performance' has already begun. As the verse quickly builds into the chorus, the camera takes us through the control room window to reveal the whole band playing in a vast room draped with banners signifying a NASA space-shuttle mission. There is no audience visible in the room, but subsequent shots reveal that the performance is being watched by staff on an array of monitors in a mission control centre, together with people at home, watching on TV. The second verse intercuts between Tyler (who addresses the camera directly), the band and shots of an attractive young couple preparing to kiss outdoors. Subsequent shots reveal the same couple in a different setting: he is an astronaut and they are kissing their goodbyes as he prepares to board his mission (see figure 50). As the music builds to the second chorus, the space-shuttle banners are dramatically pulled

50. Still from *Armageddon* (USA, 1998), footage featured in Aerosmith's 'I Don't Want to Miss a Thing' (USA, Music video, 1998); photo: Pictorial Press

away to reveal an extensive string section accompanying the song. Behind the band, we can now see the launchpad lit up at night, and, as the chorus builds again towards the 'middle eight', a formation of jet fighters with dramatic vapour trails sweeps directly overhead. As the middle eight plays, we intercut between the band and fragmented shots of a space-mission boarding and countdown sequence (although any linear chronology is not clear). The music reaches an emotional climax as the shuttle blasts away to cheering crowds; Tyler and the band are covered in dust from the power of the giant rockets. The third chorus sees the mission hurtling through space, again intercut with the band playing. The space shots are action-packed, even when it is clear that things are starting to go wrong. We see close-ups of a granite-faced Bruce Willis in an astronaut's helmet. Back on earth, we cut to a shot of people running out from a country church. The young woman we had seen kissing the astronaut goodbye is now in tears inside mission control. An over-the-shoulder shot reveals her looking, distraught, at Tyler singing on the monitors. As the vocal finishes and the accompaniment (heavy on the sweeping strings) repeats to fade, the tearstained woman extends her hand to the nearest monitor as if to caress Tyler's face. All she can feel is the glass. The face disappears in a rush of static hiss. The music fades completely as the camera tracks back. All that remains is the static, the hand and silence.

The 'I Don't Want to Miss a Thing' video appears to conform to each of the features and criteria we have listed for the music video. It draws on both filmic and televisual languages and conventions. It is shot on film and made in a cinematic aspect ratio. The editing is heavy on montage. On the other hand, vocalist Tyler addresses the camera directly. The structure of the video broadly follows the music, however: the intro ties in with the opening shot of the asteroid, while the first verse is introduced by the first shot of the 'concert performance'. Musical climaxes are counterpointed by visual climaxes, such as the shuttle blasting off as the middle eight peaks into the chorus. As the music fades, the monitor turns to static, the camera pulls slowly back and the screen cuts to black.

There is no attempt at naturalism here. We are perpetually aware that what we are watching is a formal construct that draws attention to its own artifice. The storyteller (Tyler) is the dominating presence, and the narrative (such as it is) is deeply and repeatedly fractured. We might argue that there is some linear development in terms of a space mission which sets off and goes wrong, but there is a marked discontinuity with the song, which is sung in the present tense and has no linear narrative at all. Indeed, we cannot easily see the connection between the lyrical content of the song and the narrative content of the video. What we hear is a power-ballad about someone who wants to stay awake to watch his loved one sleeping because he doesn't want to 'miss a thing'. At the end of the song, the loved one is still alive. It says nothing about asteroids, rockets and loss in space.

To make sense of this video, it is necessary to have some important extra-textual knowledge. The space-mission clips, together with the majority of the sets, are taken from the feature film *Armageddon* (USA, 1998), which we conveniently examined earlier. But in the same way that the video has little

to do with the song, the song actually has precious little to do with the film. Its connection (such as it is) is with the 'love' interest in *Armageddon*. Here, roughneck-turned-astronaut A. J. Frost (Ben Affleck) is in love with boss Harry S. Stamper's (Bruce Willis) daughter Grace (Liv Tyler). Harry initially disapproves of the relationship, but ultimately lays down his own life to save that of A. J., together with the rest of humanity as we know it. The song appears twice in the film. First, it is heard with an edited, orchestral arrangement during the love scene, in which A. J. and Grace spend what could be their last night together. Neither party, however, is shown asleep, watching or dreaming. The application of this love song to this love scene, then, is generic rather than specific. The second time we hear the song is over the closing titles in which we also see shots of A. J. and Grace's wedding. The arrangement here is much more similar to that on the video – and to the soundtrack album released at the same time as the film.

To an extent, then, we can begin to make sense of it all. Shots of Steve Tyler and the band are interspersed with shots from the film. To help us distinguish between the two, the shots of the band seem to have the colour artistically 'drained' from them, while shots from the feature are shown in their full splendour. Once we know the film, we start to understand the video. Once we start to look at the video closely, however, we begin to realize that the situation is rather more complex: a number of the shots in the video which appear to be taken straight from the film are, in fact, convergences of the two. This happens most importantly when the TV and monitor screens – which in the film are showing the mission to NASA controllers and to the public – are, on the video, showing pictures of Steve Tyler's vocal performance, thanks to some clever special effects. In the film, Harry Stamper says goodbye to daughter Grace over the monitors at NASA just before he sacrifices his life for her (and everyone else's) future. She reaches out to touch his face. In the video, she reaches out and touches Steve Tyler. This has an added extra-textual significance: in 'real life', the actress Liv Tyler is the singer Steve Tyler's daughter. In the film, Liv Tyler caresses the face of her 'screen father'; in the video it is her real father. In both cases, of course, she only gets to touch the screen.

We have seen how the full meaning of the 'I Don't Want to Miss a Thing' video is not inherent to the video itself, but needs to be informed by the feature film *Armageddon*. We have now to go even further, for the 'fatherhood' meaning of the video is not inherent to the song, the film or even the video, but develops through a confluence of all three in addition to a wider knowledge of celebrity culture. Goodwin argued that while a music video typically made no linear, temporal or narrative sense, understanding was still possible because the audience was already familiar with the conventions of pop.[34] Our analysis of 'I Don't Want to Miss a Thing' suggests that we need to take this even further: what is required is not just a knowledge of pop music, but also a knowledge of popular culture.

It may seem, then, that in order to understand a music video, we need first to understand all manner of other things. Our case study has certainly shown that we need to venture outside the text in order to comprehend the layered meanings of that particular video in relation to film and to fatherhood. We need

also to remain aware of the political economy of the music video, in which (at its most basic level) the video is designed to promote record sales or, in the instance of our case study, the video helps the film and the record promote each other. Does that mean, though, that without a prior understanding of all these things a music video has no meaning?

We discussed in chapter 2 how music was not a figurative or mimetic form. If so, a piece of music is unlikely to have a direct 'visual equivalent'. As music has no direct visual meaning, then the images we derive from it need make no logical sense. It is true that the images may follow the words, but again we remember that, in popular music, the words frequently serve as relatively unimportant vehicles for the tune. A pop music video, therefore, is more likely to visualize the form rather than the content. This, of course, connects us to points we had previously made about abstract painting: to look for literal meanings is usually to miss the point. The image can communicate its own meaning regardless of any reference it might make to conventional narrative or to the physical world. It makes sense, therefore, that the meaning of a music video might lie in its formal rather than its literal properties.

The argument for the formal understanding of the music video would have made perfect sense to Sergei Eisenstein. Eisenstein, we recall, championed the use of 'montage' theory in film. Here, film communicated by a succession of juxtaposed images that did not need to have a linear, narrative or consequential relationship between them. Shot 'A' followed by shot 'B' created a new meaning 'C' in the mind of the viewer. Eisenstein likened this to 'haiku' – a traditional Japanese poetic form in which a short succession of separate images combines in the mind of the reader to create a total meaning which is greater than the sum of its component parts.[35] In this way, meaning is suggested rather than stated. Eisenstein hoped to communicate specific meanings, but in the haiku (and arguably in some music videos) the implication is far more abstract.[36] No matter how specific or otherwise the intended meanings of the images appearing in a music video may be, we can understand that, just like the haiku, the music video can still have meanings even in the absence of a logical, sequential narrative structure. The logical extension of this is that a good music video could still work with the sound down: haiku for the eyes.

We began this chapter on new media by marking a distinction between new kinds of text and new kinds of delivery system. In this section, we have consistently referred to the music 'video' as if the text and the delivery system were one and the same. In reality, of course, they are not. Many so-called 'videos' are actually shot on film, while many others go to a great deal of trouble to suggest that they were. Originally designed for TV, they may be transmitted via cable, satellite or terrestrial means in any one of three international formats, to say nothing of the Internet and popular sites such as YouTube. Either way, the typical viewer never sees the film or tape – simply the resulting image. Some consumers obtain music 'videos' by rental or purchase for home viewing, but nowadays the so-called 'video' is actually obtained on DVD. The DVD version of *Armageddon* proudly boasts that it includes the 'video' of 'I Don't Want to Miss a Thing', but, of course, it is not a video at all. This does not mislead viewers, however, because they know that 'video' nowadays refers to a specific

kind of text and not to the system used to deliver it. This being so, we can con-
clude that the music video really is a new addition to visual culture.

Our proverbial jury is still out on precisely what constitutes 'new media', and
the problem is exacerbated by the great variety of potential new media forms. It
remains true, however, that just because we are unable to explain everything, it
does not mean we are unable to conclude anything at all.

It is no coincidence that the handy little program-related images we see on our
computer screens are called 'icons'. They are partly interpretable by experience
and partly by convention. What they do in either case is stand for something,
and they are frequently recognizable across different programs by different
manufacturers. As they are visual rather than verbal, they are also recognizable
across different languages and countries. If we are unsure of what they mean,
we can look them up in a manual – just like the iconology and emblem books
of previous centuries. If we were minded to do it, we could probably begin our
own research into the iconology of computer-based media. It seems very likely
that, with the distance of some years, we will even be able to make scholarly
claims for its intrinsic meaning.

The iconology of the music video is something we could attempt more readily.
As with film (with which it shares many similarities), the content of the music
video is usually carefully planned and considered. Indeed, the relatively short
running time suggests that every aspect of the music video must be considered
in detail if the maximum meaning is to be condensed into only a few minutes.
Many of the visual components will be recognizable from everyday experience,
but others depend on prior knowledge of youth and music culture for their con-
ventional meaning to be understood. Intrinsically, the *Weltanschauung* of the era
might also be discernible, but we might do well to temper our iconology with
some of the sociology we studied in chapter 4: the world vision articulated in a
music video may represent discrete social groups rather than Panofsky's sweep-
ing 'basic attitude of a nation' or a 'period' as a whole.[37] If this is true of music
video, of course, it might also be true of Renaissance painting . . . but that takes
us back, again, to chapter 4.

Form is, of course, important to all media forms, and 'new media' are no
exception. If we accept that, in many cases, the 'new' media simply provide
a new delivery system for traditional forms, then our formal analysis should
embrace the methodologies relevant to the original medium. If we feel that the
text has undergone formal change as a result of the medium of delivery (as with,
for example, the translation of some films to television as we discussed in the
last chapter), then we should draw attention to those changes and to the way
they might affect the meaning of the final text. Again, our focus should remain
on the message rather than simply the medium. We have argued in this chapter
that the Internet is more of a new gateway to existing forms than a new form in
its own right. This is not to say, of course, that the gateway itself is devoid of
formal qualities. We have all noticed how much 'web design' has improved over
recent years. Indeed, the very word 'design' betrays the importance of formal
considerations to this development. It is interesting to apply Fry's thinking
about form and content to web design. To what extent is it possible to have a
web page without content – and, again, how much of what we see is the result

of practice rather than theory? We know that advances in web design have proceeded hand-in-hand with advances in information technology. How much, then, of the formal content of web design is dependent upon current technology rather than the innate properties of the medium?

The issue of form in the music video is rather more straightforward. In many ways, formal analysis proceeds much as it does with film and television – music videos are, after all, frequently short films shown on television. Where analysis becomes much more interesting and specific is when we go back to Goodwin's argument about the relationship between the musical and the visual form within the music video. If, as he contends, it is the visual content that follows the music rather than vice versa (as is usually the case in film), then perhaps a study and analysis of musical form is essential to the formal analysis of the music video. This again serves to underline claims for music television as a genuinely 'new' medium.

Art-historical approaches to the analysis of 'new media' will inevitably be hindered by disagreement about what actually constitutes 'new' media. More than that, the traditional concerns of art historians do not, as yet, meld well with these (potentially) new forms. As things stand, it would be difficult to populate a narrative history of web design with great works and great artists in the manner of Ernst Gombrich. With the best will in the world, it is difficult to come up with canonical examples of web design or even the names of 'genius' web designers. Things (as Dylan[38] has observed) change. For the time being, however, one is unable to speak of web masters and old masters in the same breath. We can certainly speak usefully of the context of web design, but attribution is, as yet, of little interest. Provenance, the third ingredient of traditional art history, seems inapplicable to web design. No one, after all, physically owns a web page. Its existence is both virtual and ephemeral.

An art history of the music video is more manageable. It is true that the public at large is generally unaware of (or even uninterested in) the identity of music video directors.[39] On the other hand, certain music videos are already recognized as Gombrichian 'landmarks' in the history of the genre. Narrative histories of the music video are equally likely to create such landmarks in retrospect.

The ideology of 'new media' is already subject to vigorous debate. This is partly, of course, due to its content or, more correctly, to the content to which new media provide the gateway. The Internet, for example, provides easy access to avowedly ideological sites, ranging from those opposed to global capitalism to those in favour of religious strife. Others, such as pornographic sites, contain an ideology that is (ironically) less explicit but nevertheless extant. This is all very different, of course, from an ideology of the Net itself. If it is possible to speak of the ideology of a delivery system, we might become interested not only in its accessibility and demographic. It is significant, for example, that the HTML system that underpins the Internet is English-language based, and that most domain names (even international ones) are in ASCII (The American Standard Code for Information Interchange) characters. To what extent, then, might this contribute to a cultural imperialism of the Internet?

The ideological content of the music video is already a focus for analysis. Song lyrics clearly carry their own ideological messages (intended or otherwise), but

we could study these with equal success in their printed state. With the music video, however, a whole visual world is created around the song, and this is frequently ideologically loaded. We notice, for example, that female artistes are usually expected to look beautiful in music videos, while it is normally sufficient for male performers to look imposing. Men and women are also used as characters, dancers or extras in music videos, in addition to the musical performers. How are they portrayed? Is it true, as Berger argues of painting, that men 'act' while women 'appear'?[40] Heavy metal and rap videos are widely thought to articulate sexist attitudes towards women; in addition, rap music videos provide fertile ground for the ideological investigation of attitudes towards race and property. Any conclusions on this are likely to prove contentious.

The sociological context in which music videos are produced is certainly of significance to analysts in the school of Pierre Bourdieu. It must always be remembered that music videos are designed commercially to promote a product. As such, they are firmly located in both the economic and the political fields. Their position within the field of literature and the arts is more intriguing. Certainly, a music video can be judged to have artistic merit. What is less clear is the genre's claim to 'autonomy'. Is it possible to produce a promotional video solely for 'video's sake'? The views of record company executives and video directors are likely to differ considerably on this point. Neither should be taken at face value.

The semiotic analysis of new media is subject to the by now familiar complications of layering and delivery. Should a semiotic analysis of the *Mona Lisa* as viewed on a computer screen, for example, differ from an analysis of the *Mona Lisa* as viewed when standing in the Louvre? In terms of reception theory, of course, the readings would be different. The semiotic content of the text itself, however, is less likely to have been changed. Much more rewarding, it seems to me, would be a semiotic analysis of the visual aspects of computer software. This could, of course, be done with obvious material such as computer games and entertainment packages, but we might again spend too much time wondering how the semiotics of the same text might differ if experienced in (say) an amusement arcade or if played on a computer or TV screen. It is with application software, however, that the most interesting work might be done. To what extent are the familiar symbols, graphics, logos and even typefaces of popular programs a matter of connotation as much as denotation? And if they are, what and how do these apparently simple signs connote? Are these signs always arbitrary? And how much of what apparently 'goes without saying' (as Barthes might put it) in the appearance of software packages is in fact only deceptively obvious? Could we be confusing nature with history, as Barthes warned? There is work here to be done.

The semiotics of the music video owe much to the semiotics of film and television. It is not necessary to repeat the argument again. It is, however, worth pre-empting a misconception that sometimes dogs the semiotic analysis of music video texts. All too frequently, the inexperienced analyst presumes that the video is a straightforward, semiotic representation of the values and characteristics of the musicians involved. It should be remembered, however, that the music video is essentially an advertisement, either for sales of a specific record

or for the marketing of a band in general. If the musicians have creative control over their videos (which is rare), then it is likely that the semiotic analysis of these texts is more likely to reveal how they would *like* to be perceived rather than the sort of people they genuinely are. More typically, the video is created and directed by outside parties who have been hired by a record company to do the job. In this situation, the music video is even less likely to be a semiotic articulation of the genuine values, lifestyle and philosophy of the musicians. In other words, a semiotic analysis of a music video should take into account that it has been made in order to promote a commercial product. As with other forms of advertising, the perceived and actual values of the product might be far from identical. A semiotic analysis of an advertisement is, after all, not designed to reveal much about the actual product: it is intended to reveal far more about the advertisement itself.

One of the commendable features of the hermeneutic approach to the analysis of visual culture is that it is prepared to admit that its conclusions may be wrong. We began this closing chapter on new media with an admission that we, too, might be wrong. If our culture is indeed a compilation of stories we tell ourselves about ourselves, then the story of new media is still very much in the telling. None of us knows how it will end.

Key Debate

'How do we relate to images on a computer screen?'

When you read the chapter on 'New Media' you will have noticed a tone of caution. Certainly, we believe you should think twice before joining in with those who excitedly and all too easily refer to the 'revolution' created by new visual media, especially those associated with a screen and a computer. Do these new technological means involve a new viewing experience? As we have argued in this chapter, they certainly do. But do such viewing experiences *radically differ* from those of pre-computer technologies? That is the question we will address in this Key Debate section, following the work of Lev Manovich, a new media writer whose rigorous approach distances him from any sort of uncritical views on the matter, including both the enthusiastic and alarmist positions.[41]

Using the conceptual framework provided by Manovich, we will focus on the relationship between the viewer and the computer screen. A close look at what happens in that situation – a daily occurrence for most of us in the twenty-first century – will help us to continue our critical evaluation of how new the 'new media' really are.

Starting from the beginning, we should acknowledge that a computer screen is, well, a screen. So far, so good: but how should we actually define a screen? Manovich offers an initial definition that seems undisputable: a screen, he writes, is 'a rectangular surface that frames a virtual world and that exists within the physical world of a viewer without completely blocking her visual field'.[42] Further on, he formulates a second definition, describing the screen as 'a flat, rectangular surface . . . intended for frontal viewing (which) exists in our normal

space, the space of our body, and acts as a window to another space'.[43] This second definition may be seen as complementary to the first, and looks equally undisputable. But, if we think about it, these descriptions of the computer screen are also broad enough to fit a cinema screen, a television screen – or even an Old Master painting. Are not all these screens framed surfaces which simultaneously exist in the physical world of the viewer and yet constitute a window to a space of representation in which some outside referent is constructed before the viewer's eyes? If the answer is 'yes' and the general definition is accepted, the computer screen can hardly be regarded as the instrument of a major 'revolution' of our times: it has been around for centuries.

This broad definition of the screen gives us a sense of historical groundedness. But we believe that 'new media' mix elements of tradition with novelty, resulting in new viewing experiences. In order to understand the novelty, we need to proceed from the definition of the screen and extend our observation to what the screen displays and the way we relate to it.

Not all 'new media' viewing experiences use the screen. To the 'representation' process enabled by the screen we can add the 'simulation' processes allowed by Virtual Reality (VR) devices, such as the headgear used to play certain computer games. Unlike the screen, VR technology immerses the viewer within an absolute virtual environment, erasing the boundaries between 'real' and 'represented' space created by the screen. Like the screen, however, the viewing experience we refer to as 'simulation' goes back much further than the emergence of 'new media' technologies. If we think of the viewing regime experienced in the interior of a Gothic cathedral or at the centre of a nineteenth-century 360 degree panorama, for example, 'simulation' sounds like an adequate concept to describe them all.

The panorama (also called the diorama and the cyclorama) was a 'new media' craze of the late nineteenth century, and remains part of the visual cultural history of both the United States and (to a lesser extent) Europe. Typically, the panorama was a specially built attraction in which an historical scene was realistically painted on a huge, 360 degree canvas which completely surrounded the spectators. This was in turn housed within a cylindrical building with a viewing platform in the centre. In the hinterland between the painting and the viewing public, pieces of 'real' scenery were included to add to the graduated realism of the total effect.

The New York Times in 1886 reported on the preview of one such panorama at Madison Avenue and 59th Street in Manhattan, under the headline 'Art That Resembles Nature'. The panorama depicted the American Civil War naval battle between the ships *Merrimac* and *Monitor*, which had taken place some twenty-five years earlier. The *Times* described not only the painting, which occupied '20,000 feet of canvas', but added:

> The foreground between the observation stand for visitors and the painting is filled with natural earth, grass, trees, and other objects. These are so artfully carried out that it is difficult to tell where one ends and the other begins.

It is difficult to say how impressive this would have been by today's standards,

but the *Times* certainly declared it 'remarkably realistic'.[44] From our perspective, it remains an important example not only of the continuing search for 'new' media, but of the way in which 'immersive', three-dimensional spectacles comfortably pre-date the computer screen and certainly electronic headset 'new' media.

The sense of familiarity we feel when comparing the features of (say) an Old Master painting and a computer screen should not obscure the fact that the screen has nevertheless changed over time. Distinct display possibilities, coupled with the different ways the viewer relates to the screen, indicate an evolution that took place within the broad, historical definition of a screen.

In his 'genealogy' of the screen, Manovich suggests three types of screen: the classical type, the dynamic type and the real-time type. The transition from the classical to the dynamic type happened a century ago, when the invention of cinema added something new to the overall representational properties of the screen: moving images that change over time. Time is also the key concept in the change from the dynamic screen to the real-time screen, of which the computer screen constitutes a subtype. The novelty added here is the possibility of displaying images that change in real time, that is to say, images that instantaneously reflect changes in their referents. The dynamic screen, which originated in public entertainment (see chapter 9 on film), displays images that change over time, but necessarily represent past events. However, real-time screens, originated by the development of military surveillance, enable the representation of concurrent events, displaying changes as they happen.

Radar was the military surveillance technology that eliminated the necessary delay between the referent and its image displayed in the dynamic screen. The intention was, of course, to make the time of surveillance coincide with the time of access to the data, with obvious military advantages. But, despite its pioneering real-time screen, radar lacks another important feature of the computer screen: interactivity. That is another word frequently used by the enthusiasts of the 'new media revolution'. Indeed, the possibility of engaging in an active and creative relation with the images displayed on a computer screen is often mentioned to stress the inherent and radical novelty of the 'new media' viewing regime. Once again, however, we should tread carefully here.

In the first place, it is arguable that all images, regardless of the technological apparatus mobilized for their display, are interactive. That is to say, all images demand some kind of action on the part of the viewer. Without the active engagement of the viewer, no visual representation can be apprehended. In chapter 9 on film, we described the psychological processes of 'filling in' required to make sense of the edited moving images shown to the viewer. Cognitive demands are also placed on someone looking at a painting, as we explained in chapter 7 on fine art. And sometimes even physical action is required, as in the case of a viewer who moves around a sculpture so as to fully apprehend that particular three-dimensional representation. In this sense, interactivity, like the screen, is not a 'revolutionary' novelty: it has been around for a very long time.

When discussing the 'revolution' of the screen, we pointed out that its long-lasting broad definition should not obscure the evolution that has nevertheless taken place. The same can be said about interactivity. The circumstance that

all images are interactive by definition should not prevent us from investigating new modalities of interactivity created by 'new media'. Manovich offers a particularly provocative perspective in that respect – and one that might surprise (and even upset) radical advocates of the 'new media revolution'. Manovich claims that what computer technology brought about was not interactivity per se, but rather a specific form of interactivity, which differs from 'traditional' interactivity given its 'closed' character. The idea is that the interactivity that takes place between a viewer and the images displayed on a computer screen leads to the externalization and objectification of the mental operations that were involved in pre-computer forms of interactivity. Whereas in 'traditional' interactivity, the viewer is urged to engage in private, internal, intangible and unique mental processes of association, in 'new media' such processes become public, external, tangible and standardized. The concept might be clarified if we think of hyperlinking, the 'new media' interactivity operation par excellence. Manovich claims that previously, 'we would look at an image and mentally follow our own *private* associations with other images. Now interactive computer media ask us to click on an image in order to get another image' (our emphasis).[45] And he adds: 'In short, we are asked to follow pre-programmed objectively existing associations.'[46]

The notion that the kind of 'closed' interactivity promoted by computer technology corresponds to an 'externalization of the mind' has serious social and political implications. If we regard the transformation of private mental operations into public objectified associations that facilitate control, 'new media' interactivity does not look like a liberating novelty, but rather like an instrument of the increasing standardization and regulation that allegedly characterize the highly visual contemporary mass societies. That makes for a very odd kind of 'revolution.'

Further Study

There is no doubt that the 'new media' provide a vibrant and relevant area for further study. The difficulties, however, reflect the concerns expressed at the beginning of this chapter. First, this is a field of such rapid change that even the most up-to-date of studies can be out of date by the time it reaches the shelves. Second, the field is so new that relatively few classic texts have yet become established. Third, even the very term 'new media' presents problems of definition. The printing press was, after all, a new medium in its day. This is not, of course, to discourage further study in this area. Far from it. It does seem fair, however, to point out that the excitement of study in a new and expanding field is not without its dangers and insecurities – even though these do at the same time add to the excitement.

The concept of a 'communications revolution' is not a new one. In 1965, the social and broadcast historian Asa Briggs gave a lecture titled 'The Communications Revolution' at the University of Leeds.[47] This lecture tells us little about today's 'new media' technologies, but it does provide a very good base from which to ask fundamental questions about the media, 'revolution' and

change. The question of 'newness' in media is pondered by Carolyn Marvin in *When Old Technologies Were New*.[48] The idea of just what does constitute a scientific 'revolution' is investigated by Thomas Kuhn in his classic *The Structure of Scientific Revolutions*.[49] This is a book that should be required reading for anyone (mis)using the word today.

For media histories that include 'new media', there is much to be said for selecting reading on the basis of how recently it was published. This is an approach that lacks sophistication, however. Brian Winston's *Media Technology and Society* places the issues in their crucial social context, besides also being available (appropriately) on Kindle as an 'eBook'. David Crowley and Paul Heyer's edited *Communication in History* has been published in various editions, while Hugh Mackay and Tim O'Sullivan's *The Media Reader: Continuity and Transformation* is older but still contains a selection of relevant articles.[50]

In terms of technology, Stephen Lax's *Beyond the Horizon: Communications Technologies, Past, Present and Future*, which was also recommended in the previous chapter, helps explain old and new systems to the non-scientist. Tony Feldman's *Introduction to Digital Media* was published in 1997, while Michael Mirabito's *The New Communications Technologies* has been updated in various editions.[51] The question of what may or will happen in the future is one which involves dangerous speculation. Such issues are discussed in William Dutton's edited volume *Information Communication Technologies: Visions and Realities*, while Patrick Barwise and Kathy Hammond's *Media* forms an intriguing contribution to the 'Predictions' series of books. The extent of the debate is exemplified on the one hand by titles such as Frances Cairncross's *The Death of Distance: How the Communications Revolution Will Change Our Lives* and, on the other, by Michael Traber's edited *The Myth of the Information Revolution*.[52]

More definitely focused reading is available on specific media. As the music video has been with us for several decades now, it is fair to recommend Andrew Goodwin's *Dancing in the Distraction Factory* as an important text. This was followed twelve months later by *Sound and Vision: The Music Video Reader*, in which Goodwin collaborated with Simon Frith and Lawrence Grossberg.[53] Goodwin was not the first, however, to write about music television. E. Ann Kaplan, for example, published her *Rocking Around the Clock*, which set the issue against a background of postmodernism and consumer culture, in 1987, while a sociological stance was taken by Lisa A. Lewis in *Gender Politics and MTV*.[54]

David Bell's *An Introduction to Cybercultures* provides a useful overview of the issues (as opposed to simply the technologies) emerging in cyberspace, while David Gauntlett's work, including the edited *Web.Studies* examines the uses and implications of the World Wide Web from the varying perspectives of diverse international authorities. An additional and valuable compilation is Steven G. Jones's *Virtual Culture: Identity and Communication in Cybersociety*. Don Tapscott's popular *Growing Up Digital: The Rise of the Net Generation*, meanwhile, is very optimistic about the potential of the Internet in many directions, including creativity.[55]

For digital photography as a 'new medium', Martin Lister's edited compilation *The Photographic Image in Digital Culture* contains many useful essays. The practice of digital photography is included in Terence Wright's *The Photography*

Handbook, while Anne-Marie Willis's provocative 'Digitisation and the Living Death of Photography' is included in Philip Hayward's compilation *Culture, Technology and Creativity*.[56] The same Martin Lister shares with Jon Dovey, Seth Giddings, Ian Grant and Kieran Kelly the authorship of *New Media: A Critical Introduction*, a book where you will find an extensive section on new media visual culture and a stimulating variety of case studies, ranging from Napster to Pokémon.[57] Another interesting and more recent book is Nicholas Gane and David Beer's *New Media: The Key Concepts*.[58] Lev Manovich, the author whose work guides our Key Debate in this chapter, is well represented in this last book, where there are also substantial references to thinkers discussed in other chapters, such as Jean Baudrillard (semiotics) and Gilles Deleuze (film).

The fusion of film and 'new media' is described in practice in Steven Ascher and Edward Pincus's *The Filmmaker's Handbook: A Comprehensive Guide for the Digital Age*. For those who wish an insight into 'multimedia' production, Nigel Chapman and Jenny Chapman's readable and well-illustrated *Digital Multimedia* introduces the technical, production and contextual issues, while an additional resource on both technologies and concepts is Richard Wise's *Multimedia: A Critical Introduction*.[59]

The final – and possibly most productive – area for further study is the visual texts themselves. This, indeed, can be said of all the chapters and topics we have covered in this book. Fine art, photographs, films, television programmes and new media images are all sources and authorities in their own right. They are the objects of our investigation. We may argue about theories and methodologies. We may even argue about the meanings of the texts themselves, but the ontology of the texts remains. No matter how much we enjoy the 'literary' debate, we must never leave the visual out of visual culture.

CONCLUSION

We have come a long way in these chapters. We began with the simple analysis of relatively straightforward works and ended with the examination of new and multimedia texts. As the texts have become more complex, so has our analysis. As we have proceeded along this path, we have discovered things not only about our visual culture, but also about ourselves.

We may have had one reservation, though. The singer Billy Bragg once wrote that the trouble with taking precious things apart to see how they work is that they never seem to fit together again. Well, maybe not all the things we have taken apart here are equally precious, but we still understand what he means. So often, it seems, the analysis of the arts can remove the enjoyment from them.

This need not necessarily be the case, however. The fact that we have figured out how something works might actually increase our admiration for it. Equally, an analysis of something we had formerly admired or maybe just accepted as inevitable might unmask its pretensions or undermine its assumptions.

Understanding and emotion need not be mutually exclusive. Neither our learning nor our intelligence has to immunize us from our emotions. They are all part of us; there is no reason why they should not all enrich each other.

NOTES

Cross-references to page numbers are listed in the order to which they are referred in the main text.

Preface to the Second Edition

1 Ian Buruma, 'Theater of War', in the *New York Times*, 17 September 2006: <http://www.nytimes.com/2006/09/17/books/review/Buruma.t.html?pagewanted=1&_r=1&sq=Ian Buruma Theater of War&st=cse&scp=1>; accessed 29 December 2010.
2 Craig Lambert, 'Reviewing Reality', in *Harvard Magazine* (March–April 2007): 40–5, 41.
3 This figure is given in 'Religion and freedom of speech' by Robert Post, in *Constellations* , Volume 14/1: 72–90.

Introduction

1 For more on the importance of the study of media to the preservation of democracy, see Richard Howells, 'Media, Education and Democracy', in *The European Review* 9/2 (2001): 159–68.
2 For more on the relationship between war and the media, including news, censorship and propaganda, see Philip M. Taylor, *Munitions of the Mind: A History of Propaganda from the Ancient World to the Present Era* (Manchester: Manchester University Press, 1995); Philip M. Taylor, *War and the Media: Propaganda and Persuasion in the Gulf War* (Manchester: Manchester University Press, 1998); and Phillip Knightley, *The First Casualty: The War Correspondent as Hero and Myth-maker from the Crimea to Kosovo* (London: Prion, revised edn, 2000).
3 Gyorgy Kepes, 'Introduction', in Gyorgy Kepes (ed.), *Education of Vision*, Vision and Value (New York: George Braziller, 1965), p. ii.

Chapter 1 Iconology

1 Look, for example, at Hans Holbein the Younger's famous portrait of Henry VIII, painted in 1540. Painting, oil on panel, National Gallery, Rome.

2 George Richardson, *Iconology* (New York: Garland, 1974 [1799]), p. 71.

3 Some authorities give different names to this painting. The National Gallery, London, for example, calls it simply *The Arnolfini Portrait*. Disputes over the title need not detain us here.

4 Art historians at the National Gallery themselves insist that she is '*not* pregnant' (their emphasis).

5 Where the author of a painting from this period is unknown, art historical convention will often refer to him as 'The Master of . . .', depending upon where it was he lived and worked. Some authorities believe that The Master of Flémalle was called Robert Campin.

6 We may see the term 'iconography' used as an alternative term for 'iconology'. Even Panofsky does this. The differences (if any) do not concern us here.

7 This is not, of course, to diminish the importance of the work of Aby Warburg, but despite the influence of Warburg's earlier thinking, it was Panofsky who published most significantly on this subject. For more on Warburg, see the Further Study section at the end of this chapter.

8 Erwin Panofsky, *Studies in Iconology* (New York: Harper and Row, 1972), p. 3. The following section is an explanation of Panofsky's basic methodology, which can be found in the original in Panofsky on pp. 3–17.

9 Ibid., p. 7.

10 Ibid., p. 9.

11 Dan Brown, *The Da Vinci Code* (New York: Random House, 2003).

12 We were unable to get permission to reproduce the original image in this book. This seems odd, as the image is so widely available by other means. It is such a good case study, however, that it is still worth including. The cover, together with unused images from the original shoot, is widely available on the Internet.

13 Although *Let it Be* (8 May 1970) was released after *Abbey Road* (26 September 1969), it was in fact recorded previously. The release of *Let it Be* was delayed by creative and business disputes within the band.

14 Panofsky, *Studies in Iconology*, p. 9, says that it is sometimes necessary to 'widen the range of our practical experience by consulting a book or an expert'. The divisions between his levels of analysis, therefore, are not watertight. The point here, however, is not to get lost in detailed debate at the cost of understanding the big picture.

15 The photograph was taken on the morning of 8 August 1969 during a break from the *Abbey Road* sessions. The studios only became known as the Abbey Road Studios after the success of the record.

16 Half of the shots show The Beatles crossing the road in the opposite direction. Time was clearly at a premium.

17 Panofsky, to be fair, was aware of the dangers of over-interpretation.

18 W. J. T. Mitchell, *Iconology: Image, Text, Ideology* (Chicago, IL, and London: University of Chicago Press, 2003), p. 8.

19 Ibid., p. 8. We have more to say on the difficult question of ideology itself in chapter 4.

20 Ibid., p. 4.

21 Ibid., p. 9.

22 Ibid., p. 14.

23 Ibid., p. 17.
24 We will explain what we mean by semiotics (and its related terms) in chapter 5.
25 W. J. T. Mitchell, 'Word and Image', in Robert Nelson and Richard Shiff (eds), *Critical Terms for Art History* (Chicago, IL, and London: University of Chicago Press, 1996), p. 53. This is an area of such interest to scholars that a specialist and respected journal, *Word & Image*, was established specially to continue the discussion. We refer to one of our own articles in it in chapter 8.
26 Ibid.
27 Ibid.
28 Ibid.
29 Richard Howells and Robert W. Matson, *Using Visual Evidence* (Milton Keynes and New York: Open University Press/McGraw-Hill Education, 2009).
30 W. J. T. Mitchell, 'Word and Image', p. 56.
31 E. H. Gombrich, *Aby Warburg: An Intellectual Biography* (Oxford: Phaidon, 2nd edn, 1986).
32 Cesare Ripa, *Iconologia; with Translations and Commentaries by Edward A. Masser* (New York: Dover, 1971).
33 Christophorus Giarda, *Bibliothecae Alexandrinae Icones Symbolicae; with Introductory Notes by Stephen Orgel* (New York: Garland, 1979); George Richardson, *Iconology; with Introductory Notes by Stephen Orgel* (New York: Garland, 1974).
34 Emile Mâle, *Religious Art in France: The XIIIth Century* (Princeton, NJ: Princeton University Press, 1984); *Religious Art in France: The Late Middle Ages* (Princeton, NJ: Princeton University Press, 1986).
35 Johan Huizinga, *The Waning of the Middle Ages* (Harmondsworth: Penguin, 1972); Erwin Panofsky, *The Life and Art of Albrecht Dürer* (Princeton, NJ: Princeton University Press, 1971).
36 W. J. T. Mitchell, *What do Pictures Want? The Lives and Loves of Images,* (Chicago, IL, and London: University of Chicago Press, 2005).
37 Roland Barthes, *Mythologies*, trans. Annette Lavers (London: Vintage, 1993).

Chapter 2 Form

1 Virginia Woolf, *Roger Fry* (Harmondsworth: Peregrine Books, 1979), p. 35.
2 In 1887, he was elected to membership of the 'Apostles', which was then Cambridge's most prestigious and secretive intellectual society. It later became notorious as a breeding ground for 'gentleman' spies such as Guy Burgess and Anthony Blunt, but that is another story.
3 Roger Fry, 'An Essay in Aesthetics', in *Vision and Design* (Harmondsworth: Pelican Books, 1937), p. 23.
4 Ibid., pp. 26, 27–8, 24, 26, 29, 33.
5 Ibid., p. 40.
6 Woolf, *Roger Fry*, p. 133.
7 Ibid.
8 Roger Fry, 'Retrospect', in *Vision and Design* (Harmondsworth: Pelican Books, 1937), p. 234.
9 Ibid., p. 235.
10 Purists will, of course, note that *Layla* was originally recorded by Clapton under the pseudonym of Derek and the Dominoes. Quite right.
11 The progressive rock band 'Yes' recorded a purely instrumental album track called *Mood for a Day*. The point is well taken.
12 Fry, 'An Essay in Aesthetics', pp. 26–33.

13 Ibid., pp. 33, 36, 37.

14 Ibid., p. 35.

15 Ibid.

16 Roger Fry, 'The French Post-Impressionists', in *Vision and Design*, p. 195.

17 Ibid., pp. 197, 195–6.

18 Clive Bell, 'The Aesthetic Hypothesis', in Charles Harrison and Paul Wood (eds), *Art in Theory 1900–1990* (Oxford: Blackwell, 1992), p. 113. This is an extract from Bell's monograph *Art* (1914), the full text of which is available in a version edited by J. B. Bullen (Oxford: Oxford University Press, 1987).

19 Ibid., p. 114.

20 Ibid., pp. 115, 116.

21 In 1999/2000, the National Gallery in London, together with the Mauritshuis in The Hague, gathered a remarkable exhibition of Rembrandt's self-portraits from around the world. They were hung in chronological order so that people could study not only Rembrandt's changing appearance, but also his changing representation of himself.

22 Roger Fry, 'The Double Nature of Painting', in *Apollo* (May 1969): 363. Fry's lecture had been given in French in Brussels in 1933, but was not published until 1969 when his daughter Pamela Diamond translated and abridged it for posthumous publication in *Apollo*.

23 Ibid., p. 371.

24 Figure 10 in Fry's article is the Rembrandt self-portrait held at Kenwood House, London. The caption dates this as circa 1663; more recent scholarship believes it to have been painted one or even two years earlier. Traditional art historians (see chapter 3) really enjoy these sorts of discussion. For our purposes, it is the same picture whatever the date.

25 Fry, 'The Double Nature of Painting', p. 371.

26 Fry, 'Retrospect', p. 229.

27 Although many Kantian scholars like to refer to the original German editions, we both recommend and cite modern English versions: *Critique of Pure Reason*, translated and edited by Marcus Weigelt, based on the translation by Max Müller (London: Penguin Classics, 2007), and Immanuel Kant, *Critique of Judgment*, translated by James Creed Meredith and edited by Nicholas Walker (Oxford: Oxford University Press, 2007).

28 Readers without a prior grounding in philosophy may wish to begin with Roger Scruton's *Kant: A Very Short Introduction* (Oxford: Oxford University Press, 2001) to which this summary is partially indebted. Our quotations from Kant himself, however, come from the Müller and Meredith editions (see the previous note) and not from Scruton, who has made his own translations from the German.

29 Scruton, *Kant: A Very Short Introduction*, p. 102.

30 Kant, *Critique of Judgment*, p. 115.

31 Ibid., p. 166.

32 Kant, *Critique of Pure Reason*, p. 271.

33 Pierre Bourdieu, *Distinction*, translated by Richard Nice (London: Routledge, 2010).

34 Kant, *Critique of Judgment*, p. 68. Kant uses the term *sensus communis*.

35 Ibid., pp. 68–9.

36 Scruton, *Kant: A Very Short Introduction*, p. 103.

37 Kant, *Critique of Judgment*, p. 68.

38 Ibid., p. 143.

39 Scruton, p. 109.

40 Kant, *Critique of Judgment*, p. 98. Kant's emphasis.

41 Ibid., p. 301. Kant's emphasis.

42 Scruton, *Kant: A Very Short Introduction*, p. 96.

43 Fry, *Essay in Aesthetics*, p. 34.

44 Ibid.

45 Kant, *Critique of Pure Reason*, p. 60.

46 Fry, *Retrospect*, p. 230.

47 Ibid., p. 244.

48 Ibid.

49 Fry, *An Essay on Aesthetics*, p. 30.

50 Ibid., p. 24.

51 Fry, *Retrospect*, p. 244.

52 Wilhelm Worringer, *Abstraction and Empathy: A Contribution to the Psychology of Style*, trans. Michael Bullock (London: Routledge and Kegan Paul, 1948), p. 3.

53 Theodor Lipps, *Aesthetik. Psychologie des Shonen and der Kunst* (Hamburg and Leipzig: Voss, 1903).

54 Worringer, *Abstraction and Empathy*, p. 5.

55 Ibid., p. 7.

56 Riegl, A. , *Stilfragen: Grundlegungen zu einer Geschichte der Ornamentik* (Berlin: G. Siemens, 1893).

57 Worringer, *Abstraction and Empathy*, p. 9. This is something we will explore further in chapter 7, in which we discuss the 'riddle' of different styles throughout the history of art.

58 Ibid., p. 13.

59 Ibid.

60 Arthur Shopenhauer, *Kritik der Kantishen Philosophie* (1819), quoted by Worringer, *Abstraction and Empathy*, p. 18. 'Maya' is the Indian philosophical term to designate the illusory nature of the universe.

61 Clement Greenberg, *Homemade Aesthetics: Observations on Art and Taste* (Oxford: Oxford University Press, 1999); *Collected Essays and Criticism*, ed. John O'Brian, 4 vols (Chicago, IL: University of Chicago Press, 1986–93); Michael Fried, *Art and Objecthood* (Chicago, IL: University of Chicago Press, 1998).

62 Gyorgy Kepes, 'Introduction', in Kepes (ed.), *Education of Vision* (New York: George Braziller, 1965), p. i.

63 Anton Ehrenzweig, *The Hidden Order of Art* (London: Weidenfeld and Nicolson, 1967), pp. xii, 5.

Chapter 3 Art History

1 E. H. Gombrich, *The Story of Art* (Oxford: Phaidon, 15th edn, 1989), p. vii. There are, of course, many editions of Gombrich. The details may differ, but it is the unified approach with which we are concerned.

2 Ibid., pp. vii, viii. Gombrich explains, reasonably, that as a two-dimensional form, painting lends itself to book illustration much more easily than sculpture or architecture. See ibid., p. ix.

3 Ibid., pp. viii, 3, 17.

4 Ibid., pp. vii, viii, ix, xii, 9.

5 Ibid., pp. 19, 31, 46, 52, 80.

6 Ibid., pp. 95, 97, 102, 133, 136.

7 The authors particularly recommend a visit to Sainte-Chapelle in Paris. Where Notre Dame is impressive, Sainte-Chapelle is elegantly beautiful.

8 Gombrich, *The Story of Art*, p. 150.

9 Ibid., pp. 151, 154.
10 Ibid., p. 375.
11 Ibid., pp. 167, 176–9, 179–80.
12 Ibid., pp. 217, 218, 220, 277.
13 Ibid., pp. 280, 277, 338, 330, 323, 336.
14 Ibid., p. 363.
15 Ibid., pp. 386, 394.
16 Ibid., pp. 395, 396, 397, 398, 399.
17 Ibid., pp. 406, 411, 427, 428.
18 Ibid., pp. 432, 433, 437, 438, 441.
19 Ibid., pp. 446, 447, 451, 452, 454.
20 Ibid., p. 461. Notice how Gombrich and Fry differ slightly over this. Gombrich attributes to the Cubists what Fry had attributed to the Post-Impressionists.
21 Ibid., p. 467.
22 Ibid., pp. 483, 484. *The Story of Art* has a number of seemingly 'false endings' – the result of additions to the text since the original edition was published in 1950.
23 Ibid., p. vii.
24 Ibid., pp. 4, 17, 66–7, 150–1, 222, 330, 435–6.
25 This is a fascinating debate, contributions to which have been provided by anthropologists such as Ruth Benedict, in *Patterns of Culture* (London: Routledge and Kegan Paul, 1935) and theorists such as Lucien Goldmann, in *Towards a Sociology of the Novel*, trans. Alan Sheridan (London: Tavistock Publications, 1975).
26 The Rembrandt Research Project has been particularly active here. Supported by the Netherlands Organization for the Advancement of Scientific Research, it has been investigating works attributed to Rembrandt since 1968.
27 Jacob Rosenberg, Seymour Slive and E. H. ter Kuile, *Dutch Art and Architecture, 1600–1800* (Harmondsworth: Penguin, 3rd edn, 1977), p. 96.
28 This painting is nowadays attributed to a 'follower' of Rembrandt.
29 See, for example, Rozsika Parker and Griselda Pollock, *Old Mistresses: Women, Art and Ideology* (London: Routledge and Kegan Paul, 1981).
30 We will probably need a reasonable working knowledge of art history to come up with names such as Rosa Bonheur, Artemisia Gentileschi, Judith Lyster and Georgia O' Keeffe.
31 Gombrich, *The Story of Art*, p. 3.
32 Ibid., p. viii.
33 Ibid., pp. 476, 220, 217, 277, 406.
34 Ibid., pp. viii, 17.
35 Ladislav Kesner, 'Is a Truly Global Art History Possible?', in James Elkins (ed.), *Is Art History Global? (The Art Seminar)* (London and New York: Routlege, 2006), pp. 81–111.
36 Ibid., p.82.
37 Ibid., p. 83.
38 James Elkins, interviewed by Tâmara Bissel, Uméní, 46, p. 151, quoted by Kesner, pp. 86–8
39 Kesner, 'Is a Truly Global Art History Possible?', p. 88.
40 Ibid., p. 87.
41 Ibid., p. 88.
42 Ibid., p. 91.
43 Ibid., p. 102.
44 Ibid.
45 Ibid., p. 104.

46 Ibid., p. 105.

47 There are many different editions of Janson, which is published in both New York and London. In some, Dora Janson is credited as co-author, while others are expanded and revised by his son Anthony F. Janson. With the 6th edition, Anthony Janson is credited as co-author and editor. See H. W. Janson and Anthony F. Janson, *History of Art*, 6th edn (New York: Harry N. Abrams, 2001); H. W. Janson, *History of Art*, 6th edn, ed. Anthony F. Janson (London: Thames and Hudson, 2001).

48 Kenneth Clark (Baron Clark), *Civilization* (London: BBC and John Murray, 1969).

49 Slive is responsible for many publications in this area, including specialist works on Rembrandt and Hals. For a general survey of the 'golden age' of Dutch painting, see Seymour Slive, *Dutch Painting 1600–1800* (New Haven, CT, and London: Yale University Press, 1995). See also Erwin Panofsky, *The Life and Art of Albrecht Dürer* (Princeton, NJ: Princeton University Press, 1971).

50 Linda Nochlin, *Women, Art, and Power and Other Essays* (New York: Harper and Row, 1988); Ann Sutherland Harris and Linda Nochlin, *Women Artists 1550–1950* (Los Angeles, CA: County Museum of Art and New York: Alfred A. Knopf, 1978); Rozsika Parker and Griselda Pollock, *Old Mistresses: Women, Art and Ideology* (London: Routledge and Kegan Paul, 1981).

51 Ruth Benedict, *Patterns of Culture* (London: Routledge and Kegan Paul, 1935; 5th impression, 1952); Lucien Goldmann, *Towards a Sociology of the Novel*, trans. Alan Sheridan (London: Tavistock Publications, 1975).

52 James Elkins, Zhiva Valiavicharska and Alice Kim (eds), *Art and Globalization* (Philadelphia, PA: Pennsylvania University Press, 2010).

53 John Onians, J. (ed), *Art Atlas* (London: Lawrence King Publishing Ltd, 2004).

54 Keith Moxey, K., *The Practice of Theory: Poststructuralism, Cultural Politics and Art History* (Ithaca, NY: Cornell University Press, 1994).

55 John Roberts, *Art Has No History!* (London: Verso, 1994); Donald Preziosi, *Rethinking Art History* (New Haven, CT: Yale University Press, 1989).

56 John Berger, *Ways of Seeing* (London: BBC and Penguin Books, 1972).

Chapter 4 Ideology

1 John Berger, *Ways of Seeing* (London: BBC and Penguin Books, 1972), p. 33.

2 Ibid., pp. 7, 10, 11.

3 See John B. Thompson, *Ideology and Modern Culture* (Cambridge: Polity, 1990; repr. 1994), p. 5.

4 Ibid., p. 7.

5 Ibid., p. 5.

6 Berger, *Ways of Seeing*, pp. 15–16, 32, 33.

7 See, for example, Gervase Jackson-Stops (ed.), *The Treasure Houses of Britain: Five Hundred Years of Private Patronage and Art Collecting* (Washington, DC: National Gallery of Art; New Haven, CT: Yale University Press, 1985).

8 Berger, *Ways of Seeing*, pp. 24, 21.

9 The steps of the Philadelphia Museum of Art provided the setting for one of the best-remembered sequences from the movie *Rocky* (USA, 1976). Here, the protagonist (Sylvester Stallone) trains for his up-and-coming fight by running up the steps in the early light of dawn. This information serves both to enable the reader to picture the scene and as a reminder that all sorts of interesting things can be found seemingly hidden in footnotes.

10 Berger, *Ways of Seeing*, pp. 21, 23, 30.

11 Ibid., pp. 31, 29.
12 Berger makes clear that he is referring especially to oil traditional painting between 1500 and 1900: see ibid., p. 84.
13 Ibid., p. 86.
14 Simon Schama, *An Embarrassment of Riches: An Interpretation of Dutch Culture in the Golden Age* (London: Collins, 1987).
15 Berger, *Ways of Seeing*, p. 83.
16 Kenneth Clark, *Landscape into Art*, cited in ibid., p. 106.
17 Ibid., pp. 107, 108, 109.
18 Ibid., pp. 90, 95, 96.
19 In *The Ambassadors' Secret: Holbein and the World of the Renaissance* (London: Hambledon and London, 2002), John North undertakes a detailed iconological analysis of the painting, with a special emphasis on its astronomical, mathematical and geometrical content.
20 Berger, *Ways of Seeing*, pp. 13, 15, 13.
21 Ibid., p. 11.
22 Cited in ibid., p. 13.
23 Ibid., p. 11.
24 Ibid., p. 14.
25 Peter Fuller, *Seeing Through Berger* (London: The Claridge Press, 1988), p. 7. *Seeing Through Berger* is a compilation of articles, essays and letters written by Fuller, together with contributions by Mike Dibb and Toni del Renzio, between 1980 and 1988. Some of the same material had previously appeared in Fuller's booklet *Seeing Berger* (London: Writers and Readers Publishing Coop Ltd, 2nd edn, 1981). Fuller also complained about the 'art-shaped hole' in an article for the (London) *Daily Telegraph* called 'The Wrong Perspective on Art', Weekend Telegraph section, 13 January 1990, p. xv.
26 Fuller, *Seeing Through Berger*, pp. 7–8.
27 The equation of Marxian with Thatcherite policy was reiterated in Fuller, 'The Wrong Perspective on Art'.
28 Fuller, *Seeing Through Berger*, p. 9. This also reminds us that the seemingly staid world of scholarship is, in fact, populated with egos and personal rivalries in addition to bow ties, sherry, tea and tweeds.
29 Ibid., pp. 13, 14, 15, 16.
30 Ibid., pp. 16, 48, 17, 31, 33.
31 Ibid., pp. 39, 15.
32 Cited in ibid., pp. 93–4.
33 Ibid., p. 15.
34 Ibid., pp. 61, 57. The *New Society* article is reprinted in *Seeing Through Berger*.
35 Ibid., p. 67.
36 Ibid., pp. 69, 70. Dibb's comments were made in a letter published in *New Society* in 1988 and reprinted in *Seeing Through Berger*.
37 Ibid., p. 95.
38 Ibid., p. 78.
39 Ibid., pp. 83, 84, 85, 86. Fuller's *Art Monthly* article is reprinted in *Seeing Through Berger*.
40 Ibid., pp. 89, 92, 93.
41 Fuller insisted that the friendship fell apart because of their disagreement, and not vice versa.
42 See Seymour Slive, *Frans Hals*, exhibition catalogue, National Gallery of Art, Washington; Royal Academy of Arts, London; Frans Hals Museum, Haarlem; 1989–90 (Munich: Prestel, 1989), p. 367.

43 Slive says: 'it is safe to assume that his clients were satisfied with the first group portrait' and so permitted him to proceed with the second. They must have been happy with the work. They were, after all, 'exacting and litigious' patrons (ibid.).

44 Peter Fuller, 'Frans Hals' (Royal Academy exhibition review), in *Modern Painters* 2/2 (winter 1989): 74.

45 Actually, this is not exactly what Slive said. He dismissed the 'myth' that Hals was himself a resident in the almshouse, but agreed that he was 'dirt poor' in his last years. He was well paid for the almshouse commission, however. See Slive, *Frans Hals*, p. 366.

46 Fuller, 'Frans Hals', p. 75. He wrote: 'Berger's interpretation was based on a subjective projection of himself' on to what he wrongly presumed was Hals's way of seeing.

47 Ibid.

48 Berger is not, of course, the only critic to have approached painting from a sociopolitical perspective. He is simply one of the most approachable and controversial. Michael Baxandall, for example, said: 'pictures become documents as valid as any chapter or parish roll'. He added: 'One just has to learn to read it, just as one has to learn to read a text from a different culture': *Painting and Experience in Fifteenth Century Italy* (Oxford: Oxford University Press, 1974, p. 152).

49 Protests against global capitalism and multinational corporations gained a high media profile at the turn of the current millennium. It remains to be seen whether this is indicative of a wider return to student and intellectual radicalism.

50 Berger, *Ways of Seeing*, pp. 46, 47, 54, 55, 63.

51 Ibid., p. 64.

52 Laura Mulvey, 'Visual Pleasure and Narrative Cinema', in *Screen* 16/3 (1975): 6–18. The precedent of Berger is noted by Linda Williams in *Viewing Positions*: *Ways of Seeing Film* (New Brunswick, NJ: Rutgers University Press, 1995), p. 1.

53 Williams, *Viewing Positions*, pp. 2, 1.

54 We attribute this phrase to John B. Thompson, whose additional influence we acknowledge in the following discussion of cultural production in general and of Pierre Bourdieu in particular.

55 Lucien Goldmann, *The Hidden God: A Study of Tragic Vision in the 'Pensées' of Pascal and the Tragedies of Racine*, trans. Philip Thody (New York: Humanities Press; London: Routledge and Kegan Paul, 1964), p. 17.

56 Thompson, *Ideology and Modern Culture*, p. 24. Thompson provides an additional, crisp definition of 'the fallacy of internalism' (p. 291).

57 Barthes' total argument is, of course, rather more complex. See his *Image, Music, Text*, trans. Stephen Heath (London: Fontana, 1977).

58 Pierre Bourdieu, *The Field of Cultural Production*, ed. Randal Johnson (Cambridge: Polity, 1993; repr. 2000). Bourdieu's thinking on this topic had, in fact, been formulated over many of the preceding years. The essays in *The Field of Cultural Production*, for example, were first published (variously) during the 1980s.

59 The concepts of 'habitus' and 'field' were first developed by Bourdieu in the 1970s. They are published in English as *Outline of a Theory of Practice*, trans. Richard Nice (Cambridge: Cambridge University Press, 1977) and *The Logic of Practice*, trans. Richard Nice (Cambridge: Polity; Stanford, CA: Stanford University Press, 1990).

60 Bourdieu, *The Field of Cultural Production*, p. 71.

61 This is our phrase and not Bourdieu's.

62 Bourdieu, *The Logic of Practice*, p. 53.

63 Randal Johnson, 'Editor's Introduction' to Bourdieu, *The Field of Cultural Production*, p. 5.

64 Bourdieu, *The Logic of Practice*, p. 53.

65 This, endearingly, is a direct translation from the French *champ*. It seems like it should be 'Franglais', but it isn't.

66 Bourdieu, *The Field of Cultural Production*, p. 64.

67 Ibid., pp. 37–8. Bourdieu introduces the largest field simply as 'the field of class relations' (p. 38), but it is clear from ideological context and subsequent use that he means this to include the economic as well.

68 Ibid., p. 38.

69 Ibid., p. 116.

70 See, for example, ibid., p. 68.

71 Erwin Panofsky, *Studies in Iconology* (New York: Harper and Row, 1972), p. 7.

72 Ibid.

73 Bourdieu, *The Field of Cultural Production*, p. 29.

74 See, for example, Richard Howells 'Atlantic Crossings: Nation, Class and Identity in "Titanic" (1953) and "A Night to Remember" (1958)', in *The Historical Journal of Film, Radio and Television* 9/4 (October 1999): 421–38, esp. pp. 435–6.

75 Berger, *Ways of Seeing*, p. 13; Fuller, *Seeing Through Berger*, p. 14.

76 Ernst Gombrich, *The Story of Art* (Oxford: Phaidon, 5th edn, 1977), pp. 18, 430.

77 Richard Howells was among Slive's students of Dutch art at Harvard in the 1980s. Whether or not he always agreed with him, his continuing interest in the 'golden age' owes much to Seymour Slive.

78 Marita Sturken and Susan Cartwright, *Practices of Looking – An Introduction to Visual Culture* (Oxford, New York; Auckland, Cape Town, Dar es Salam, Hong Kong, Karachi, Kuala Lumpur, Madrid, Melbourne, Mexico City, Nairobi, New Delhi, Shanghai, Taipei, Toronto: Oxford University Press, 2009), p. 103.

79 Louis Althusser, 'Ideology and Ideological State Apparatuses', in *Lenin and Philosophy and Other Essays*, trans. Ben Brewster (London: Monthly Review Press, 1971), pp. 127–86.

80 Sturken and Cartwright, *Practices of Looking – An Introduction to Visual Culture*, p. 103.

81 Nicholas Mirzoeff, 'The Subject of Visual Culture', in N. Mirzoeff (ed.), *The Visual Culture Reader* (London and New York: Routledge, 1999), p. 10.

82 Ibid., p. 10.

83 Michel Foucault, *Discipline and Punish: The Birth of the Prison*, trans. Alan Sheridan (New York: Vintage, 1979), p. 214.

84 Karl Marx and Friedrich Engels, *The Communist Manifesto* (Harmondsworth: Penguin, 1967).

85 Walter Benjamin, 'The Work of Art in the Age of Mechanical Reproduction', in *Illuminations*, ed. Hannah Arendt, trans. Harry Zohn (New York: Schocken Books, 1969), pp. 217–51.

86 Nicos Hadjinicolaou, *Art History and Class Struggle*, trans. Louise Asmal (London: Pluto, 1978).

87 Laura Mulvey, *Visual and Other Pleasures* (Bloomington, IN: Indiana University Press, 1988). This volume contains a variety of essays by Mulvey, written between 1971 and 1986.

88 Judith P. Butler, *Gender Trouble* (New York and London: Routledge, 1990).

89 Edward W. Said, *Orientalism* (New York: Pantheon, 1978).

90 Pierre Bourdieu, *The Field of Cultural Production*, ed. Randal Johnson (Cambridge: Polity, 1993, repr. 2000).

91 John B. Thompson, *The Media and Modernity* (Cambridge: Polity, 1995).

92 Nicholas Mirzoeff, 'The Subject of Visual Culture', in N. Mirzoeff (ed.), *The Visual Culture Reader* (London and New York: Routledge, 1999).

93 Elizabeth Chaplin *Sociology and Visual Representation* (London: Routledge, 1994).

Chapter 5 Semiotics

1 Generally, the word 'semiotics' is used in North America, 'semiology' in Europe. The terms are more or less interchangeable.
2 Precisely who can be considered a 'structuralist' is a contentious point among intellectual historians. This need not concern us here.
3 Barthes specifically acknowledges his debt to Saussure in (among other places) the preface to the 1970 edition of *Mythologies*. See Roland Barthes, *Mythologies*, trans. Annette Lavers (London: Vintage 1993), p. 9 (all citations are from this edition).
4 Ibid., pp. 110, 111, 109.
5 Ibid., pp. 111, 113, 115.
6 Ibid., p. 114.
7 Ibid., pp. 115, 116, 120.
8 Ibid., p. 122.
9 Ibid., pp. 124, 126, 128, 131, 132.
10 For a fuller discussion of myth and popular culture, see Richard Howells, *The Myth of the Titanic* (London: Macmillan; New York: St Martin's Press, 1999), esp. pp. 37–59.
11 Herman Melville, *Moby Dick* (Hertfordshire: Woodsworth Editions Limited, 1993), ch. 99.
12 See Fred Inglis, *Media Theory* (Oxford: Blackwell, 1990), pp. 98–9.
13 Barthes, *Mythologies*, pp. 137–8. These are, of course, enormous simplifications of complex concepts, but such reduction is appropriate in this context.
14 Ibid., pp. 129, 128, 143.
15 The expression is ours, not Barthes', but is designed to explain Barthes succinctly.
16 Barthes, *Mythologies*, pp. 143, 142.
17 Barthes, pp. 143, 11.
18 Ibid., pp. 15–24. 'Justice in the raw' is our phrase, in summary of Barthes.
19 Ibid., pp. 32, 58, 59.
20 Ibid., p. 26.
21 Ibid., pp. 100, 101, 102.
22 Till was fourteen years old when murdered on a visit to Mississippi in 1955. Barthes uses the spelling 'Emmet'; others use 'Emmett.' We have employed Barthes' spelling in this context.
23 Ibid., pp. 101, 83, 93.
24 Ibid., pp. 75, 76, 75.
25 Ibid., pp. 76, 77.
26 Ibid., pp. 75, 77.
27 Ibid., pp. 88, 89, 90.
28 Ibid., pp. 148, 146, 147, 148.
29 See, for example, David King, *The Commissar Vanishes: The Falsification of Photographs and Art in Stalin's Russia* (Edinburgh: Canongate, 1997).
30 The perceptive observer will also notice that this is a left-hand-drive car.
31 The deliberate cross-referencing of familiar themes within different advertisements is known to advertisers as 'synergy'. In this way, separate advertisements are supposed to cross-fertilize each other.
32 James Helmer, 'Love on a Bun: How McDonald's Won the Burger Wars', in *Journal of Popular Culture* 26/2 (fall 1992): 91.
33 Barthes, *Mythologies*, p. 36.

34 Jean Baudrillard, 'Simulacra and Simulations', in Mark Poster (ed.), *Selected Writings* (Cambridge: Polity, 2001), pp. 169–87.

35 Ibid., p. 169.

36 Ibid.

37 Jean Baudrillard, 'The Evil Demon of Images', in Clive Cazeaux (ed.), *The Continental Aesthetics Reader* (London and New York: Routledge, 2000), pp. 444–52.

38 'The Gulf War did not take place' is the general title for a series of articles published in London (*Guardian*) and in Paris (*Libération*) between January and March 1991.

39 Baudrillard, 'Simulacra and Simulations', p. 169.

40 Ferdinand de Saussure, *Cours de Linguistique Générale*, ed. Eisuke Komatsu (French) and George Wolf (English and trans.), Language and Communication Library, vol. 15 (Oxford: Pergamon, 1996).

41 Charles S. Peirce, *Peirce on Signs*, ed. James Hoopes (Chapel Hill, NC: University of North Carolina Press, 1991); *Semiotic and Significs*, ed. Charles S. Hardwick and James Cook (Bloomington, IN: Indiana University Press, 1977); Douglas Greenlee, *Peirce's Concept of Sign* (The Hague and Paris: Mouton, 1973).

42 Roland Barthes, *Elements of Semiology/Writing Degree Zero*, trans. Annette Lavers and Colin Smith (Boston, MA: Beacon, 1968); *Image, Music, Text*, trans. Stephen Heath (London: Fontana, 1977); *The Semiotic Challenge*, trans. Richard Howard (Oxford: Blackwell, 1988); *S/Z*, trans. Richard Miller (Oxford: Blackwell, 1990).

43 Umberto Eco, *A Theory of Semiotics* (Bloomington, IN, and London: Indiana University Press, 1976).

44 Judith Williamson, *Decoding Advertisements* (London: Marion Boyars, 1978; repr. 1994); *Consuming Passions* (London: Marion Boyars, 1985).

45 Christian Metz, *Film Language: A Semiotics of the Cinema*, trans. Michael Taylor (New York: Oxford University Press, 1974).

46 Peter Wollen, *Signs and Meaning in the Cinema* (London: British Film Institute Publishing, 4th rev. edn, 1998).

47 Richard G. Smith (ed.), *The Baudrillard Dictionary* (Edinburgh: Edinburgh University Press, 2010).

48 Chris Horrocks and Zoran Jetvic, *Introducing Baudrillard: A Graphic Guide* (New York, Totem Books, 1996).

Chapter 6 Hermeneutics

1 We gratefully acknowledge John B. Thomson's thinking on the evolution of the term 'culture'.

2 T. S. Eliot, *Notes Towards the Definition of Culture* (London: Faber and Faber, 1948), p. 31.

3 Ibid., p. 41.

4 Fred Inglis, *Clifford Geertz* (Cambridge: Polity, 2000), p. 1.

5 Clifford Geertz, *The Interpretation of Cultures* (New York: Basic Books, 1973), pp. 6–7.

6 Ibid., p. 29.

7 Ibid., pp. 448, 18, 26, 10.

8 Ibid., p. 16. Geertz acknowledges Thoreau on this point.

9 Ibid., pp. 5, 20.

10 Matthew 5: 30.

11 Ibid., 26: 26–8.

12 Anthony Giddens, graduate seminar in hermeneutics, Faculty of Social and Political Sciences, University of Cambridge, 30 January 1992.

13 Geertz, *Interpretation of Cultures*, p. 417.
14 Ibid., p. 421.
15 Ibid., p. 443.
16 Cited in ibid., p. 443. From Auden's poem 'In Memory of W. B. Yeats' (1939).
17 Ibid., pp. 444, 448.
18 Vincent Crapanzano, 'Hermes' Dilemma: The Masking of Subversion in Ethnographic Description', in James Clifford and George E. Marcus (eds), *Writing Culture* (Berkeley, CA: University of California Press, 1986), p. 51.
19 Ibid., pp. 52, 69, 74.
20 Inglis, *Clifford Geertz*, pp. 154, 155.
21 Graham McCann, 'Jouissance: A Messy Business', in *The Modern Review* (winter 1991/92): 31.
22 John Dunn, *Political Obligation in its Historical Context* (Cambridge: Cambridge University Press, 1980), pp. 87, 107.
23 Cited in ibid., p. 97 (from *Emma*, ch. 49).
24 Susan Suleiman and Inge Crossman, 'Introduction: Varieties of Audience-orientated Criticism', in Susan Suleiman and Inge Crossman (eds), *The Reader in the Text* (Princeton, NJ: Princeton University Press, 1980), p. 37.
25 Roger Fry, *Vision and Design* (Harmondsworth: Pelican Books, 1937), pp. 22–40.
26 Dunn, *Political Obligation*, pp. 110, 109.
27 Clifford Geertz, *Local Knowledge* (New York: Basic Books, 1983), p. 45.
28 Geertz, *Interpretation of Cultures*, pp. 9, 448, 453.
29 Geertz, *Local Knowledge*, pp. 8, 48.
30 Geertz, *Interpretation of Cultures*, p. 4.
31 Erwin Panofsky, *Studies in Iconology* (New York: Harper and Row), pp. 5, 3.
32 Fry, *Vision and Design*, pp. 166, 203; 'The Double Nature of Painting', in *Apollo* (1969), p. 363.
33 Panofsky, *Studies in Iconology*, p. 7.
34 Ibid., pp. 7, 15.
35 Geertz, *Interpretation of Cultures*, p. 448.
36 John Berger, *Ways of Seeing* (London: British Broadcasting Corporation and Penguin Books, 1972), pp. 32, 11.
37 Fry, *Vision and Design*, p. 235.
38 Panofsky, *Studies in Iconology*, p. 7.
39 Berger, *Ways of Seeing*, p. 86.
40 Geertz, *Interpretation of Cultures*, p. 448.
41 Ibid., p. 5.
42 This is a topic explored, in a different way, in Richard Howells, *The Myth of the Titanic* (London: Macmillan; New York: St Martin's Press, 1999).
43 Nigel Whiteley, 'Readers of the Lost Art', in Heywood and Sandywell (eds), *Interpreting Visual Culture – Explorations in the Hermeneutics of the Visual* (London and New York: Routledge, 1999), pp. 99–122.
44 Ibid., p. 99.
45 Ibid., p. 100. We could imagine the somewhat pained voice of Roger Fry being raised in support of Whiteley here.
46 Ibid., p. 99.
47 Ibid., p. 100.
48 Werner Haftmann, *Painting in the Twentieth Century: An Analysis of the Artists and Their Work* (New York: Holt Rinehart Winston, 1965), p. 76., cited by Whiteley, p. 100.
49 Whiteley, 'Readers of the Lost Art', p. 101.

50 Ibid., p. 103.

51 Ibid., p. 103.

52 Carol Duncan, 'Virility and Domination in Early Twentieth Century Vanguard Painting' (1973), reprinted in Normal Broude and Mary Garrard (eds), *Feminism and Art History* (New Haven, CT: Yale University Press, 1982), p. 300, cited by Whiteley, pp. 103–5.

53 Gill Perry, 'The Decorative and the "culte de la vie": Matisse and Fauvism', in Charles Harrison, Francis Frascina and Gill Perry, *Primitivism, Cubism, Abstraction: The Early Twentieth Century* (New York: Harper and Row, 1993), p. 59, cited by Whiteley, pp. 103–5.

54 Whiteley, 'Readers of the Lost Art', p. 106.

55 Griselda Pollock, 'Trouble in the Archives', *Women's Art Magazine* 54 (September/October 1993): 11, cited by Whiteley, p. 106.

56 Whiteley, 'Readers of the Lost Art', p. 109. We can hear a distinct echo here of Peter Fuller's complaint from chapter 4 about approaches to art that leave an 'art-shaped hole' in the history of art. Fuller's complaint was ideological, Whiteley's hermeneutical. The objection is much the same.

57 Thomas McEvilley, 'Father and Void', in *Art and Discontent: Theory at the Millennium* (New York: Documentext, 1991), p. 117, cited by Whiteley, p. 109–10.

58 Our own is, of course, entirely without blemish.

59 Perry, 'The Decorative and the "culte de la vie": Matisse and Fauvism', p. 59, quoted by Whiteley, p. 104.

60 See Matthew Arnold, *Culture and Anarchy*, ed. Samuel Lipman (New Haven, CT, and London: Yale University Press, 1994).

61 Ruth Benedict, *Patterns of Culture* (London: Routledge, 1935; 5th impression, 1952).

62 Dan Sperber, 'Claude Lévi-Strauss', in John Sturrock (ed.), *Structuralism and Since* (Oxford: Oxford University Press, 1977), pp. 19–51.

63 James Clifford and George E. Marcus (eds), *Writing Culture* (Berkeley, CA: University of California Press, 1986).

64 Hans-Georg Gadamer, *Truth and Method*, ed. Garrett Barden and John Cumming, trans. William Glen-Duepel, (London: Sheed and Ward, 1975); *Philosophical Hermeneutics*, ed. and trans. David Linge (Berkeley, CA: University of California Press: 1976).

65 Ricoeur's essays on hermeneutics are published variously in Don Ihde (ed.), *The Conflict of Interpretations: Essays in Hermeneutics* (Evanston, IL: Northwestern University Press, 1974); *From Text to Action: Essays in Hermeneutics II*, trans. Kathleen Blamey and John Thompson (London: Athlone, 1991); *Hermeneutics and the Human Sciences*, ed. and trans. John Thompson (Cambridge: Cambridge University Press, 1981).

66 Pierre Maranda, 'The Dialectic Metaphor: An Anthropological Essay on Hermeneutics', in Susan Suleiman and Inge Crossman (eds), *The Reader in the Text* (Princeton, NJ: Princeton University Press, 1980).

67 John Dunn, 'Practising History and Social Science on "Realist" Assumptions', in *Political Obligation*, pp. 81–111.

68 Charles Harrison, Francis Frascina and Gill Perry, *Primitivism, Cubism, Abstraction: The Early Twentieth Century* (New York: Harper and Row, 1993).

69 Charles Harrison and Paul Wood, *Art in Theory: An Anthology of Changing Ideas*, (Malden, MA, and Oxford: Blackwell, 2003).

70 Jacques Derrida, *The Truth in Painting* (Chicago, IL: University of Chicago Press, 1987).

Chapter 7 Fine Art

1 The final painting was never actually completed. The cartoon is nowadays considered a masterpiece in its own right.

2 Connoisseurs will argue that these are really hugely different, and that anyone (for instance) can tell the difference between a Monet and a Renoir. In the grand scheme of things, of course, they have much more in common than they do apart.

3 See E. H. Gombrich, *Art and Illusion* (Oxford: Phaidon Press, 5th edn, 1977), p. 1.

4 Ibid., p. 1.

5 Gombrich's theory presented something of a paradigm shift from the previously accepted Ruskinian concept of the 'innocent eye', a discussion of which follows.

6 Gombrich, *Art and Illusion*, p. 1. Gombrich claimed his approach was psychological. Psychologists may disagree.

7 Again, there is no substitute for reading Gombrich in the original. But as the aim of this book is (among other things) to distil a broad range of theories and theorists into one volume, then some sort of précis is appropriate. In the original, chapter 9 is particularly recommended.

8 Gombrich, *Art and Illusion*, p. 12.

9 Ibid., pp. 246, 251, 247. Gombrich refers both to schema (sing.) and schemata (pl.).

10 Gombrich goes into this in ibid., p. 6.

11 Gombrich, sadly, omits the whiskers himself.

12 Ibid., p. 247.

13 As Gombrich says: 'No child sees its mother in terms of those crude schemata it draws' (ibid.).

14 Gombrich pays particular attention to this idea in ibid., ch. 3.

15 Ibid., pp. 279, 99.

16 Ibid., p. 268.

17 Erwin Panofsky, *The Life and Art of Albrecht Dürer* (Princeton, NJ: Princeton University Press, 1971), p. 4.

18 See the editor's Introduction, in Leon Battista Alberti, *On Painting*, ed. and trans. John R. Spencer (New Haven, CT: Yale University Press, 1966), pp. 11, 21.

19 It should be remembered, of course, that *Della Pittura* was available only in manuscript for more than 100 years. In 1540 it was first printed in Basle, and then only in Latin.

20 Alberti, *On Painting*, p. 56.

21 See, esp, ibid., pp. 56–8.

22 Unfortunately, this painting was destroyed by bombing in the Second World War, but is preserved in photographs. It demonstrates a remarkably sophisticated mastery of perspective which, frankly, puts Masaccio and Perugino to shame.

23 Panofsky, *Albrecht Dürer*, pp. 9, 118.

24 Richard Howells in conversation with David Hockney at the opening of his 'Stages' exhibition, Salt's Mill, Saltaire, Yorkshire, 22 July 2000. Hockney's findings were subsequently published in *Secret Knowledge* (London: Thames and Hudson, 2001). See the Further Study section at the end of this chapter.

25 Ellen Harvey, *Painting is a Low Tech Special Effect*, De Chiara-Stewart Gallery, New York City, 1 June–1 July 2000.

26 Sir Joshua Reynolds, *Discourses in Art*, ed. Robert R. Wark (New Haven, CT: Yale University Press, 1975), I: 96, I: 92, VI: 26ff, VI: 81ff.

27 H. W. Janson and Anthony F. Janson, *History of Art* (New York: Harry N. Abrahams, 1986), p. 562.

28 Ernst Gombrich, *The Story of Art* (Oxford: Phaidon Press, 15th edn, 1989), pp. 133, 135, 136.

29 Roger Fry, 'An Essay in Aesthetics', in *Vision and Design* (Harmondsworth: Pelican Books, 1937), p. 23.

30 John Russell, 'Art View: In View of the Real Thing', in the *New York Times*, 1 December 1985.

31 Ernst van de Wetering, quoted in Nicola Kuhn 'Das Prinzip der Kennerschaft', *Der Tagesspiegel*, 29 January 2006. We thank Albrecht Funk for his help in translating this article.

32 Abraham Bredius, 'A New Vermeer', in *The Burlington Magazine for Connoisseurs* 71/416 (November 1937): 210–11.

33 For the full story, see (for example) Frank Wynne, *I Was Vermeer: The Legend of the Forger Who Swindled the Nazis* (London: Bloomsbury, 2006). To add to the irony, Van Megeren died before being sent back to prison – this time for forgery – while Göring committed suicide the night before he was due to be hanged for war crimes.

34 For a vehement defence of this argument, see Arthur Koestler, 'The aesthetics of snobbery', in *Horizon* 8 (1965): 50–3.

35 It is important to stress that the Berlin 'Rembrandt' was never considered a forgery or a fake: it was simply a question of misatribution. Meanwhile, van Meegeren's 'Vermeer' was not a copy but an invention using the master's style and technique. Unlike the 'Rembrandt', however, it was deliberately intended to deceive.

36 Denis Dutton, 'Artistic Crimes', in A. Neil and A. Ridley (eds), *Arguing About Art: Contemporary Philosophical Debates* (London: Routledge, 2007) pp. 100–11.

37 Dutton, p. 102.

38 Walter Benjamin, *The Work of Art in the Age of Mechanical Reproduction*, trans. J. A. Underwood (London: Penguin Books, 2008, first published 1936).

39 Ibid., p. 11.

40 Ibid., p. 5.

41 Ibid.

42 Ibid., p. 9.

43 Ibid., p. 10.

44 Ibid.

45 Ibid., p. 12.

46 Ibid., p. 14.

47 Marjorie E. Wieseman, *A Closer Look: Deceptions and Discoveries* (London: National Gallery, 2010).

48 Ibid., p. 5.

49 Ibid., p. 8.

50 Ibid., p. 6.

51 Ibid., p. 88.

52 Ibid., p. 18.

53 Ibid., pp. 31–2.

54 Wynne, *I Was Vermeer*, p. 233.

55 Nick Groom, *The Forger's Shadow: How Forgery Changed the Course of Literature* (London: Picador, 2002), p. 292.

56 R. L. Gregory and E. H. Gombrich, *Illusion in Nature and Art* (London: Duckworth, 1973).

57 Alberti, *On Painting*, pp. 56, 59.

58 Leon Battista Alberti, *On the Art of Building in Ten Books*, trans. Joseph Rykwert, Neil Leach and Robert Tavernor (Cambridge, MA, and London: MIT Press, 1988); *De Statua* usually published in editions that also include *On Painting*, such as Leon

Battista Alberti, *On Painting and On Sculpture*, ed. and trans. Cecil Grayson (London: Phaidon, 1972).

59 The content and importance of these works is fully described in Panofsky, *The Life and Art of Albrecht Dürer*, pp. 242–84.

60 Reynolds, *Discourses on Art*, I: 92, III: 294, VI: esp. 22 and 81.

61 John Ruskin, *The Elements of Drawing*, notes by Bernard Dunstan (London: Herbert, 1991).

62 Hockney, *Secret Knowledge*, pp. 67, 13, 131, 14. Although *Secret Knowledge* is a splendidly illustrated and clearly written study, a working knowledge of art history and existing theories of art and illusion (including linear perspective) is helpful in advance of a close reading of the book.

63 András Szunyoghy and György Fehér, *Human Anatomy for Artists* (Cologne: Könemann, 2000); Patrick Seslar, *The One-Hour Watercolourist* (Newton Abbot, Devon: David and Charles, 2001).

64 Walter Benjamin, Theodor Adorno, Ernst Bloch, Bertolt Brecht and Georg Lukács, *Aesthetics and Politics* (London and New York: Verso, 2007).

65 Guy Debord, *Society of the Spectacle*, trans. Donald Nicholson-Smith (New York: Zone Books, 1994; originally published in 1967).

66 Nigel Wheale (ed.), *The Postmodern Arts: An Introduction* (London and New York: Routledge, 1995).

Chapter 8 Photography

1 In 2002, Sotheby's offered for sale an earlier 'heliogravure' by Niépce dated as 1827. This, they claimed, was the first real photograph. Photographic historians have yet to decide.

2 Gelatin-based roll film was introduced in 1884 and replaced by improved celluloid stock in 1889.

3 The *Kaiser Wilhelm II* was built in Germany in 1903 and was, from 1906 to 1907, the world's fastest ship. It was designed for the Bremerhaven–New York Service and had accommodation for first-, second- and steerage-class passengers. It was seized by the US authorities at the start of the First World War, turned into an American troop ship and renamed *Agamemnon*.

4 An early colour process known as 'autochrome' had been developed by the Lumière brothers in France in 1907 and preceded the Kodak products. This was a specialist technique and not widely available to the public, however. The first mass-produced colour film was the Kodachrome transparency or 'slide' film; Kodacolor print film was not introduced until 1941.

5 Nubia is a region stretching between southern Egypt and Sudan.

6 Some argue that the first president to be photographed was John Quincy Adams in 1843, although at that time he was, of course, an ex-president. Polk was the first sitting president to be photographed.

7 The Crimean War was fought in the southern Ukraine from 1853 to 1856.

8 Cited in Beaumont Newhall, *The History of Photography* (New York: The Museum of Modern Art, 5th edn, 1986), p. 85.

9 Ibid., p. 89.

10 Photographic technology at the time did not permit the fast shutter speeds necessary for action shots.

11 William Henry Fox Talbot, 'The Art of Photogenic Drawing', read to the Royal Society, January 1839, cited in Carol Armstrong, *Scenes in a Library* (Cambridge, MA: MIT Press, 1998), p. 169.

12 Roger Scruton, *The Aesthetic Understanding* (London: Methuen, 1984), p. 114.

13 Ibid., p. 113.

14 Roger Fry, 'An Essay in Aesthetics', in J. B. Bullen (ed.), *Vision and Design* (Oxford: Oxford University Press, 1981), p. 20.

15 Nathan Lyons, *Aaron Siskind, Photographer* (New York: George Eastman House, 1965), pp. 6–7.

16 Cited in ibid., p. 7.

17 Scruton, *The Aesthetic Understanding*, p. 111.

18 Susan Sontag, *On Photography* (New York: The Noonday Press, 1989), pp. 6–7.

19 James Monaco, *How to Read a Film* (New York and Oxford: Oxford University Press, rev. edn, 1981), p. 330.

20 André Bazin, 'The Ontology of the Photographic Image', in *What is Cinema? Volume I*, trans. Hugh Gray (Berkeley, CA: University of California Press, 1967), pp. 14, 15, 16.

21 Nathaniel Hawthorne, *The Scarlet Letter* (New York and Cambridge: Literary Classics of the United States and the Press Syndicate, University of Cambridge, 1983), p. 149. Weaver's presentation was given at the Royal Academy, London, on 8 December 1989. It is important to stress that Hawthorne was not talking about photography, but that Weaver was using the situation in *The Scarlet Letter* as an analogy.

22 Bazin, 'Ontology', p. 14.

23 William L. King, 'Scruton and Reasons to Look at Photographs', in Alex Neil and Aaron Ridley (eds), *Arguing about Art: Contemporary Philosophical Debates* (London: Routledge, 1995, 2nd edn 2002).

24 Nigel Warburton, 'Individual Style in Photographic Art', in Alex Neil and Aaron Ridley (eds), *Arguing about Art: Contemporary Philosophical Debates* (London: Routledge, 1995, 2nd edn 2002).

25 The usefulness of 'ask the audience' methodologies in visual culture (and much else besides) is a debate for another occasion.

26 King, 'Scruton and Reasons to Look at Photographs', p. 218.

27 In addition to William King, Warburton identifies R. A. Sharpe (*Contemporary Aesthetics* (Brighton: Harvester, 1983), Robert Wicks, 'Photography as Representational Art, *British Journal of Aesthetics* 29/1 (1989): 1–9, and Warburton himself ('Varieties of Photographic Representation', *History of Photography* 15/3 (autumn 1991): 203–10 as advocates of a 'weak' reply to Scruton.

28 A strong example of the appropriation by photographers of procedures imported from other media is offered by the work of Aaron Siskind, which we analyzed in the main body of our chapter on photography.

29 Warburton, 'Individual Style in Photographic Art', p. 226.

30 Ibid., p. 227.

31 Ibid., p. 229.

32 Beaumont Newhall, *The Daguerreotype in America* (New York: Dover Publications/ London: Constable, 1976); Mark Haworth-Booth (ed.), *The Golden Age of British Photography* (Millerton, New York: Aperture, 1984).

33 Beaumont Newhall, *The History of Photography* (New York: The Museum of Modern Art, 5th edn, 1986). A revised edition of Newhall was also published in London by Secker and Warburg in 1982.

34 Michel Frizot (ed.), *A New History of Photography* (Cologne: Könemann, 1998).

35 Mike Weaver (ed.), *The Art of Photography 1839–1989* (London: The Royal Academy of Arts/New Haven: Yale University Press, 1989).

36 Jean-Claude Lemagny and André Rouillé (eds), *A History of Photography*, trans. Janet Lloyd (Cambridge: Cambridge University Press, 1987).

37 Pierre Bourdieu, *Photography: A Middle-brow Art*, trans. Shaun Whiteside (Cambridge: Polity, 1990; paperback edn 1996). In this study, Bourdieu also considers photography's relationship with reality. See esp. pp. 73–7.

38 Anne Wilkes Tucker, Claire Cass and Stephen Daiter, editors, *This Was the Photo League* (Chicago, IL: Stephen Daiter Gallery/Houston: John Cleary Gallery, 2001).

39 Richard Howells, 'Order and Fantasy: An Interview with Aaron Siskind', in *Word and Image* 15/3 (1999): 277–85; Carl Chiarenza, *Aaron Siskind: Pleasures and Terrors* (New York: New York Graphic Society, 1982): this biography was, of course, completed before Siskind's death and so does not include his later life and work.

40 Roland Barthes, *Image, Music, Text*, trans. Stephen Heath (London: Fontana, 1977); *Camera Lucida*, trans. Richard Howard (London: Flamingo, 1984); John Tagg, *The Burden of Representation* (Basingstoke: Macmillan Education, 1988); Stuart Hall, 'The Work of Representation', and Peter Hamilton, 'Representing the Social: France and Frenchness in Post-War Humanist Photography', in Hall (ed.), *Representation: Cultural Representations and Signifying Practices* (London: Sage, 1997), pp. 13–74 and 75–150.

41 W. J. T. Mitchell, *The Reconfigured Eye – Visual Truth in the Post-Photographic Era* (Cambridge, MA: MIT Press, 1992).

42 Liz Wells (ed.), *Photography: A Critical Introduction* (London: Routledge, 2nd edn, 2000); Terence Wright, *The Photography Handbook* (London: Routledge, 1999).

43 Barbara London and John Upton, *Photography* (New York and Harlow: Longman, 6th edn, 1998).

44 Nelson Goodman *Languages of Art: An Approach to a Theory of Symbols* (Indianapolis, IN: Hacket, 1976).

45 Robert Wicks 'Photography as a Representational Art', in *British Journal of Aesthetics* 29/1 (winter, 1989): 1–9.

Chapter 9 Film

1 *La Sortie des Ouvriers de l'Usine*, Lumière Brothers (France, 1895).

2 James Monaco, *How to Read a Film* (New York: Oxford University Press, 1981), p. 452.

3 *How it Feels to be Run Over*, Hepworth Manufacturing Company (UK, 1900).

4 In film-maker's shorthand, this is also known as the POV shot.

5 *The Explosion of a Motor Car*, Hepworth Manufacturing Company (UK, 1900).

6 It is interesting to speculate how such films were received by audiences at the time. It has often been reported that the Lumière brothers' *L'Arrivée d'un Train en Gare* (*The Arrival of a Train at a Station*) of 1895 had audiences diving for cover as the engine advanced upon them. More recent commentators have wondered, however, if people ever really were so impressionable. See, for example, David A. Cook, *A History of Narrative Film*, 3rd edn (New York: W. W. Norton and Company, 1996), p. 11(n).

7 The French film producer Georges Méliès was another pioneer of special effects, although specializing in studio novelties rather than live-action, outdoor productions. Stop-motion photography is not limited to early film: it was the stock–in trade of novelty TV situation comedies such as *Bewitched* and *I Dream of Jeannie*.

8 *Rescued by Rover*, Hepworth Manufacturing Company (UK, 1905).

9 Lassie is even a similar breed of dog to Rover. Lassie (in various reincarnations) was featured in a variety of films and television series from 1943. The Hollywood movie *Lassie Come Home* was directed by Fred M. Wilcox (USA, 1943) and featured a young Elizabeth Taylor, while the first American TV version of *Lassie* ran from 1954.

The Australian TV series *Skippy* (also syndicated internationally as *Skippy the Bush Kangaroo*) ran for ninety-one episodes, sometimes directed by Ed Devereaux, who also appeared as Matt, the head ranger.

10　Different people tend to use different terms for similar things in film-making, and this can lead to disagreements. Some people call the editing we see in *Rescued by Rover* 'match cutting on action'; others refer to it as a 'jump cut'. Monaco insists that it is the latter and that it must not be confused with the former (*How to Read a Film*, pp. 437 and 440). Cook prefers the former (*History of Narrative Film*, pp. 966 and 968). However, it is the concept rather than the nomenclature that concerns us here.

11　Some people call this 'cross-cutting'.

12　*The Lonedale Operator*, W. D. Griffith (USA, 1911). Cook argues for Edwin S. Porter's *The Life of an American Fireman* (USA, 1905) as the first example of cross-cutting, and that this achieved 'narrative omniscience over the linear flow of time, which the cinema of all arts can most credibly sustain' (*History of Narrative Film*, pp. 23–4).

13　An early and famous example of parallel action appears in Sergei Eisenstein's silent classic *The Battleship Potemkin* (USSR, 1925). Here, a group of sailors is ordered to open fire on a group of mutinous comrades. Eisenstein cuts back and forth between all manner of different shots, not only to heighten but also to lengthen the suspense.

14　To maintain spatial orientation, a number of other important conventions have to be applied, such as eye-line matching and the '180-degree rule'. This chapter seeks only to introduce the reader to the basic concepts and terminology. It does not attempt to serve as a film-maker's handbook.

15　The keen-eyed will be rewarded by the sight of the shadow of the helicopter used to photograph this sequence passing over the ground in the bottom right-hand corner of the frame.

16　In practice, some directors are more ethically motivated than others.

17　This is an expression used by the Scottish documentary film pioneer John Grierson.

18　Kracauer's aesthetic is best explained in his *Theory of Film: The Redemption of Physical Reality* (Princeton, NJ: Princeton University Press, 1997; orig. pub. Oxford: Oxford University Press, 1960).

19　See Rudolf Arnheim, *Film as Art* (London: Faber, 1969).

20　See, for example, T. W. Adorno and Max Horkheimer, 'The Culture Industry: Enlightenment as Mass Deception', in *The Dialectic of Enlightenment*, trans. John Cumming (London: Verso Editions, 1979).

21　See especially Walter Benjamin, 'The Work of Art in the Age of Mechanical Reproduction', in *Illuminations*, ed. Hannah Arendt, trans. Harry Zohn (New York: Schocken Books, 1969), pp. 217–51.

22　For more on the educational role of the media, including film, see Richard Howells, 'Media, Education and Democracy', in *The European Review* 9/2 (2001): 159–68.

23　This is, it must be said, a contentious point among media sociologists. Some claim that film creates rather than reflects public attitudes. Even if this is true, of course, it is still a useful documentation of the attitudes it has created.

24　Christian Metz, *Film Language: A Semiotics of the Cinema*, trans. Michael Taylor (New York: Oxford University Press, 1974); Peter Wollen, *Signs and Meaning in the Cinema* (London: British Film Institute, 4th rev. edn, 1998).

25　It is possible to speak, of course, of 'narrative' painting – but not in the same way.

26　Robert Stam, *Film Theory – An Introduction* (Malden, MA, and Oxford: Wiley-Blackwell, 2000), p. 256.

27　Gilles Deleuze, *Cinema I: The Movement-Image*, trans. Hugh Tomlinson and Barbara Habberjam (London: Athlone Press, 1986), and Gilles Deleuze, *Cinema*

II: The Time-Image, trans. Hugh Tomlinson and Robert Galeta (Minneapolis, MN: University of Minnesota Press, 1989).

28 Gilles Deleuze, *Cinema II: The Time-Image*, p. 17.

29 Henri Bergson, *Matter and Memory*, trans. Nancy M. Paul and W. Scott Palmer (New York: Zone Books, 1988; original French edition 1896).

30 Marc Augé, *Non-places – Introduction to an Anthropology of Supermodernity*, translated by John Howe (London and New York: Verso, 1995).

31 Gilles Deleuze, *Cinema II: The Time-Image*, p. xi.

32 We wonder if the proliferation of mobile phones and personal stereos has further increased the indeterminate nature of the public space today.

33 Gerald Mast, *A Short History of the Movies*, revised by Bruce Kawin (Boston, MA, and London: Allyn and Bacon, 6th edn, 1996).

34 David Bordwell, Janet Staiger and Kristin Thompson, *The Classical Hollywood Cinema* (London: Routledge, 1988).

35 Arnheim, *Film as Art*; Kracauer, *Theory of Film*.

36 Metz, *Film Language*; Wollen, *Signs and Meaning in the Cinema*.

37 J. Dudley Andrew, *The Major Film Theories* (London: Oxford University Press, 1976); David Bordwell and Kristin Thompson, *Film Art: An Introduction* (New York and London: McGraw-Hill, 4th edn, 1993); Gerald Mast, Marshall Cohen and Leo Braudy, *Film Theory and Criticism* (Oxford: Oxford University Press, 4th edn, 1992).

38 See, for example, Adorno and Horkheimer, 'The Culture Industry'.

39 Fred Inglis, *Media Theory* (Oxford: Blackwell, 1990).

40 Martha Wolfenstein and Nathan Leites, *Movies: A Psychological History* (Glencoe, IN: The Free Press, 1950).

41 Siegfried Kracauer, *From Caligari to Hitler* (Princeton, NJ: Princeton University Press, 5th printing, 1974), p. 5.

42 Stephen Powers, David J. Rothman and Stanley Rothman, *Hollywood's America* (Oxford: Westview, 1996); Jeffrey Richards, *Films and British National Identity* (Manchester: Manchester University Press, 1997).

43 Noel Carrol and Jinhee Choi (eds), *The Philosophy of Film and Motion Pictures: An Anthology* (Malden, MA, and Oxford: Wiley-Blackwell, 2006).

44 Ronald Bogue *Deleuze on Cinema* (New York and London, Routledge, 2003).

45 Thomas Elsaesser and Malte Hagener, *Film Theory: An Introduction through the Senses* (New York and Abingdon: Routledge, 2010).

46 James Monaco, *How to Read a Film* (New York and Oxford: Oxford University Press, rev. edn 1981).

47 Edward Pincus and Steven Ascher, *The Filmmaker's Handbook* (New York and Scarborough, Ontario: New American Library, 1984); Steven Ascher and Edward Pincus, *The Filmmaker's Handbook: A Comprehensive Guide for the Digital Age* (New York: Plume, 1999).

Chapter 10 Television

1 Andrew Bergman, *We're in the Money* (Chicago, IL: Elephant Paperbacks, 1992), p. xii. Bergman's book is an academic study of American films of the depression era. He also co-wrote *Blazing Saddles* (USA, 1974) with director Mel Brooks, wrote and directed *Honeymoon in Vegas* (USA, 1992), and wrote and directed the underrated *The Freshman* (USA, 1990), starring Matthew Broderick and Marlon Brando.

2 This is, of course, a necessarily introductory definition of the concept of the *auteur*.

3 James Monaco, *How to Read a Film* (New York and Oxford: Oxford University Press, 1981), p. 211.

4 Robert Warshow, *The Immediate Experience* (New York: Doubleday, 1962), p. 28.

5 Eugene Weber, *France: Fin de Siècle* (Cambridge, MA, and London: Harvard University Press, 1986), p. 4.

6 T. S. Eliot, *Notes Towards the Definition of Culture* (London: Faber and Faber, 1948), p. 92.

7 *The Predator*, directed by John McTiernan (USA, 1987).

8 Martha Wolfenstein and Nathan Leites, *Movies: A Psychological History* (Glencoe, IN: The Free Press, 1950), p. 306.

9 Anon, *Sir Gawain and the Green Knight*, trans. Burton Raffel (New York: 1970), ll. 1330–6.

10 Ian Fleming, *Dr No* (London: Heineman/Octopus, 1978), p. 23.

11 The show takes its name from British criminal slang for the police: 'the old Bill'.

12 This special episode was screened in 1994.

13 John Fiske, *Television Culture* (London and New York: Routledge, 1987), p. 21.

14 Linda S. Lichter, S. Robert Lichter and Stanley Rothman, *Watching America* (New York: Prentice Hall, 1991), pp. 114–15, 185, 197.

15 The precise number of episodes for *The Cosby Show* varies from 201 to 197, depending on whether pilots, double episodes etc. are included. The show was first screened in the USA in September 1984; worldwide circulation dates, of course, vary.

16 *The Brady Bunch* was first screened in 1969 and ran for 117 episodes until 1974.

17 Herman Gray, *Watching Race* (Minneapolis, MN: University of Minnesota Press, 1995), pp. 74, 75, 76, 77, 79.

18 Ibid., pp. 79, 80, 83.

19 Figures taken from The Center for Popular Economics, *The Economic Report of the People* (1986), and the US Department of Commerce, *Statistical Abstract of the United States* (1990), cited in Sut Jhally and Justin Lewis, *Enlightened Racism* (Boulder, CO, and Oxford: Westview Press, 1992), pp. 61–2.

20 See ibid., p. 63.

21 George Melly, *Revolt Into Style* (London: Allen Lane/Penguin Press, 1970), pp. 7–9; Ernst Mandel, *Delightful Murder* (London: Pluto Press, 1984), p. 134.

22 Richard Bruton, 'Today's Highlights', in the (London) *Daily Telegraph*, TV and Radio Section, 21 November 1992, p. 2.

23 Lichter et al., *Watching America*, pp. vii, 4, 21.

24 Mark Crispin Miller, *Boxed In* (Evanston, IL: Northwestern University Press, 1988), p. 61.

25 Jhally and Lewis, *Enlightened Racism*, p. 71.

26 Gray, *Watching Race*, p. 132.

27 Lichter et al., *Watching America*, p. 21.

28 Gray, *Watching Race*, pp. 80, 83.

29 Jhally and Lewis, *Enlightened Racism*, p. 132.

30 Gray, *Watching Race*, p. 79.

31 Ibid., pp. 81, 83.

32 Jhally and Lewis, *Enlightened Racism*, p. 132.

33 Gray, *Watching Race*, p. 81.

34 See, for example, David Gauntlett, *Moving Experiences: Understanding Television's Influences and Effects* (London: John Libbey, 1995).

35 Gray, *Watching Race*, p. 82.

36 This is, of course, a very partial and superficial summary of Frankfurt theory. For a provocative introduction to Frankfurt theory on popular culture, see T. W. Adorno and Max Horkheimer, 'The Culture Industry: Enlightenment as Mass Deception',

in *The Dialectic of Enlightenment*, trans. John Cumming (London: Verso Editions, 1979), pp. 120–67.

37 Jhally and Lewis, *Enlightened Racism*, pp. 71, 132, 138, 137.

38 Miller, *Boxed In*, p. 65.

39 Ibid.

40 Lichter et al., *Watching America*, pp. 4–14, 290.

41 Herbert Gans, *Popular Culture and High Culture* (New York: Basic Books, 1974), p. 103; also cited in Lichter et al., *Watching America*, p. 3.

42 Jhally and Lewis, *Enlightened Racism*, p. xv.

43 Early film stock has its own conservation problems.

44 This process began earlier in the United States than it did in the UK and the rest of the world.

45 John Fiske, *Television Culture* (London and New York: Routledge, 1987), p. 21.

46 Fiske *Television Culture*, p. 21.

47 John Hartley, 'Less Popular but More Democratic? *Corrie*, Clarkson and the Dancing *Cru*', in Graeme Turner and Jinna Tay (eds), *Television Studies after TV – Understanding Television in the Post-Broadcast Era* (New York: Routledge, 2009), pp. 20–30.

48 Hartley, 'Less Popular but More Democratic? *Corrie*, Clarkson and the Dancing *Cru*', p. 23.

49 Ibid.

50 Ibid.

51 Ibid., p. 21.

52 Arguably, academics, college professors, experts and 'media dons' also fit in this category.

53 Hartley, 'Less Popular but More Democratic? *Corrie*, Clarkson and the Dancing *Cru*', p. 21.

54 Ibid., p. 29.

55 The rise in interactive media has the potential, at least, to revive what Habermas has lamented as a 'de-politicized' public sphere.

56 Mark Andrejevic, 'The Twenty-first-century Telescreen', Graeme Turner and Jinna Tay (eds), *Television Studies after TV – Understanding Television in the Post-Broadcast Era* (New York: Routledge, 2009).

57 Ibid., p. 32.

58 John Fiske and John Hartley, *Reading Television* (London and New York: Routledge, 1978).

59 Marshall McLuhan, *The Gutenberg Galaxy* (London: Routledge and Kegan Paul, 1962); *Understanding Media* (London: Routledge and Kegan Paul, 1964); *The Mechanical Bride* (London: Routledge and Kegan Paul, 1967; first pub. New York: Vanguard Press, 1951).

60 Neil Postman, *Amusing Ourselves to Death* (New York: Viking, 1985).

61 Raymond Williams, *Television, Technology and Cultural Form*, ed. Ederyn Williams (London: Routledge, 2nd edn, 1990; first pub. London: Fontana, 1974); *Raymond Williams on Television*, ed. Alan O'Connor (New York: Routledge, 1989); David Marc, *Demographic Vistas* (Philadelphia, PA: Philadelphia University Press, rev. edn, 1996).

62 Richard Dyer, *Light Entertainment* (London: British Film Institute, 1973); Roger Silverstone, *The Message of Television* (London: Heinemann Educational, 1981).

63 Lynne Joyrich *Re-viewing Reception: Television, Gender and Postmodern Culture* (Bloomington, IN: Indiana University Press, 1996).

64 Milly Buonanno, *The Age of Television: Experiences and Theories*, translated by Jennifer Radice (Chicago, IL: University of Chicago Press, 2007).

65 Stephen Lax, *Beyond the Horizon: Communications Technologies, Past, Present and Future* (Luton: University of Luton Press, 1997).

Chapter 11 New Media

1 We acknowledge the many useful conversations Richard Howells had with Terry Prendergast on the digital 'revolution' in photography.

2 For more on the 'Cottingley fairies', see Joe Cooper, *The Case of the Cottingley Fairies* (London: Robert Hale, 1990), and a series of articles by Geoffrey Crawley in the *British Journal of Photography* from 1982 to 1985.

3 For a full account of political photography from this period, see David King, *The Commissar Vanishes: The Falsification of Photographs and Art in Stalin's Russia* (Edinburgh: Canongate, 1997).

4 John Ellis, for example, has argued that the typical form of the cinema is the Hollywood movie, while the typical forms of television are the series and the serial. For this reason, he argues that cinema and television are not interchangeable media. See John Ellis, *Visible Fictions* (London: Routledge and Kegan Paul, 1982).

5 See Marshall McLuhan, *Understanding Media* (London: Routledge and Kegan Paul, 1964).

6 That McLuhan used 'deliberate overstatement' is the view of Fred Inglis in *Media Theory* (Oxford: Blackwell, 1990), p. 42(n).

7 'Panning and scanning' is a process by which a film is effectively rephotographed by a moving television camera so as not to miss action that would otherwise be lost by cutting a widescreen film down to size to make it fit a standard television screen (see ch. 10).

8 Some critics have claimed that there is a significant theoretical difference between the two media in that one is projected onto a screen while the other is radiated from a screen. That there is a difference is clear, but its significance is debatable.

9 John Logie Baird first demonstrated television to the Royal Institution in London in 1926, while the BBC began its first public TV broadcast service ten years later. The medium underwent a hiatus during the Second World War, but started gathering momentum in the 1940s. It was the following decade, however, that saw the real expansion of television as a mass consumer medium on both sides of the Atlantic. It was during the 1950s, also, that television began to make an impact on cinema audiences.

10 Linda Lichter, S. Robert Lichter and Stanley Rothman, *Watching America* (New York: Prentice Hall), p. 80.

11 The precise life span of the domestic video tape can, at this stage, be only a matter of educated conjecture.

12 The DVD is also known as the 'Digital Versatile Disc'. It was launched in 1996, reaching consumer markets the following year.

13 See, for example, Peter Golding and Graham Murdock, 'Culture, Communications and Political Economy', in James Curran and Michael Gurevich (eds), *Mass Media and Society* (London: Edward Arnold, 1991), pp. 15–32, and Nicholas Garnham, *Capitalism and Communication* (London: Sage, 1990). The contribution of the Frankfurt School to media theory is based upon broad (rather than specific) assumptions about its political economy.

14 See, for example, Roland Barthes, *Image, Music Text*, ed. and trans. Stephen Heath (London: Fontana, 1997); Susan R. Suleiman and Inge Crossman (eds), *The Reader in the Text* (Princeton, NJ: Princeton University Press, 1980).

15 See Janice Radway, *Reading the Romance* (Chapel Hill, NC: University of North

Carolina Press, 1984), and Ien Ang, *Watching Dallas*, trans. Della Couling (London: Methuen, 1985).

16 For an argument in favour of the development of a sociology of reception, see, for example, John B. Thompson, 'Mass Communication and Modern Culture: Contribution to a Critical Theory of Ideology', in *Sociology* 22 (August 1988): 359–83.

17 See, for example. Stephen Lax, 'The Internet and Democracy', in David Gauntlett (ed.), *Web.Studies* (London: Arnold, 2000), pp. 159–69.

18 Economies of scale, of course, affect the amateur photographer as well as the professional.

19 Michael Baxandall, *Painting and Experience in Fifteenth Century Italy* (Oxford: Clarendon Press, 1972).

20 John Berger, *Ways of Seeing* (London: BBC and Penguin Books, 1972). See esp. pp. 21–30.

21 Walter Benjamin, 'The Work of Art in the Age of Mechanical Reproduction', in *Illuminations*, ed. Hannah Arendt, trans. Harry Zohn (New York: Schocken Books, 1969), p. 244.

22 Communications technology theorists may argue that the WWW is an 'interface' rather than a medium.

23 The extent to which interactivity is socially as opposed to technologically constrained is a matter for further discussion.

24 Eva Pariser, 'Artists' Websites: Declarations of Identity and Presentations of Self', in David Gauntlett (ed.), *Web.Studies* (London: Arnold, 2000), p. 62.

25 See Andrew Goodwin, *Dancing in the Distraction Factory* (Minneapolis, MN: University of Minnesota Press, 1992), pp. 29 and 202(n).

26 See, for example, ibid., p. 4.

27 Ibid., pp. 30, xvii.

28 Ibid., pp. 50ff.

29 Ibid., p. 75. Goodwin further notes the importance of the television variety show, in particular, to the music video (p. 77).

30 Ibid., p. xxii.

31 Ibid., pp. 70, 62, 72–3, 75, 78–84.

32 Ibid., p. 90.

33 The video was directed by Francis Lawrence and produced by Lynn Zekanis. It was actually shot on film on a sound stage in Nevada once *Armageddon* was almost complete.

34 Goodwin, *Dancing in the Distraction Factory*, p. 84.

35 The traditional haiku originated in the sixteenth century and comprises three non-rhyming lines of five, seven and five syllables each.

36 For more on Eisenstein's montage theory, see Sergei Eisenstein, *Film Form*, ed. and trans. Jay Leyda (Cleveland, OH: Meridian, 1957), and *Film Sense*, ed. and trans. Jay Leyda (Cleveland, OH: Meridian, 1957).

37 Erwin Panofsky, *Studies in Iconology* (New York: Harper and Row), p. 7.

38 Bob, not Thomas.

39 A possible exception would be when a noted film director makes a music video, such as when John Landis directed work for Michael Jackson in the 1980s.

40 Berger, *Ways of Seeing*, p. 47. Some music videos, such as Madonna's *Express Yourself* (directed by David Fincher, USA, 1989), appear to reverse the equation.

41 Lev Manovich, *The Language of New Media* (Cambridge, MA: MIT Press, 2002).

42 Ibid., p. 16.

43 Ibid., p. 95.

44 Anonymous, 'Art That Resembles Nature', in the *New York Times*, 10 January 1886.

45 Manovich, *The Language of New Media*, p. 61.

46 Ibid.

47 Asa Briggs, 'The Communications Revolution', third Mansbridge Memorial Lecture, delivered to the University of Leeds, 16 October 1965, pamphlet (Leeds: University of Leeds 1966).

48 Carolyn Marvin, *When Old Technologies Were New* (Oxford: Oxford University Press, 1988).

49 Thomas S. Kuhn, *The Structure of Scientific Revolutions* (Chicago, IL, and London: University of Chicago Press, 3rd edn, 1996).

50 Brian Winston, *Media Technology and Society* (London: Routledge, 1998); David Crowley and Paul Heyer (eds), *Communication in History* (New York and Harlow: Longman, 3rd edn, 1999); Hugh Mackay and Tim O'Sullivan (eds), *The Media Reader* (London: Sage, 1999).

51 Stephen Lax, *Beyond the Horizon: Communications Technologies, Past, Present and Future* (Luton: University of Luton Press, 1997); Tony Feldman, *An Introduction to Digital Media* (London: Routledge, 1997); Michael M. A. Mirabito, *The New Communications Technologies* (Boston, MA, and Oxford: Focal Press, 3rd edn, 1997).

52 William H. Dutton (ed.), *Information and Communication Technologies: Visions and Realities* (Oxford: Oxford University Press, 1996); Patrick Barwise and Kathy Hammond, *Media* (London: Phoenix, 1998); Frances Cairncross, *The Death of Distance: How the Communications Revolution Will Change Our Lives* (London: Texere, 2nd edn, 2001); Michael Traber, *The Myth of the Information Revolution* (London: Sage, 1986).

53 Simon Frith, Andrew Goodwin and Lawrence Grossberg, *Sound and Vision: The Music Video Reader* (London: Routledge, 1993).

54 E. Ann Kaplan, *Rocking Around the Clock* (New York and London: Methuen, 1987); Lisa A. Lewis, *Gender Politics and MTV* (Philadelphia, PA: Temple University Press, 1990).

55 David Bell, *An Introduction to Cybercultures* (London: Routledge, 2001); David Gauntlett (ed.), *Web.Studies* (London: Arnold, 2000); Steven G. Jones (ed.), *Virtual Culture: Identity and Communication in Cybersociety* (London: Sage, 1997); Don Tapscott, *Growing Up Digital: The Rise of the Net Generation* (New York: McGraw Hill, 1998).

56 Martin Lister (ed.), *The Photographic Image in Digital Culture* (London: Routledge, 1995); Terence Wright, *The Photography Handbook* (London: Routledge, 1999); Anne-Marie Willis, 'Digitisation and the Living Death of Photography', in Philip Hayward (ed.), *Culture, Technology and Creativity* (London: John Libbey, 1990; repr. Luton: University of Luton Press, 1994), pp. 197–208.

57 Martin Lister, Jon Dovey, Seth Giddings, Ian Grant and Kieran Kelly, *New Media: A Critical Introduction* (London and New York: Routledge, 2003).

58 Nicholas Gane and David Beer, *New Media: The Key Concepts* (Oxford: Berg, 2008).

59 Steven Ascher and Edward Pincus, *The Filmmaker's Handbook: A Comprehensive Guide for the Digital Age* (New York: Plume, 1999); Nigel Chapman and Jenny Chapman, *Digital Multimedia* (Chichester, West Sussex: Wiley, 1999); Richard Wise with Jeanette Steemers, *Multimedia: A Critical Introduction* (London: Routledge, 2000).

BIBLIOGRAPHY

Adorno, T. W. and Max Horkheimer, 'The Culture Industry: Enlightenment as Mass Deception', in *The Dialectic of Enlightenment*, trans. John Cumming (London: Verso Editions, 1979).

Alberti, Leon Battista, *On Painting*, ed. and trans. John R. Spencer (New Haven, CT: Yale University Press, 1966).

Alberti, Leon Battista, *On Painting and On Sculpture*, ed. and trans. Cecil Grayson (London: Phaedon, 1972).

Alberti, Leon Battista, *On the Art of Building in Ten Books*, trans. Joseph Rykwert, Neil Leach and Robert Tavernor (Cambridge, MA, and London: MIT Press, 1988).

Althusser, Louis, 'Ideology and Ideological State Apparatuses: Notes Towards and Investigation', in Althusser (ed.), *Lenin and Philosophy and Other Essays*, trans. Ben Brewster (London: Monthly Review Press, 1971), pp. 85–126.

Andrejevic, Mark, 'The twenty-first-century Telescreen', in Graeme Turner and Jinna Tay (eds), *Television Studies after TV – Understanding Television in the Post-Broadcast Era* (New York: Routledge, 2009), pp. 31–40.

Andrew, J. Dudley, *The Major Film Theories* (London: Oxford University Press, 1976).

Ang, Ien, *Watching Dallas*, trans. Della Couling (London: Methuen, 1985).

Anon, *Sir Gawain and the Green Knight*, trans. Burton Raffel (New York: 1970), ll. 1330–6.

Armstrong, Carol, *Scenes in a Library* (Cambridge, MA: MIT Press, 1998).

Arnheim, Rudolf, *Film as Art* (London: Faber, 1969).

Arnold, Matthew, *Culture and Anarchy*, ed. Samuel Lipman, Rethinking the Western Tradition (New Haven, CT, and London: Yale University Press, 1994).

Ascher, Steven, and Edward Pincus, *The Filmmaker's Handbook: A Comprehensive Guide for the Digital Age* (New York: Plume, 1999).

Augé, Marc, *Non-places – Introduction to an Anthropology of Supermodernity*, trans. John Howe (London and New York: Verso Editions, 1995).

Barthes, Roland, *Elements of Semiology/Writing Degree Zero*, trans. Annette Lavers and Colin Smith (Boston, MA: Beacon Press, 1968).

Barthes, Roland, *Image, Music, Text*, trans. Stephen Heath, Fontana Communications (London: Fontana, 1977).

Barthes, Roland, *Camera Lucida*, trans. Richard Howard (London: Flamingo, 1984).

Barthes, Roland, *The Semiotic Challenge*, trans. Richard Howard (Oxford: Blackwell, 1988).

Barthes, Roland, *S/Z*, trans. Richard Miller (Oxford: Blackwell, 1990).

Barthes, Roland, *Mythologies*, trans. Annette Lavers (London: Vintage, 1993).

Barwise, Patrick, and Kathy Hammond, *Media*, Predictions 16 (London: Phoenix, 1998).

Baudrillard, Jean, 'The Evil Demon of Images', in Clive Cazeaux (ed.), *The Continental Aesthetics Reader* (London and New York: Routledge, 2000), pp. 444–52.

Baudrillard, Jean, 'Simulacra and Simulations', in Mark Poster (ed.), *Selected Writings* (Cambridge: Polity, 2001), pp. 169–87.

Baxandall, Michael, *Painting and Experience in Fifteenth Century Italy* (Oxford: Oxford University Press, 1974).

Bazin, André, 'The Ontology of the Photographic Image', in *What is Cinema? Volume I*, trans. Hugh Gray (Berkeley, CA: University of California Press, 1967), pp. 9–16.

Bell, Clive, *Art*, ed. J. B. Bullen (Oxford: Oxford University Press, 1987 [1914]).

Bell, Clive, 'The Aesthetic Hypothesis', in Charles Harrison and Paul Wood (eds), *Art in Theory* (Oxford: Blackwell, 1992), pp. 113–16.

Bell, David, *An Introduction to Cybercultures* (London: Routledge, 2001).

Benedict, Ruth, *Patterns of Culture* (London: Routledge and Kegan Paul, 1935; 5th impression, 1952).

Benjamin, Walter, *The Work of Art in the Age of Mechanical Reproduction*, trans. J. A. Underwood (London: Penguin Books, 2008, first published 1936).

Benjamin, Walter, Theodor Adorno, Ernst Bloch, Bertolt Brecht and Georg Lukács, *Aesthetics and Politics* (London and New York: Verso 2007).

Berger, John, *Ways of Seeing* (London: British Broadcasting Corporation and Penguin Books, 1972).

Bergman, Andrew, *We're in the Money* (Chicago, IL: Elephant Paperbacks, 1992).

Bergson, Henri, *Matter and Memory*, trans. Nancy M. Paul and W. Scott Palmer (New York: Zone Books, 1988; original French edition 1896).

Bogue, Ronald, *Deleuze on Cinema* (New York and London, Routledge, 2003).

Bordwell, David, and Kristin Thompson, *Film Art: An Introduction* (New York and London: McGraw-Hill, 4th edn, 1993).

Bordwell, David, Janet Staiger and Kristin Thompson, *The Classical Hollywood Cinema* (London: Routledge, 1988).

Bourdieu, Pierre, *Outline of a Theory of Practice*, trans. Richard Nice (Cambridge: Cambridge University Press, 1977).

Bourdieu, Pierre, *The Logic of Practice*, trans. Richard Nice (Cambridge: Polity, and Stanford: Stanford University Press, 1990).

Bourdieu, Pierre, *The Field of Cultural Production*, ed. Randal Johnson (Cambridge: Polity, 1993; reprinted 2000).

Bourdieu, Pierre, *Photography: A Middle-brow Art*, trans. Shaun Whiteside (Cambridge: Polity, 1990; paperback edn, 1996).

Bourdieu, Pierre, *Distinction*, translated by Richard Nice (London, Routledge, 2010).

Bredius, Abraham, 'A New Vermeer', in *The Burlington Magazine for Connoisseurs* 71/416 (November 1937): 210–11.

Briggs, Asa, 'The Communications Revolution', third Mansbridge Memorial Lecture, delivered to the University of Leeds, 16 October 1965, pamphlet (Leeds: University of Leeds, 1966).

Brown, Dan, *The Da Vinci Code* (New York: Random House, 2003).

Bruton, Richard, 'Today's Highlights', in the (London) *Daily Telegraph*, TV and Radio Section, 21 November 1992, p. 2.

Buonanno, Milly, *The Age of Television: Experiences and Theories*, trans. Jennifer Radice (Chicago, IL: The University of Chicago Press, 2007).

Butler, Judith P., *Gender Trouble* (New York and London: Routledge, 1990).

Cairncross, Frances, *The Death of Distance: How the Communications Revolution Will Change Our Lives* (London: Texere, 2nd edn, 2001).

Carrol, Noel and Jinhee Choi (eds), *The Philosophy of Film and Motion Pictures: An Anthology* (Malden, MA, and Oxford: Wiley-Blackwell, 2006).

Chaplin, Elizabeth, *Sociology and Visual Representation* (London: Routledge, 1994).

Chapman, Nigel, and Jenny Chapman, *Digital Multimedia*, Worldwide Series in Computer Science (Chichester, West Sussex: Wiley, 1999).

Chiarenza, Carl, *Aaron Siskind: Pleasures and Terrors* (New York: New York Graphic Society, 1982).

Clark, Kenneth (Baron Clark), *Civilization* (London: British Broadcasting Corporation and John Murray, 1969).

Clifford, James, and George E. Marcus, *Writing Culture* (Berkeley, CA: University of California Press, 1986).

Cook, David A., *A History of Narrative Film* (New York: W. W. Norton and Company, 3rd edn, 1996).

Cooper, Joe, *The Case of the Cottingley Fairies* (London: Robert Hale, 1990).

Crapanzano, Vincent, 'Hermes' Dilemma: The Masking of Subversion in Ethnographic Description', in James Clifford and George E. Marcus (eds), *Writing Culture* (Berkeley, CA: University of California Press, 1986), pp. 51–76.

Crowley, David, and Paul Heyer (eds), *Communication in History* (New York and Harlow: Longman, 3rd edn, 1999).

Debord, Guy, *Society of the Spectacle*, trans. Donald Nicholson-Smith (New York: Zone Books, 1994; originally published in 1967).

Deleuze, Gilles, *Cinema I: The Movement-Image*, trans. Hugh Tomlinson and Barbara Habberjam (London: Athlone Press, 1986).

Deleuze, Gilles, *Cinema II: The Time-Image*, trans. Hugh Tomlinson and Robert Galeta (Minneapolis, MN: University of Minnesota Press, 1989).

Derrida, Jacques, *The Truth in Painting* (Chicago, IL: University of Chicago Press, 1987).

Duncan, Carol 'Virility and Domination in Early Twentieth Century Vanguard Painting' (1973), reprinted in Normal Broude and Mary Garrard (eds), *Feminism and Art History* (New Haven, CT: Yale University Press, 1982).

Dunn, John, *Political Obligation in its Historical Context* (Cambridge: Cambridge University Press, 1980).

Dutton, Denis, 'Artistic Crimes', in Alex Neil and Aaron Ridley (eds), *Arguing About Art: Contemporary Philosophical Debates* (London: Routledge, 2007), pp. 100–11.

Dutton, William H. (ed.), *Information and Communication Technologies: Visions and Realities* (Oxford: Oxford University Press, 1996).

Dyer, Richard, *Light Entertainment*, BFI Television Monographs (London: British Film Institute, 1973).

Eco, Umberto, *A Theory of Semiotics*, Advances in Semiotics (Bloomington, IN, and London: Indiana University Press, 1976).

Ehrenzweig, Anton, *The Hidden Order of Art* (London: Weidenfeld and Nicolson, 1967).

Eisenstein, Sergei, *Film Form*, ed. and trans. Jay Leyda (Cleveland, OH: Meridian, 1957).

Eisenstein, Sergei, *Film Sense*, ed. and trans. Jay Leyda (Cleveland, OH: Meridian, 1957).

Eliot, T. S., *Notes Towards the Definition of Culture* (London: Faber and Faber, 1948).

Elkins, James, *Is Art History Global? (The Art Seminar)* (London and New York: Routledge, 2006).

Elkins, James, Zhivka Valiavicharska, and Alice Kim (eds), *Art and Globalization* (Philadelphia, PA: The Pennsylvania University Press, 2010).

Ellis, John, *Visible Fictions* (London: Routledge and Kegan Paul, 1982).

Elsaesser, Thomas, and Malte Hagener, *Film Theory: An Introduction through the Senses* (New York and Abingdon: Routledge, 2010).

Feldman, Tony, *An Introduction to Digital Media* (London: Routledge, 1997).

Fiske, John, *Television Culture* (London and New York: Routledge, 1987).

Fiske, John, and John Hartley, *Reading Television*, New Accents (London and New York: Routledge, 1978).

Ian Fleming, *Dr No* (London: Heineman/Octopus, 1978).

Foucault, Michel, *Discipline and Punish: The Birth of the Prison*, trans. Alan Sheridan (New York: Vintage, 1979).

Fried, Michael, *Art and Objecthood* (Chicago, IL: University of Chicago Press, 1998).

Frith, Simon, Andrew Goodwin and Lawrence Grossberg, *Sound and Vision: The Music Video Reader* (London: Routledge, 1993).

Frizot, Michel (ed.), *A New History of Photography* (Cologne: Könemann, 1998).

Fry, Roger, 'An Essay in Aesthetics', in *Vision and Design* (Harmondsworth: Pelican Books, 1937), pp. 22–40.

Fry, Roger, 'The French Post-Impressionists', in *Vision and Design* (Harmondsworth: Pelican Books, 1937), pp. 194–8.

Fry, Roger, 'Retrospect', in *Vision and Design* (Harmondsworth: Pelican Books, 1937), pp. 229–44.

Fry, Roger, 'The Double Nature of Painting', in *Apollo* (May 1969): 362–71.

Fry, Roger, *A Roger Fry Reader*, ed. Christopher Reed (Chicago, IL, and London: Chicago University Press, 1996).

Fuller, Peter, *Seeing Berger* (London: Writers and Readers Publishing Coop Ltd, 2nd edn, 1981).

Fuller, Peter, *Seeing Through Berger* (London: The Claridge Press, 1988).

Fuller, Peter, 'Frans Hals' (Royal Academy exhibition review) in *Modern Painters* 2/2 (winter 1989): 74–6.

Fuller, Peter, 'The Wrong Perspective on Art', in the (London) *Daily Telegraph*, Weekend Telegraph section (13 January 1990), p. xv.

Gadamer, Hans-Georg, *Truth and Method*, ed. Garrett Barden and John Cumming, trans. William Glen-Duepel (London: Sheed and Ward, 1975).

Gadamer, Hans-Georg, *Philosophical Hermeneutics*, ed. and trans. David Linge (Berkeley, CA: University of California Press, 1976).

Gane, Nicholas, and David Beer, *New Media: The Key Concepts* (Oxford: Berg, 2008).

Gans, Herbert, *Popular Culture and High Culture* (New York: Basic Books, 1974).

Gant, Berys, *A Philosophy of Cinematic Art* (Cambridge: Cambridge University Press, 2010).

Garnham, Nicholas, *Capitalism and Communication*, Media, Culture and Society series (London: Sage, 1990).

Gauntlett, David, *Moving Experiences: Understanding Television's Influences and Effects* (London: John Libbey, 1995).

Gauntlett, David (ed.), *Web.Studies* (London: Arnold, 2000).

Geertz, Clifford, *The Interpretation of Cultures* (New York: Basic Books, 1973).

Geertz, Clifford, *Local Knowledge* (New York: Basic Books, 1983).

Giarda, Christophorus, *Bibliothecae Alexandrinae Icones Symbolicae; with Introductory Notes by Stephen Orgel* (New York: Garland, 1979 [1628]).

Golding, Peter, and Graham Murdock, 'Culture, Communications and Political Economy', in James Curran and Michael Gurevich (eds), *Mass Media and Society* (London: Edward Arnold, 1991), pp. 15–32.

Goldmann, Lucien, *The Hidden God: A Study of Tragic Vision in the 'Pensées' of Pascal and the Tragedies of Racine*, trans. Philip Thody (New York: Humanities Press and London: Routledge and Kegan Paul, 1964).

Goldmann, Lucien, *Towards a Sociology of the Novel*, trans. Alan Sheridan (London: Tavistock Publications, 1975).

Gombrich, E. H., *Art and Illusion* (Oxford: Phaidon Press, 5th edn, 1977).

Gombrich, E. H., *Aby Warburg: An Intellectual Biography* (Oxford: Phaidon, 2nd edn, 1986).

Gombrich, E. H., *The Story of Art* (Oxford: Phaidon, 15th edn, 1989).

Goodman, Nelson, *Languages of Art: An Approach to a Theory of Symbols* (Indianapolis, IN: Hacket, 1976).

Goodwin, Andrew, *Dancing in the Distraction Factory* (Minneapolis, MN: University of Minnesota Press, 1992).

Gray, Herman, *Watching Race* (Minneapolis, MN: University of Minnesota Press, 1995).

Greenberg, Clement, *Art and Culture* (London: Thames and Hudson, 1973).

Greenberg, Clement, *Collected Essays and Criticism*, ed. John O'Brian, 4 vols (Chicago, IL: University of Chicago Press, 1986–93).

Greenberg, Clement, *Homemade Aesthetics: Observations on Art and Taste* (Oxford: Oxford University Press, 1999).

Greenlee, Douglas, *Peirce's Concept of Sign*, Approaches to Semiotics (The Hague and Paris: Mouton, 1973).

Gregory, R. L., and E. H. Gombrich, *Illusion in Nature and Art* (London: Duckworth, 1973).

Groom, Nick, *The Forger's Shadow: How Forgery Changed the Course of Literature* (London: Picador, 2002).

Hadjinicolaou, Nicos, *Art History and Class Struggle*, trans. Louise Asmal (London: Pluto, 1978).

Haftmann, Werner, *Painting in the Twentieth Century: An Analysis of the Artists and their Work* (New York: Holt Rinehart Winston, 1965).

Hall, Stuart (ed.), *Representation: Cultural Representations and Signifying Practices* (London: Sage, 1997).

Hall, Stuart, 'The Work of Representation', in Hall (ed.), *Representation: Cultural Representations and Signifying Practices* (London: Sage, 1997), pp. 13–74.

Hamilton, Peter, 'Representing the Social: France and Frenchness in Post-War Humanist Photography', in Stuart Hall (ed.), *Representation: Cultural Representations and Signifying Practices* (London: Sage, 1997), pp. 75–150.

Harris, Ann Sutherland, and Linda Nochlin, *Women Artists 1550–1950* (Los Angeles, CA: County Museum of Art and New York; Alfred A. Knopf, 1978).

Harrison, Charles, and Paul Wood (eds), *Art in Theory 1900–1990* (Oxford: Blackwell, 1992).

Harrison, Charles, and Paul Wood, *Art in Theory: An Anthology of Changing Ideas* (Malden, MA, and Oxford: Wiley-Blackwell, 2003).

Hartley, John, 'Less Popular but More Democratic? *Corrie*, Clarkson and the Dancing *Cru*', in Graeme Turner and Jinna Tay (eds), *Television Studies after TV – Understanding Television in the Post-Broadcast Era* (New York: Routledge, 2009), pp. 20–30.

Haworth-Booth, Mark (ed.), *The Golden Age of British Photography* (Millerton, New York: Aperture, 1984).

Hawthorne, Nathaniel, *The Scarlet Letter* (New York and Cambridge: Literary Classics of the United States and the Press Syndicate, University of Cambridge, 1983).

Hayward, Philip (ed.), *Culture, Technology and Creativity* (London: John Libbey, 1990; reprinted Luton: University of Luton Press, 1994).

Helmer, James, 'Love on a Bun: How McDonald's Won the Burger Wars', in the *Journal of Popular Culture* 26/2 (fall 1992): 85–97.

Hockney, David, *Secret Knowledge* (London: Thames and Hudson, 2001).

Horrocks, Chris, and Zoran Jetvic, *Introducing Baudrillard: A Graphic Guide* (New York: Totem Books, 1996).

Howells, Richard, 'Atlantic Crossings: Nation, Class and Identity in "Titanic" (1953) and "A Night to Remember" (1958)', in *The Historical Journal of Film, Radio and Television* 9/4 (October 1999): 421–38.

Howells, Richard, *The Myth of the Titanic* (London: Macmillan and New York: St Martin's Press, 1999).

Howells, Richard, 'Order and Fantasy: An Interview with Aaron Siskind', in *Word and Image* 15/3 (1999): 277–85.

Howells, Richard, 'Media, Education and Democracy', in *The European Review* 9/2 (2001): 159–68.

Howells, Richard, and Robert W. Matson, *Using Visual Evidence* (Maidenhead and New York: Open University Press/McGraw-Hill Education, 2009).

Huizinga, Johan, *The Waning of the Middle Ages* (Harmondsworth: Penguin, 1972).

Inglis, Fred, *Media Theory* (Oxford: Blackwell, 1990).

Inglis, Fred, *Clifford Geertz*, Key Contemporary Thinkers (Cambridge: Polity, 2000).

Jackson-Stops, Gervase (ed.), *The Treasure Houses of Britain: Five Hundred Years of Private Patronage and Art Collecting* (Washington, DC: National Gallery of Art; New Haven, CT: Yale University Press, 1985).

Janson, H. W., *History of Art*, ed. Anthony F. Janson (London: Thames and Hudson, 6th edn, 2001).

Janson, H. W., and Anthony F. Janson, *History of Art* (New York: Harry N. Abrams, 1986).

Jhally, Sut, and Justin Lewis, *Enlightened Racism*, Cultural Studies (Boulder, CO, and Oxford: Westview Press, 1992).

Jones, Steven G. (ed.), *Virtual Culture: Identity and Communication in Cybersociety* (London: Sage, 1997).

Joyrich, Lynne, *Re-viewing Reception: Television, Gender and Postmodern Culture* (Bloomington, IN: Indiana University Press, 1996).

Kandinsky, Wassily, *Concerning the Spiritual in Art*, trans. M. T. H. Sadler (New York: Dover Publications, 1977).

Kant, Immanuel, *Critique of Judgment*, trans. James Creed Meredith and ed. Nicholas Walker (Oxford: Oxford University Press, 2007).

Kant, Immanuel, *Critique of Pure Reason*, trans. and ed. Marcus Weigelt, based on the translation by Max Müller (London: Penguin Classics, 2007).

Kaplan, E. Ann, *Rocking Around the Clock* (New York and London: Methuen, 1987).

Kepes, Gyorgy, 'Introduction', in Gyorgy Kepes (ed.), *Education of Vision*, Vision and Value (New York: George Braziller, 1965), pp. i–vii.

Kesner, Ladislav, 'Is a Truly Global Art History Possible?', in James Elkins (ed.), *Is Art History Global? (The Art Seminar)*, (London and New York: Routlege, 2006), pp. 81–111.

King, David, *The Commissar Vanishes: The Falsification of Photographs and Art in Stalin's Russia* (Edinburgh: Canongate, 1997).

King, William L., 'Scruton and Reasons to Look at Photographs', in Alex Neil and Aaron Ridley (eds), *Arguing about Art: Contemporary Philosophical Debates* (London: Routledge, 1995; 2nd edn, 2002), 215–22.

Knightley, Phillip, *The First Casualty: The War Correspondent as Hero and Myth-maker from the Crimea to Kosovo* (London: Prion, rvsd edn, 2000).

Koestler, Arthur, 'The Aesthetics of Snobbery', in *Horizon* 8 (1965): 50–3.

Kracauer, Siegfried, *From Caligari to Hitler* (Princeton, NJ: Princeton University Press, 5th printing, 1974).

Kracauer, Siegfried, *Theory of Film: The Redemption of Physical Reality* (Princeton, NJ: Princeton University Press, 1997; orig. pub. Oxford: Oxford University Press, 1960).

Kuhn, Nicola, 'Das Prinzip der Kennerschaft', *Der Tagesspiegel* (29 January 2006).

Kuhn, Thomas S., *The Structure of Scientific Revolutions* (Chicago, IL, and London: University of Chicago Press, 3rd edn, 1996).

Lambert, Craig, 'Reviewing Reality', in *Harvard Magazine* (March–April 2007): 40–5.

Lax, Stephen, *Beyond the Horizon: Communications Technologies, Past, Present and Future* (Luton: University of Luton Press, 1997).

Lax, Stephen, 'The Internet and Democracy', in David Gauntlett (ed.), *Web.Studies* (London: Arnold, 2000), pp. 159–69.

Lemagny, Jean-Claude, and André Rouillé (eds), *A History of Photography*, trans. Janet Lloyd (Cambridge: Cambridge University Press, 1987).

Lewis, Lisa A., *Gender Politics and MTV* (Philadelphia, PA: Temple University Press, 1990).

Lichter, Linda S., S. Robert Lichter and Stanley Rothman, *Watching America* (New York: Prentice Hall, 1991).

Lipps, Theodor, *Aesthetik. Psychologie des Shonen and der Kunst* (Hamburg and Leipzig: Voss, 1903).

Lister, Martin, (ed.), *The Photographic Image in Digital Culture* (London: Routledge, 1995).

Lister, Martin, Jon Dovey, Seth Giddings, Ian Grant and Kieran Kelly *New Media: A Critical Introduction* (London and New York: Routledge, 2003).

London, Barbara, and John Upton, *Photography* (New York and Harlow: Longman, 6th edn, 1998).

Lyons, Nathan, *Aaron Siskind, Photographer* (New York: George Eastman House, 1965).

McCann, Graham, 'Jouissance: A Messy Business', in *The Modern Review* (winter 1991/92): 31.

McEvilley, Thomas, 'Father and Void', in *Art and Discontent: Theory at the Millennium* (New York: Documentext, 1991), p. 169.

Mackay, Hugh, and Tim O'Sullivan (eds), *The Media Reader* (London: Sage, 1999).

McLuhan, Marshall, *The Gutenberg Galaxy* (London: Routledge and Kegan Paul, 1962).

McLuhan, Marshall, *Understanding Media* (London: Routledge and Kegan Paul, 1964).

McLuhan, Marshall, *The Mechanical Bride* (London: Routledge and Kegan Paul, 1967).

Mâle, Emile, *Religious Art in France: The XIIIth Century* (Princeton, NJ: Princeton University Press, 1984).

Mâle, Emile, *Religious Art in France: The Late Middle Ages* (Princeton, NJ: Princeton University Press, 1986).

Mandel, Ernst, *Delightful Murder* (London: Pluto Press, 1984).

Manovich, Lev, *The Language of New Media* (Cambridge, MA: MIT Press, 2002).

Maranda, Pierre, 'The Dialectic Metaphor: An Anthropological Essay on Hermeneutics',

in Susan Suleiman and Inge Crossman (eds), *The Reader in the Text* (Princeton, NJ: Princeton University Press, 1980), pp. 183–204.

Marc, David, *Demographic Vistas* (Philadelphia, PA: Philadelphia University Press, rvsd edn, 1996).

Marvin, Carolyn, *When Old Technologies Were New* (Oxford: Oxford University Press, 1988).

Marx, Karl, and Friedrich Engels, *The Communist Manifesto* (Harmondsworth: Penguin, 1967).

Mast, Gerald, *A Short History of the Movies*, revised by Bruce Kawin (Boston, MA, and London: Allyn and Bacon, 6th edn, 1996).

Mast, Gerald, Marshall Cohen and Leo Braudy, *Film Theory and Criticism* (Oxford: Oxford University Press, 4th edn, 1992).

Melly, George, *Revolt Into Style* (London: Allen Lane/The Penguin Press, 1970).

Melville, Herman, *Moby Dick* (Hertfordshire: Woodsworth Editions Limited, 1993), ch. 99.

Metz, Christian, *Film Language: A Semiotics of the Cinema*, trans. Michael Taylor (New York: Oxford University Press, 1974).

Miller, Mark Crispin, *Boxed In* (Evanston, IL: Northwestern University Press, 1988).

Mirabito, Michael M. A., *The New Communications Technologies* (Boston, MA, and Oxford: Focal Press, 3rd edn, 1997).

Mirzoeff, N. (ed.), *The Visual Culture Reader* (London and New York: Routledge, 1999).

Mirzoeff, N., *An Introduction to Visual Culture*, (London and New York: Routledge, 2nd edn, 2009).

Mitchell, W. J. T., *The Reconfigured Eye – Visual Truth in the Post-Photographic Era* (Cambridge, MA, and London, 1992).

Mitchell, W. J. T., 'Word and Image', in Robert Nelson and Richard Shiff (eds), *Critical Terms for Art History* (Chicago, IL, and London: University of Chicago Press, 1996), pp. 51–61.

Mitchell, W. J. T., *Iconology: Image, Text, Ideology* (Chicago, IL, and London: University of Chicago Press, 2003).

Mitchell, W. J. T., *What Do Pictures Want? The Lives and Loves of Images* (Chicago, IL, and London: University of Chicago Press, 2005).

Monaco, James, *How to Read a Film* (New York: Oxford University Press, 1981; 3rd edn, 1998).

Moxey, Keith, *The Practice of Theory: Poststructuralism, Cultural Politics, and Art History* (Ithaca, NY, and London: Cornell University Press, 1994).

Mulvey, Laura, 'Visual Pleasure and Narrative Cinema', in *Screen* 16/3 (1975): 6–18.

Mulvey, Laura, *Visual and Other Pleasures*, Language, Discourse and Society (Bloomington, IN: Indiana University Press, 1988).

Newhall, Beaumont, *The Daguerreotype in America* (New York: Dover Publications/ London: Constable, 1976).

Newhall, Beaumont, *The History of Photography* (New York: The Museum of Modern Art, 5th edn, 1986).

Nochlin, Linda, *Women Art and Power and Other Essays* (New York: Harper and Row, 1988).

North, John, *The Ambassadors' Secret: Holbein and the World of the Renaissance* (London: Hambledon and London, 2002).

Onians, John (ed.), *Art Atlas* (London: Lawrence King Publishing, 2008).

Panofsky, Erwin, *The Life and Art of Albrecht Dürer* (Princeton, NJ: Princeton University Press, 1971).

Panofsky, Erwin, *Studies in Iconology* (New York: Harper and Row, 1972).

Pariser, Eva, 'Artists' Websites: Declarations of Identity and Presentations of Self', in David Gauntlett (ed.), *Web.Studies* (London: Arnold, 2000), pp. 62–7.

Parker, Rozsika, and Griselda Pollock, *Old Mistresses: Women, Art and Ideology* (London: Routledge and Kegan Paul, 1981).

Peirce, Charles S., *Semiotic and Significs*, ed. Charles S. Hardwick and James Cook (Bloomington, IN: Indiana University Press, 1977).

Peirce, Charles S., *Peirce on Signs*, ed. James Hoopes (Chapel Hill, NC: University of North Carolina Press, 1991).

Perry, Gill, 'The Decorative and the "culte de la vie": Matisse and Fauvism', in Charles Harrison, Francis Frascina and Gill Perry, *Primitivism, Cubism, Abstraction: The Early Twentieth Century* (New York: Harper and Row, 1993), p. 56.

Pincus, Edward, and Steven Ascher, *The Filmmaker's Handbook* (New York and Scarborough, Ontario: New American Library, 1984).

Pollock, Griselda, 'Trouble in the Archives, in *Women's Art Magazine* 54 (September/ October 1993): 11.

Postman, Neil, *Amusing Ourselves to Death* (New York: Viking, 1985).

Powers, Stephen, David J. Rothman and Stanley Rothman, *Hollywood's America* (Oxford: Westview, 1996).

Preziosi, Donald, *Rethinking Art History* (New Haven, CT: Yale University Press, 1989).

Radway, Janice, *Reading the Romance* (Chapel Hill, NC: University of North Carolina Press, 1984).

Reynolds, Sir Joshua, *Discourses in Art*, ed. Robert R. Wark (New Haven, CT: Yale University Press, 1975).

Richards, Jeffrey, *Films and British National Identity* (Manchester: Manchester University Press, 1997).

Richardson, George, *Iconology; with Introductory Notes by Stephen Orgel* (New York: Garland, 1974 [1799]).

Ricoeur, Paul, *The Conflict of Interpretations: Essays in Hermeneutics*, ed. Don Ihde, Studies in Phenomenology and Existential Philosophy (Evanston, IL: Northwestern University Press, 1974).

Ricoeur, Paul, *Hermeneutics and the Human Sciences*, ed. and trans. John Thompson (Cambridge: Cambridge University Press, 1981).

Ricoeur, Paul, *From Text to Action: Essays in Hermeneutics II*, trans. Kathleen Blamey and John Thompson (London: Athlone, 1991).

Riegl, A., *Stilfragen: Grundlegungen zu einer Geschichte der Ornamentik* (Berlin: G. Siemens, 1893).

Ripa, Cesare, *Iconologia; with Translations and Commentaries by Edward A. Masser* (New York: Dover, 1971 [1593]).

Roberts, John, *Art Has No History!* (London: Verso Editions, 1994).

Rosenberg, Jacob, Seymour Slive and E. H. ter Kuile, *Dutch Art and Architecture, 1600– 1800*, The Pelican History of Art (Harmondsworth: Penguin, 3rd edn, 1977).

John Ruskin, *The Elements of Drawing*, notes by Bernard Dunstan (London: Herbert, 1991).

Russell, John, 'Art View: In View of the Real Thing', in the *New York Times* (1 December 1985).

Said, Edward W., *Orientalism* (New York: Pantheon, 1978).

Saussure, Ferdinand de, *Cours de Linguistique Générale*, ed. Eisuke Komatsu (French) and George Wolf (English and trans.), Language and Communication Library, vol. 15 (Oxford: Pergamon, 1996).

Schama, Simon, *An Embarrassment of Riches: An Interpretation of Dutch Culture in the Golden Age* (London: Collins, 1987).

Scruton, Roger, *The Aesthetic Understanding* (London: Methuen, 1984).

Scruton, Roger, *Kant: A Very Short Introduction* (Oxford: Oxford University Press, 2001).

Seslar, Patrick, *The One-Hour Watercolourist* (Newton Abbot, Devon: David and Charles, 2001).

Sharpe, R. A. *(Contemporary Aesthetics* (Brighton: Harvester, 1983).

Silverstone, Roger, *The Message of Television* (London: Heinemann Educational, 1981).

Slive, Seymour, *Frans Hals*, exhibition catalogue, National Gallery of Art, Washington; Royal Academy of Arts, London; Frans Hals Museum, Haarlem; 1989–90 (Munich: Prestel, 1989).

Slive, Seymour, *Dutch Painting 1600–1800*, Yale University Press Pelican History of Art (New Haven, CT, and London: Yale University Press, 1995).

Smith, Richard G. (ed.), *The Baudrillard Dictionary* (Edinburgh: Edinburgh University Press, 2010).

Sontag, Susan, *On Photography* (New York: The Noonday Press, 1989).

Spencer, John R., 'Introduction' to Leon Battista Alberti, *On Painting* (New Haven, CT: Yale University Press, 1966), pp. 1–32.

Sperber, Dan, 'Claude Lévi-Strauss', in John Sturrock (ed.), *Structuralism and Since* (Oxford: Oxford University Press, 1977), pp. 19–51.

Stam, Robert, *Film Theory – An Introduction* (Malden, MA, and Oxford: Wiley-Blackwell, 2000).

Sturken, Marita and Susan Cartwright, *Practices of Looking – An Introduction to Visual Culture* (Oxford and New York: Oxford University Press, 2009).

Suleiman, Susan, and Inge Crossman, 'Introduction: Varieties of Audience-Orientated Criticism', in Susan Suleiman and Inge Crossman (eds), *The Reader in the Text* (Princeton, NJ: Princeton University Press, 1980), pp. 3–45.

Szunyoghy, András, and György Fehér, *Human Anatomy for Artists* (Cologne: Könemann, 2000).

Tagg, John, *The Burden of Representation* (Basingstoke: Macmillan Education, 1988).

Tapscott, Don, *Growing Up Digital: The Rise of the Net Generation* (New York: McGraw Hill, 1998).

Taylor, Philip M., *Munitions of the Mind: A History of Propaganda from the Ancient World to the Present Era* (Manchester: Manchester University Press, 1995).

Taylor, Philip M., *War and the Media: Propaganda and Persuasion in the Gulf War* (Manchester: Manchester University Press, 1998).

Thompson, John B., 'Mass Communication and Modern Culture: Contribution to a Critical Theory of Ideology', in *Sociology* 22 (August 1988): 359–83.

Thompson, John B., *Ideology and Modern Culture* (Cambridge: Polity, 1990; repr. 1994).

Thompson, John B., *The Media and Modernity* (Cambridge: Polity, 1995).

Traber, Michael, *The Myth of the Information Revolution*, Sage Communications in Society (London: Sage, 1986).

Tucker, Anne Wilkes, Claire Cass and Stephen Daiter (eds), *This Was the Photo League* (Chicago, IL: Stephen Daiter Gallery/Houston: John Cleary Gallery, 2001).

Varnedoe, Kirk, *Pictures of Nothing: Abstract Art since Pollock* (Princeton, NJ: Princeton University Press, 2006).

Warburton, Nigel, 'Varieties of Photographic Representation', *History of Photography* 15/3 (autumn 1991): 203–10.

Warburton, Nigel, 'Individual Style in Photographic Art', in Alex Neil and Aaron Ridley (eds), *Arguing about Art: Contemporary Philosophical Debates* (London: Routledge, 1995, 2nd edn 2002), pp. 223–31.

Warshow, Robert, *The Immediate Experience* (New York: Doubleday, 1962).

Weaver, Mike (ed.), *The Art of Photography 1839–1989* (London: The Royal Academy of Arts/New Haven, CT: Yale University Press, 1989).

Weber, Eugene, *France: Fin de Siècle* (Cambridge, MA, and London: Harvard University Press, 1986).

Wells, Liz (ed.), *Photography: A Critical Introduction* (London: Routledge, 2nd edn, 2000).

Wheale, Nigel (ed.), *The Postmodern Arts: An Introduction* (London and New York: Routledge, 1995).

Whiteley, Nigel, 'Readers of the Lost Art', in Heywood and Sandywell (eds), *Interpreting Visual Culture – Explorations in the Hermeneutics of the Visual* (London and New York: Routledge, 1999), pp. 99–122.

Wicks, Robert, 'Photography as a Representational Art', in *British Journal of Aesthetics* 29/1 (winter, 1989): 1–9.

Wieseman, Marjorie E., *A Closer Look: Deceptions and Discoveries* (London: National Gallery, 2010).

Williams, Linda, *Viewing Positions: Ways of Seeing Film*, Depth of Field (New Brunswick, NJ: Rutgers University Press, 1995).

Williams, Raymond, *Raymond Williams on Television*, ed. Alan O'Connor (New York: Routledge, 1989).

Williams, Raymond, *Television, Technology and Cultural Form*, ed. Ederyn Williams (London: Routledge, 2nd edn, 1990).

Williamson, Judith, *Consuming Passions* (London: Marion Boyars, 1985).

Williamson, Judith, *Decoding Advertisements*, Ideas in Progress (London: Marion Boyars, 1978; repr. 1994).

Willis, Anne-Marie, 'Digitisation and the Living Death of Photography', in Philip Hayward (ed.), *Culture, Technology and Creativity* (London: John Libbey, 1990; repr. Luton: University of Luton Press, 1994), pp. 197–208.

Winston, Brian, *Media Technology and Society* (London: Routledge, 1998).

Wise, Richard, with Jeanette Steemers, *Multimedia: A Critical Introduction* (London: Routledge, 2000).

Wolfenstein, Martha, and Nathan Leites, *Movies: A Psychological History* (Glencoe, IN: The Free Press, 1950).

Wollen, Peter, *Signs and Meaning in the Cinema* (London: British Film Institute, 4th rev. edn, 1998).

Woolf, Virginia, *Roger Fry* (Harmondsworth: Peregrine Books, 1979).

Worringer, Wilhelm, *Abstraction and Empathy: A Contribution to the Psychology of Style*, trans. Michael Bullock (London: Routledge and Kegan Paul, 1948).

Wright, Terence, *The Photography Handbook* (London: Routledge, 1999).

Wynne, Frank, *I Was Vermeer: The Legend of the Forger Who Swindled the Nazis* (London: Bloomsbury, 2006).

INDEX